REMEMBER WHEN

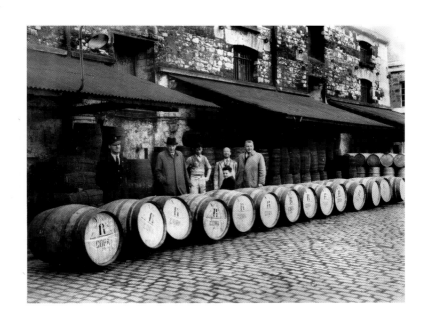

If you would like any of these photographs . . .

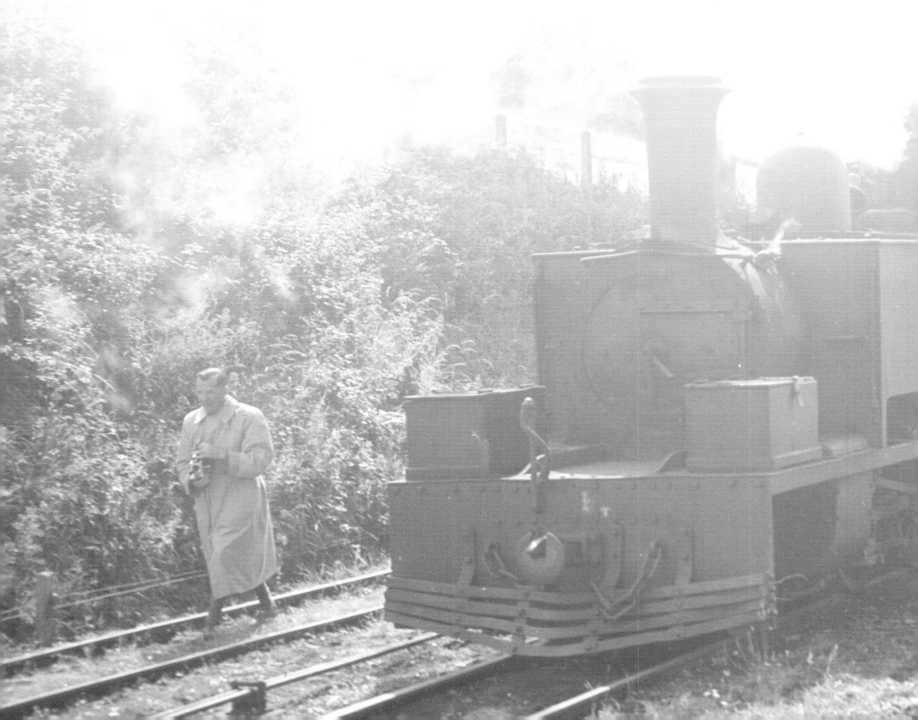

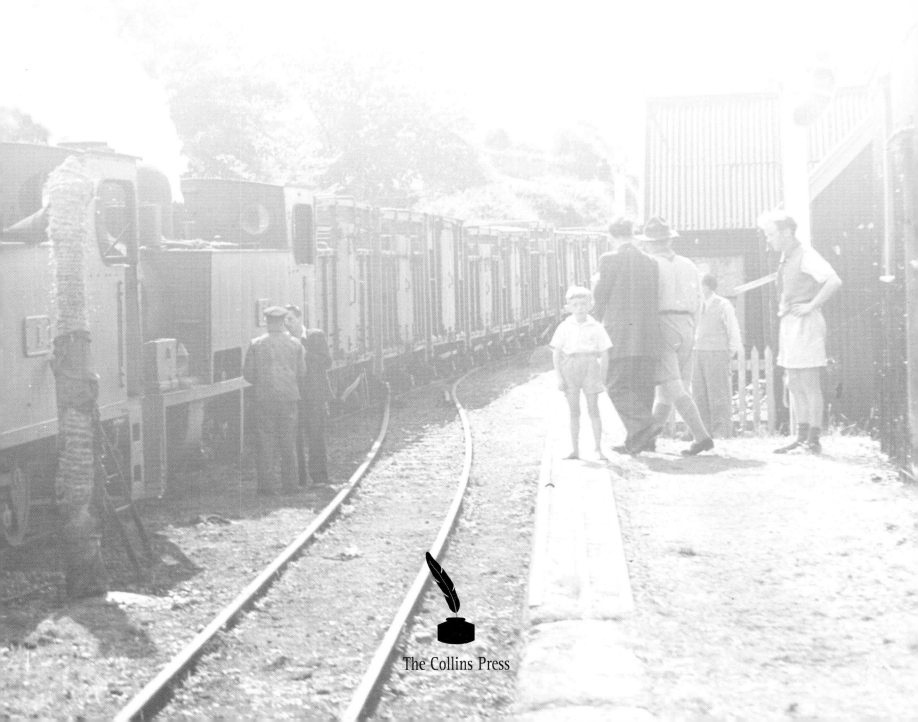

REMEMBER WHEN

Pictures from the **Irish Examiner** archive

The Collins Press

INTRODUCTION

IT WAS one of the great marketing slogans for a revolutionary invention: 'You press the button and we do the rest.' The year was 1888 and the invention was George Eastman's Kodak camera, bringing photography to the American masses for the first time.

A little over a decade later, the then *Cork Examiner* was one of the first newspapers to employ a full-time photographer, Thomas Barker. The appointment underlined the prescience of the newspaper's owners in relation to the crucial role photography would play in the years and decades ahead. Indeed, when Tom Barker went on board a ship in Cobh in 1912 to take some photographs, nobody knew then that his pictures on the deck of the *Titanic* would become such historic images that haunt to this day.

That was then and this is now, the age when virtually every teenager and adult in the developed world carries a camera with them at all times, in the form of the ubiquitous mobile phone. Now everyone can capture images of varying degrees of importance, from moments of simple family fun to on-the-spot 'citizen journalism' photographs of major international news events.

The taking of photographs is one thing, but preserving them for posterity is another. We all have taken pictures at some stage that we wish we still possessed. The book that you are holding in your hands is testimony to the importance of meticulous cataloguing and archiving, to preserve the past for the education, entertainment and sheer enjoyment of future generations.

Remember When is a wonderful snapshot of times past, mostly of ordinary people doing ordinary things – children going to school, picnics by the seaside, sports fans celebrating, people shopping – and it is all the more fascinating for that. We can see how life and fashions have changed through the years, frozen forever in time by our photographers. I wish to pay tribute to, and thank, all those photographers, too numerous to mention, who have contributed so much to making the newspaper what it is today, and to everybody who helped make this book a reality.

I hope you enjoy it.

Tim Vaughan
Editor, *Irish Examiner*

July 1980 Kathy Barry, Dalton's Avenue, off Cornmarket Street, Cork. *268/175*

28 October 1955 (following page)
Playing conkers during lunchtime at the new
Glasheen School, Cork. *586H*

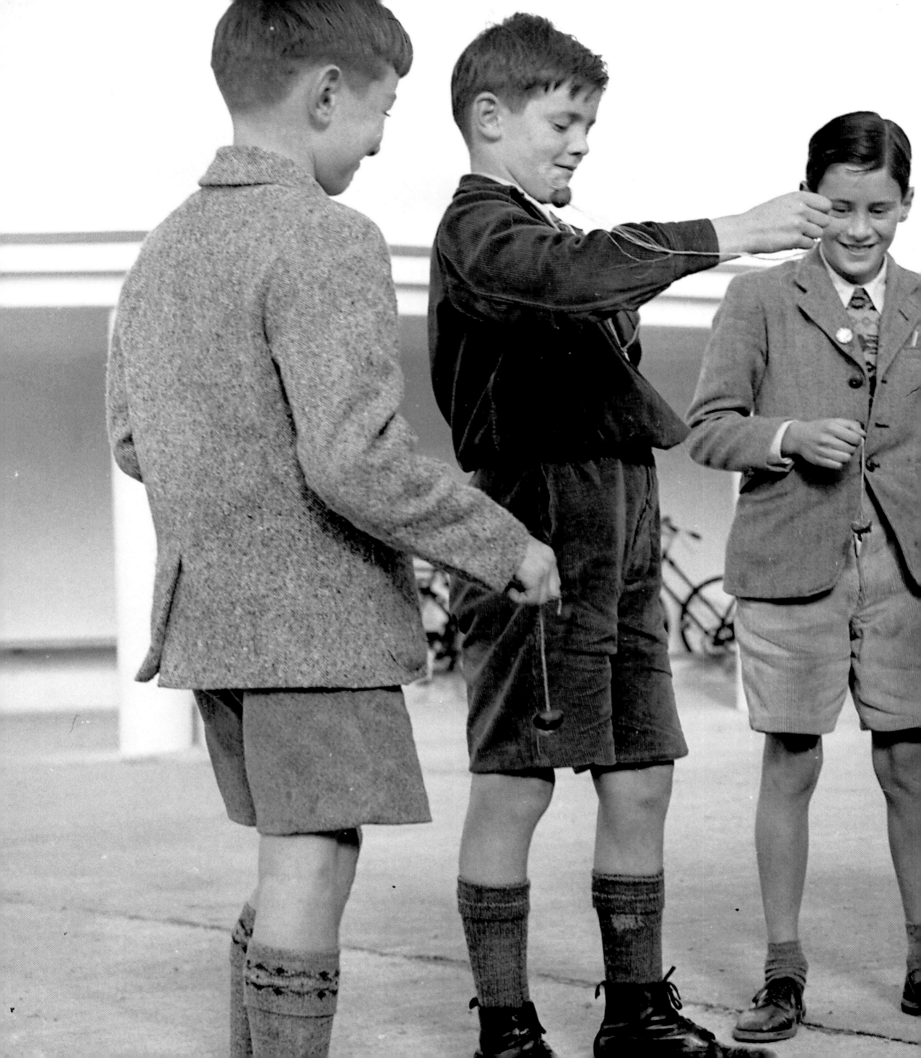

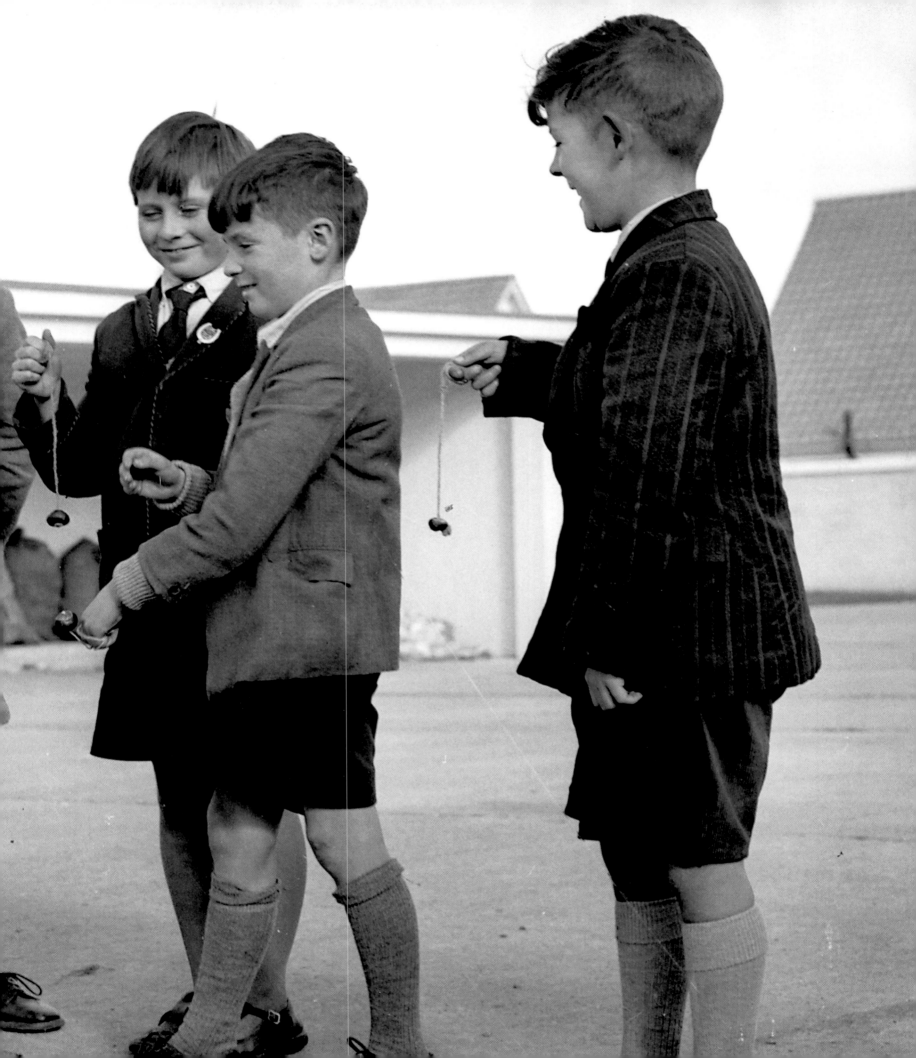

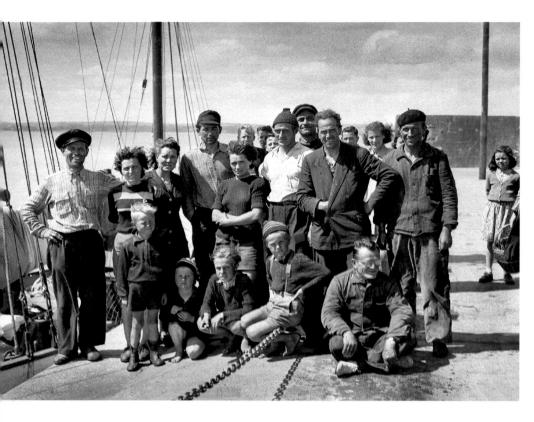

15 June 1951 Second World War refugees, who sailed from Germany, on Ballycotton pier, County Cork. *56E*

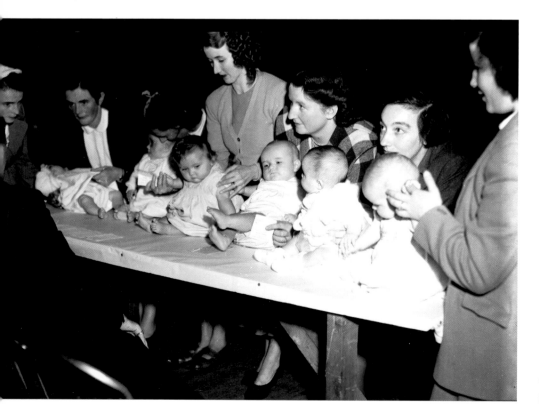

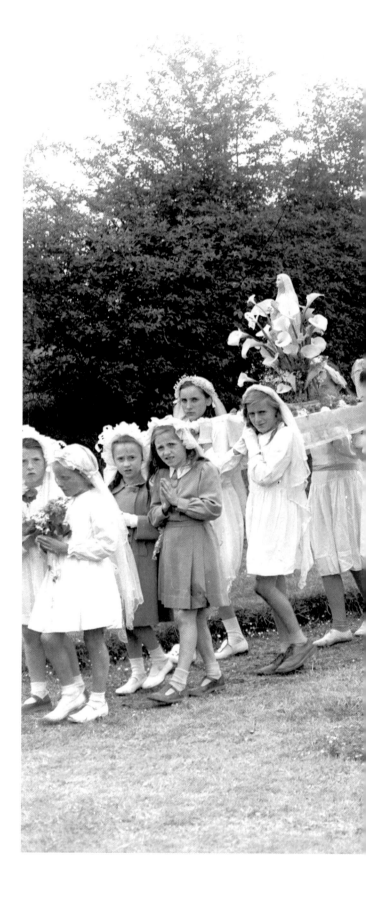

4 October 1951 Baby show at City Hall, Cork. *212E*

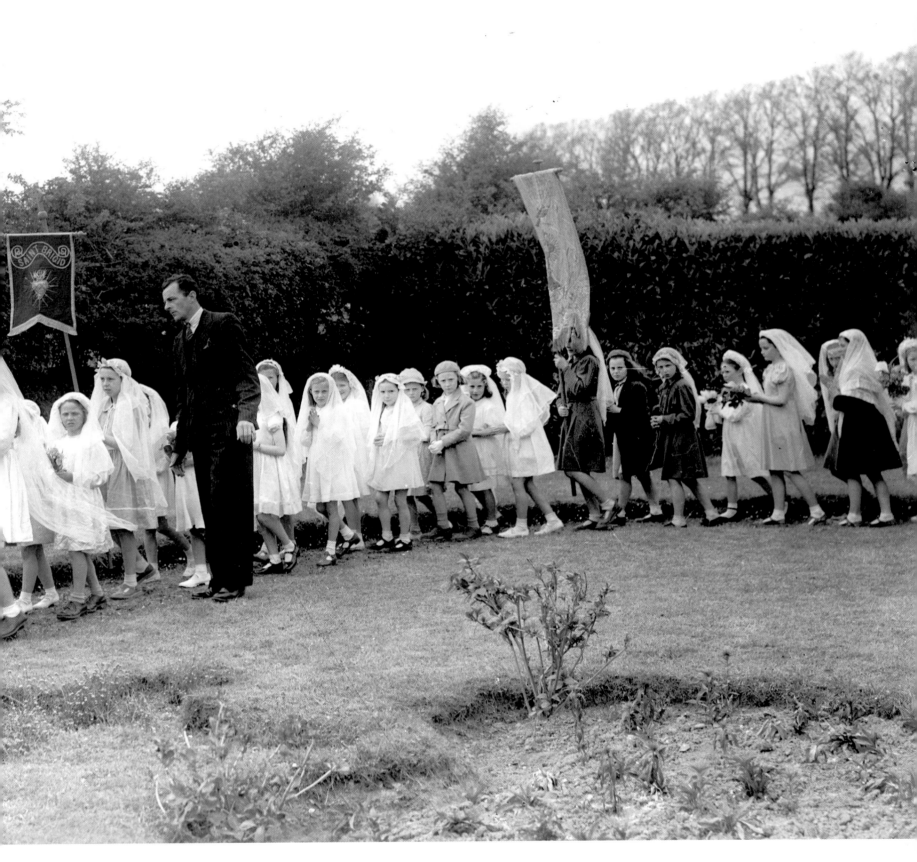

15 May 1949 May procession at Clogheen church, County Cork. *621D*

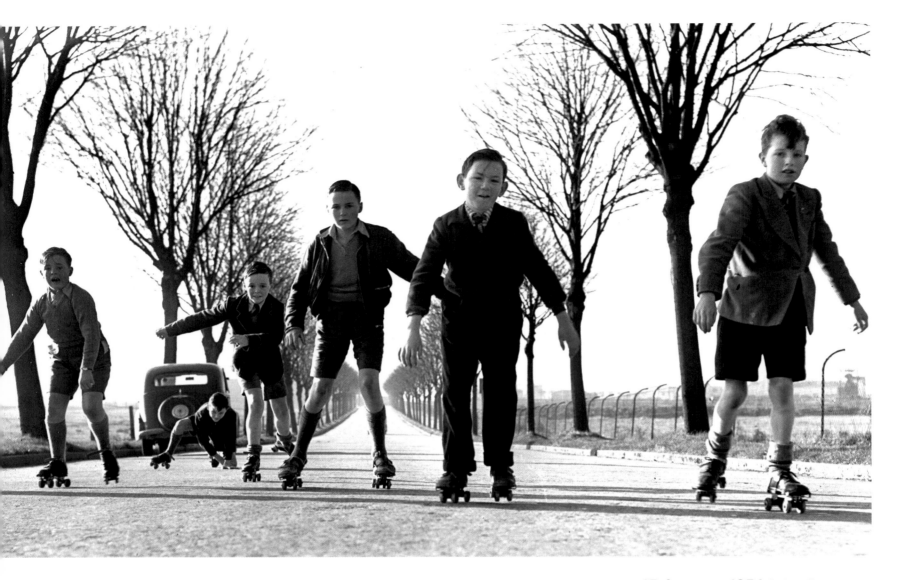

15 January 1954 Schoolboys roller-skating in Centre Park Road, Cork. *414G*

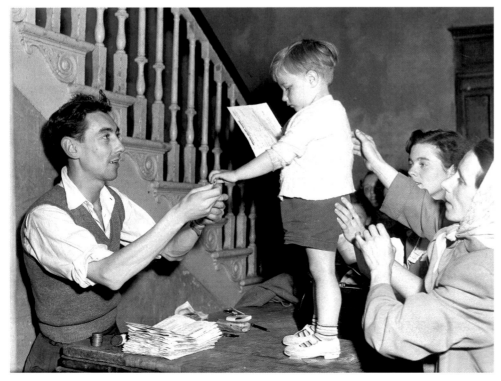

29 July 1954 A young extra holding an artist's salary voucher receives his payment on the set of the film *Moby Dick* in Youghal, County Cork. *780G*

4

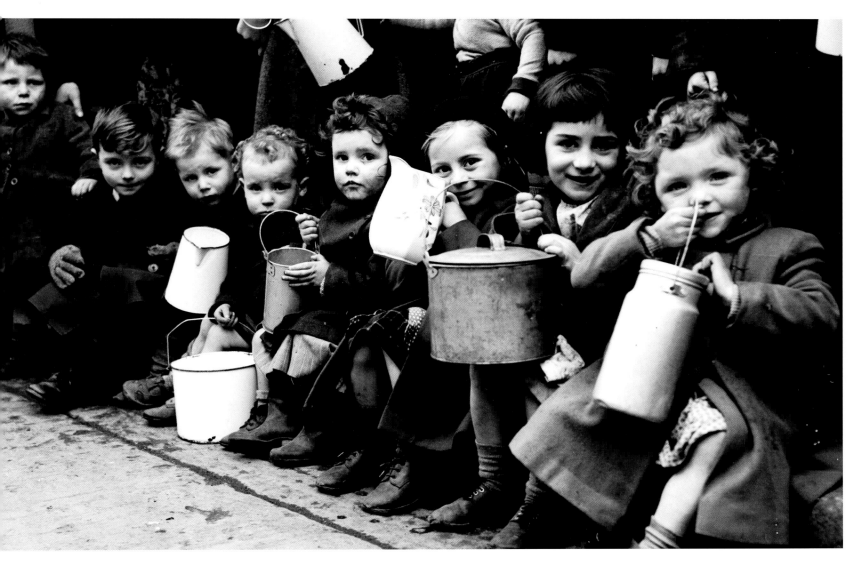

January 1953 Milk Strike: holding their empty vessels, some of these children have a smile for the camera as they wait for their turn to collect milk. *866E*

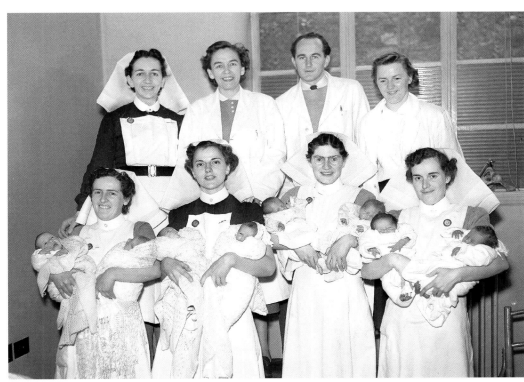

December 1956
Four sets of twins born at St Finbarr's Hospital, Cork. *592h*

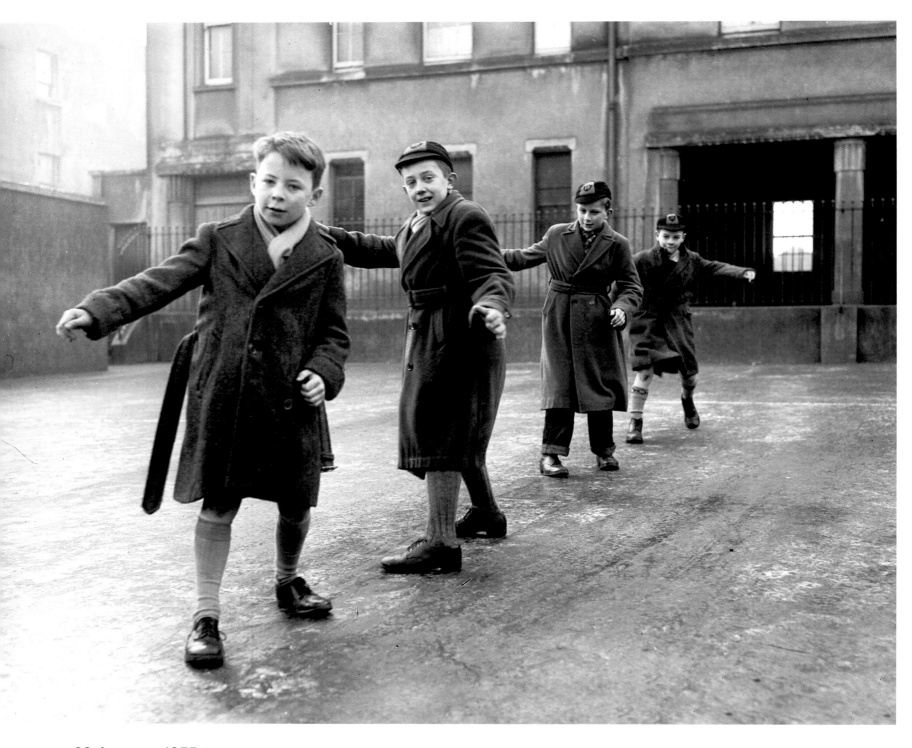

22 January 1955 Children sliding down a frozen path, Sullivan's Quay, Cork. *103H*

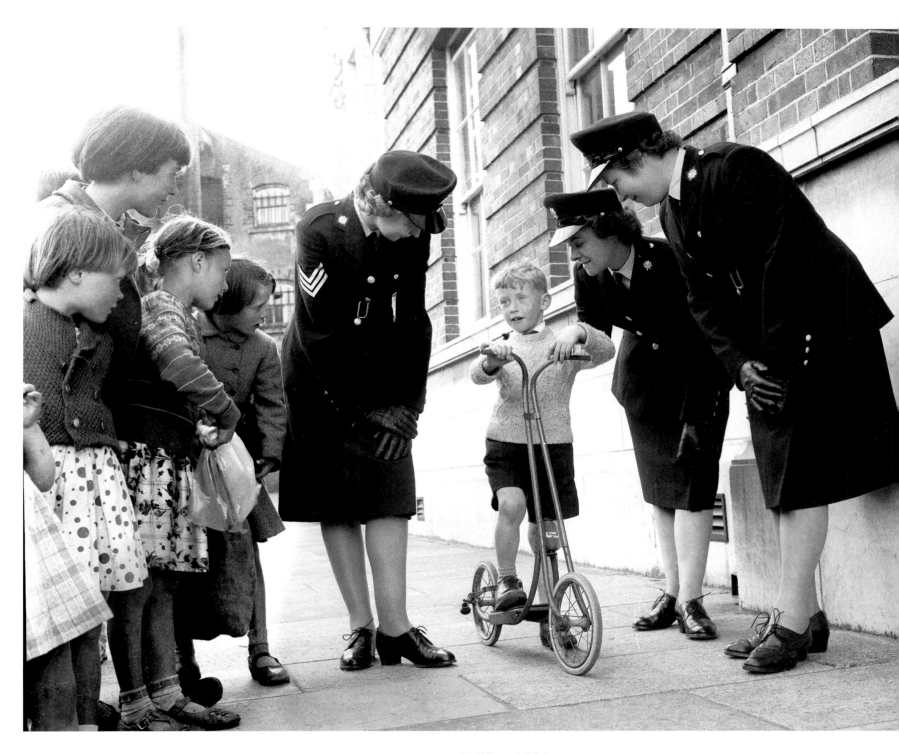

19 May 1961 Little Tony Daly from the North Mall, Cork, was driving his scooter through the city when he met these Ban Gardaí, who had started duties at the Bridewell Garda Station (l–r): Sergeant Helen Hayden, Margaret Lohan and Mary Molloy. *772L*

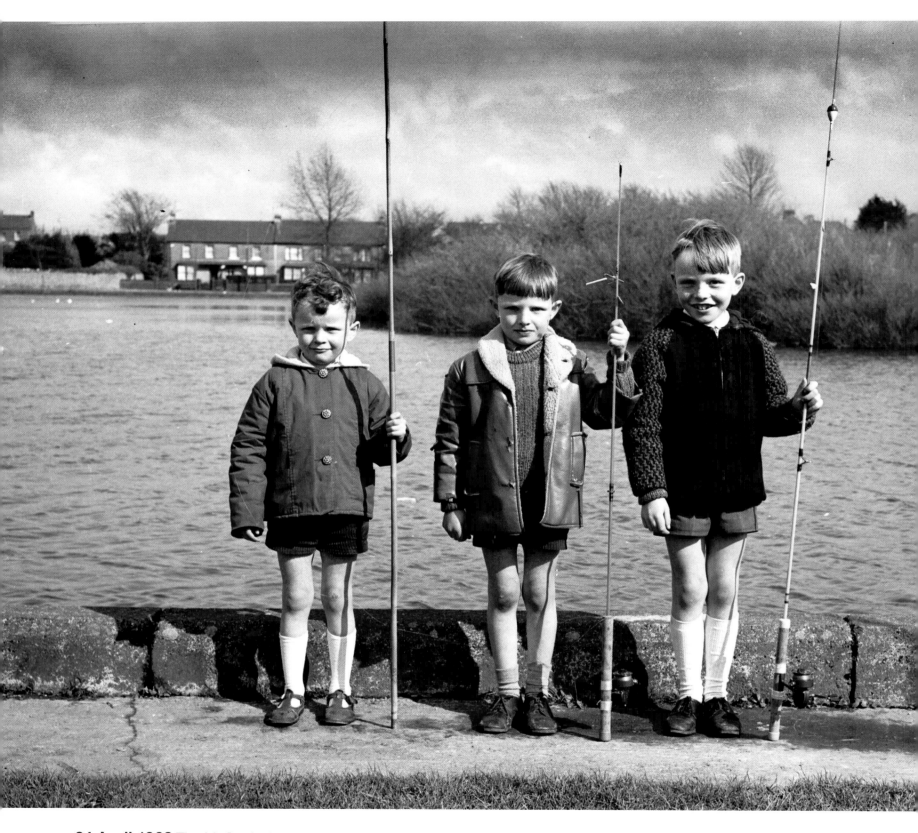

24 April 1968 The McCarthy brothers from
Pouladuff fishing at the Lough, Cork. *630P-119*

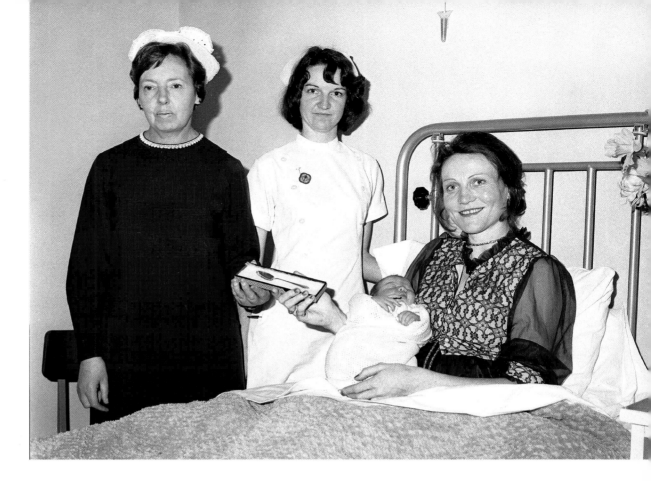

12 January 1974 The first baby born at the new maternity unit at Victoria Hospital, Cork, was a little boy born to Mrs Helen Cronin of Castletownbere. Mother and baby were presented with a silver spoon to mark the occasion. Included are (l–r): Matron Elizabeth O'Brien and Staff Midwife, Nurse C. Kelleher. *646P/128*

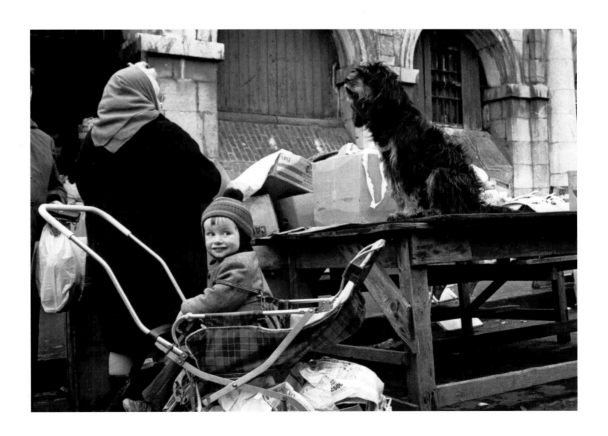

24 January 1975 The Coal Quay, Cork. *182/93*

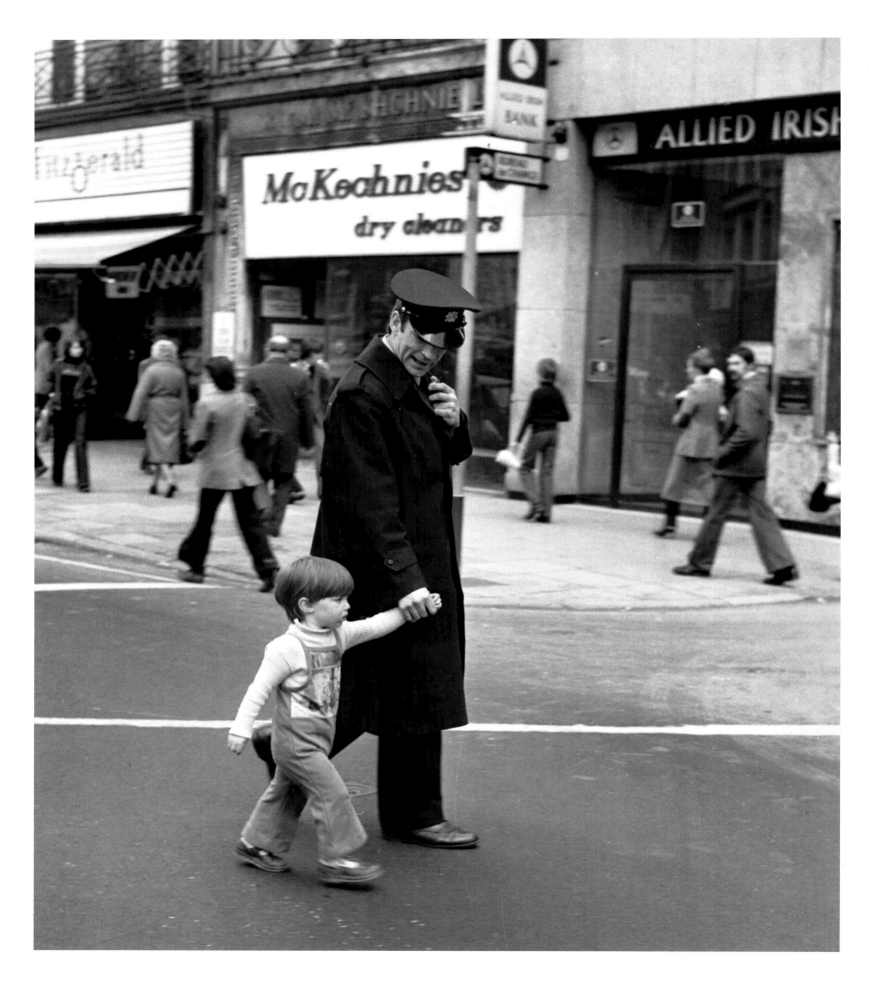

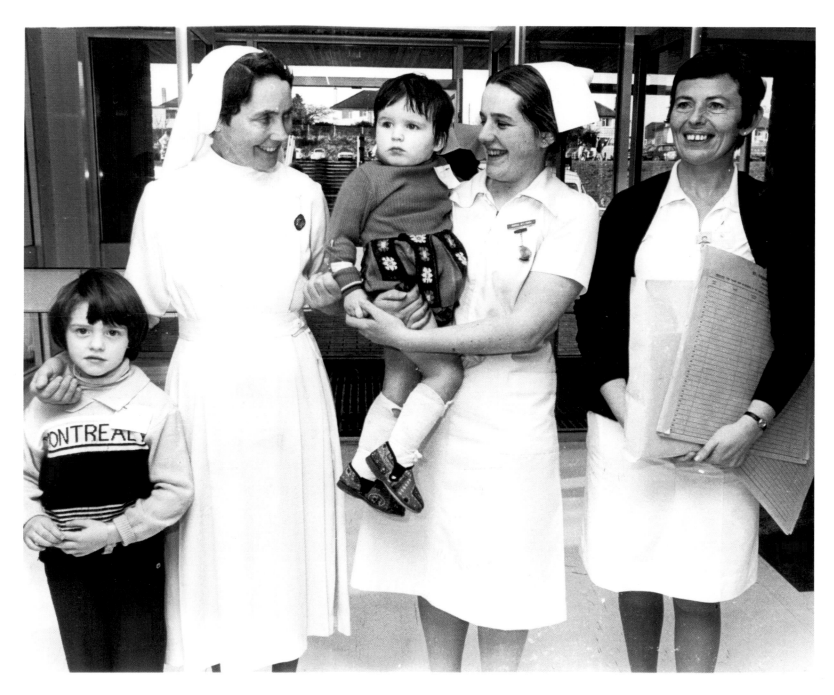

30 November 1978 Nurses with children at the opening of Cork Regional Hospital (now CUH). *223-75*

8 May 1978 A Garda helps a child to cross St Patrick's Street, Cork. *655P-166*

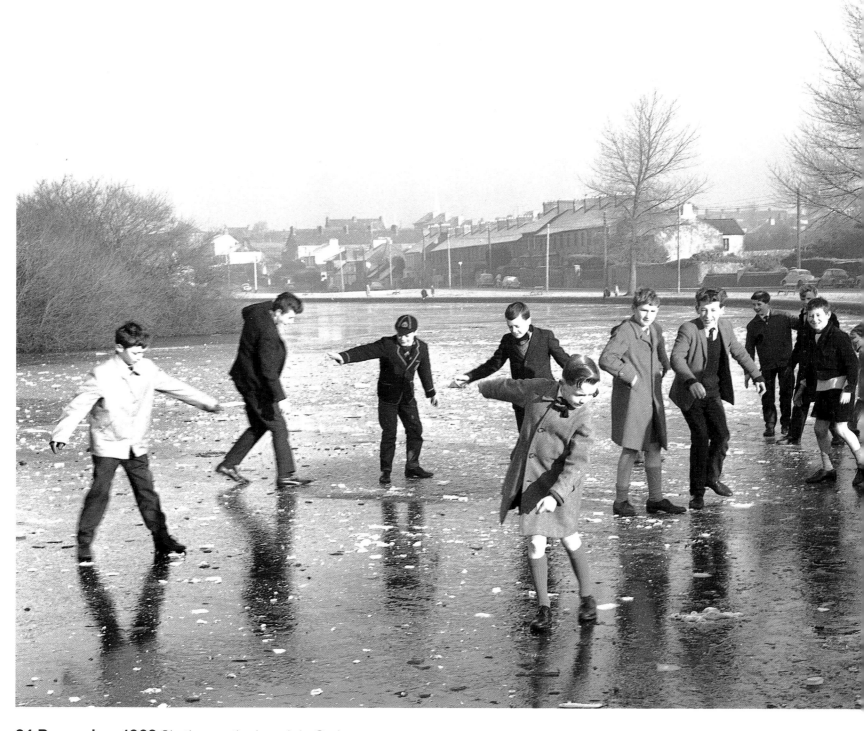

24 December 1963 Skating on the Lough in Cork. *449p*

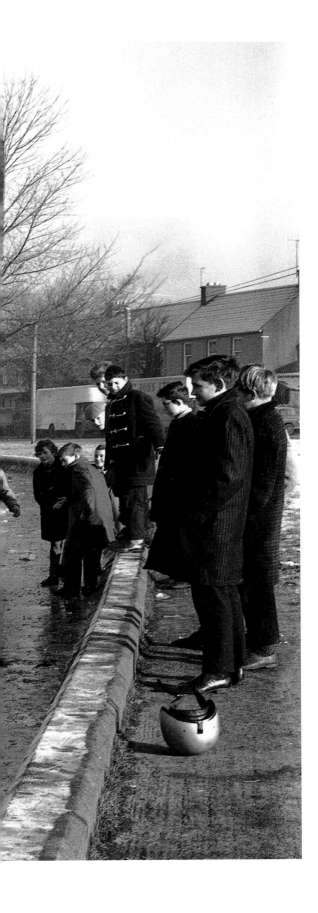

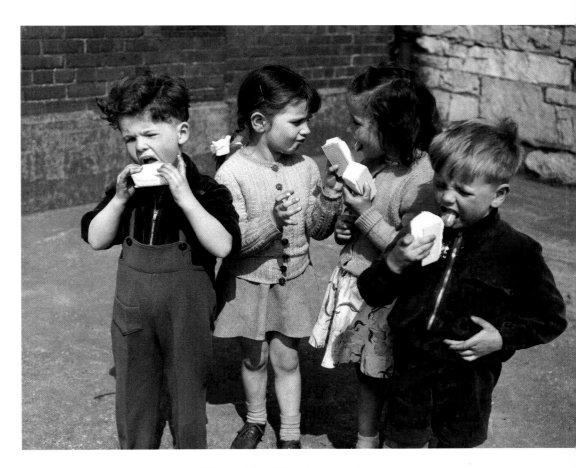

29 April 1954 Enjoying ice cream on a warm spring day in Cork city. *640G*

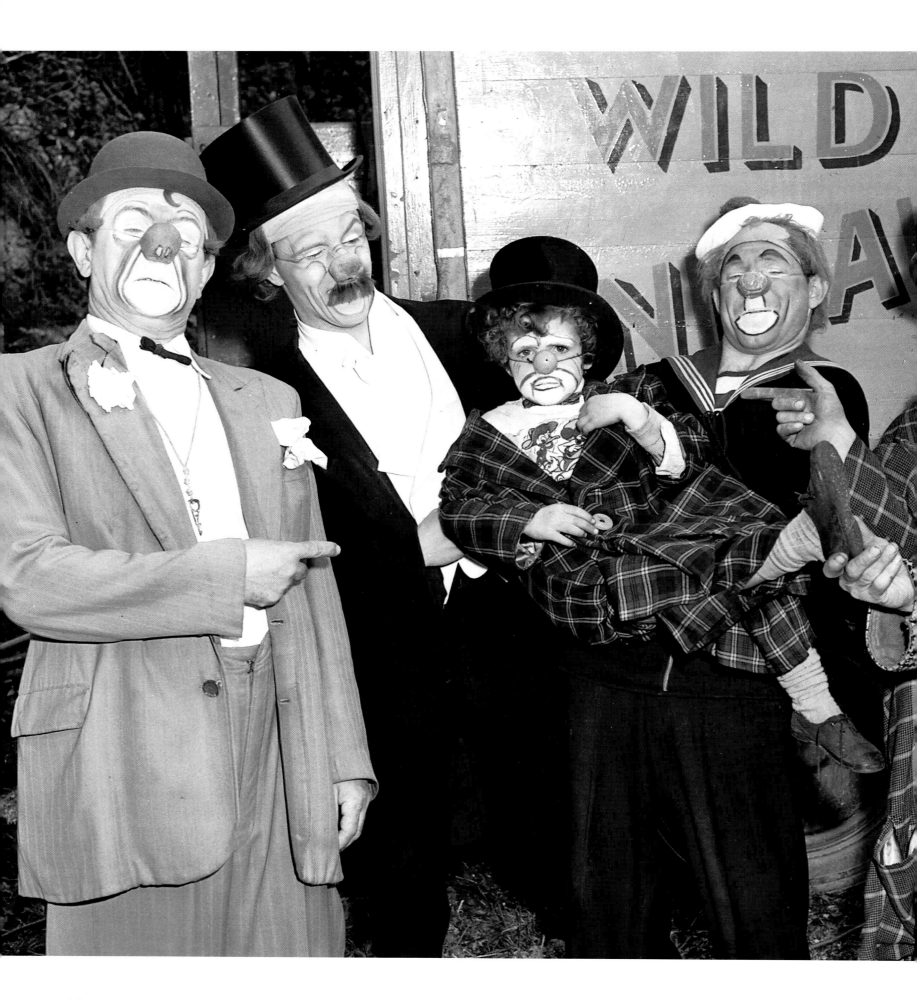

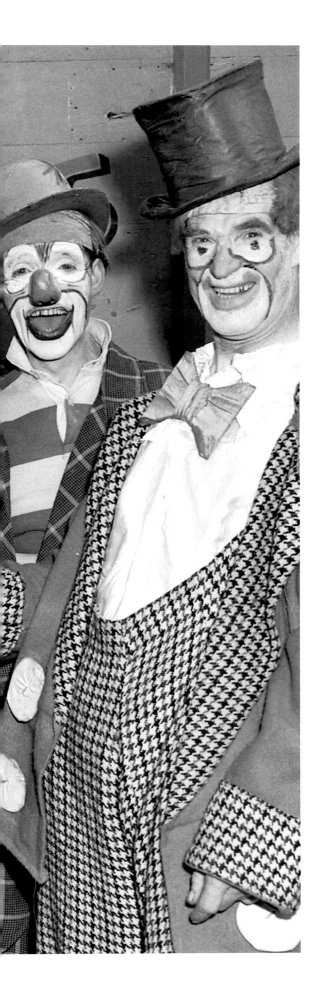

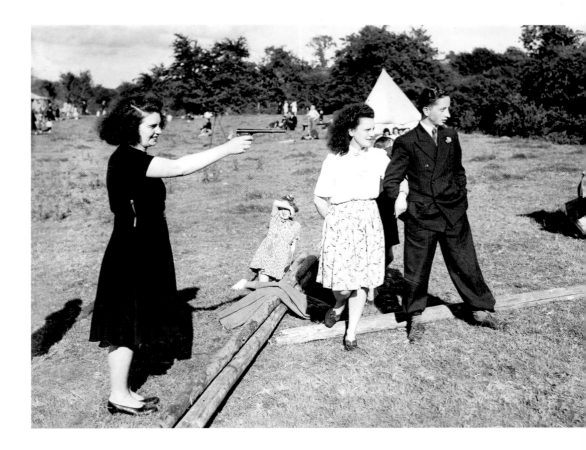

4 August 1947 Target shooting at Ballinhassig Fete, County Cork. *329D*

1 April 1953 Clowns from Duffy's Circus pictured at Gilabbey Rock, Cork. *998E*

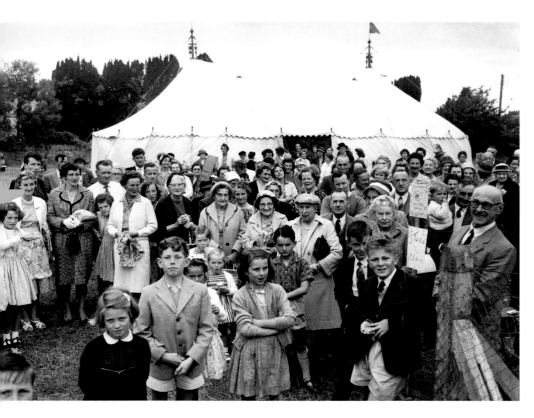

10 June 1961 Crowds at Douglas and Frankfield Garden Fete. *838L*

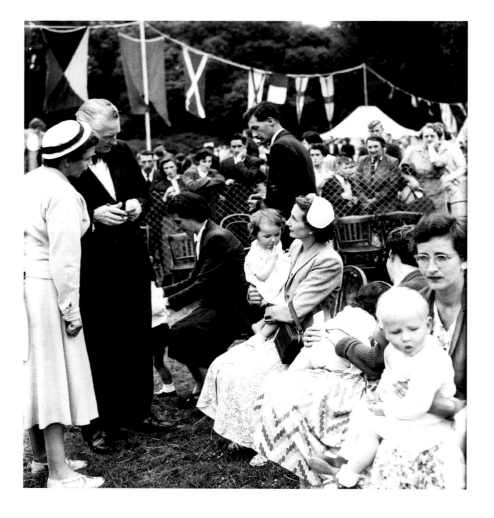

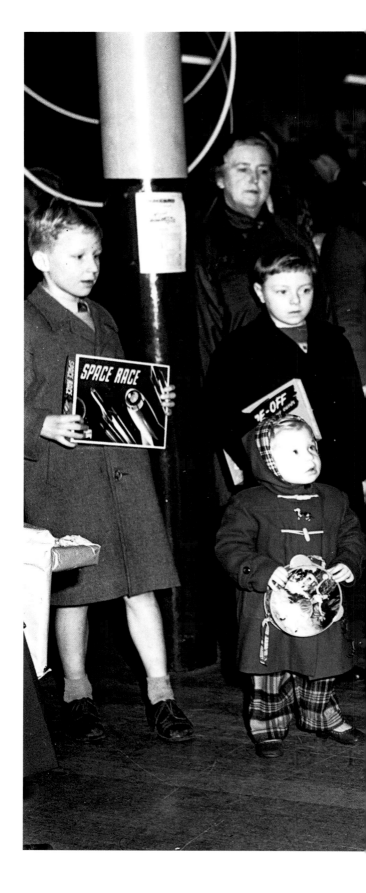

14 July 1956 Festival in the grounds of Fota, County Cork. *26J*

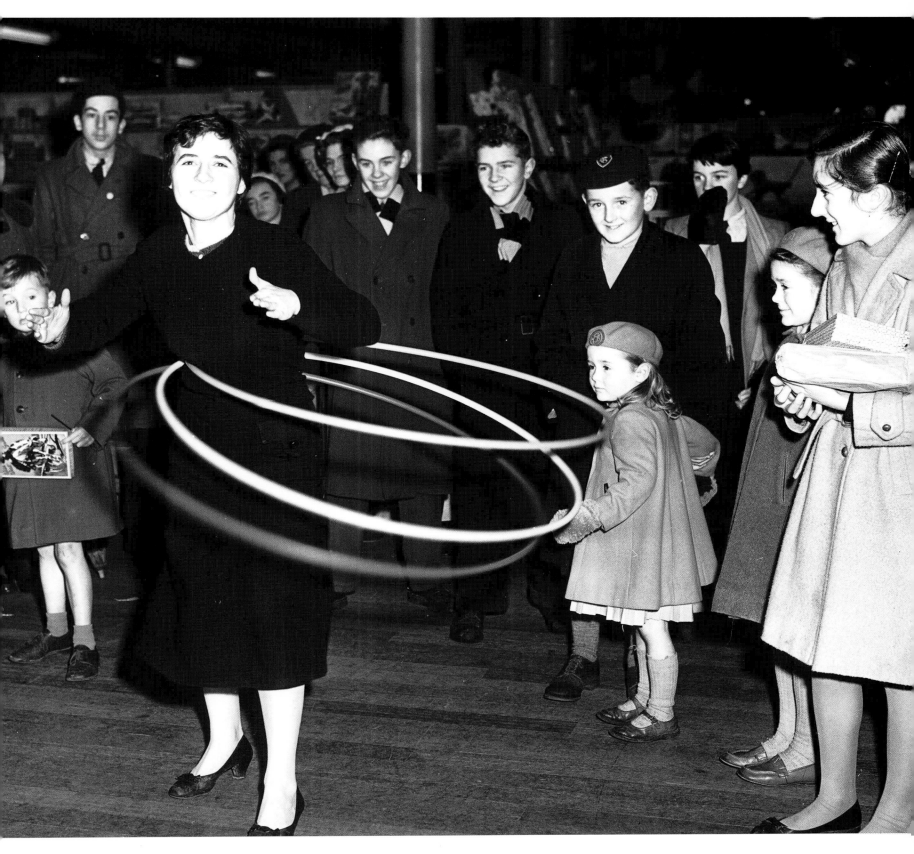

20 December 1958 A hula-hoop demonstration in City Hall, Cork. *479K*

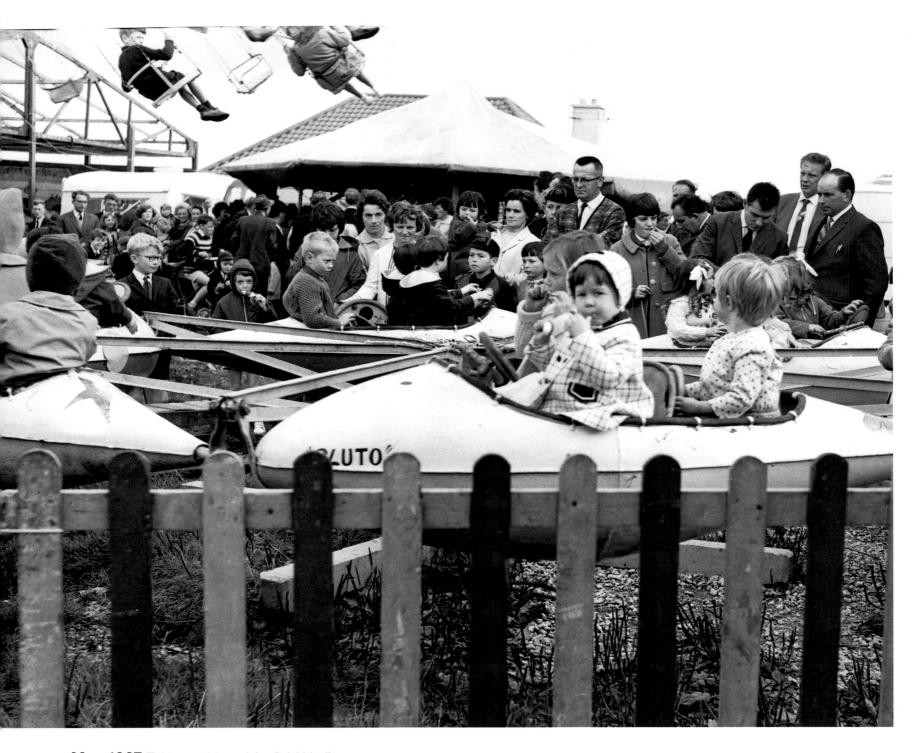

May 1967 Taking a ride at Mayfield Hurling
and Football Club carnival, Cork. *627P/9*

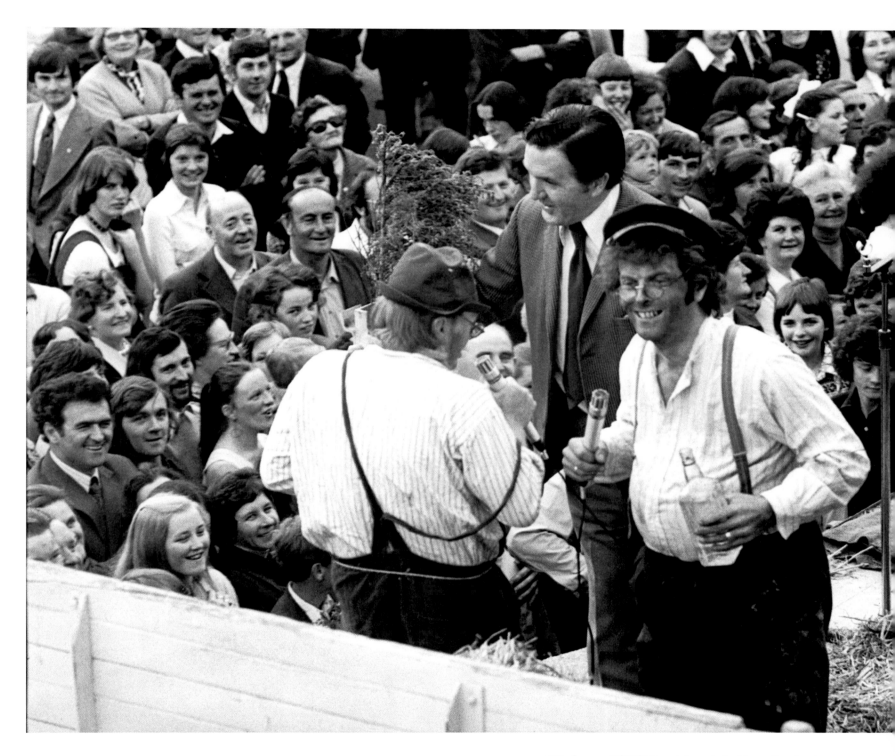

17 June 1976 The Mountain Dew Festival in Macroom, County Cork, opened by Frank Hall of RTÉ. *203/133*

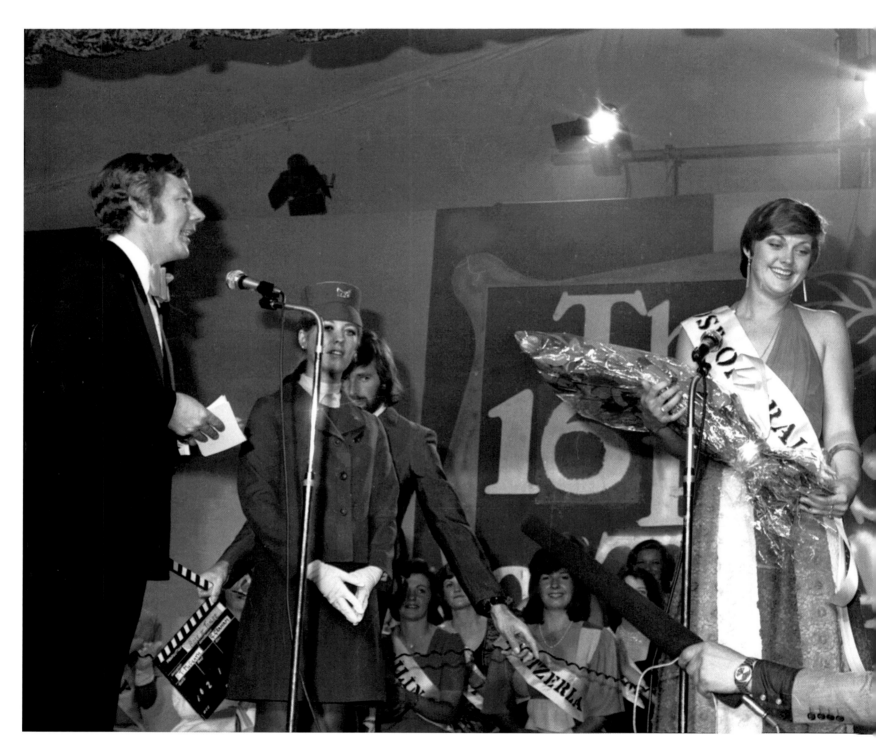

3 September 1974 Gay Byrne announces
the winner of the Rose of Tralee: Maggie
Flaherty from New York. *177/77*

20 June 1972
(L–r): Kathleen Hurley and
Breda O'Leary at the Cork
Summer Show. *143/039*

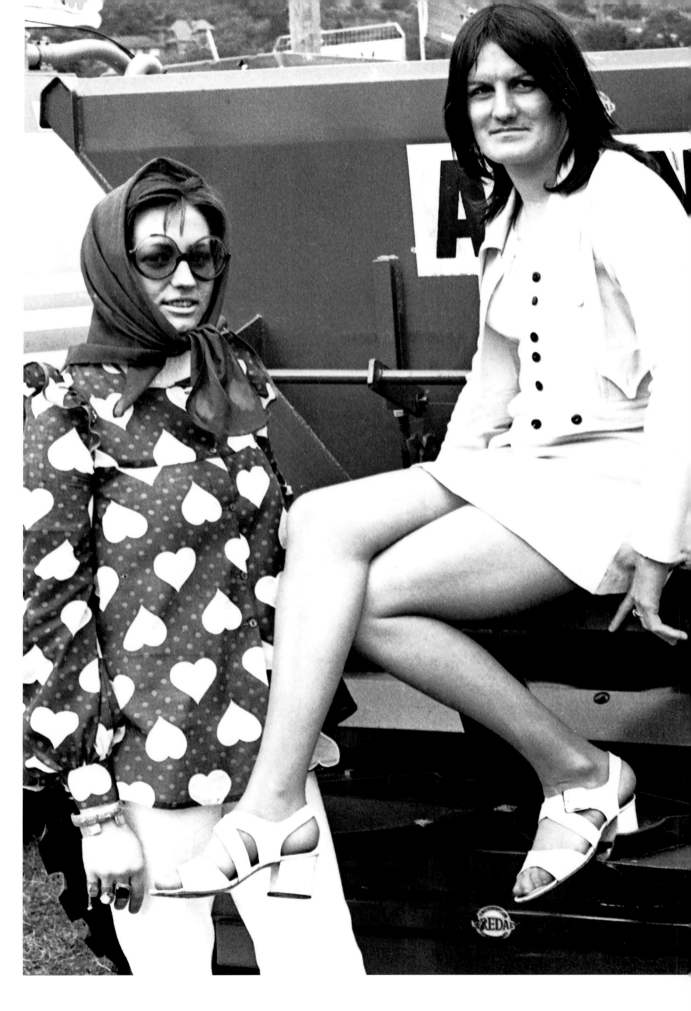

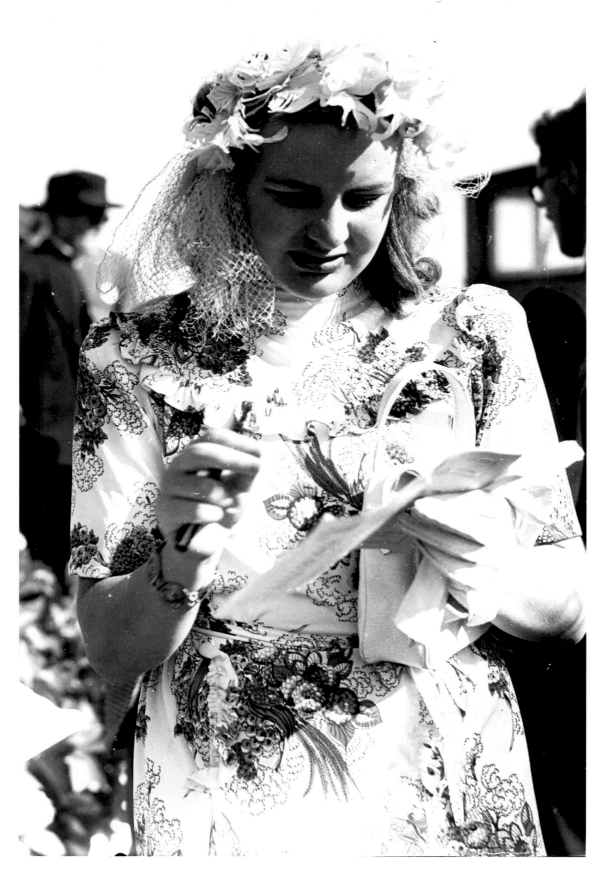

14 August 1947
Fashion at the Tralee
Races, County Kerry. *326D*

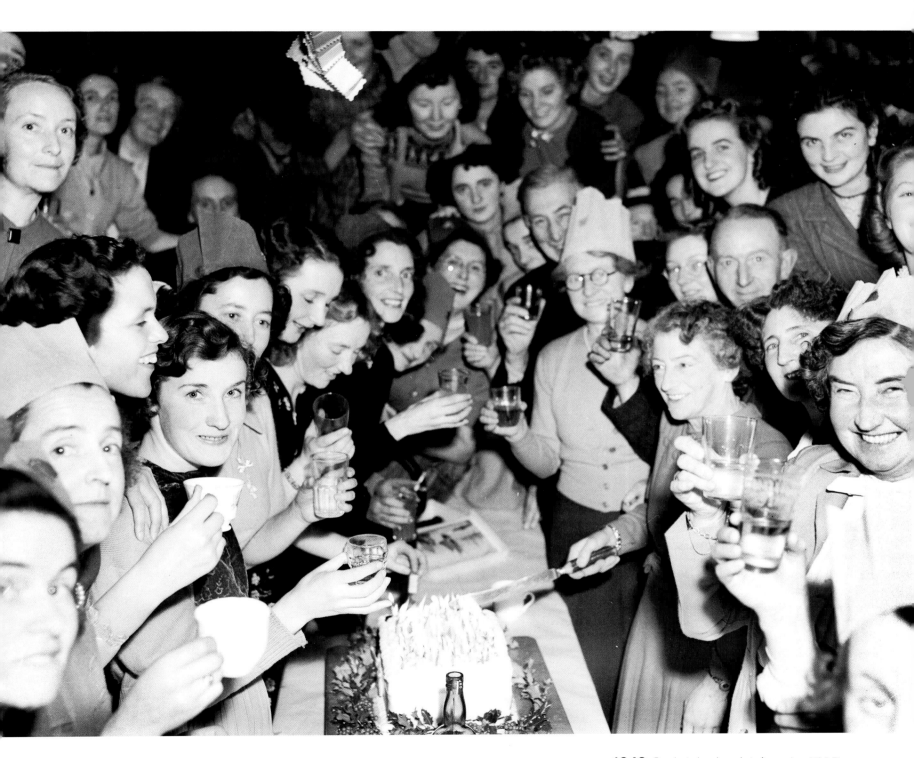

1949 Cork telephonists' party. *700D*

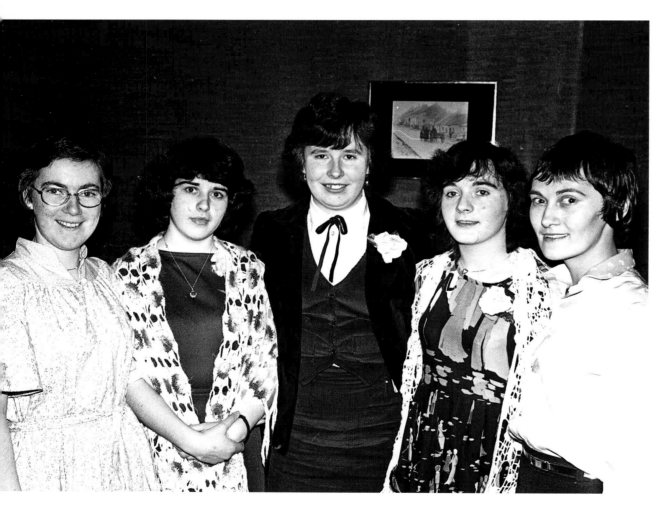

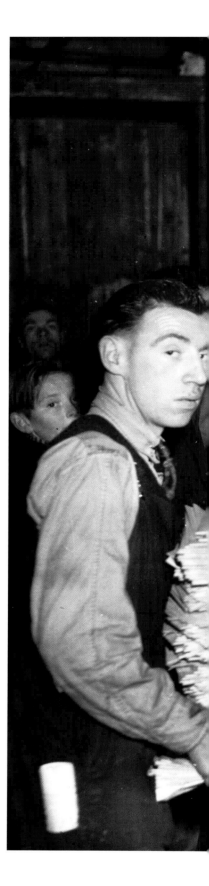

3 February 1980 Five friends at the Berrings
Macra dinner at Hotel Blarney, County Cork. *236/124*

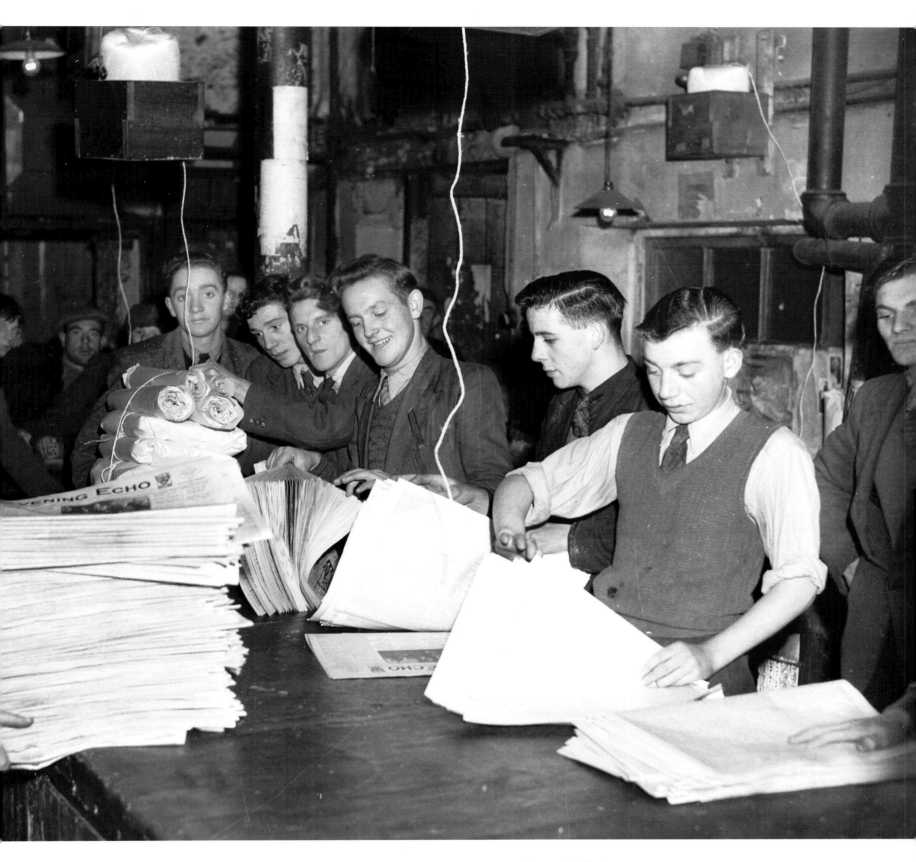

1 November 1949: Despatch department of the *Cork Examiner* and *Evening Echo*. Included are (l–r): John Tynan Snr, Raymond Riordan, Donal Crane, Michael John Courtney, Willy Leary, Liam Doyle, Paddy Callaghan, Brendan Tynan and John Cotter (hand in pocket). *702D*

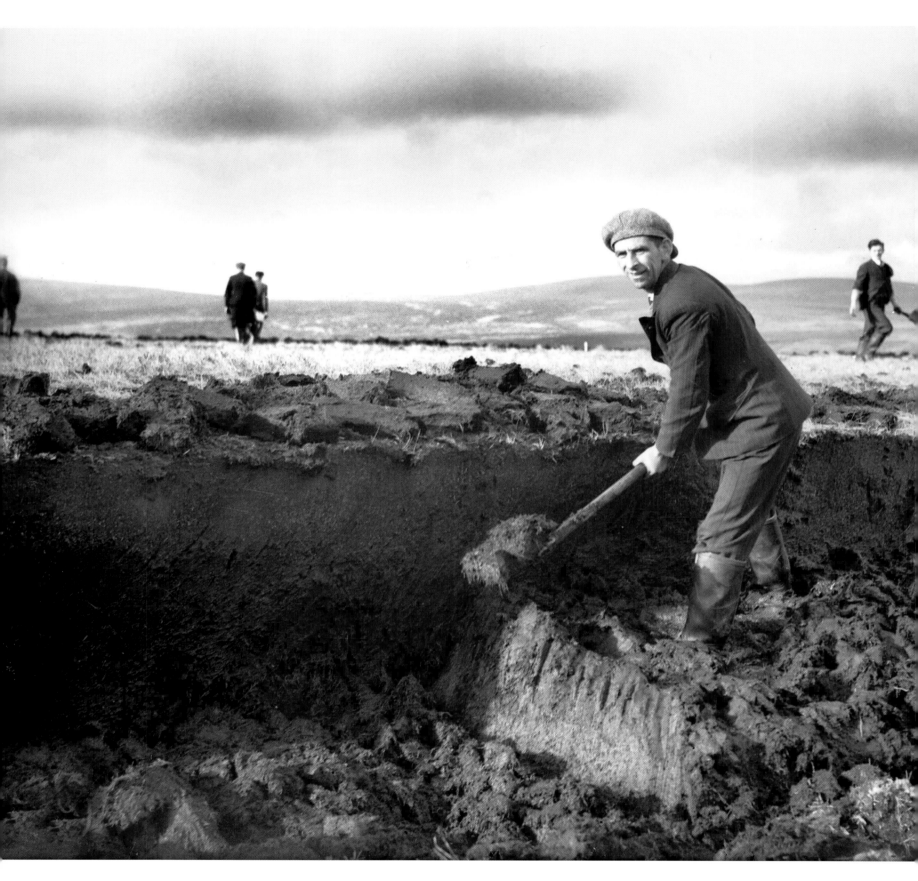

6 June 1947 Thompson's Bakery employees cutting turf at Nadd bog, County Cork, during fuel shortages. *262D*

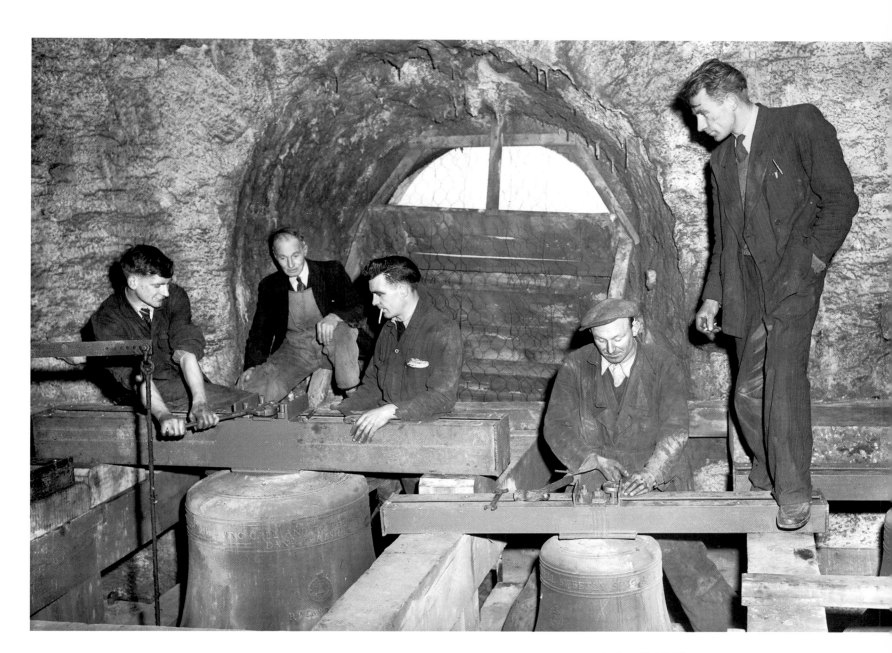

3 April 1952 Shandon bells being repaired by a work crew. *416E*

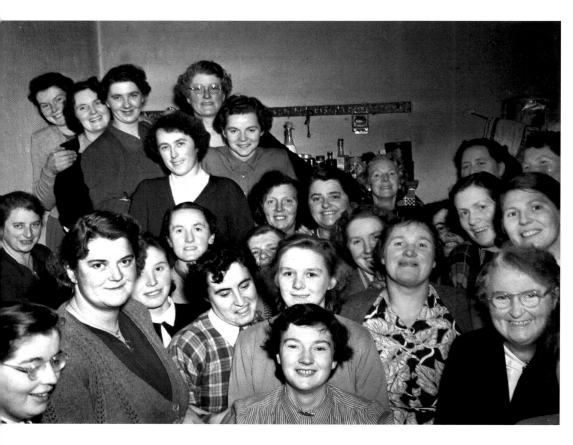

3 December 1952 Celebrating the
arrival of electricity at Carrignavar,
County Cork. *777E*

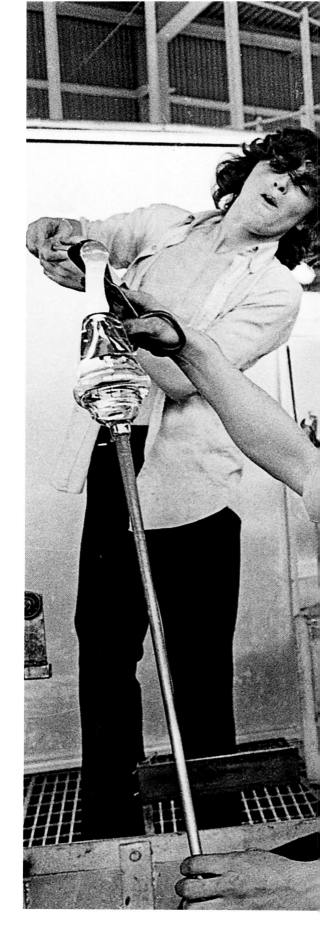

28 July 1972 Jack Lynch (third from
right) visting the Waterford Glass factory at
Dungarvan, County Waterford. *145/003*

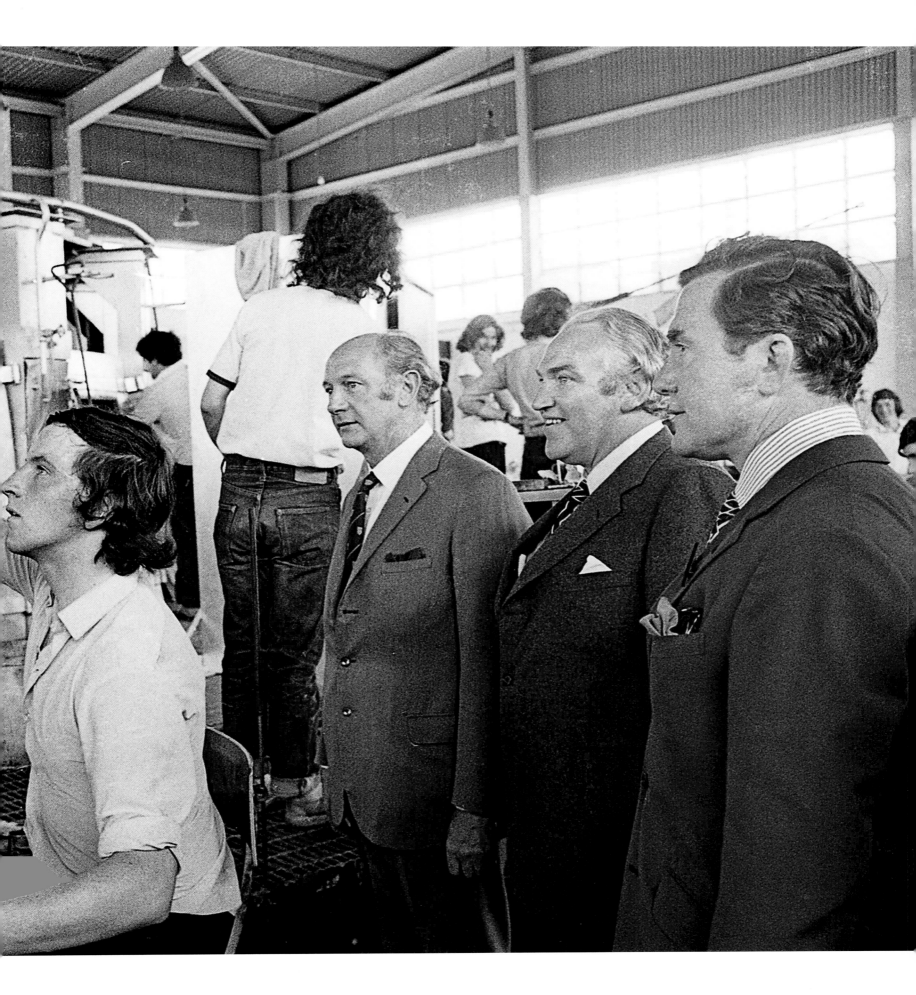

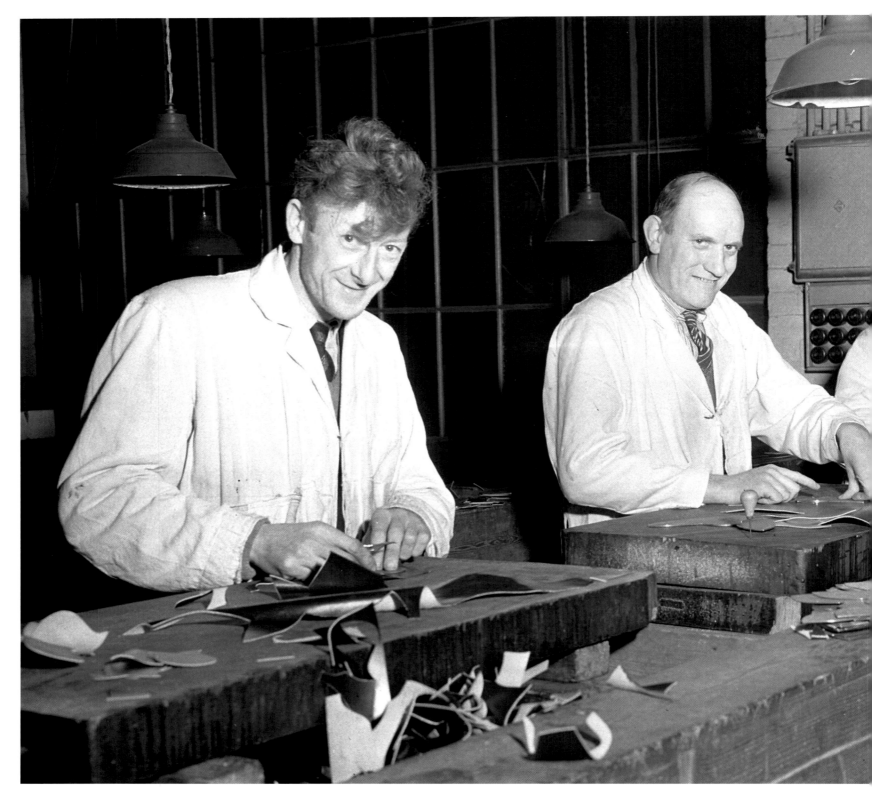

January 1953 Employees of Dwyer's boot factory, Washington Street, Cork. *840E*

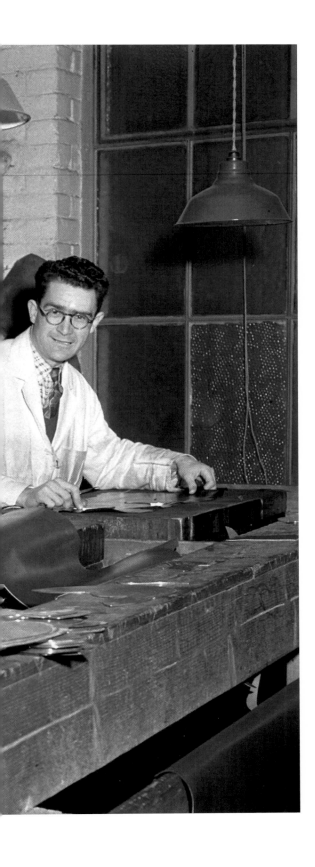

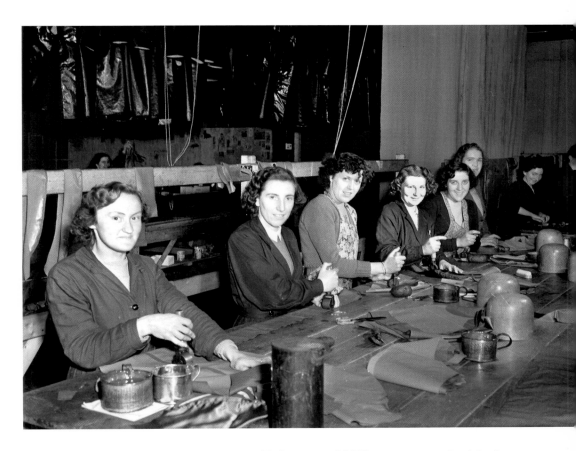

14 February 1953 Workers at the Ideal Weatherproofs factory, Cork. *876E*

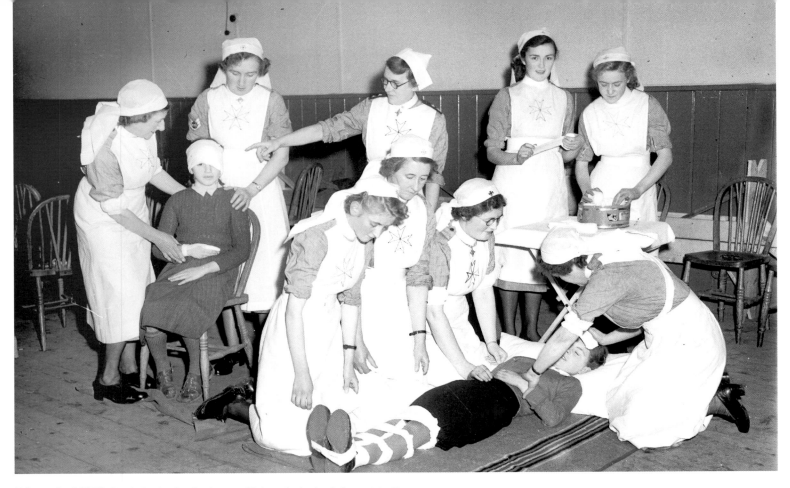

March 1953 St John's Ambulance Brigade in training. *307G*

5 May 1953 Repairing gas meters at Cork Gasworks. *20G*

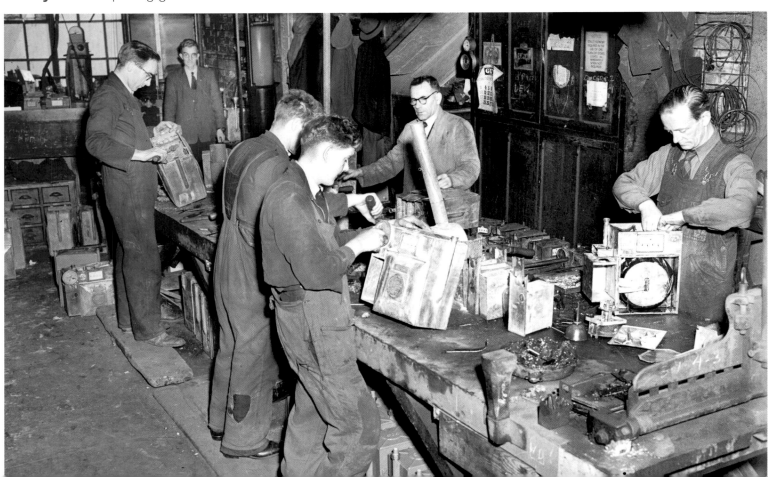

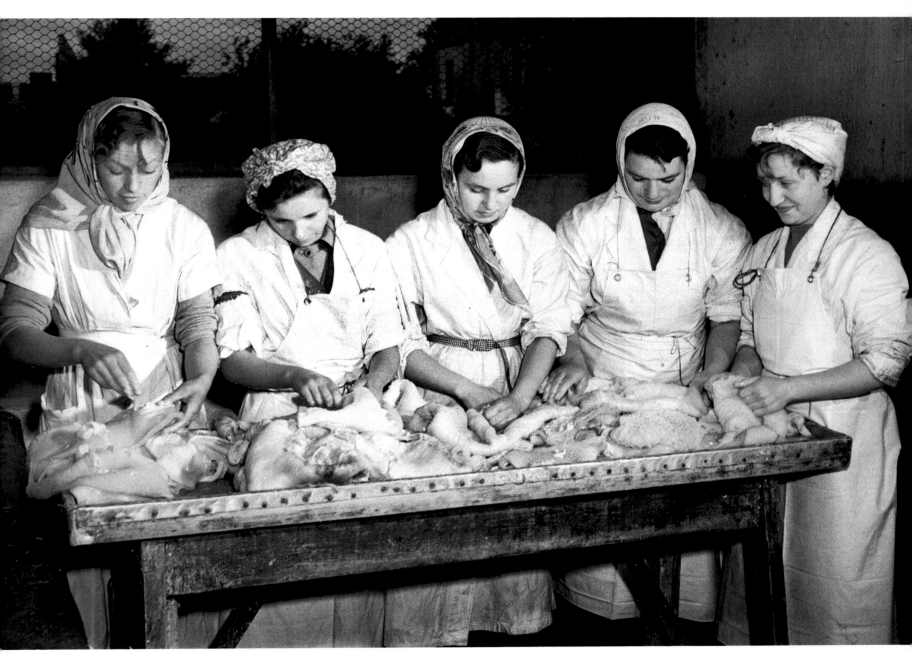

20 June 1953 Working at O'Reilly's tripe and drisheen store, St Philomena's Road, Gurranabraher, Cork. *95G*

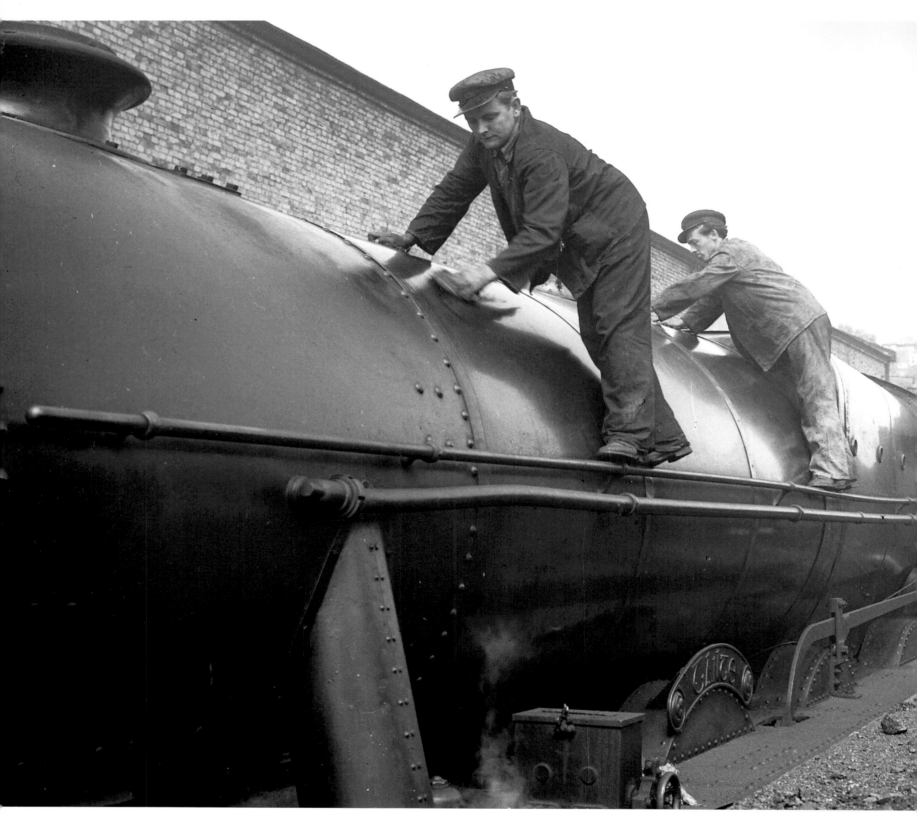

1 July 1953 Cleaning the steam engines at
Lower Glanmire Road (Kent) railway station. *155G*

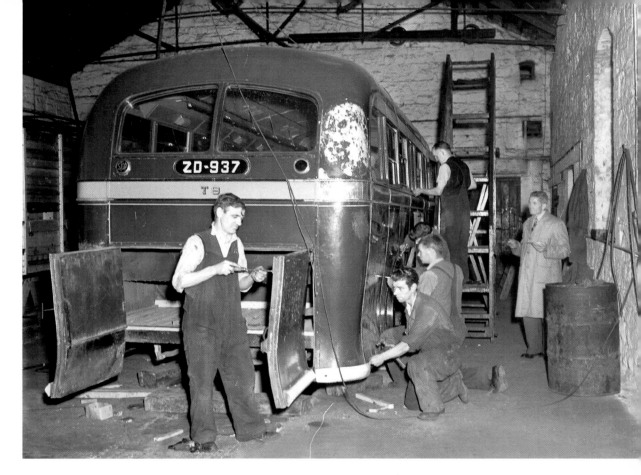

26 August 1953 Mechanics work on a bus at Capwell CIÉ Garage, Cork. *255G*

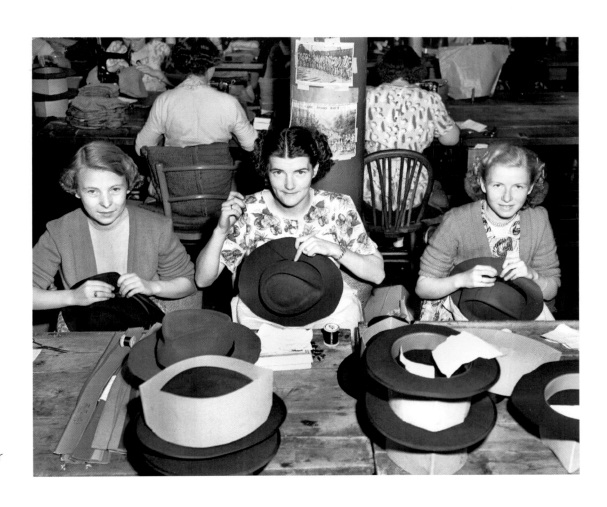

15 August 1953 Workers at O'Gorman's hat and cap factory, Exchange Street, near Shandon, Cork. *195G*

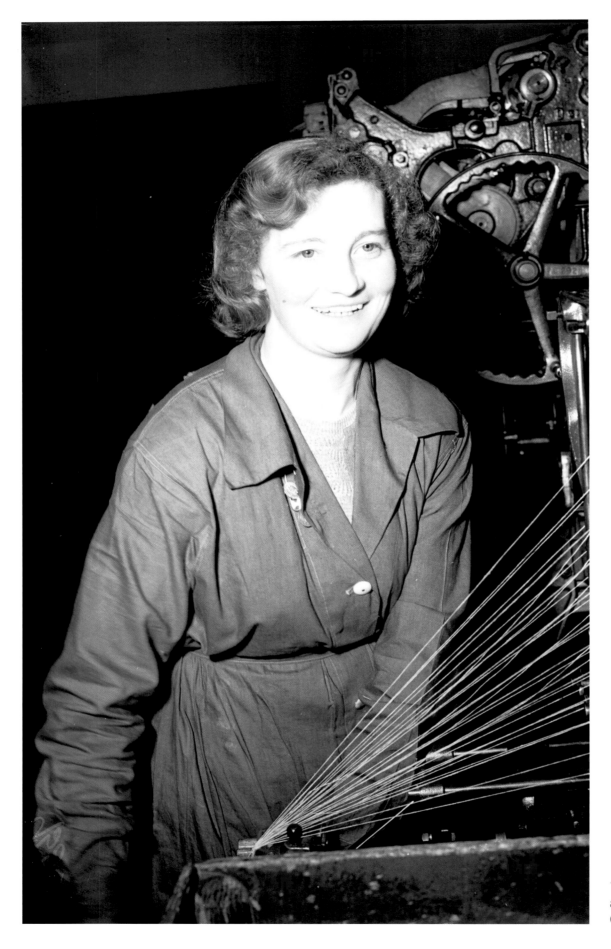

1 March 1953 A worker at Midleton Worsted Mills, County Cork. *955E*

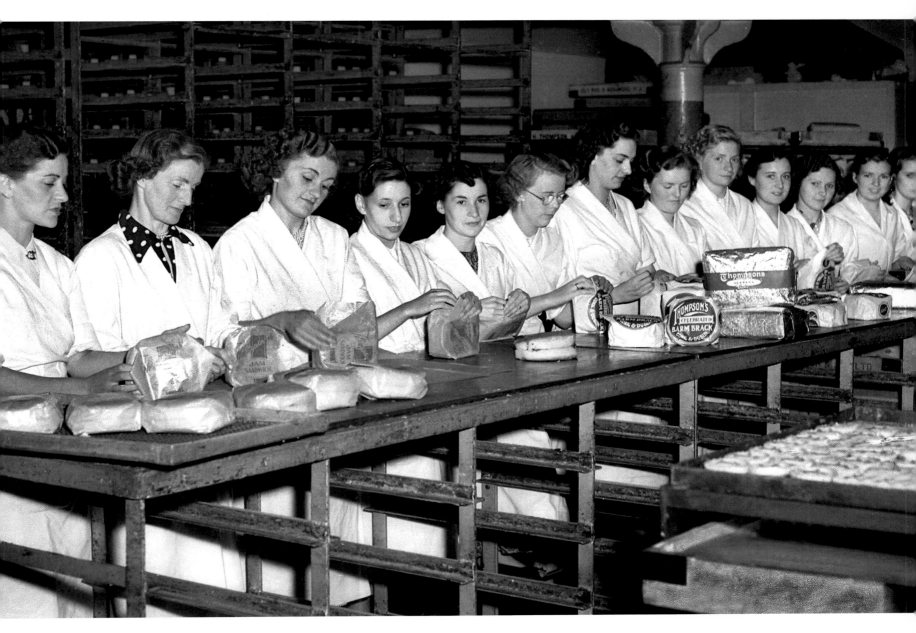

2 August 1953 Thompson's bread and cake factory, MacCurtain Street, Cork. *133G*

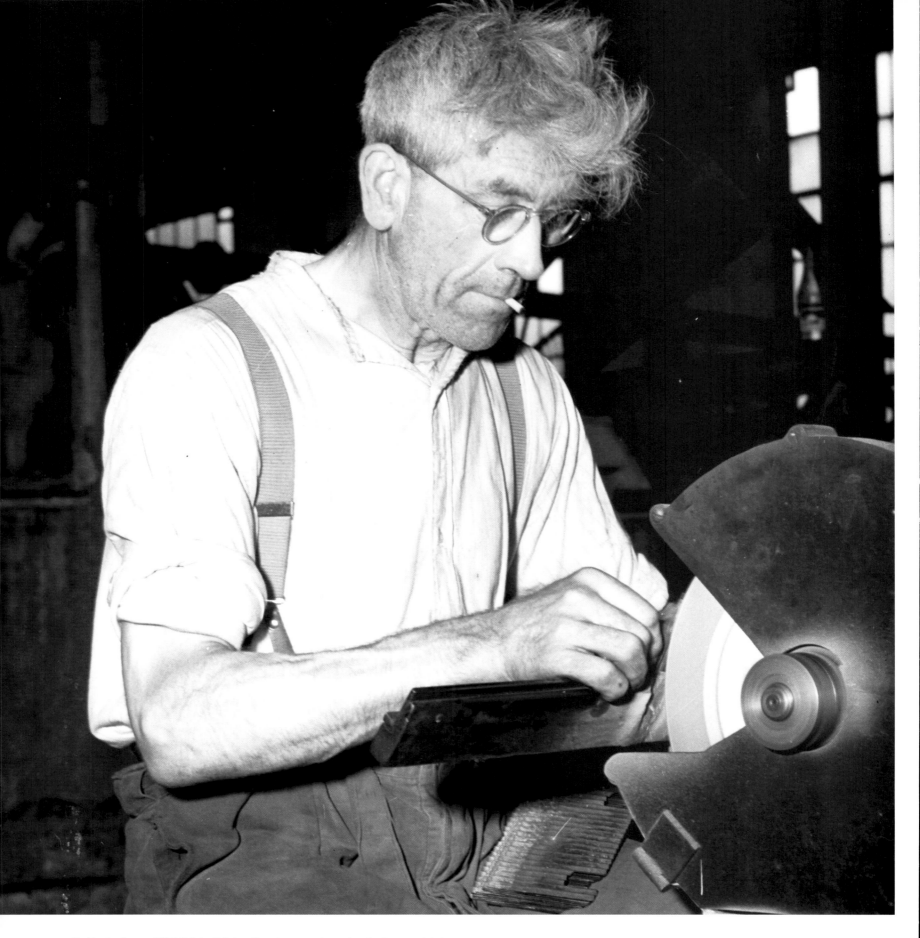

9 October 1953 Mr O'Keeffe sharpening the knives which reduce the beet to shreds at the Irish Sugar Company factory in Mallow, County Cork. *272G*

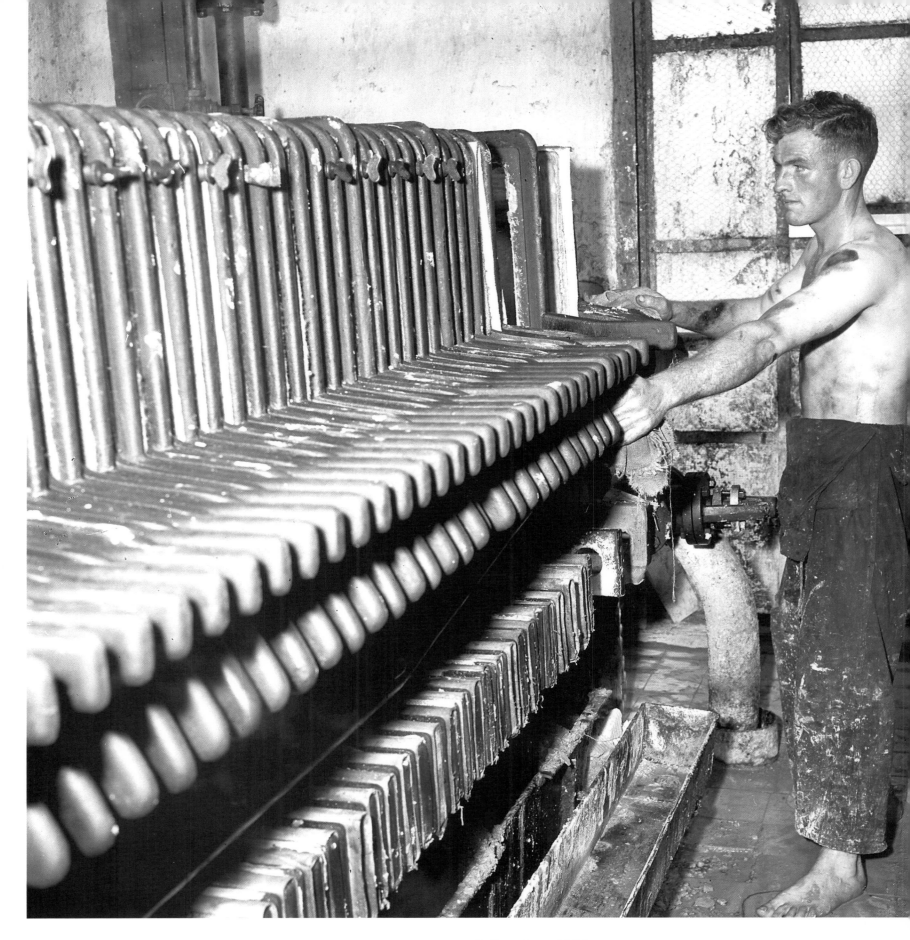

9 October 1953 Michael Walsh cleaning the lime extraction filters during the purification process at the Irish Sugar Company factory in Mallow, Country Cork. *272G*

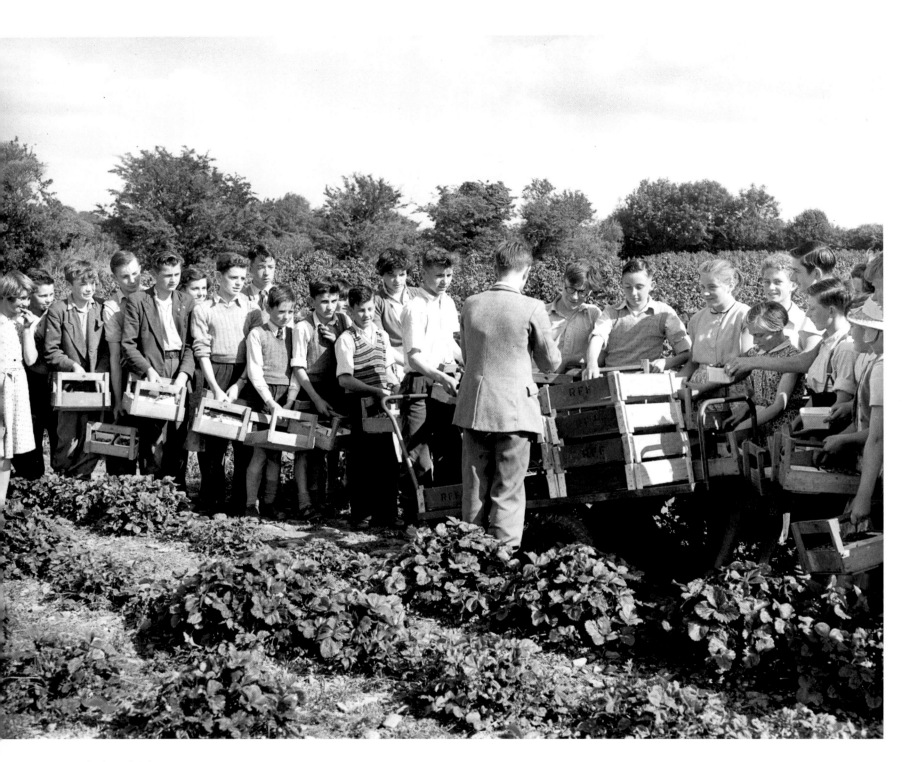

1 July 1956 Fruit pickers at Rathcooney
fruit farm, County Cork. *40J*

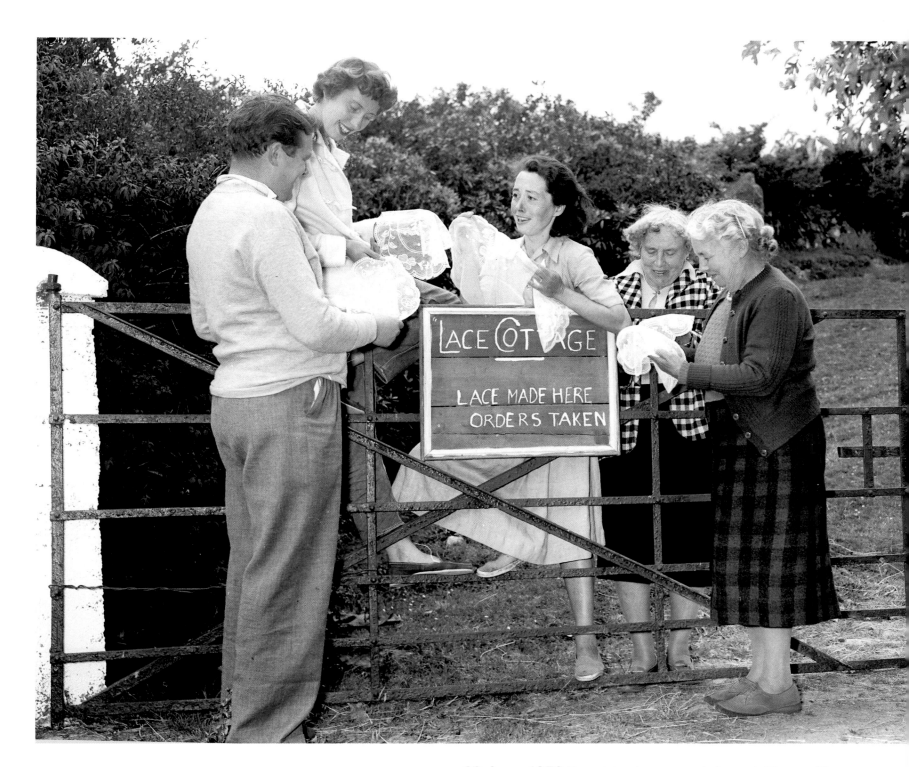

29 June 1956 Examining home-made lace at Glengarriff, County Cork. *16J*

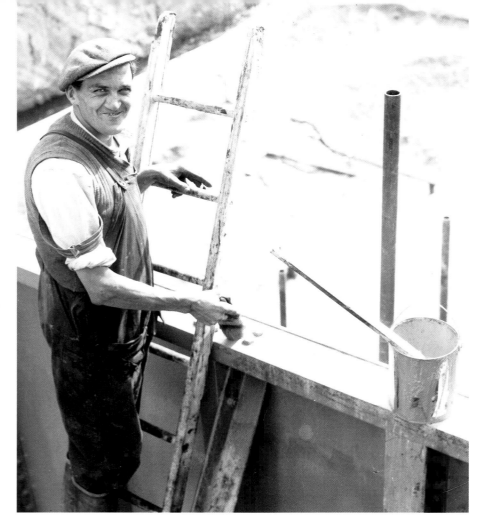

August 1956 Paddy Buckley from Blarney
working on the Inniscarra Dam, County Cork. *89J*

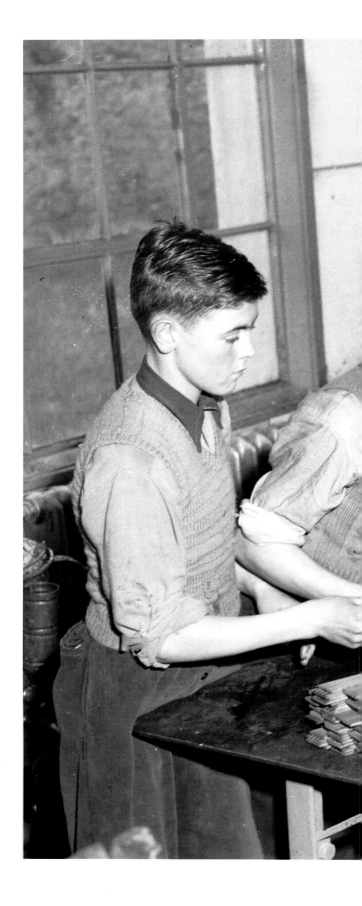

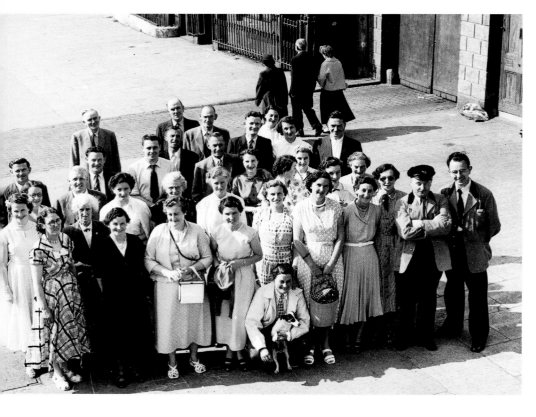

10 July 1955 The staff of the English Market,
Grand Parade, Cork. *416H*

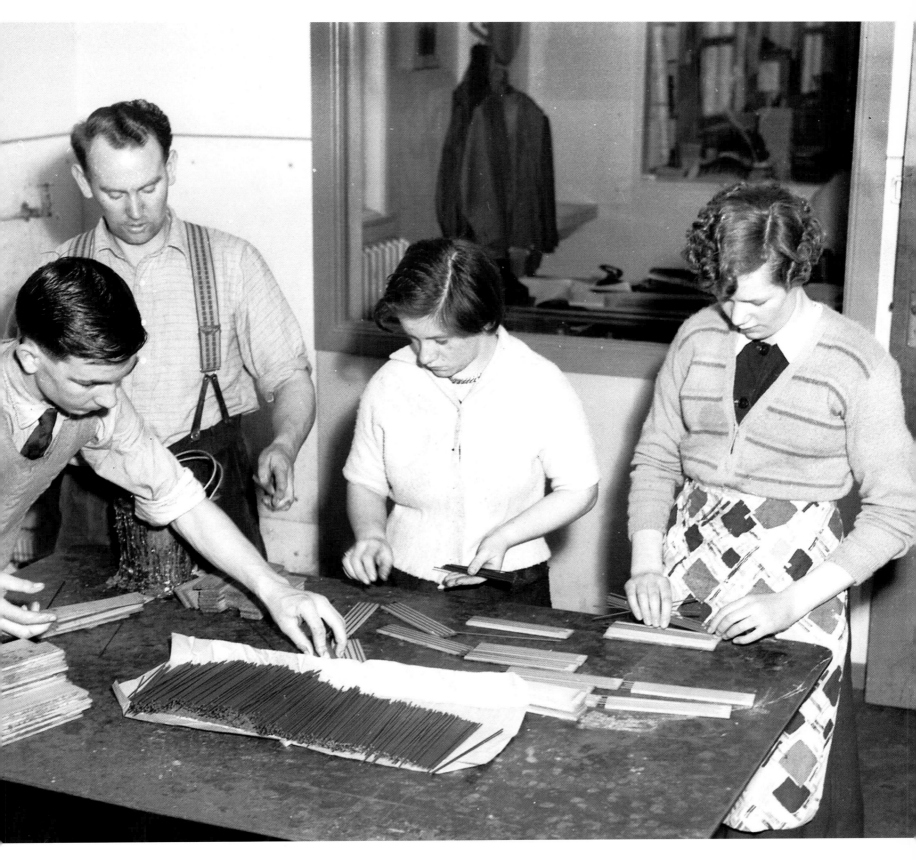

9 May 1956 Workers at the Faber-Castell
pencil factory, Fermoy, County Cork. *880H*

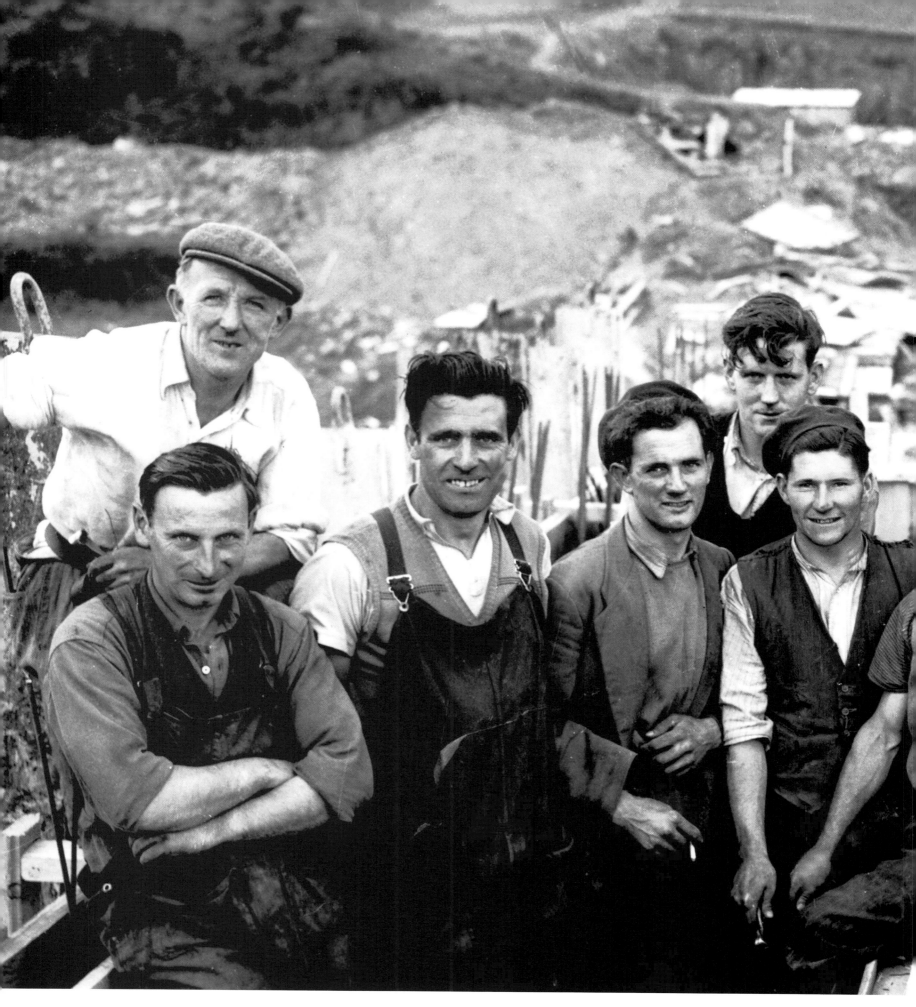

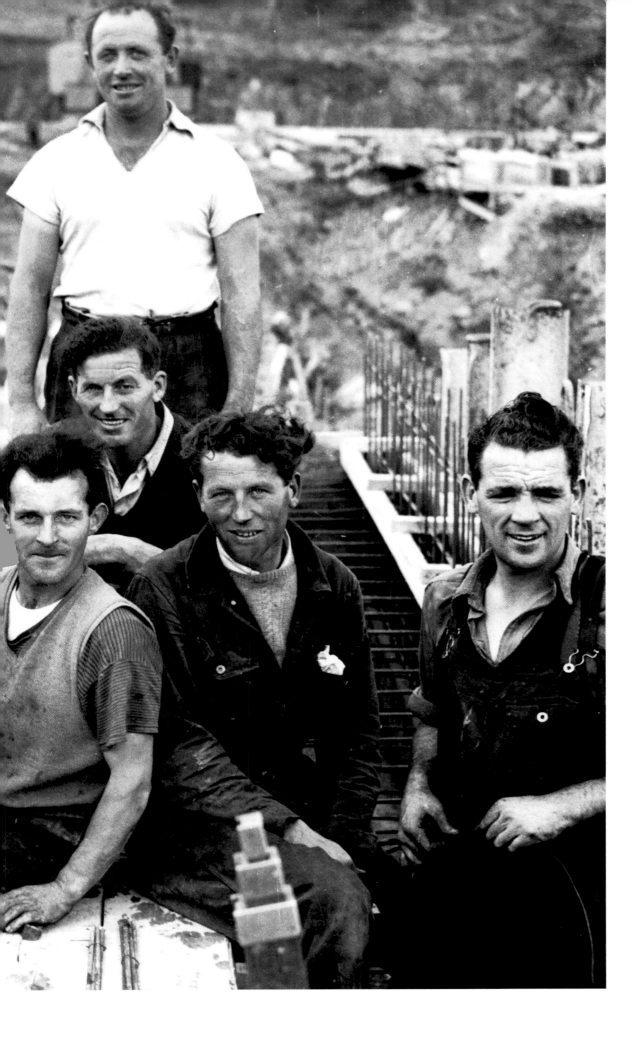

29 August 1956 Workers at the Lee Scheme, Inniscarra Dam, County Cork. *89J*

45

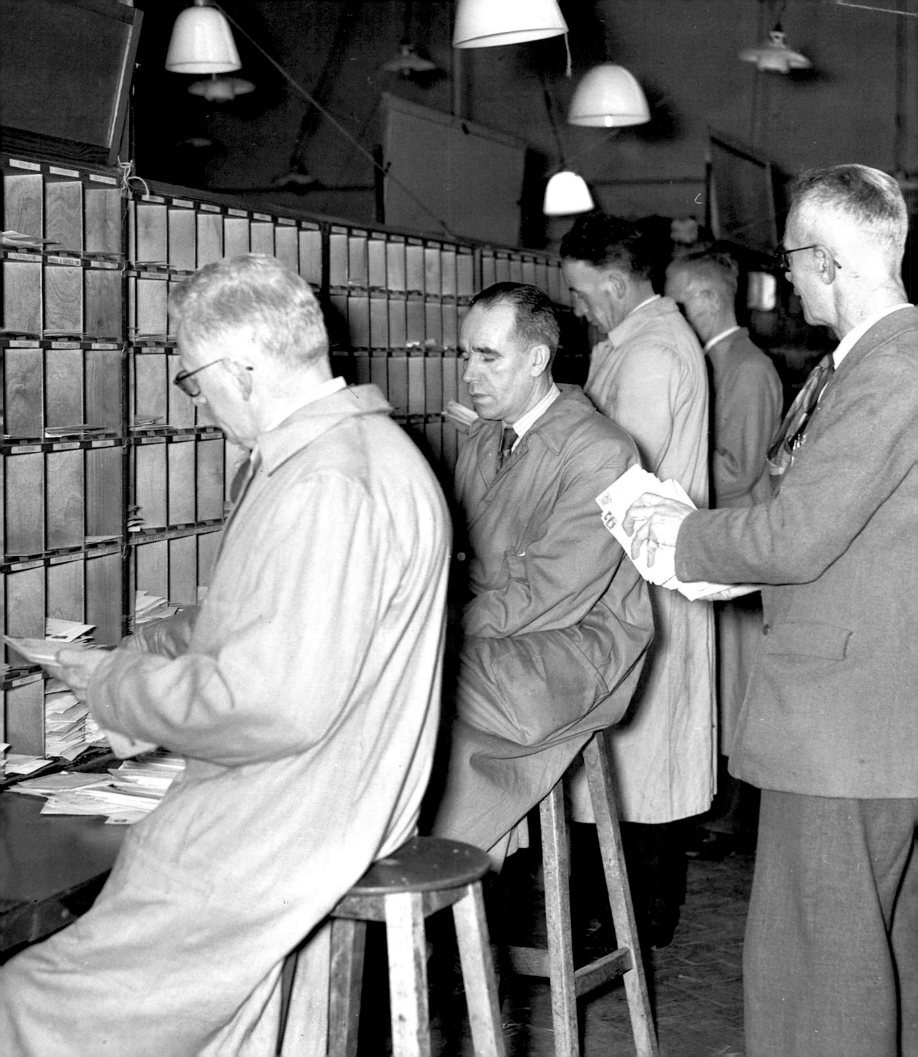

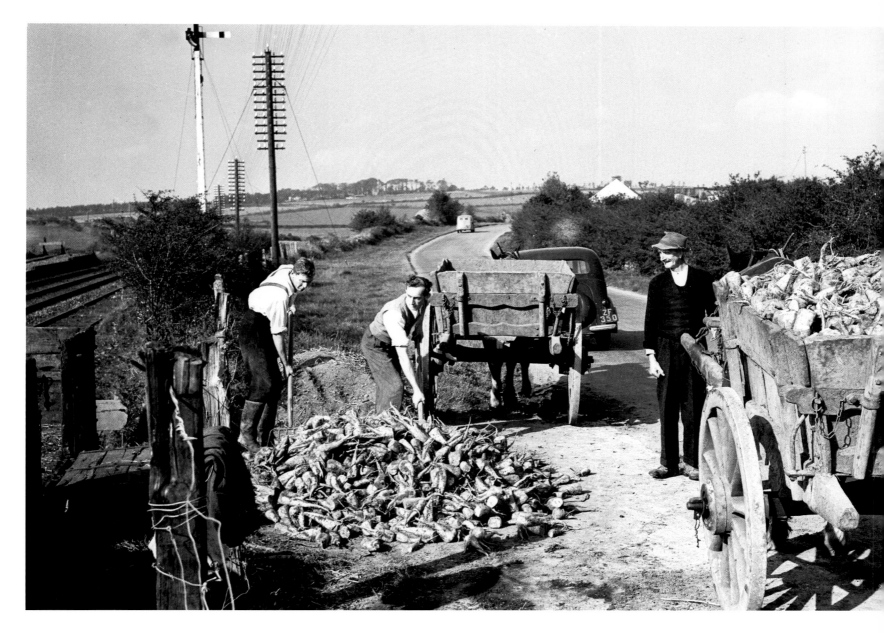

9 October 1953 Loading beet from horse-drawn butts into railway wagons at the Rathpeacon siding, Mallow Road, Cork: John Walsh (far right) with his son, John V. Walsh (left), and nephew, Donal Walsh (middle). *272G*

22 January 1958 Working at the general sorting office at Brian Boru Street, Cork. *894J*

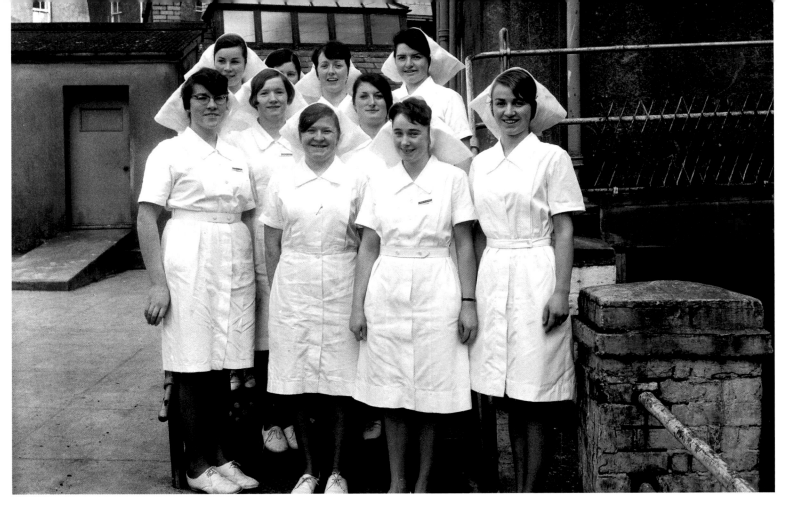

February 1968 Staff gather outside North Infirmary Hospital, Cork, for the opening of the new chapel and lecture hall. *629P-102*

26 October 1967 Nurses' prize day at South Infirmary Hospital, Cork. *49/29*

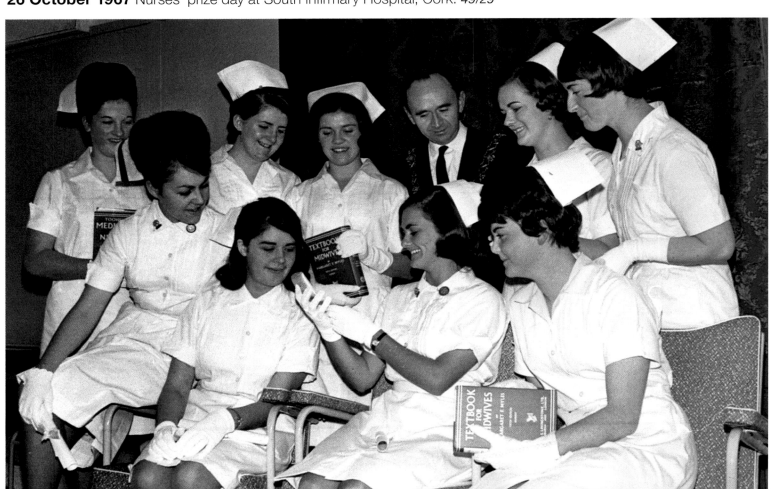

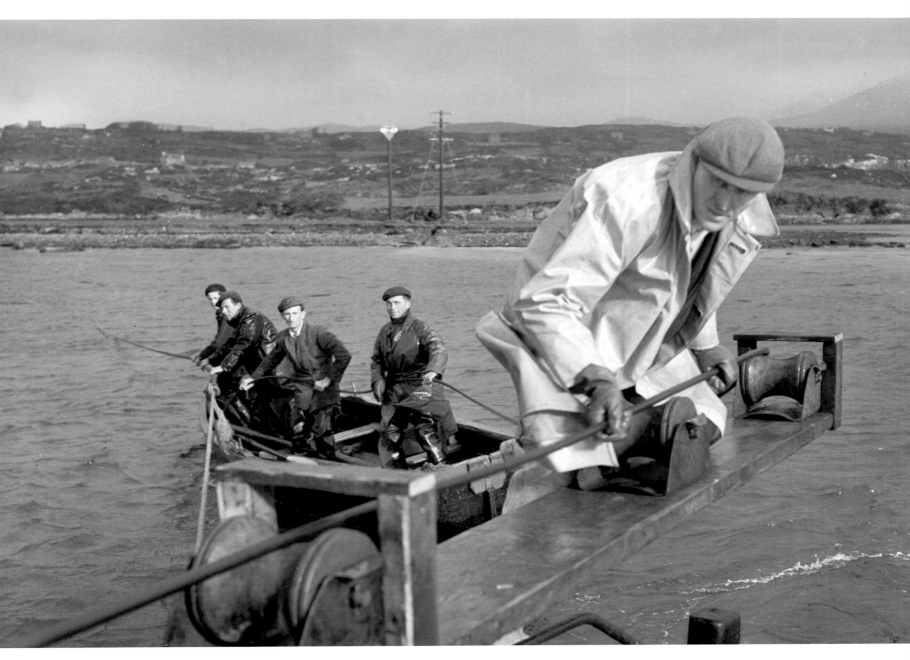

12 March 1958 The laying of the ESB cable from Castletownbere to Bere Island, County Cork. *13K*

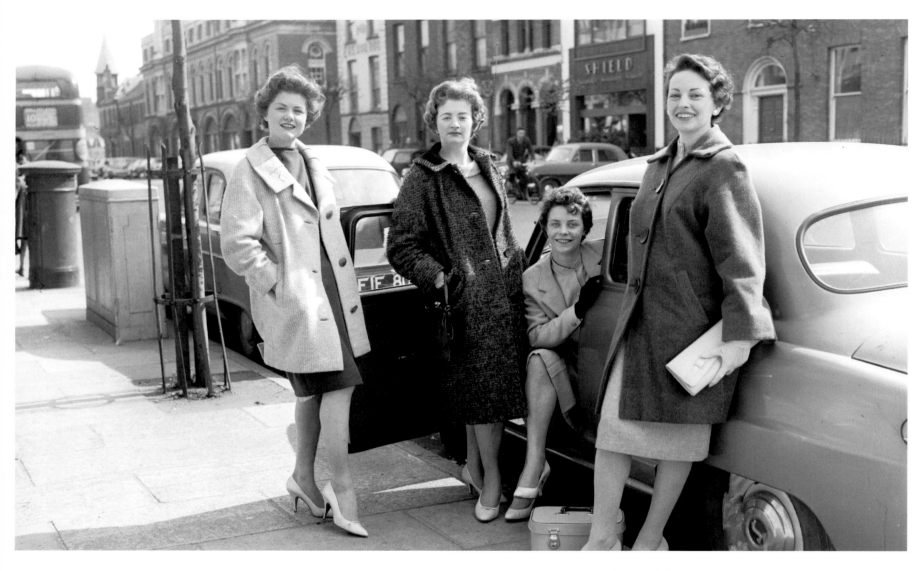

3 April 1959 Modelling for the Skibbereen Irish Countrywomen's Association building fund. *613K*

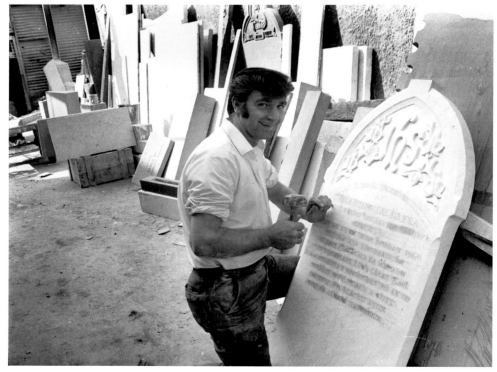

1 September 1970 Cork hurler Gerald McCarthy cutting stone destined for St Finbarr's Hospital, Cork. *117/51*

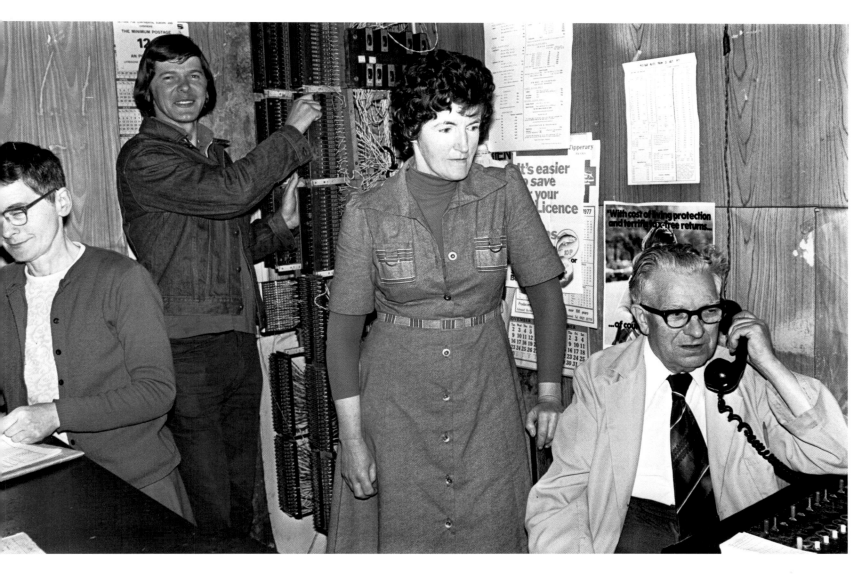

July 1977 Glanworth/Fermoy Post Office, County Cork, goes automatic. *211/016*

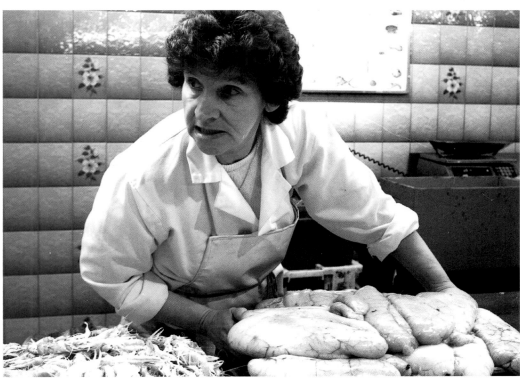

8 March 1988 Fish trader Kathleen O'Connell at the English Market, Cork. *371/090*

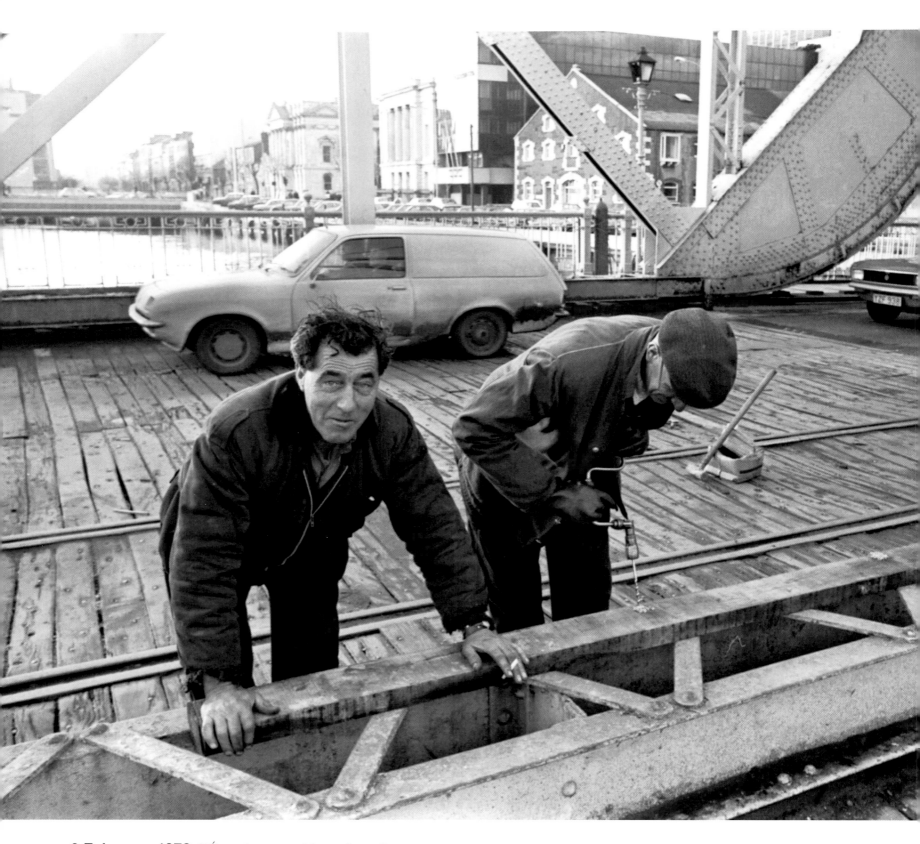

6 February 1978 CIÉ workers repairing railway lines on Clontarf Bridge, Cork. *215/171*

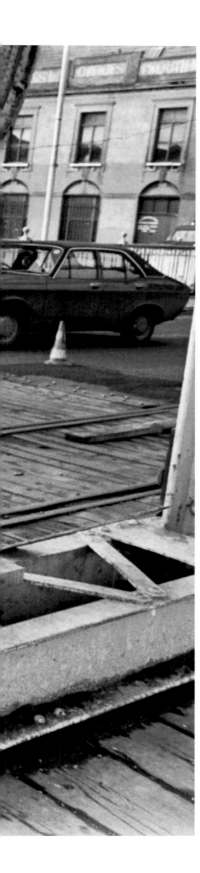

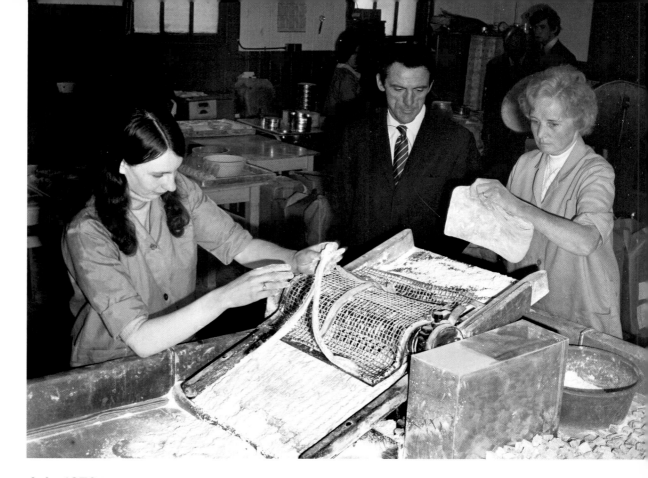

July 1976 Manufacturing Turkish Delight at Ogilvie and Moore, Parnell Place, Cork. *640P-156*

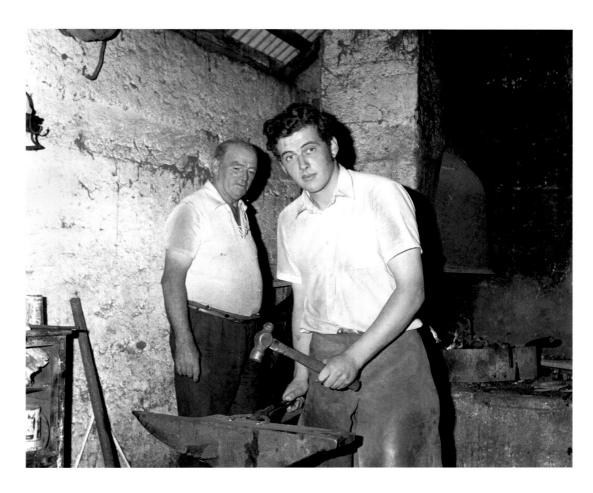

1 August 1976 Blacksmiths at work near Mallow, County Cork. *652P-272*

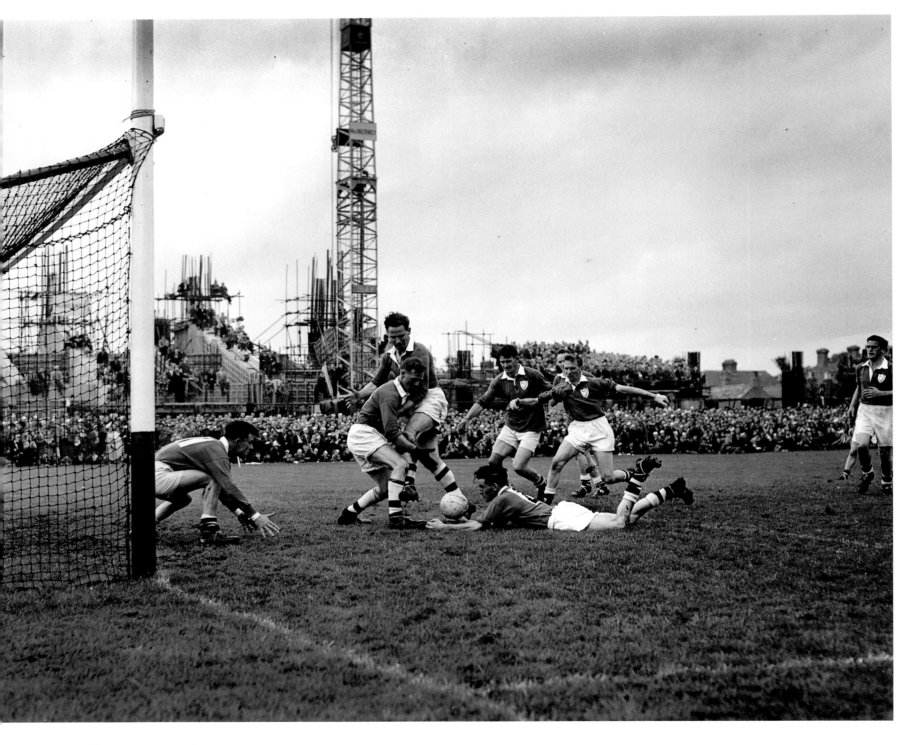

22 September 1957 Cork v Louth in the All-Ireland
Senior Football final at Croke Park, Dublin. Included is
Paddy O'Driscoll, on the ground. *694J*

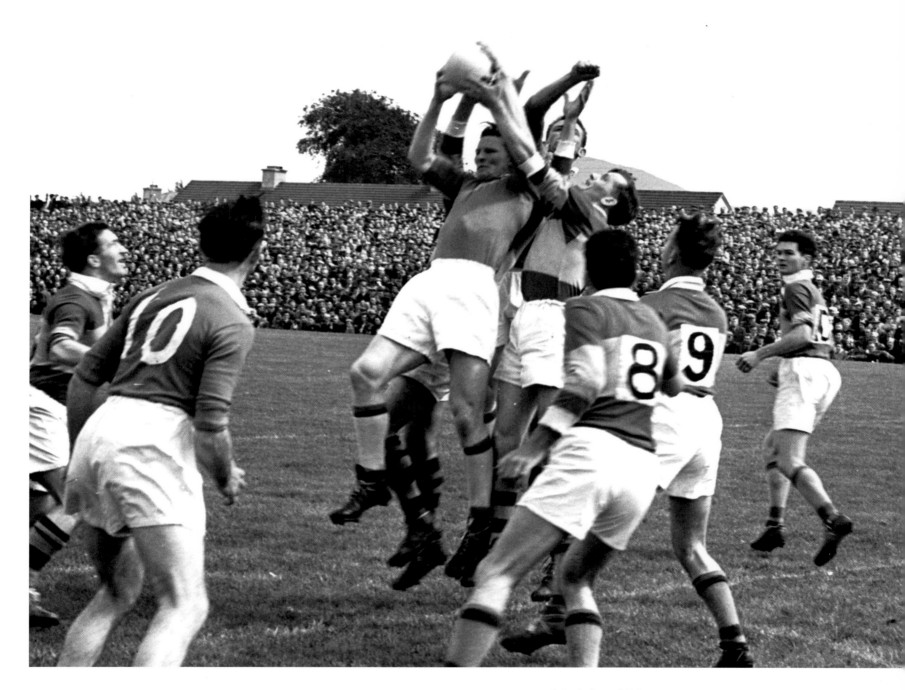

30 July 1956 Action from the Cork v Kerry
Munster Football final. *53J*

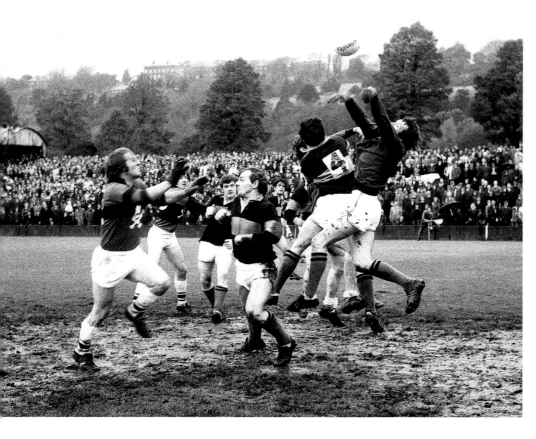

19 November 1972 Nemo v UCC at the
Athletic Grounds: Billy Morgan and Brian Murphy
clear the ball during a UCC attack. *643p-230*

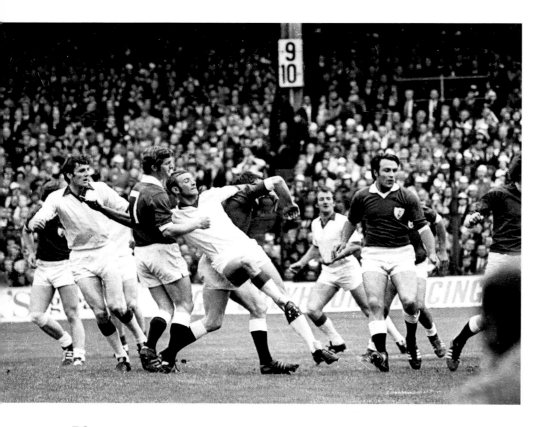

23 September 1973 Jimmy Barry Murphy
hits the ball into the net during the Cork v
Galway All-Ireland Football final at Croke
Park, Dublin. *165/47*

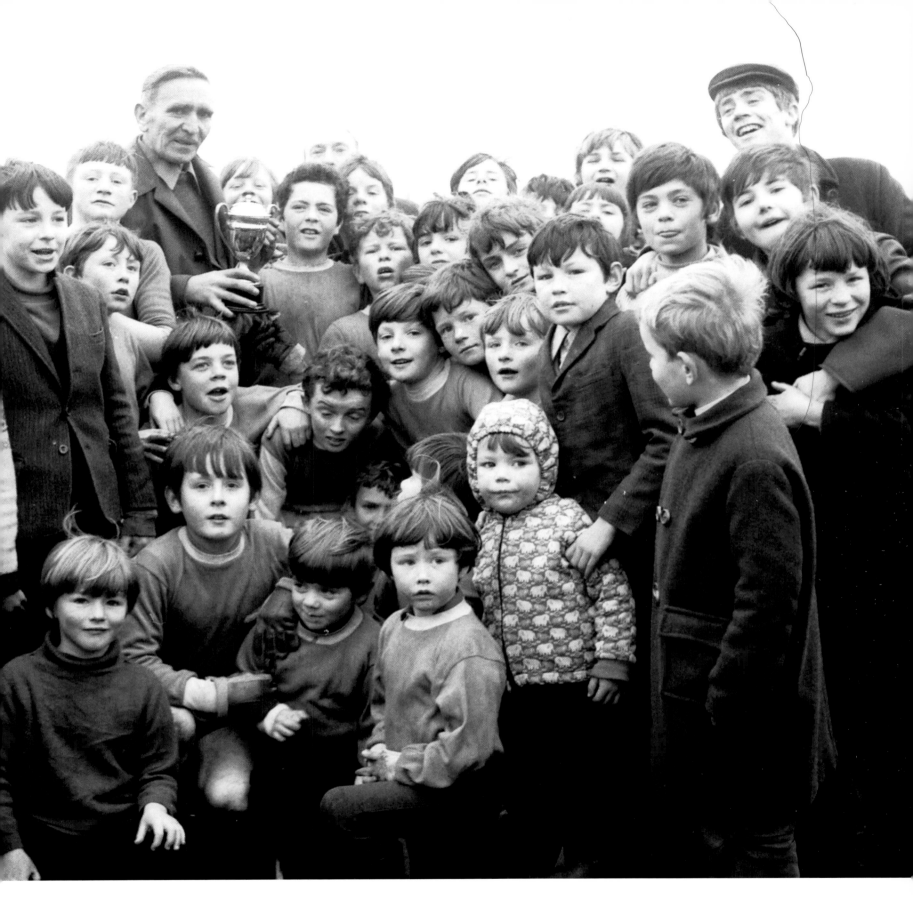

3 February 1972 The victorious Dillons Cross team and young fans after the defeat of the Old Youghal Road team in the Schoolboys' Street League Football final at the Tank Field, Cork. *644P-5*

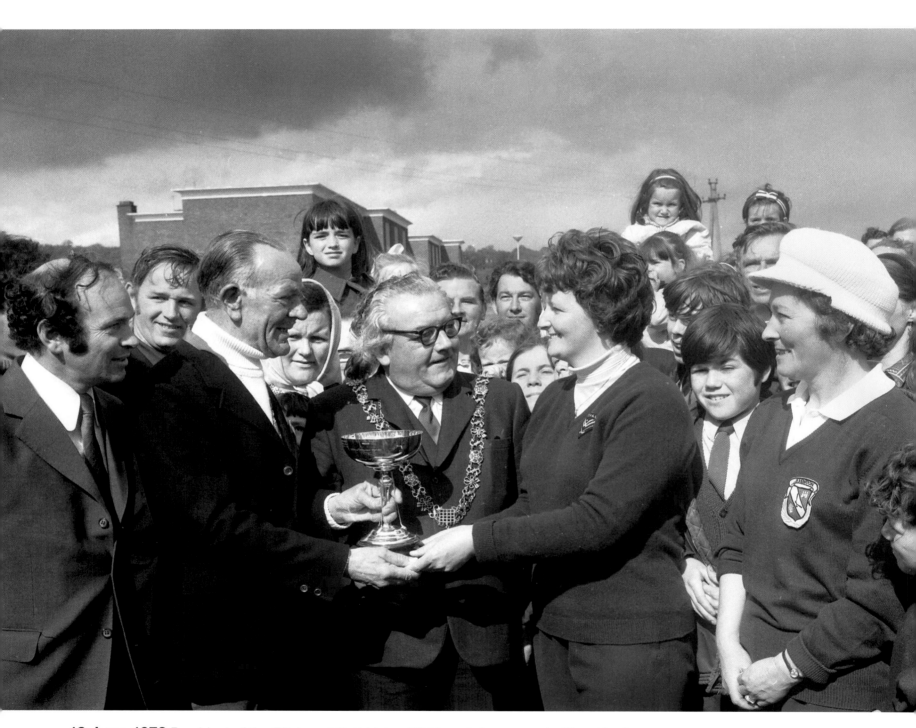

18 June 1972 President of the Pitch and Putt Union Bill Humphries presents Clare Keating with the winner's trophy of the Irish Ladies' Matchplay championship at St Anne's Club in Cork. Far left is Michael Conlon, the club president; centre, the Lord Mayor, Councillor Tim O'Sullivan; and, far right, defeated finalist Teresa McGuigan, Dublin. *643P/3*

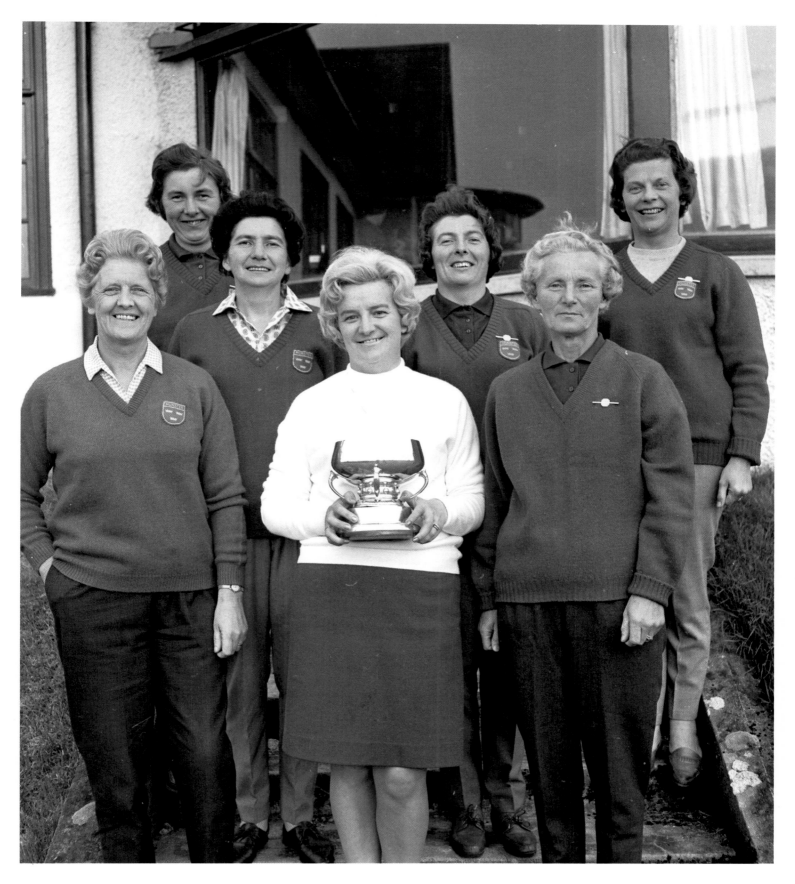

6 June 1968 The Douglas ladies golf team who were runners-up in the final of the Irish Senior Cup at Lahinch, County Clare. *630P/358*

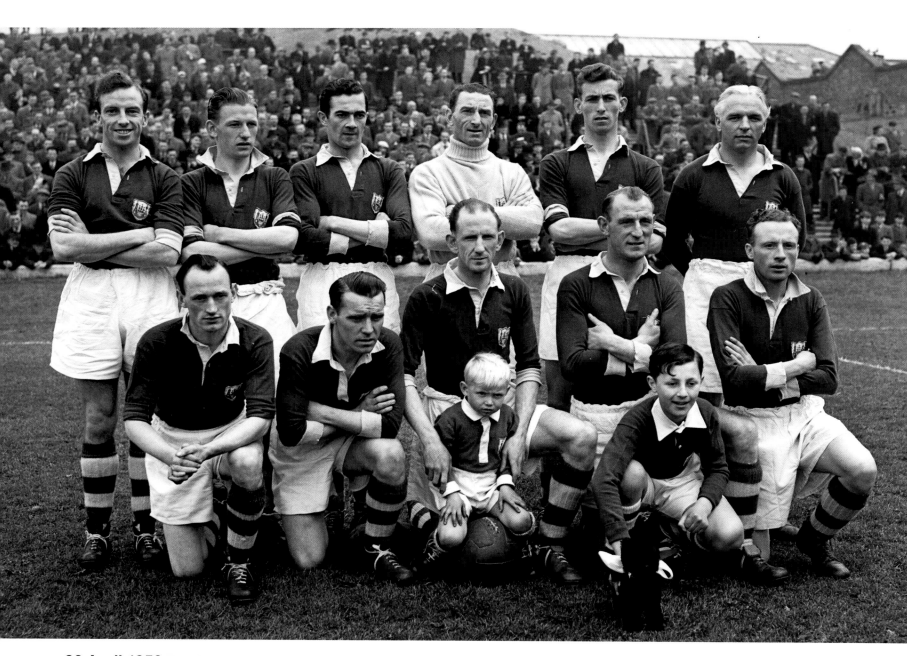

26 April 1953 The Cork Athletic team before their match against Evergreen United in the FAI Cup final at Dalymount Park, Dublin. *990E*

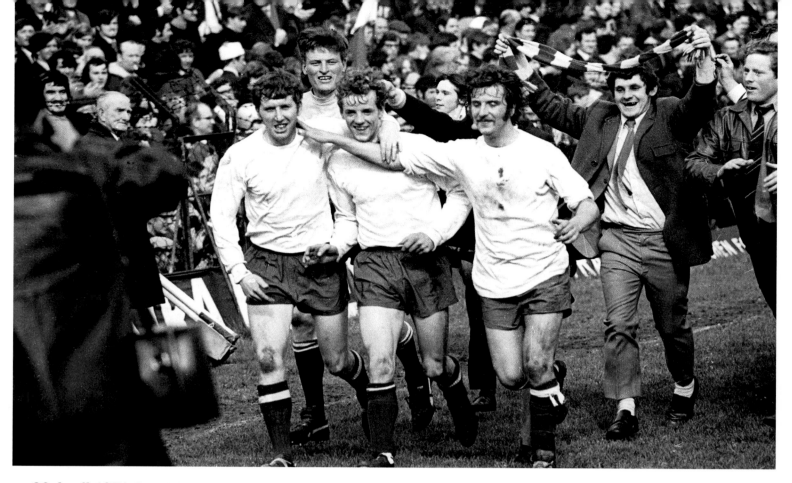

26 April 1971 Cork Hibernians players (l–r): Frank Connolly, Joe O'Grady, Miah Dennehy and John Lawson celebrate after winning the League of Ireland play-off decider against Shamrock Rovers at Dalymount Park, Dublin. *126/003*

23 November 1962 The St Dominics team who won the final of the Under-14 Mayfield Street League. *601M*

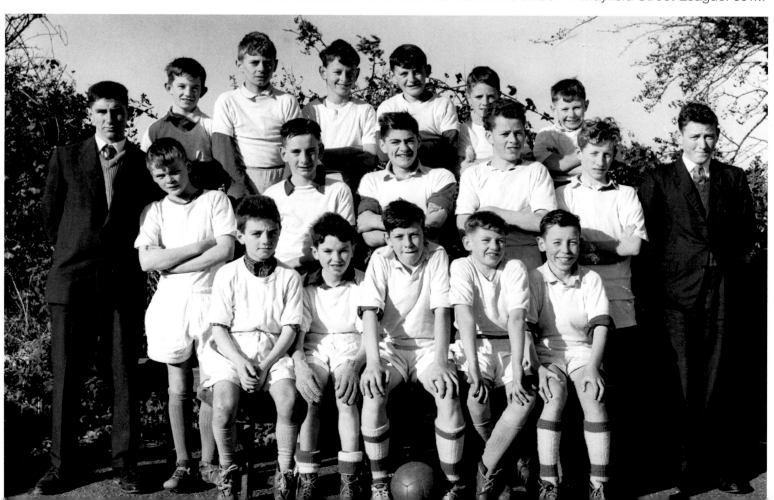

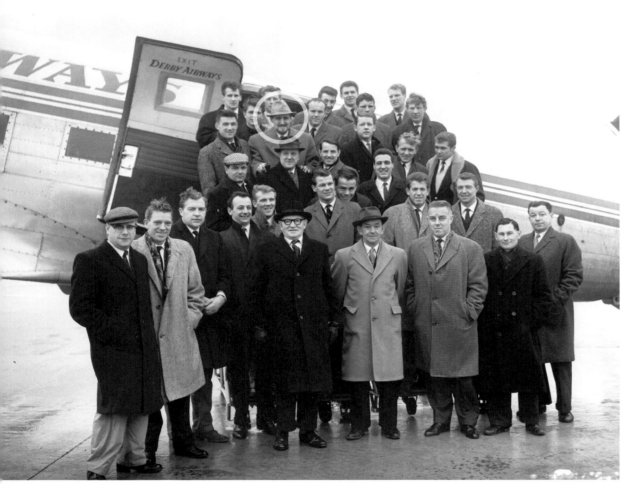

February 1963 Members of the Wolverhampton Wanderers and Coventry City football teams pictured on arrival at Cork Airport, before their match at Flower Lodge. Jimmy Hill (circled) later went on to present BBC's *Match of the Day*. *674M*

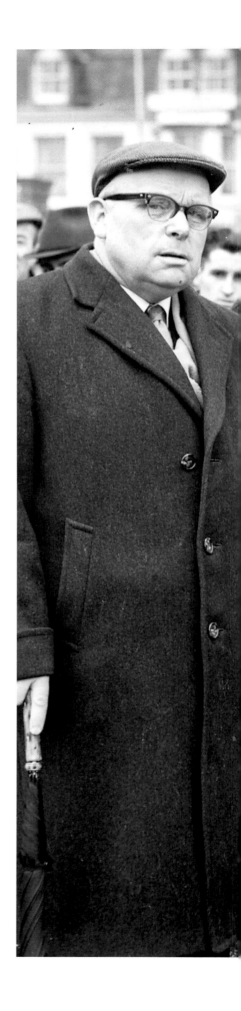

February 1963 Manchester United manager Matt Busby (second from left) pictured at Lower Glanmire Road railway station on the occasion of Manchester United's visit to Cork to play Bolton Wanderers at Flower Lodge. Also pictured is Alderman Sean Casey, TD, Lord Mayor of Cork (second from right). *681M*

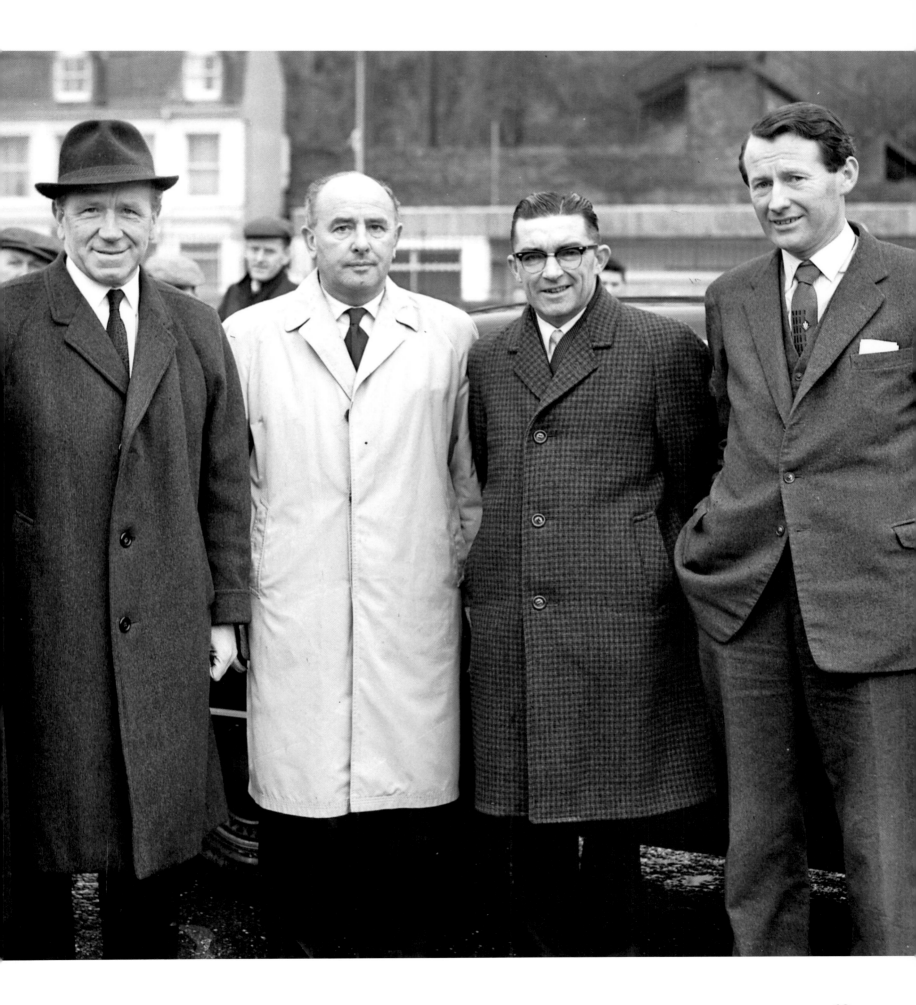

63

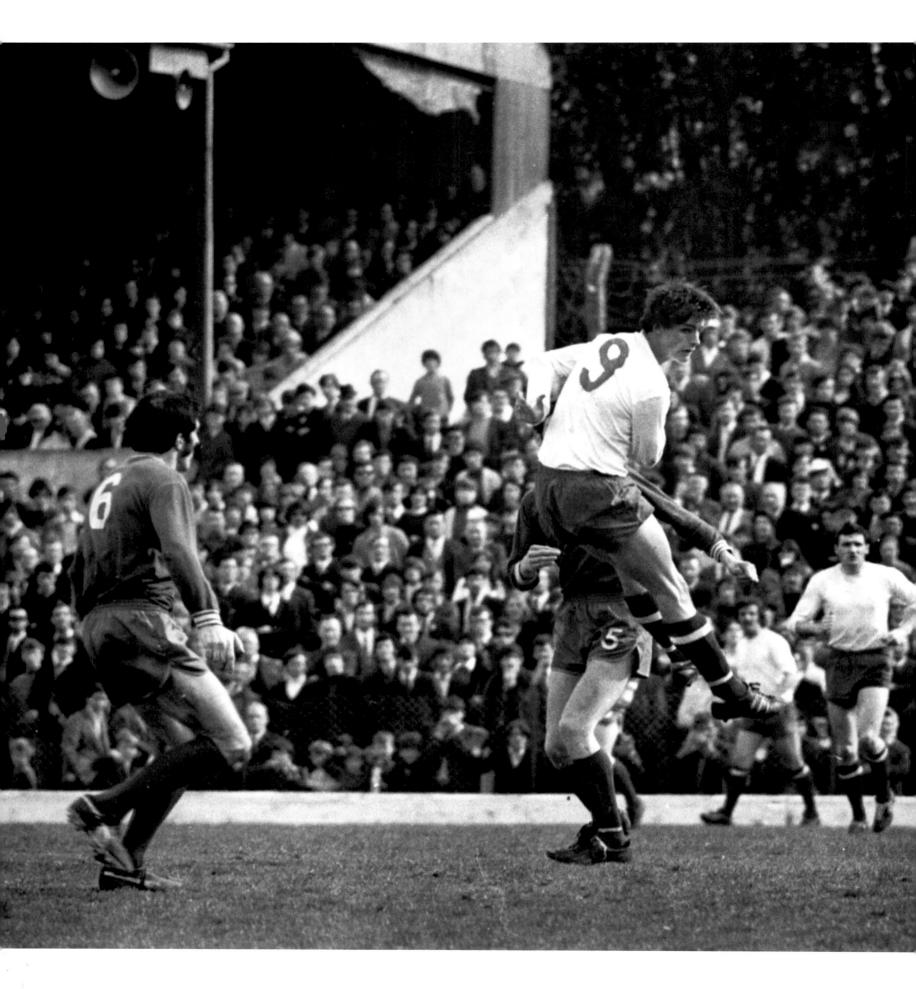

27 December 1956 M. O'Brien of South End making a brave save against Stella Maris in an Evans Cup match at Turners Cross, Cork. *290j*

11 April 1971 Tony Marsden of Cork Hibernians heads the ball goalwards during a League of Ireland soccer match against Waterford at Flower Lodge, Cork. *125/58*

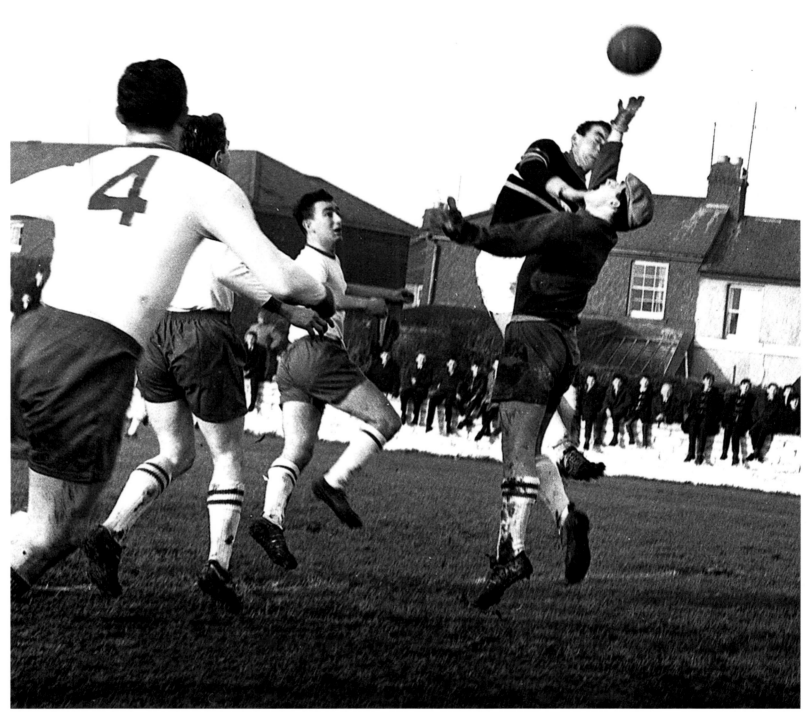

3 January 1965 Waterford's goalkeeper rises to a cross, challenged by Cork Celtic centre-forward Donal Leahy. Cork Celtic won by a goal to nil at the Turners Cross stadium. *449P/002*

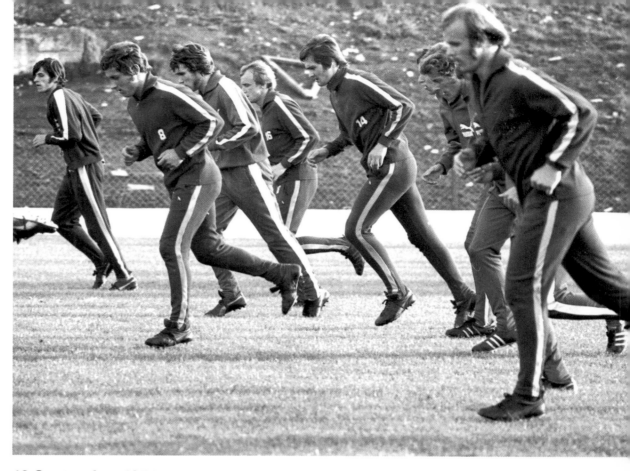

13 September 1971 Borussia Monchengladbach players training at Flower Lodge, Cork, before their Cup game with Cork Hibernians. *131/064*

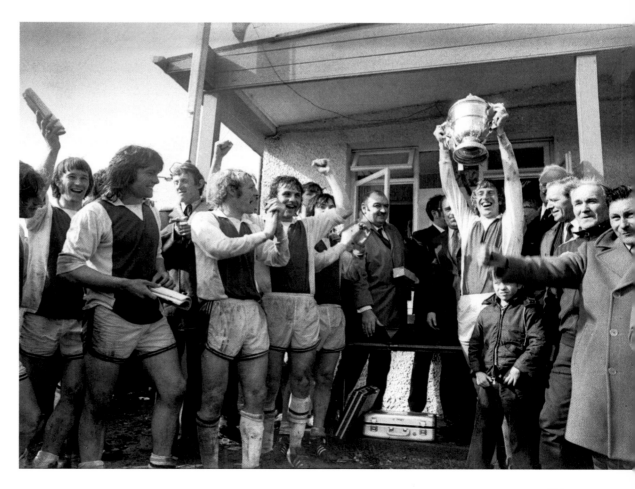

29 April 1973 Cork Hibernians celebrate their win over Shelbourne in the FAI Cup final replay at Flower Lodge, Cork. *158/62*

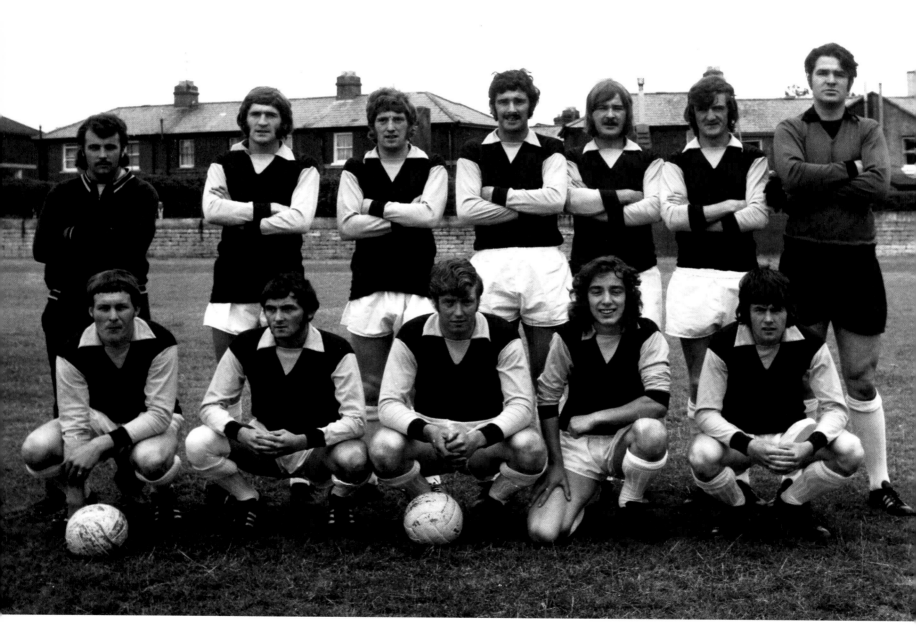

13 August 1972 The Cobh Ramblers
soccer team, before their match against
Cork Celtic at Turners Cross, Cork. *643p100*

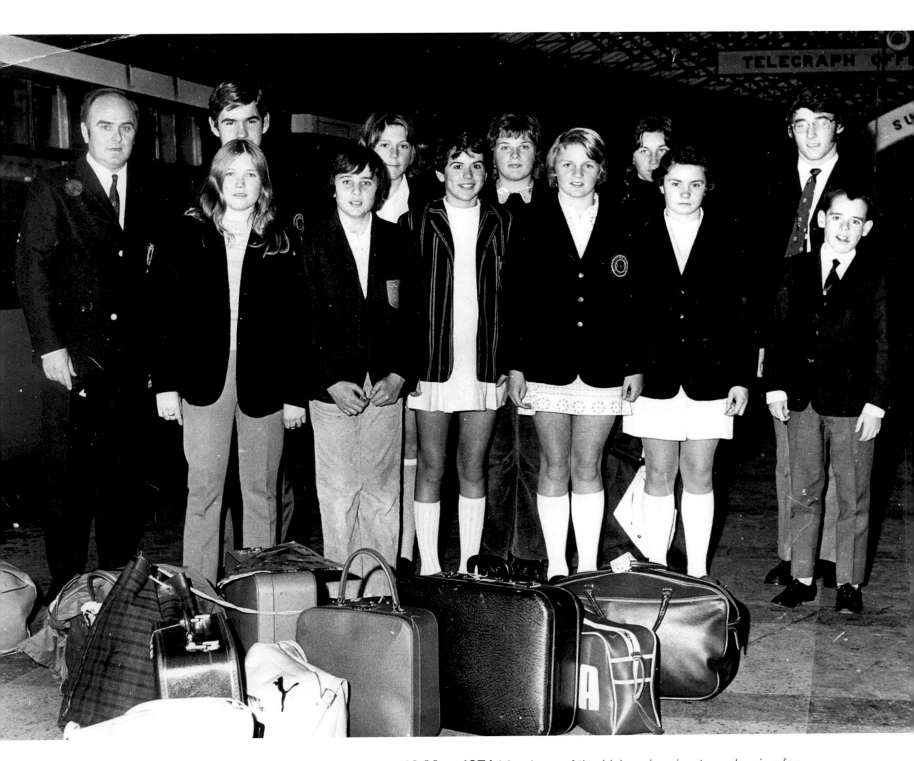

18 May 1971 Members of the Irish swimming team leaving for Coventry in 1971. Back row (l–r): E. Campion, B. Clifford, D. Cross, M. Donnelly, M. O'Neill, J. Martin; front row (l–r): A. Galvin, S. O'Sullivan, E. Campion, S. Bowles, C. Coleman and K. Logan. *338*

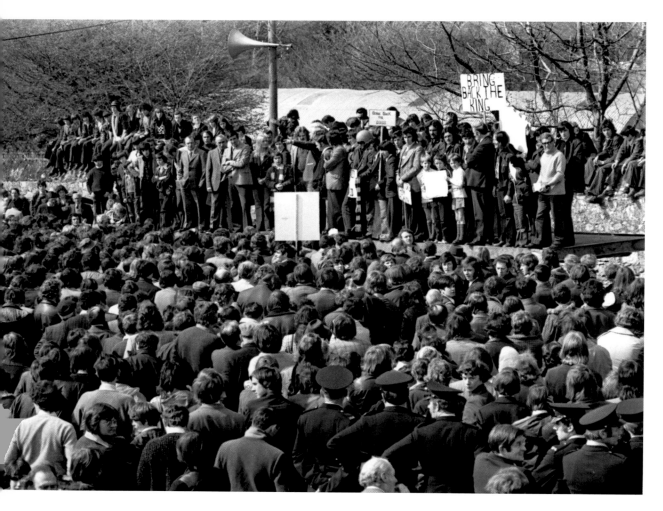

14 April 1974 A protest meeting in support of
sacked Cork Hibernians manager Dave Bacuzzi
outside Flower Lodge, Cork. *172/9*

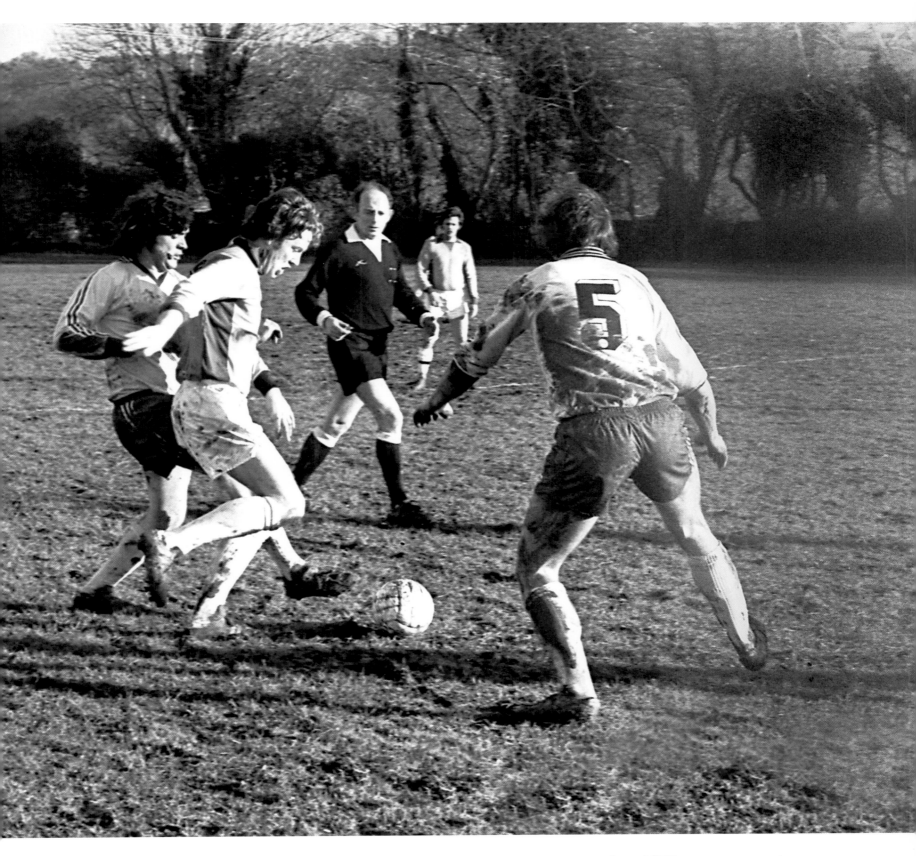

11 December 1977 Avondale United v
Tramore Athletic in the FAI Intermediate Cup at
Rochestown, County Cork. *214/40*

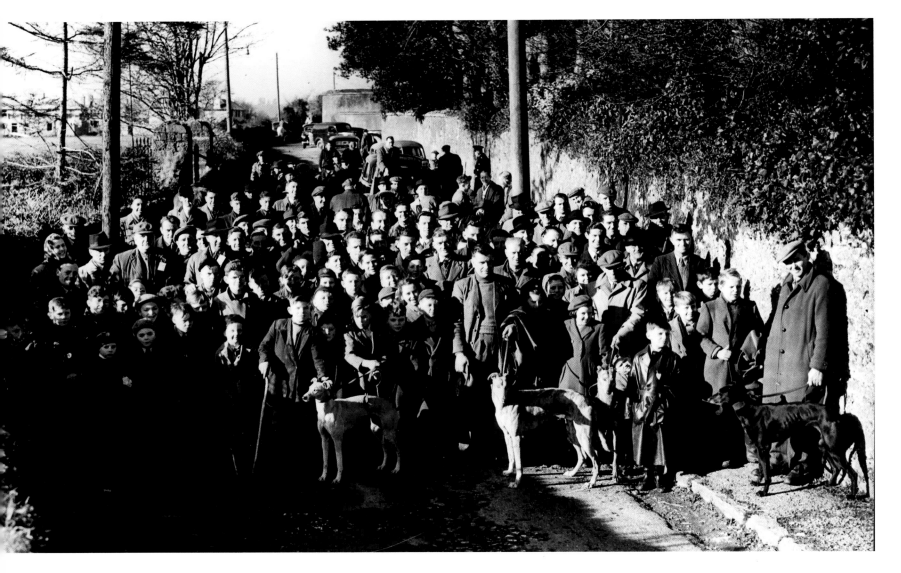

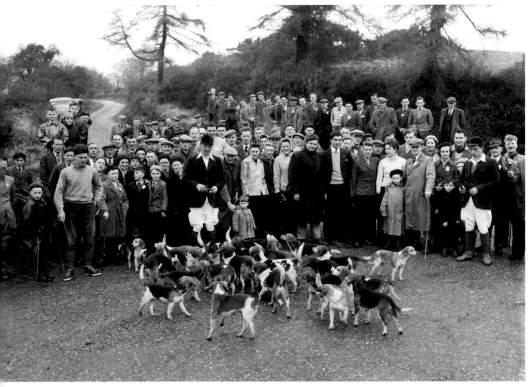

10 December 1951 Open coursing meeting at Blackrock, Cork. *920D*

4 December 1957 Riverstown Harriers and Holy Cross Foot Beagles meet at Glenroe Bridge, County Cork. *345J*

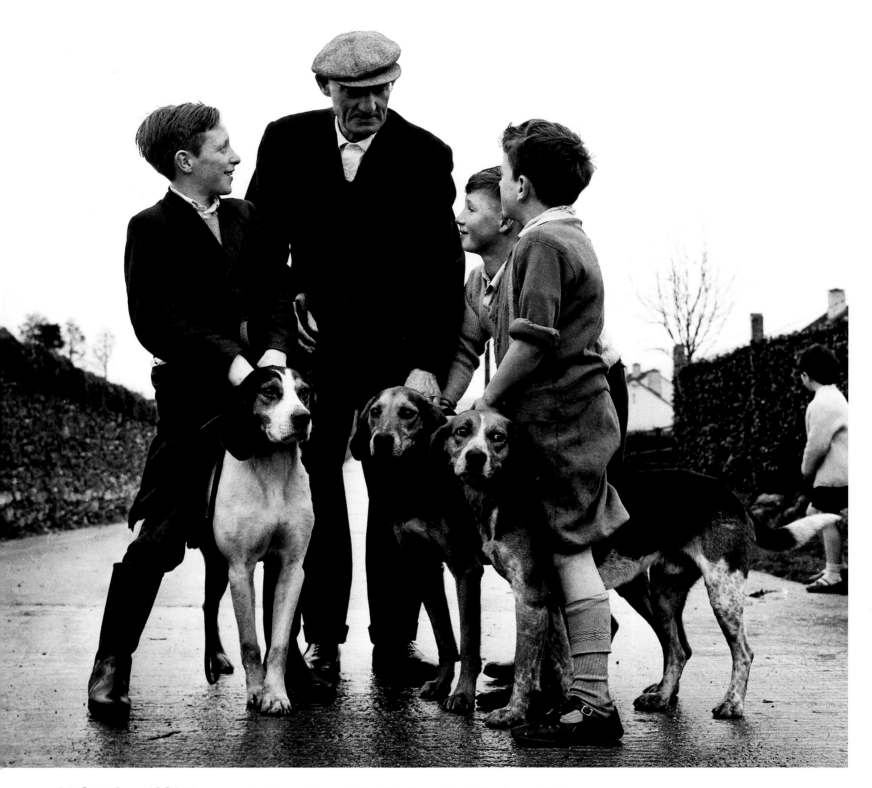

21 October 1961 Young and old members of the Northern Hunt Harriers. *38M*

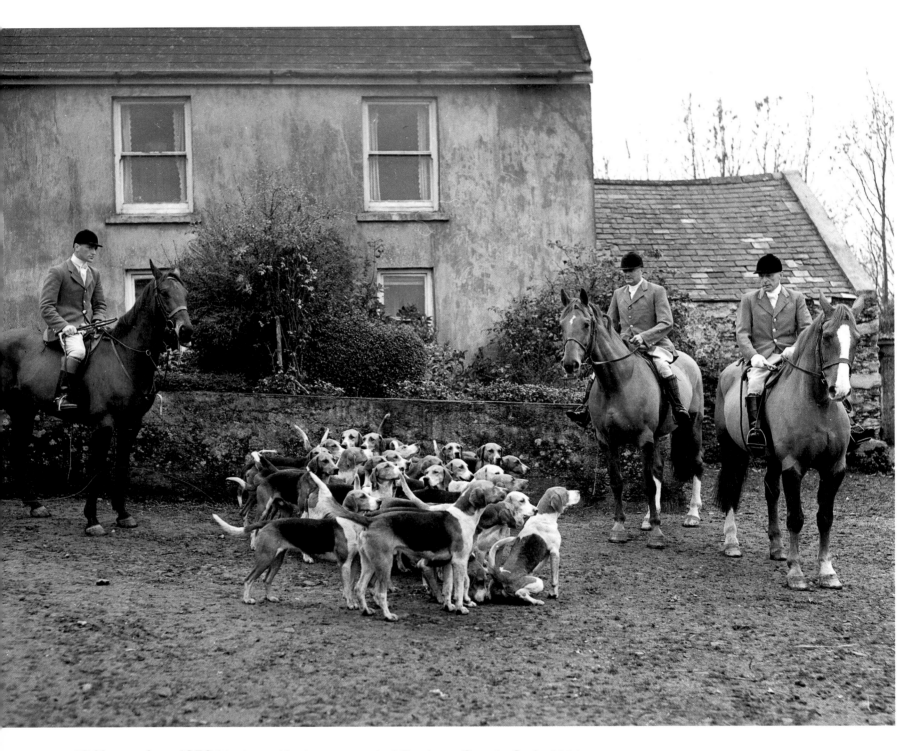

13 November 1956 Muskerry Hunt open meet at Berrings, County Cork. *223J*

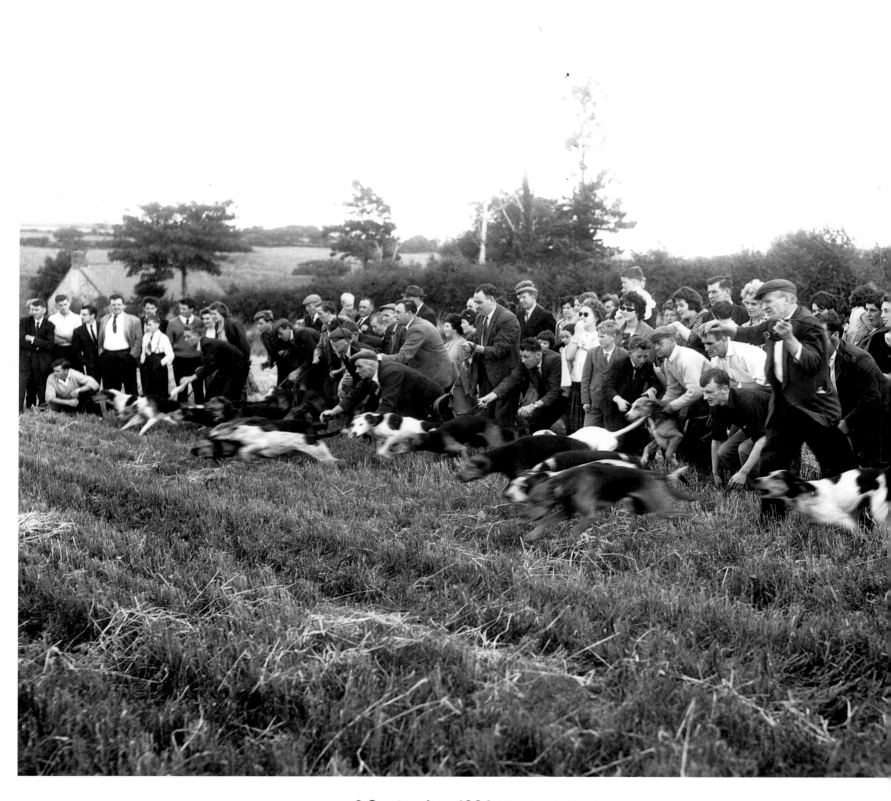

6 September 1964 All-Ireland Drag Hunt at Dripsey, County Cork. *411P*

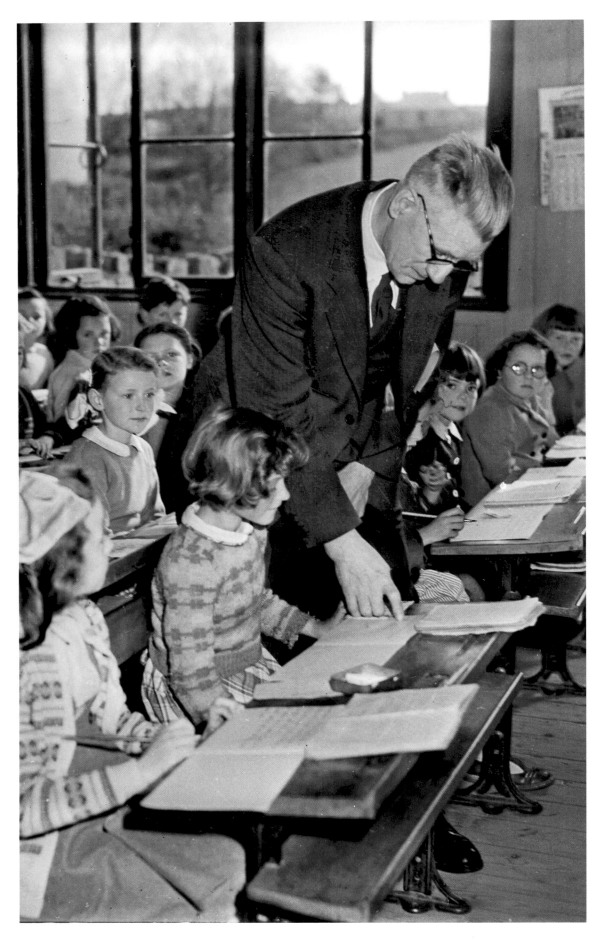

28 April 1952 Sean Moylan, Minister for Education, visits Mayfield National School, Cork. *459E*

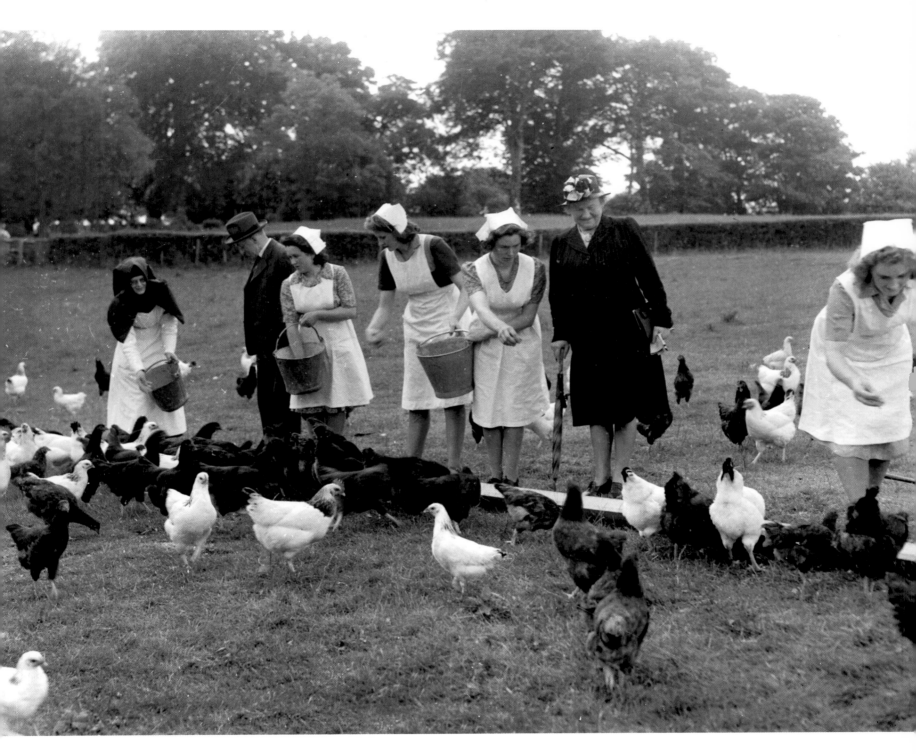

12 July 1948 Visit of General Richard Mulcahy and his wife to Drishane Convent, Millstreet, County Cork. *498D*

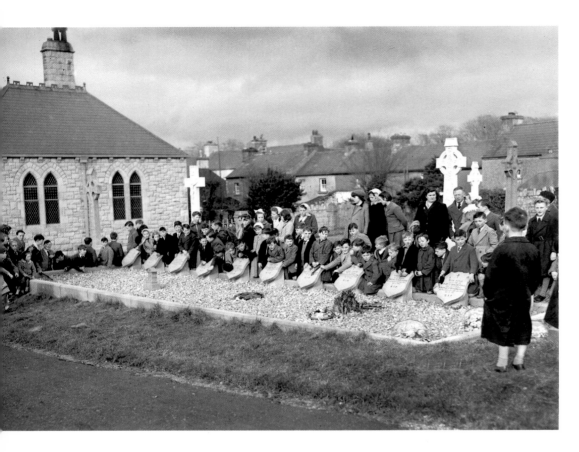

22 February 1959 The annual Clonmult Ambush commemoration at Midleton cemetery, County Cork. *550K*

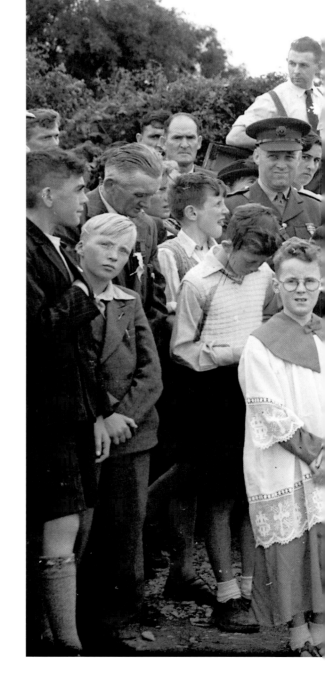

2 August 1953 A memorial to West Cork republicans is unveiled in Bandon by President Seán T. O'Kelly. Seated behind the President on the left is Commandant General Tom Barry. *169G*

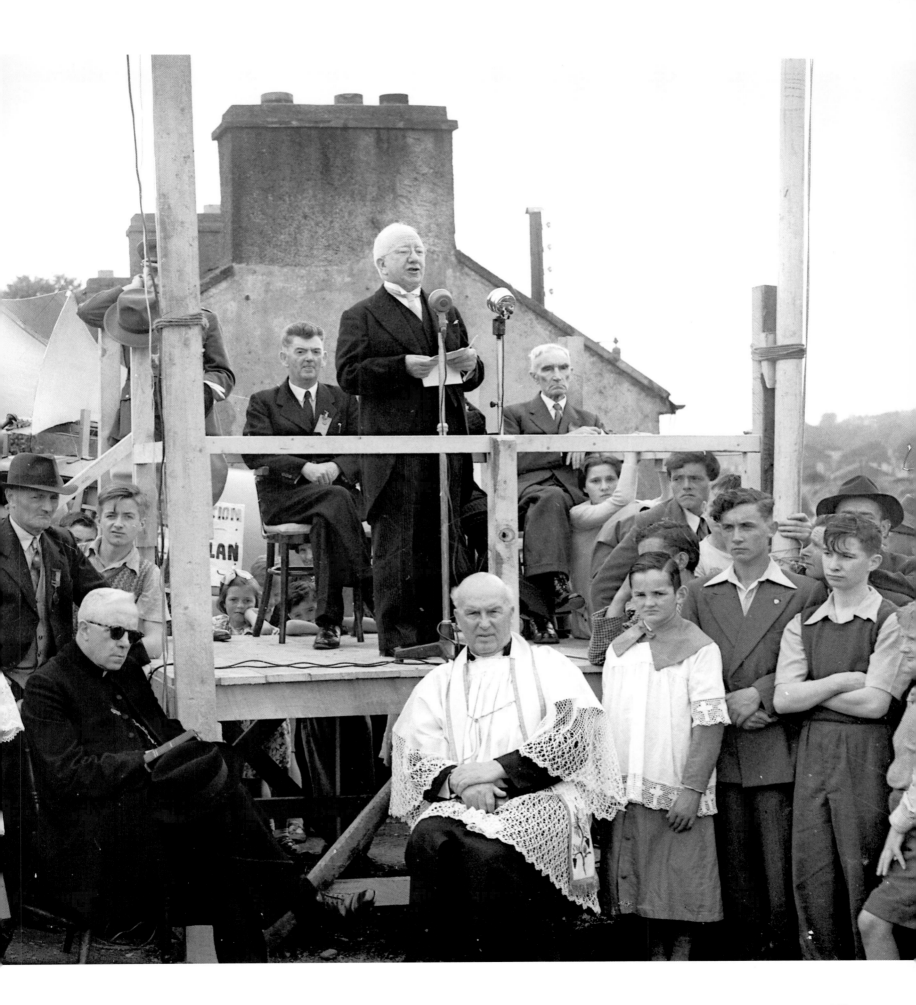

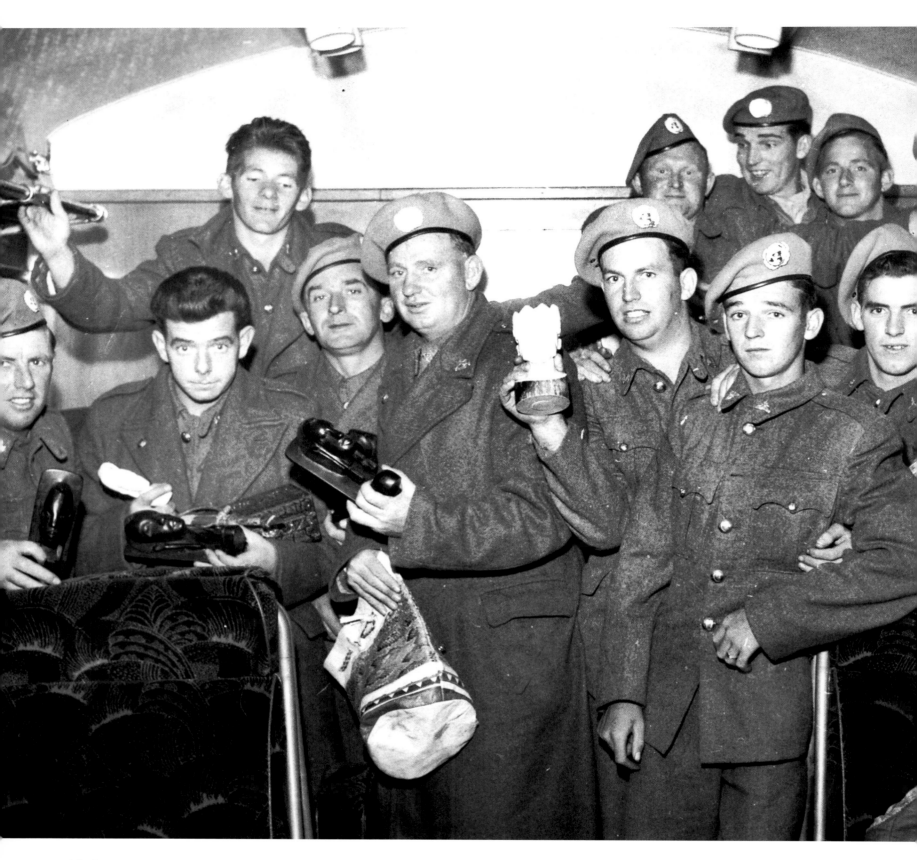

16 January 1961 Soldiers of the Irish Army at Lower Glanmire Road railway station, on their return from United Nations service in the Belgian Congo. *585L*

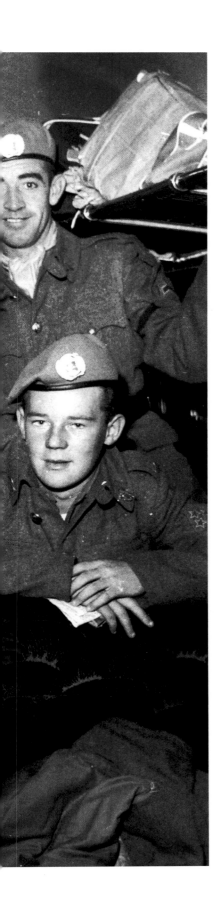

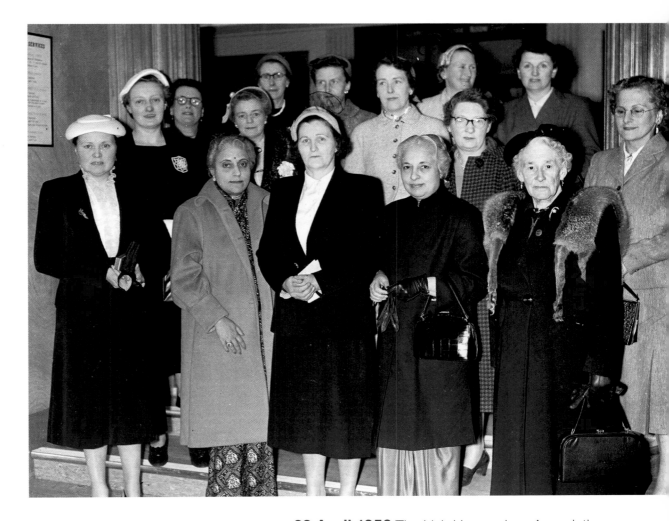

28 April 1956 The Irish Housewives Association meet with the Indian Ambassador, Madam Pandit (second from the right, front row), in Cork. *886H*

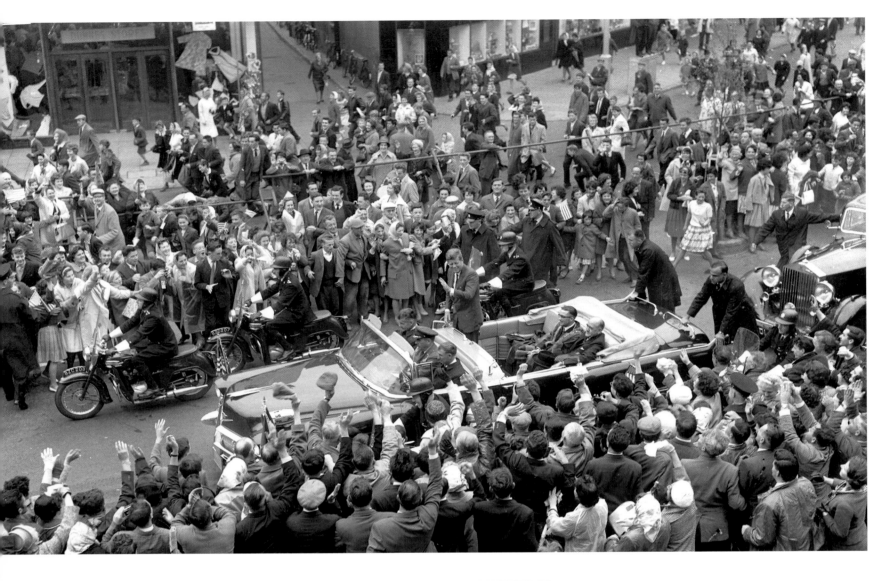

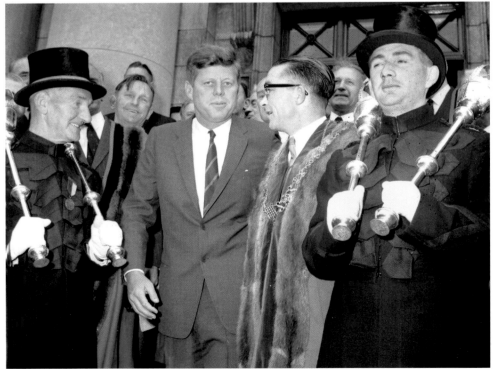

28 June 1963 American President John F. Kennedy is driven through St Patrick's Street in an open-top car with Lord Mayor Sean Casey, during his visit to Cork. *892M*

28 June 1963 John F. Kennedy at Cork's City Hall with Lord Mayor Sean Casey. *892M*

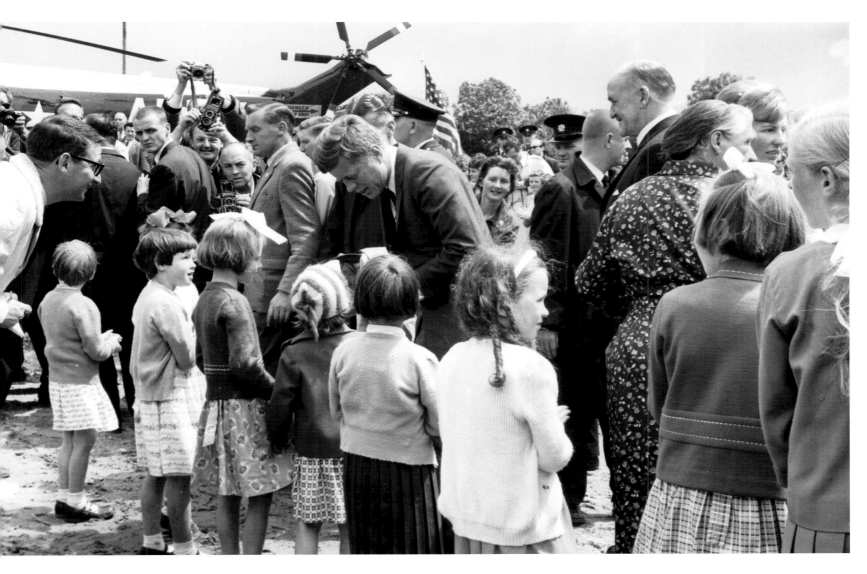

28 June 1963 American President John F. Kennedy visits his ancestral home town in Dunganstown, County Wexford. *894M*

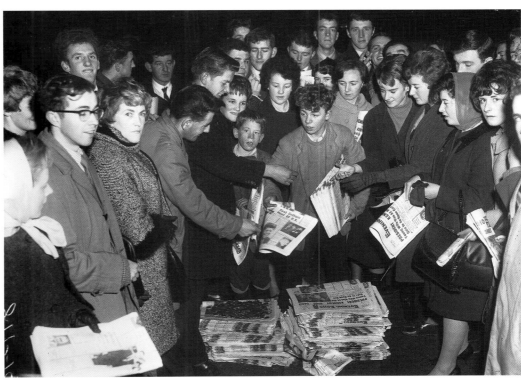

22 November 1963 People buying copies of the *Evening Echo* reporting the death of American President Kennedy. *81p*

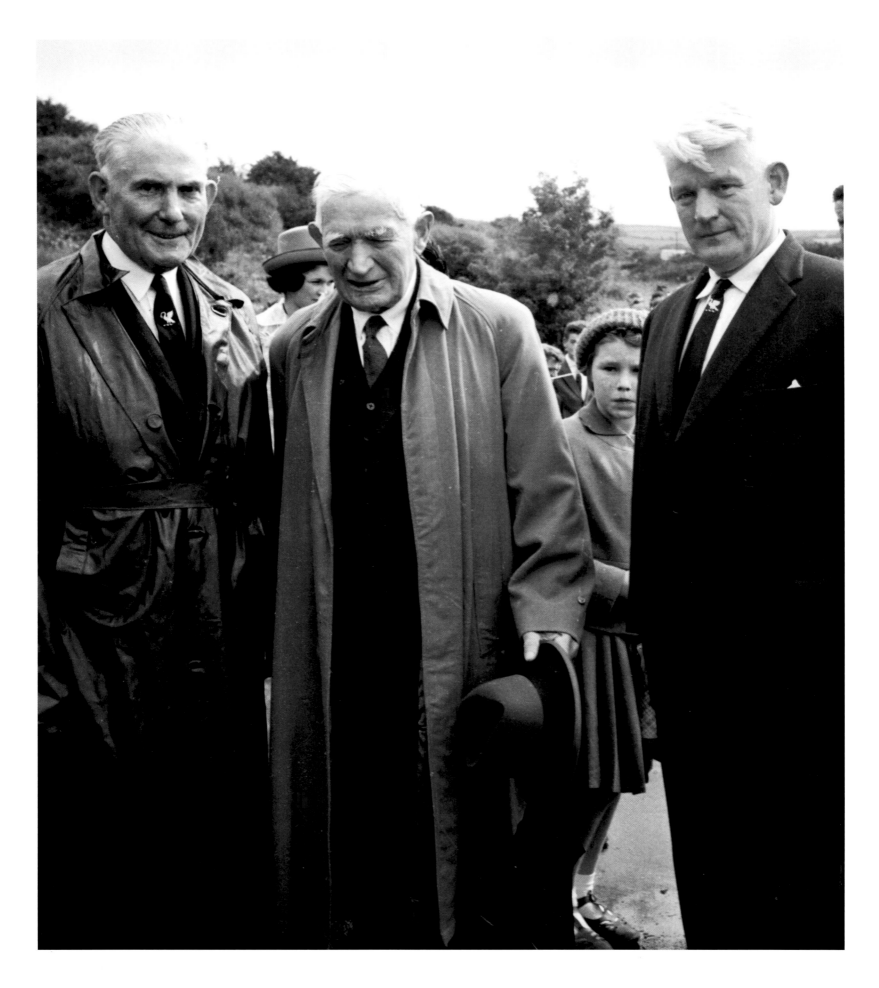

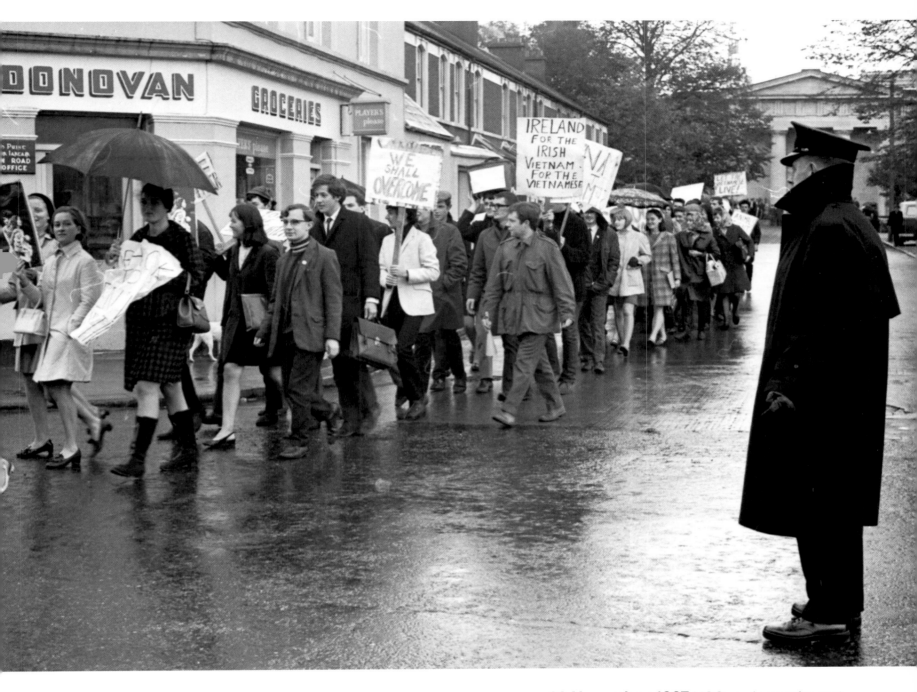

20 November 1967 UCC students take part in an anti-Vietnam War protest. *49/13*

August 1963 (L–r): General Seán MacEoin with the brother and nephew of Michael Collins at the Béal na mBláth monument, County Cork. *974M*

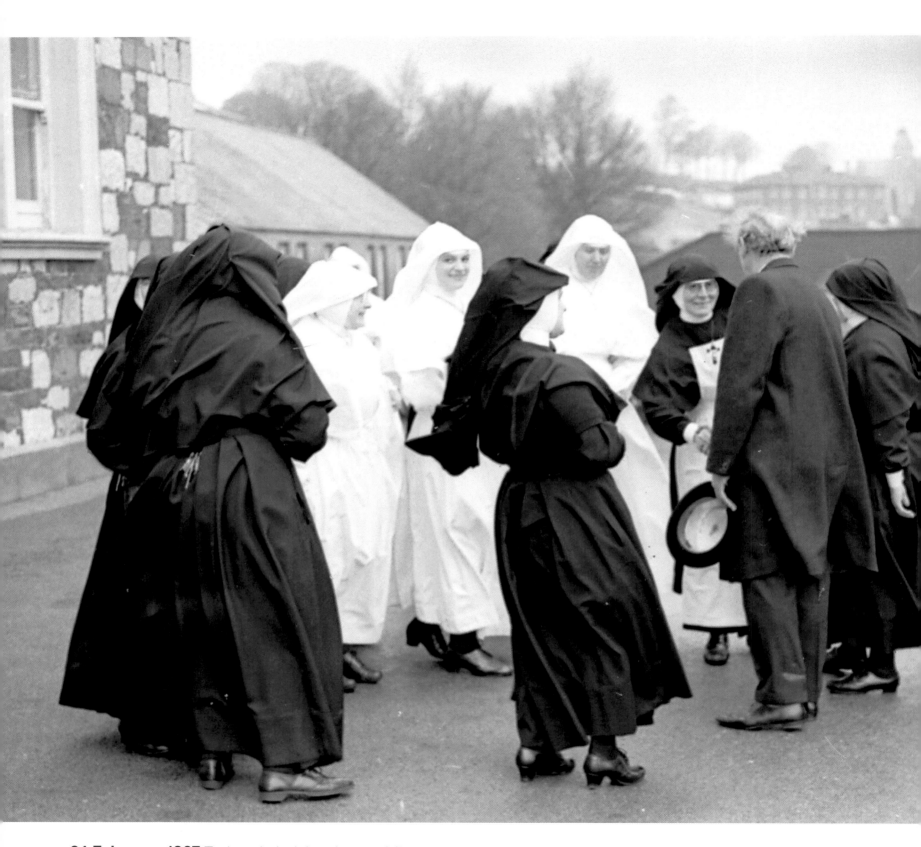

24 February 1967 Taoiseach Jack Lynch on a visit
to St Vincent's Convent, Cork. *36/55*

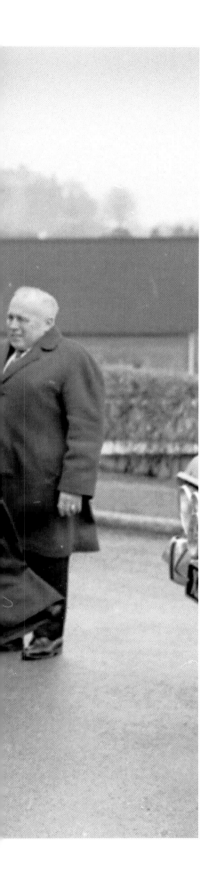

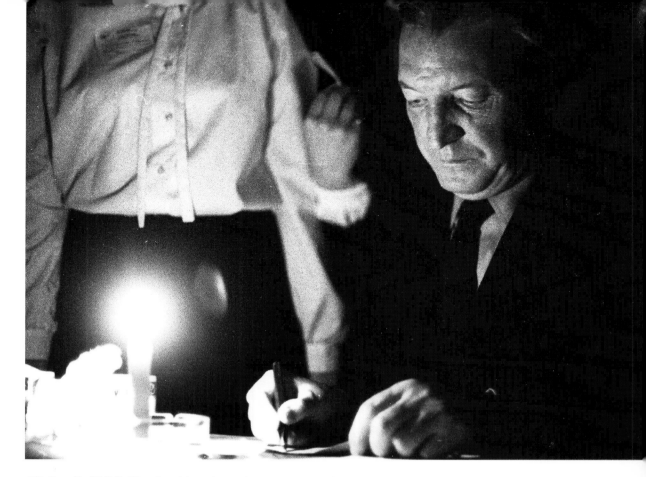

12 April 1980 Charles Haughey signs autographs at a Fianna Fáil Youth Conference in Limerick. *190KC*

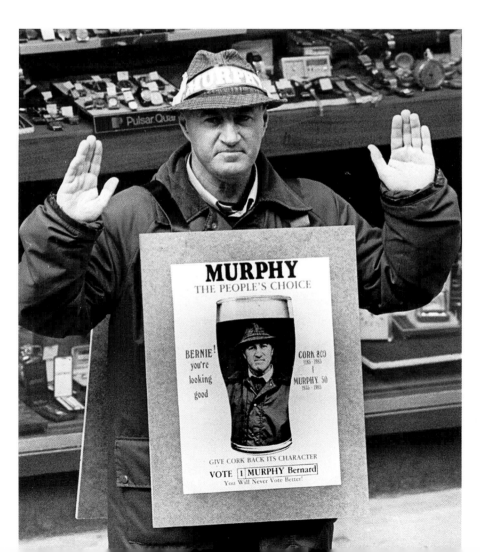

13 June 1985 Independent candidate Bernie Murphy on the election trail for Cork City Council. *309/217*

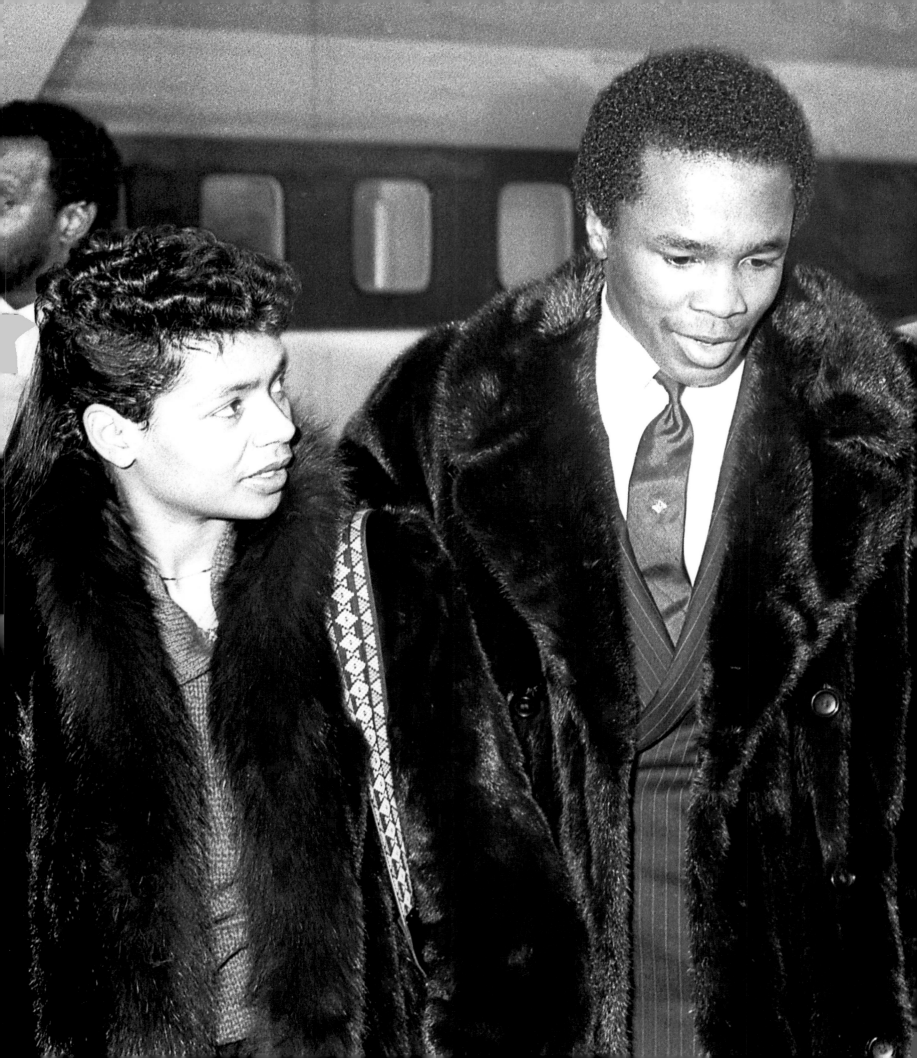

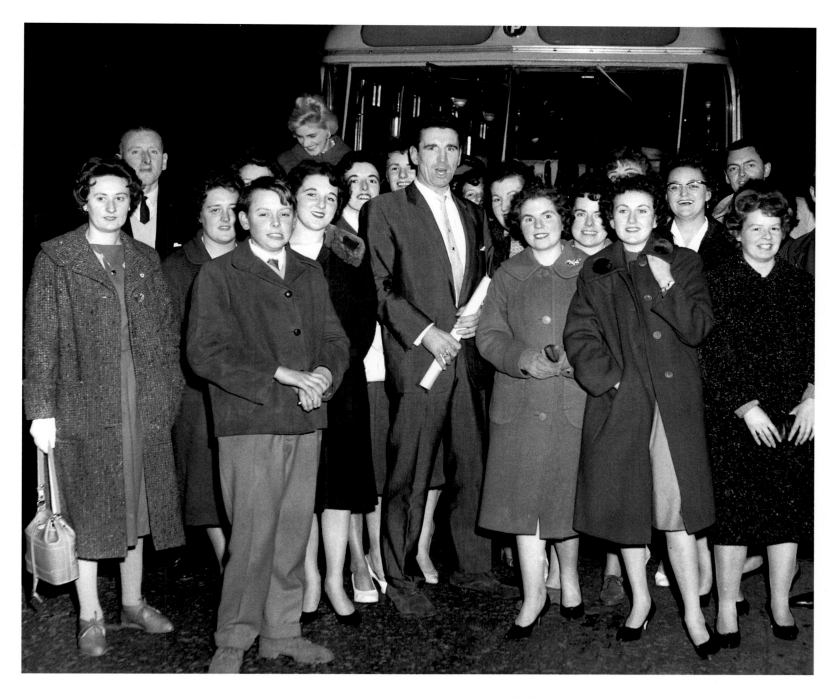

13 November 1960 Singer Brendan O'Dowda surrounded by fans outside the Palace Theatre, MacCurtain Street, Cork. *498L*

8 January 1985 Former World Welterweight champion Sugar Ray Leonard and his wife Juanita, arriving at Cork Airport before the upcoming fight between Shawn O'Sullivan and Marvin McDowell. *380/245*

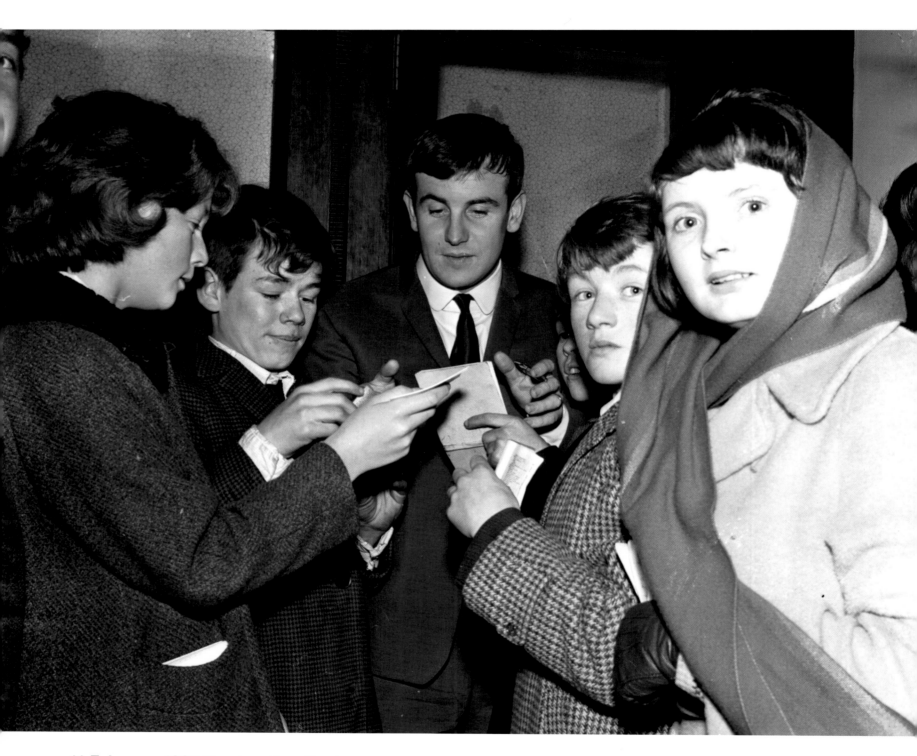

11 February 1965 Showband icon Butch Moore signs autographs at the Imperial Hotel, Cork. *459P/012*

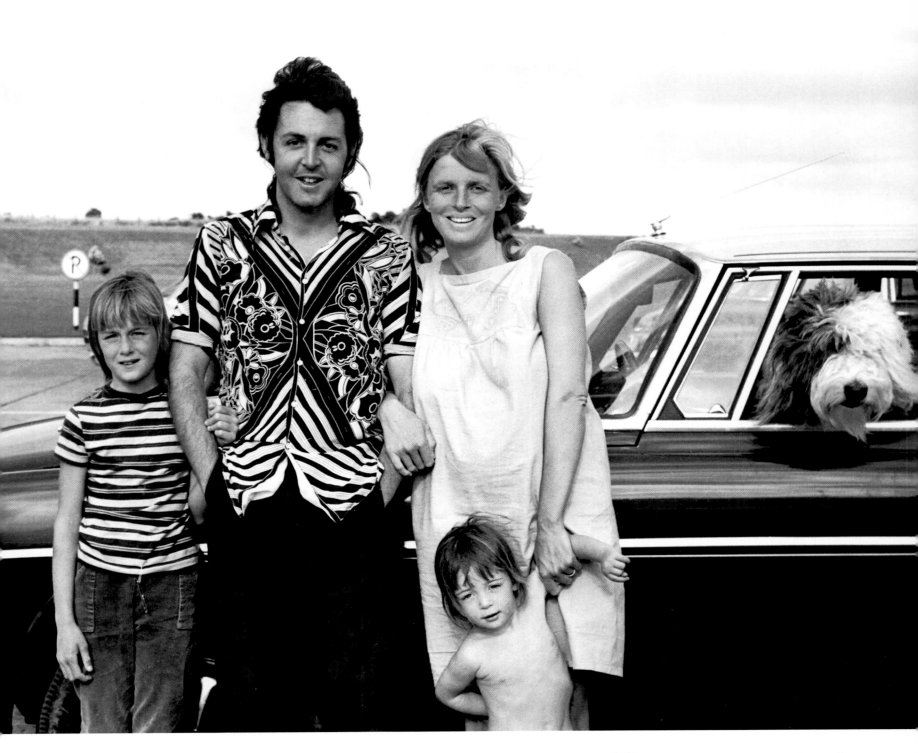

20 August 1971 Beatle Paul McCartney pictured at Cork Airport with his wife Linda and daughters Heather (aged eight) and Mary (aged four). *640P/272*

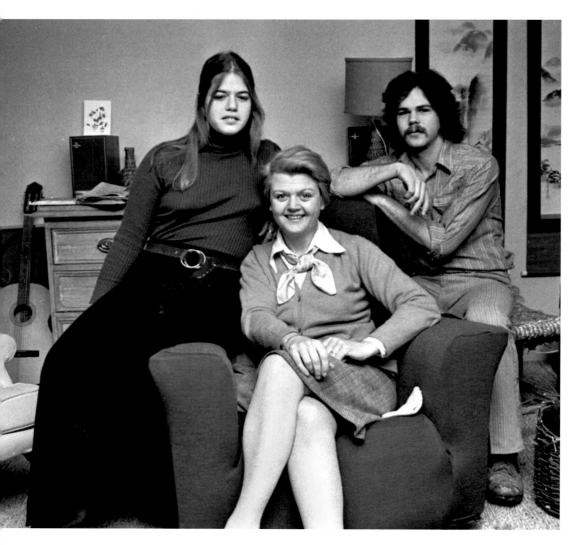

13 March 1972 American actress Angela Lansbury pictured with her daughter and son at their bungalow in Conna, County Cork. *138/34*

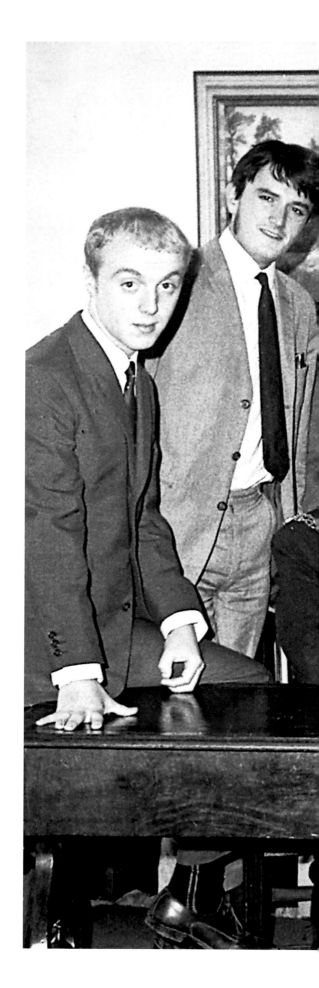

18 July 1967 The Freshmen showband with Lord Mayor Pierce Wyse on an official visit to City Hall, Cork. *44/92*

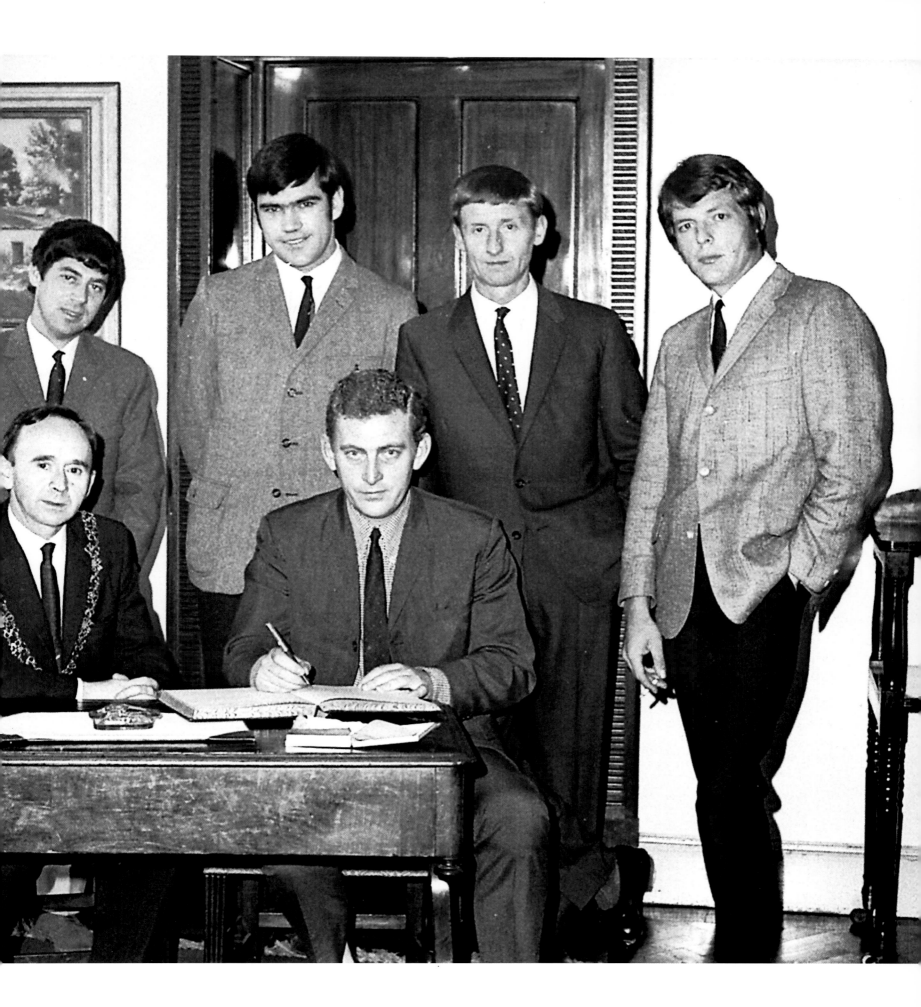

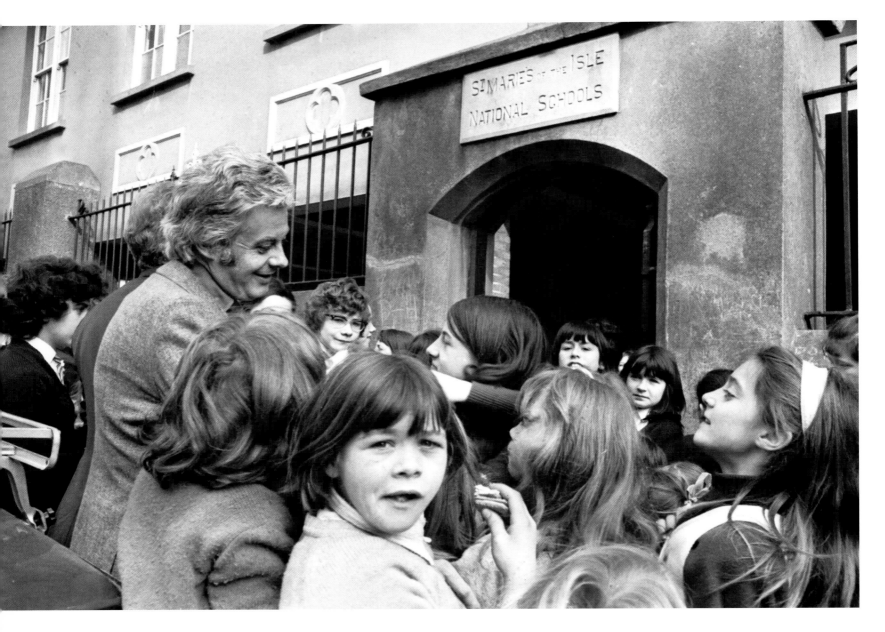

7 April 1971 Danny La Rue on a visit to St Marie's of the Isle National School, Cork. *125/53*

17 December 1987 George Best poses with a fan during the opening of a Ladbrokes betting office on Drawbridge Street, Cork. *365/145*

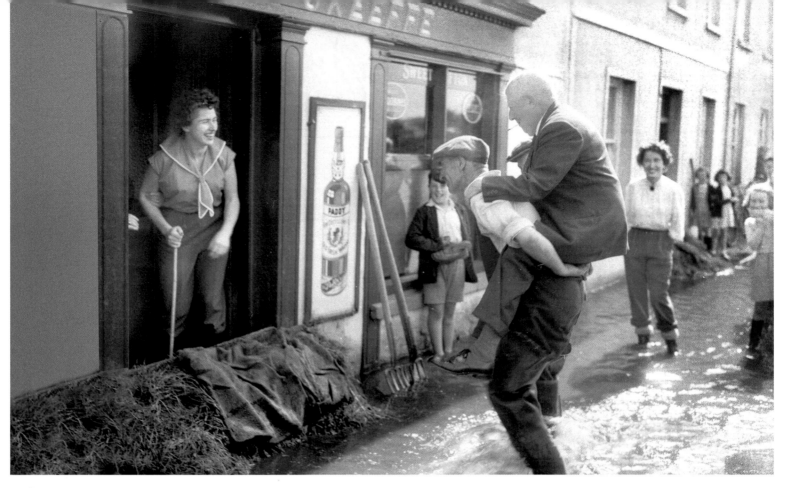

3 September 1958 A helping hand during the flooding in Castlemartyr, County Cork. *306K*

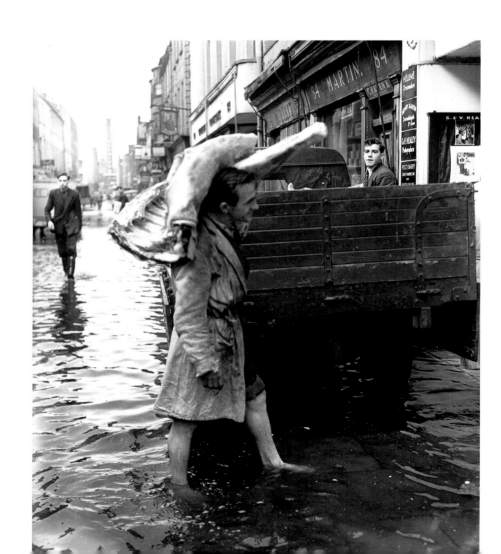

3 November 1955 Flooding in Cork City. *593h*

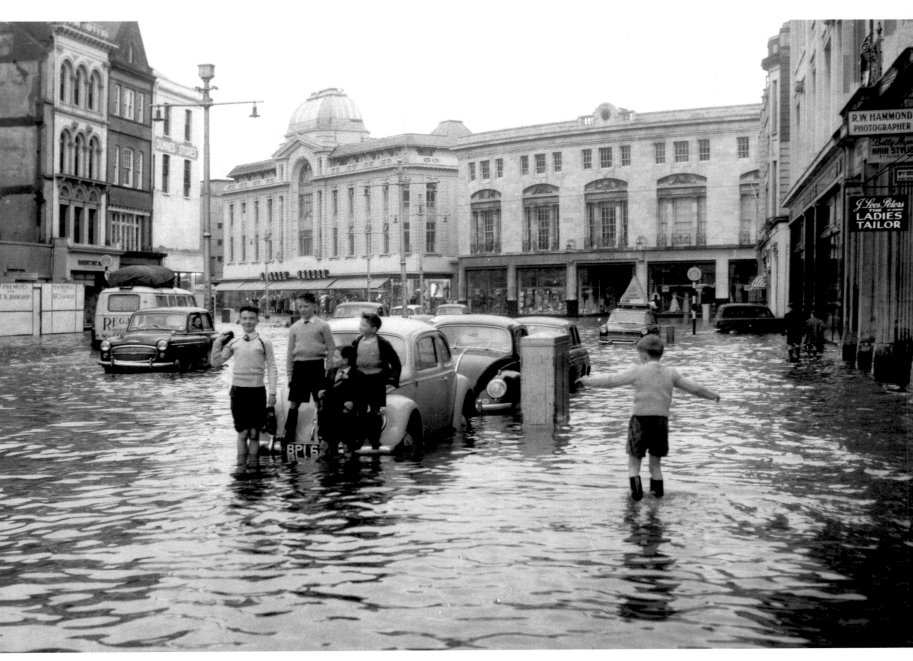

22 October 1961 Flooding on St Patrick's Street, Cork. *47M*

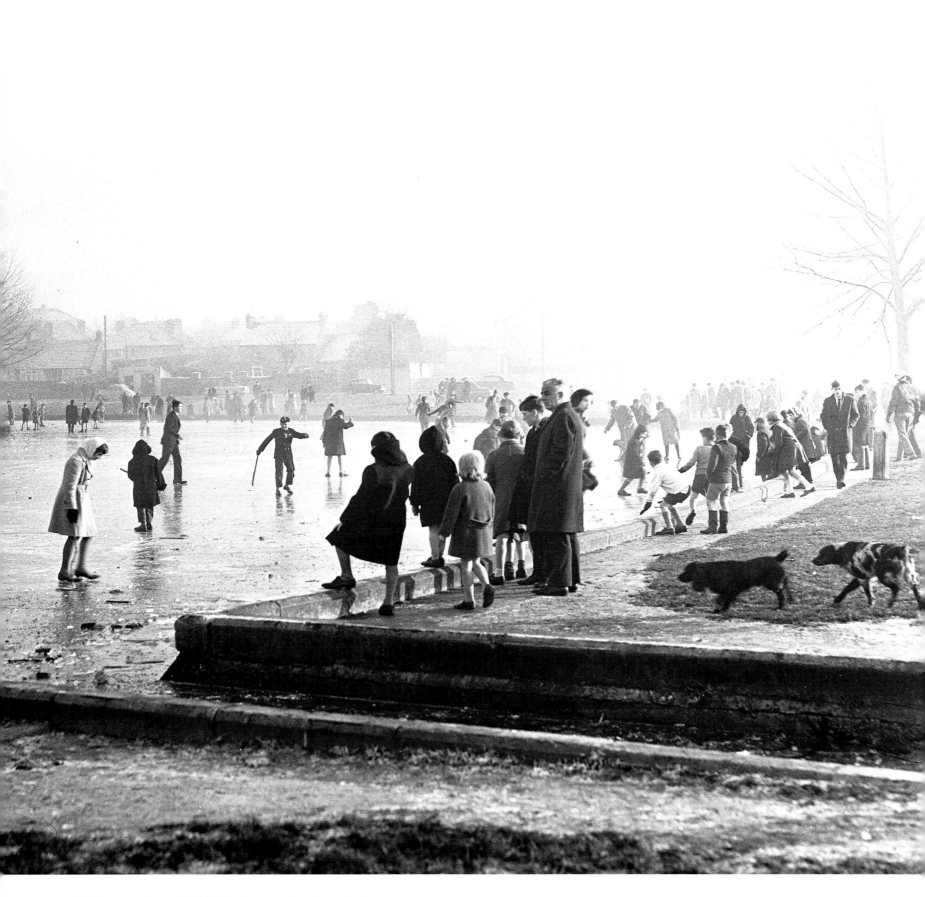

24 December 1962 Skating on the Lough, Cork. *190P*

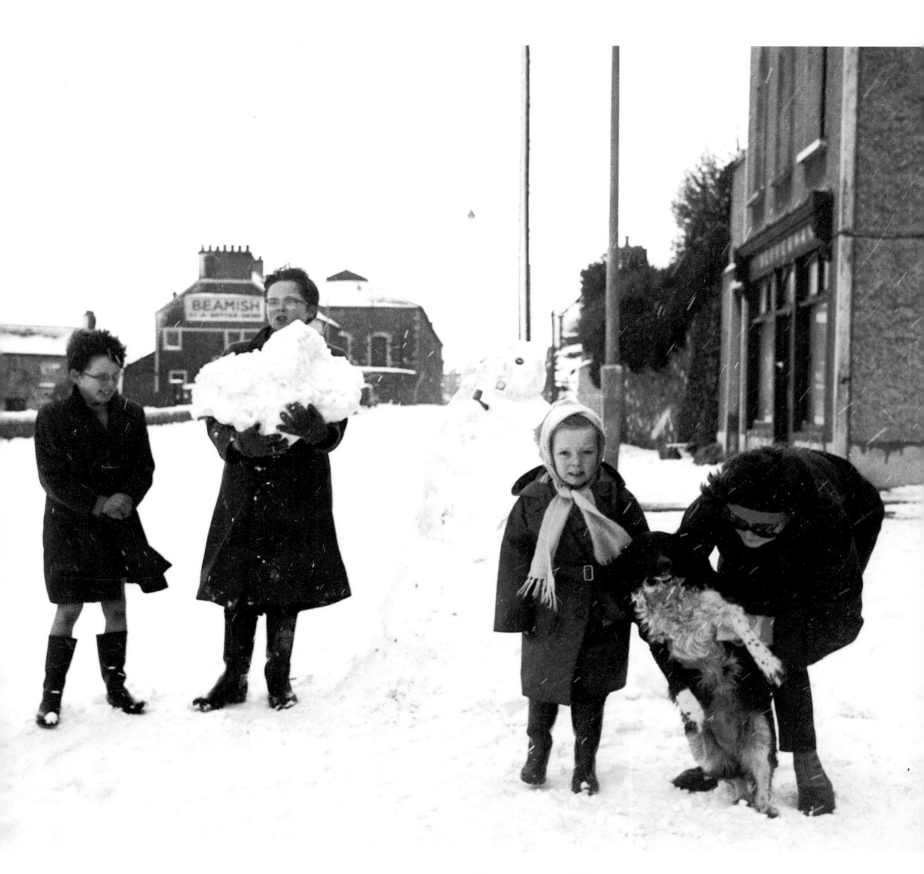

21 January 1963 Snow scenes in Montenotte, Cork. *649m*

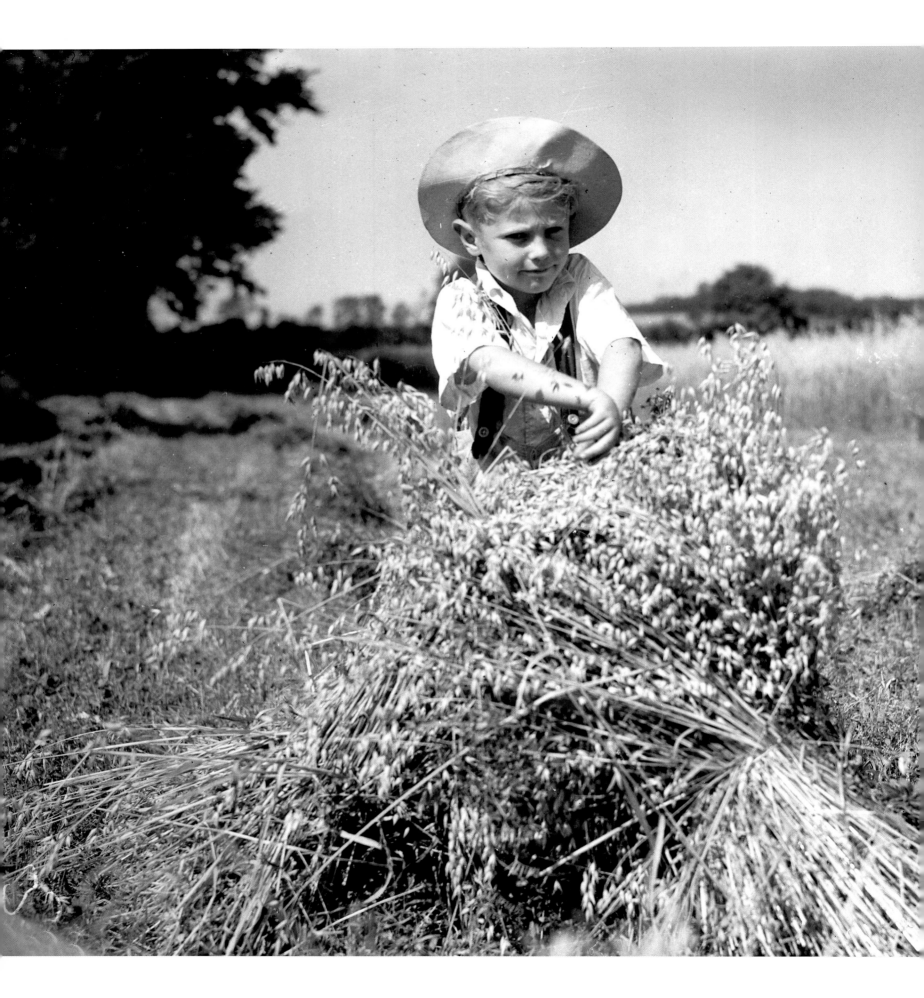

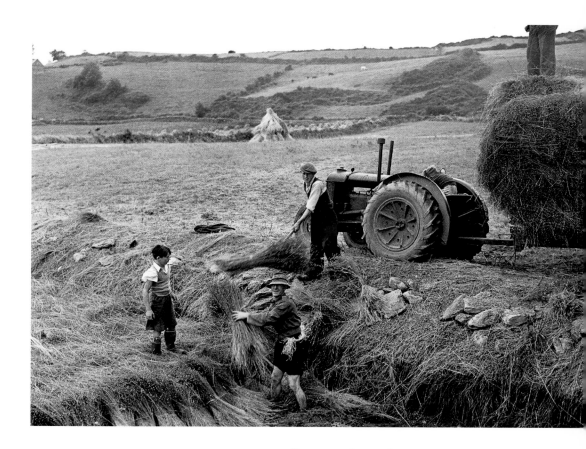

September 1951 Harvesting flax
near Rosscarbery, County Cork. *137e*

20 August 1947 Harvest time at
Carrigtwohill, County Cork. *333D*

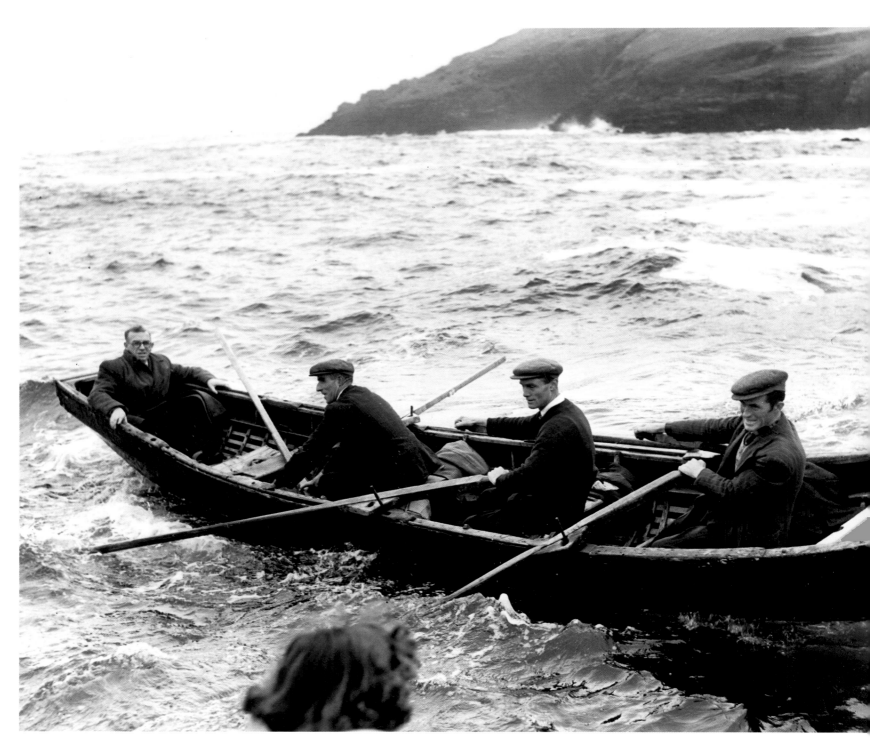

November 1953 Land Commission
agents coming in to shore at the Blasket
Islands, County Kerry. *297G*

1 October 1953
Delivering beet to the Irish
Sugar Company factory,
Mallow, County Cork. *272G*

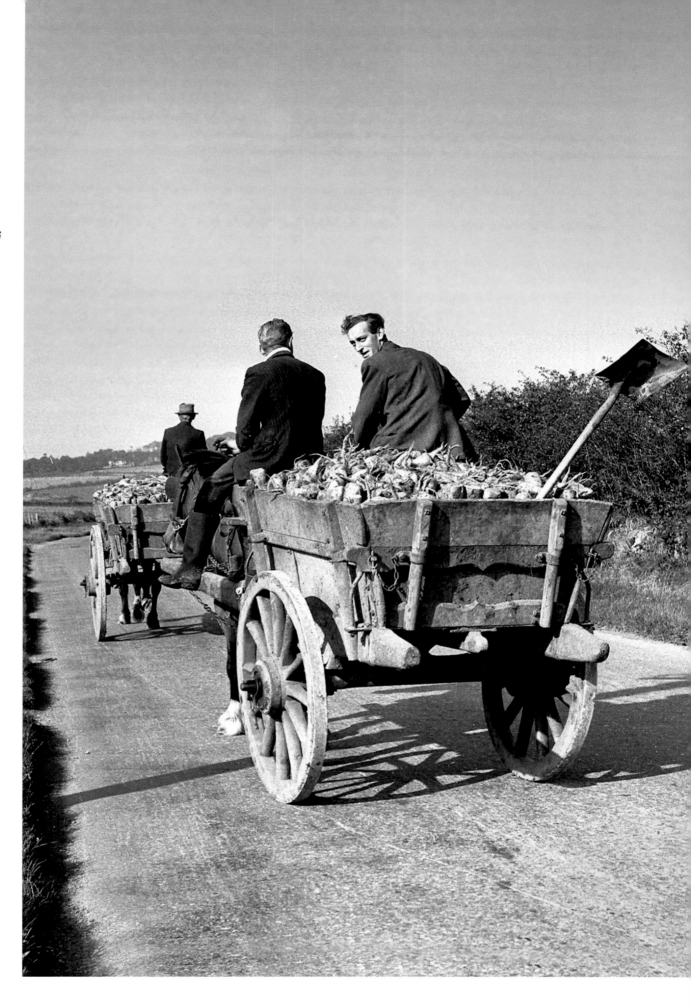

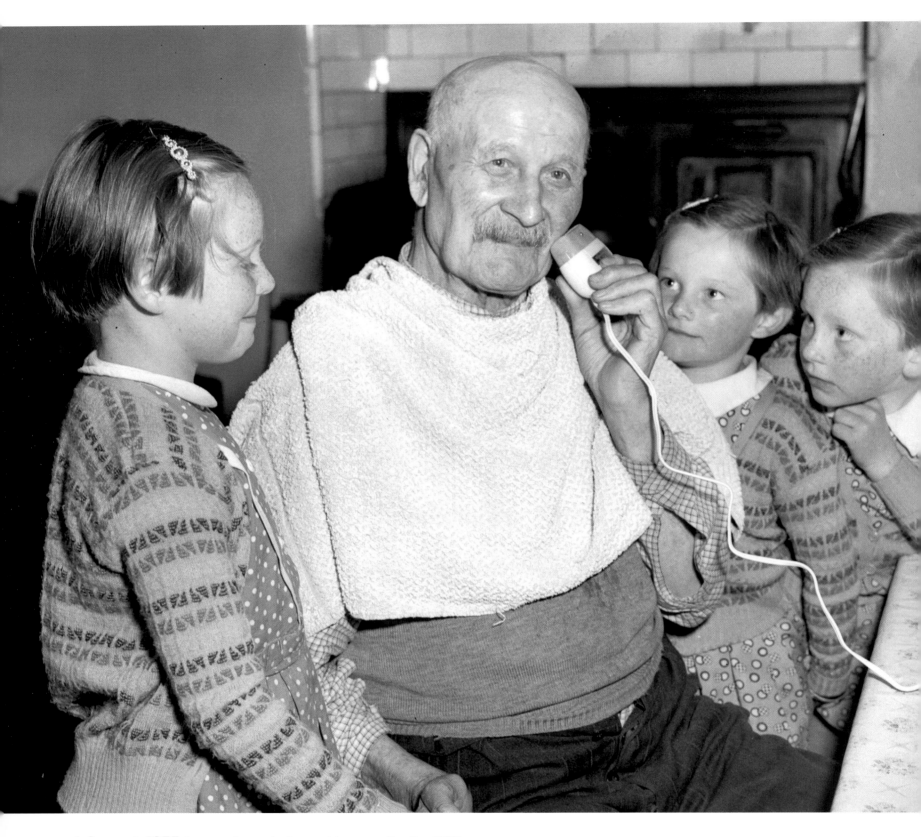

4 August 1955 A new shaver being put to use after the ESB switch-on in Ballingeary, County Cork. *462H*

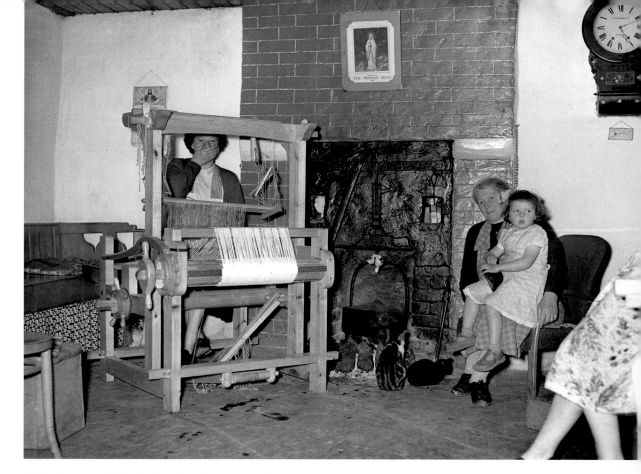

4 October 1954 Weaving in County Kerry. *921G*

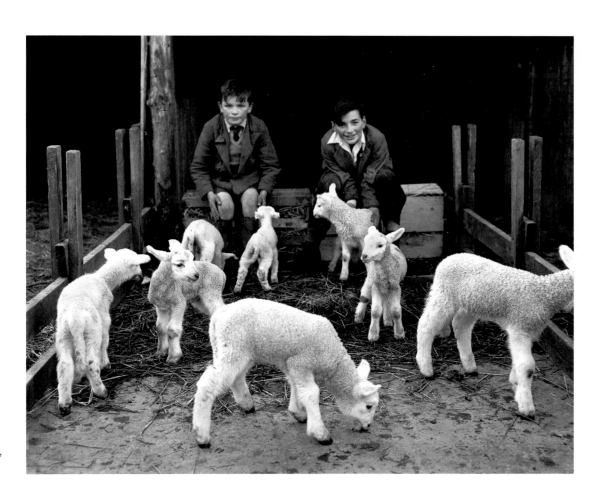

13 March 1956 Lambs born on the farm of Mr Bowen, Ballygarvan, County Cork. *803H*

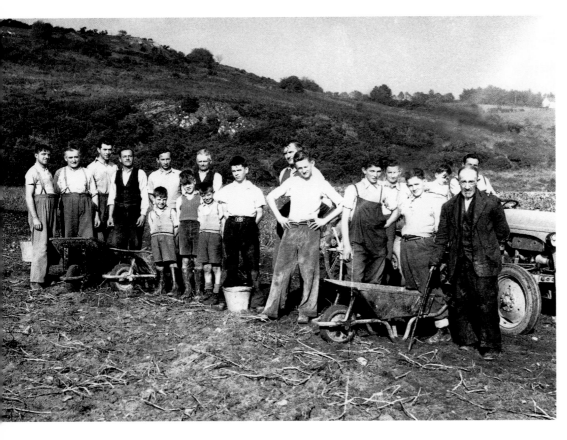

16 October 1956 Taking a break from potato digging on the farm of P. Buckley, Fergus, Dripsey, County Cork. *169J*

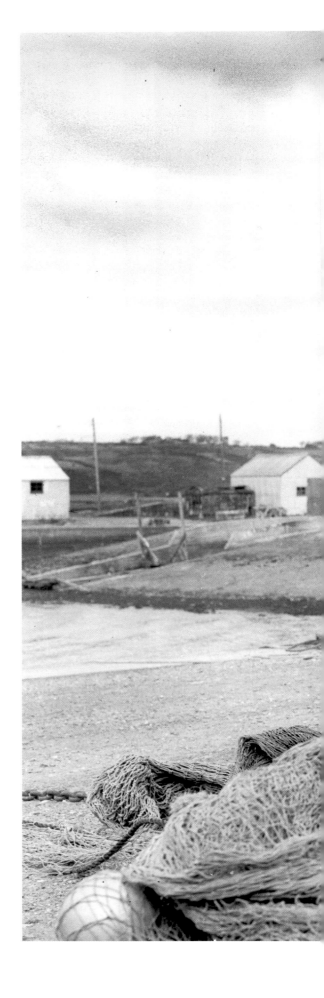

15 October 1957 Fishermen sort nets at Baltimore, west Cork. *708J*

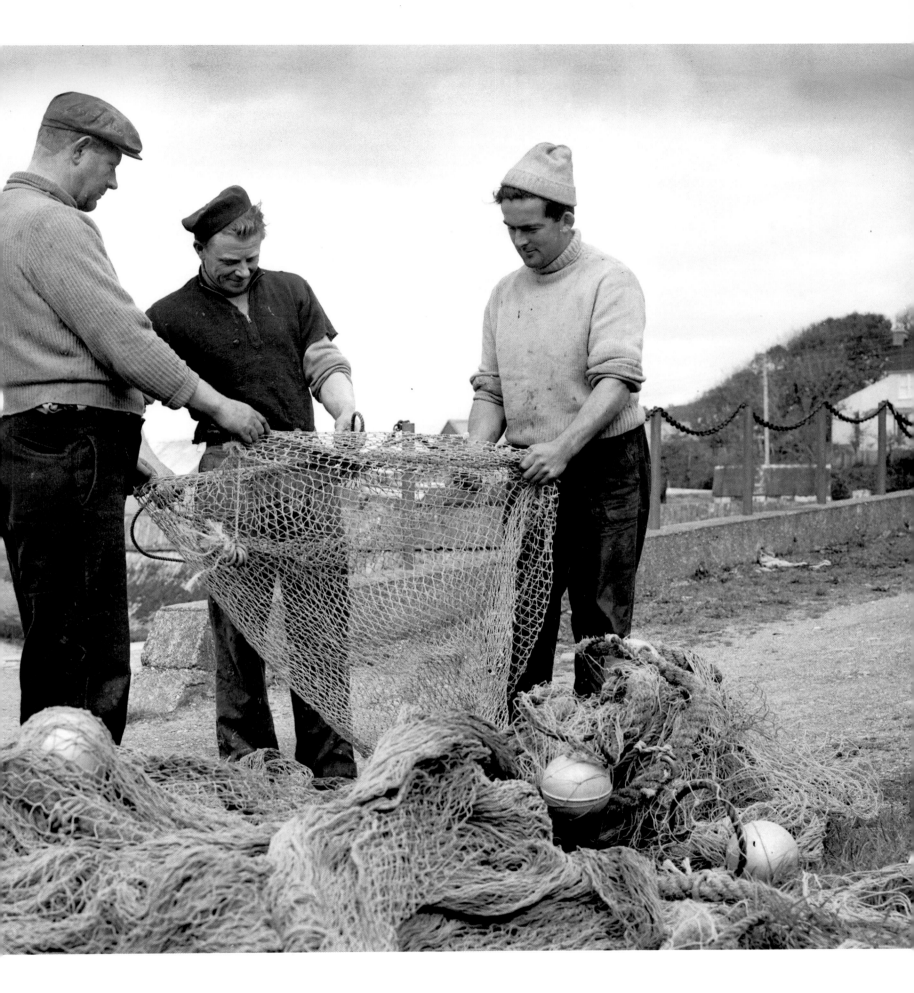

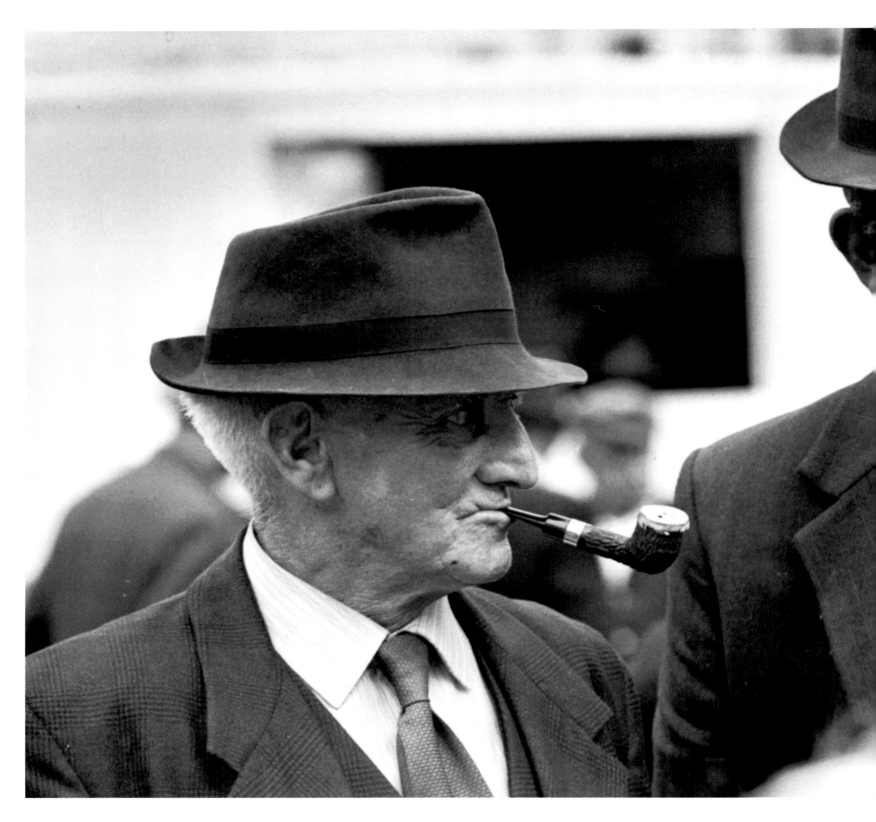

7 August 1974 Pictured at the Ballabuidhe
Horse Fair, Dunmanway, County Cork. *176/74*

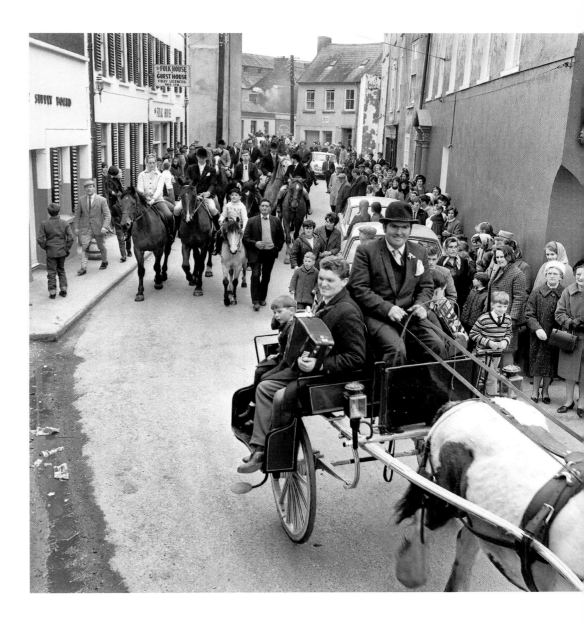

9 April 1968 Pony parade in Kinsale, County Cork. *629P-372*

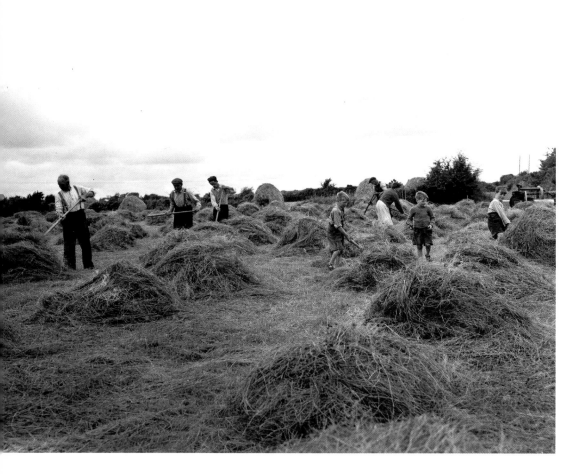

7 August 1958 Hay-saving in Glanmire, County Cork. *272k*

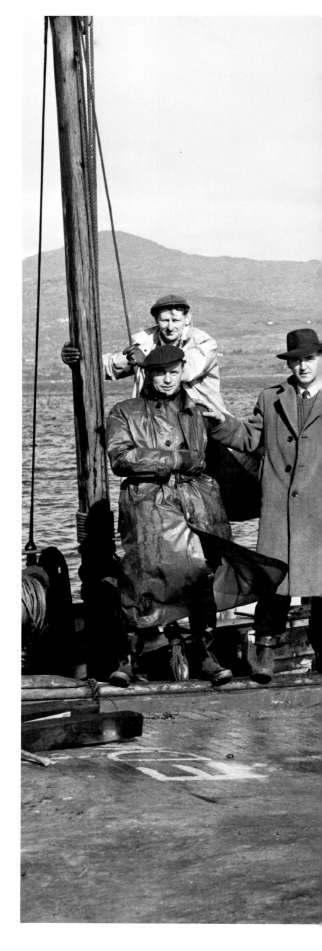

12 March 1958 A crowd gathered at the laying of the ESB cable from Castletownbere to Bere Island, County Cork. *13K*

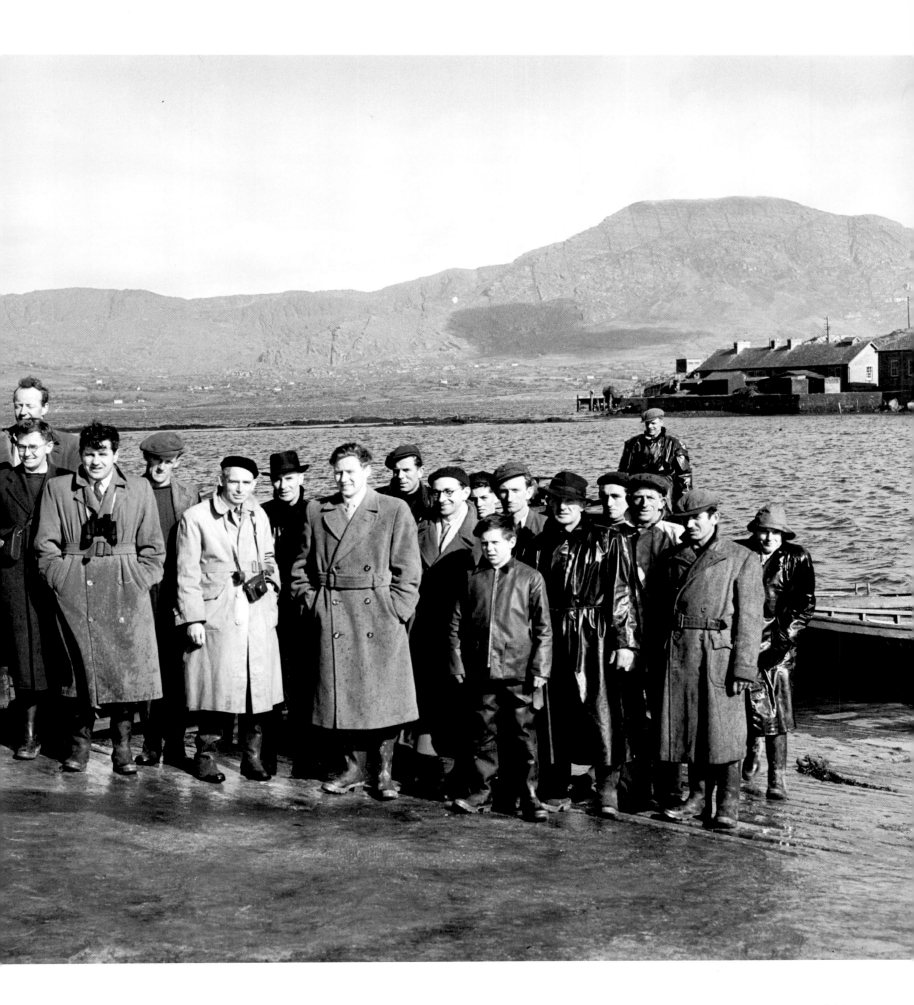

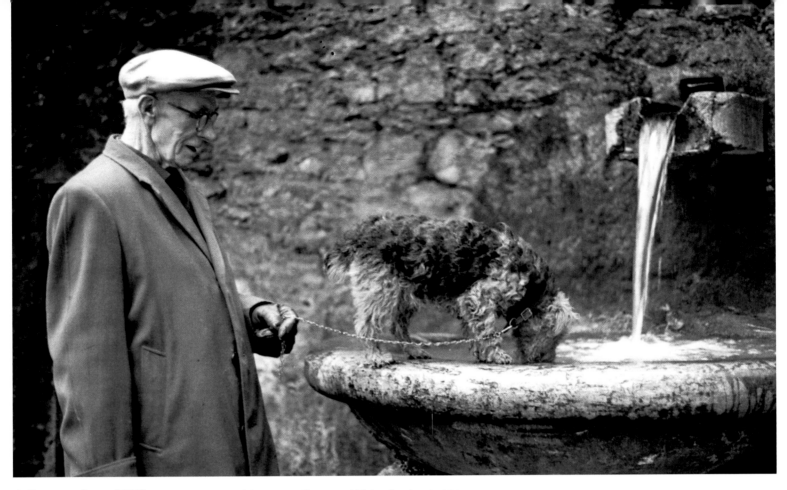

8 December 1976 Thirsty work – Lismore, County Waterford. *101/47*

July 1977 A gaggle of geese interrupts the road bowling. *1411*

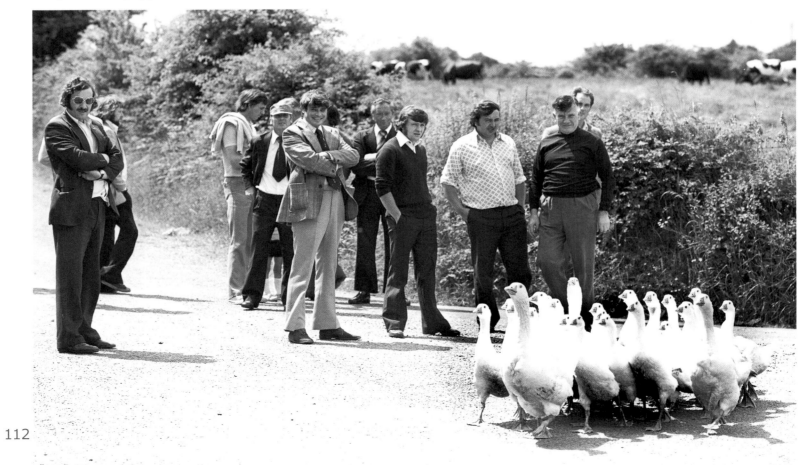

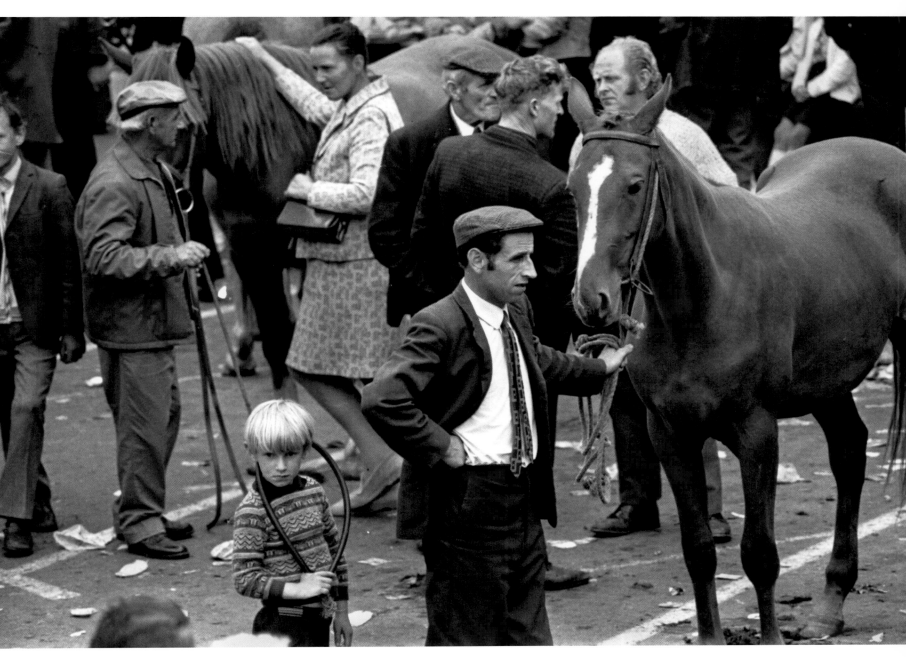

7 August 1974 The Ballabuidhe Horse Fair, Dunmanway, County Cork. *176/74*

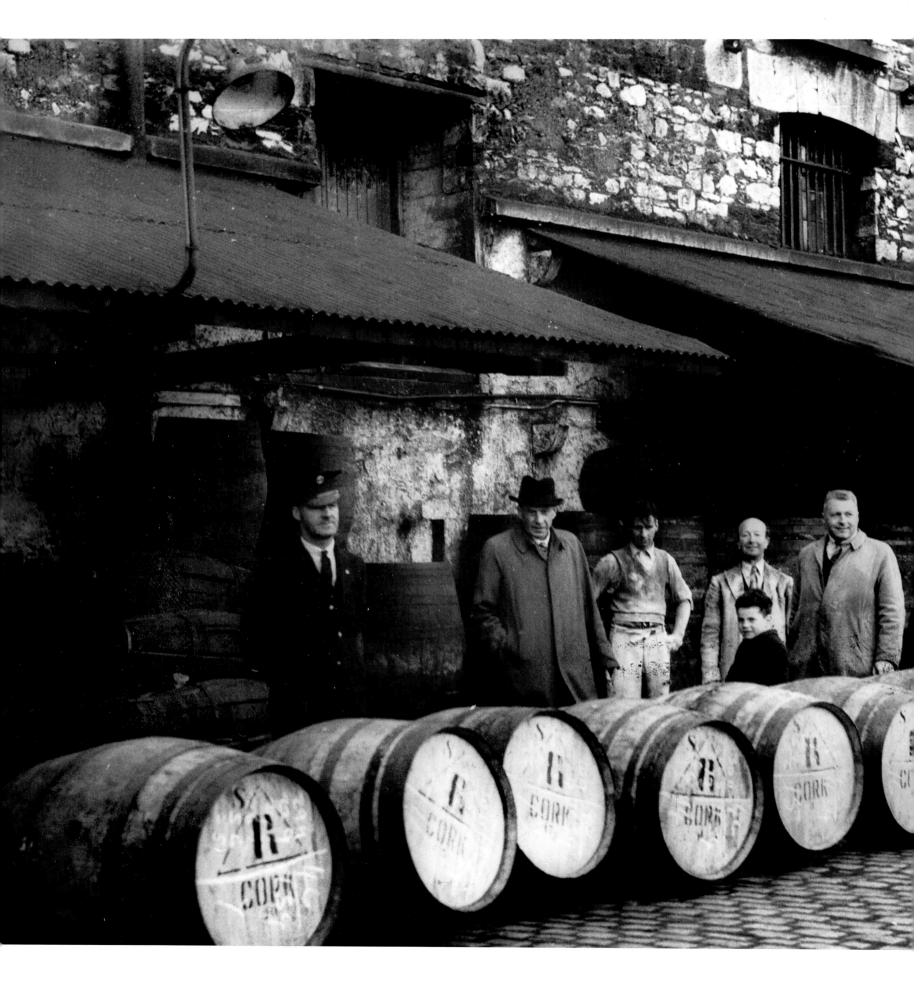

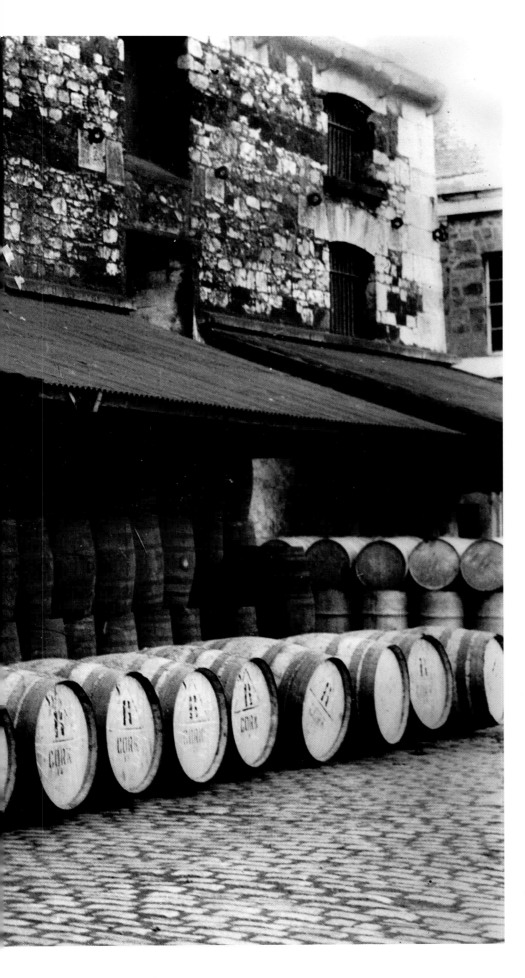

June 1946 Wine casks for Reardans, Washington Street, Cork. *55D*

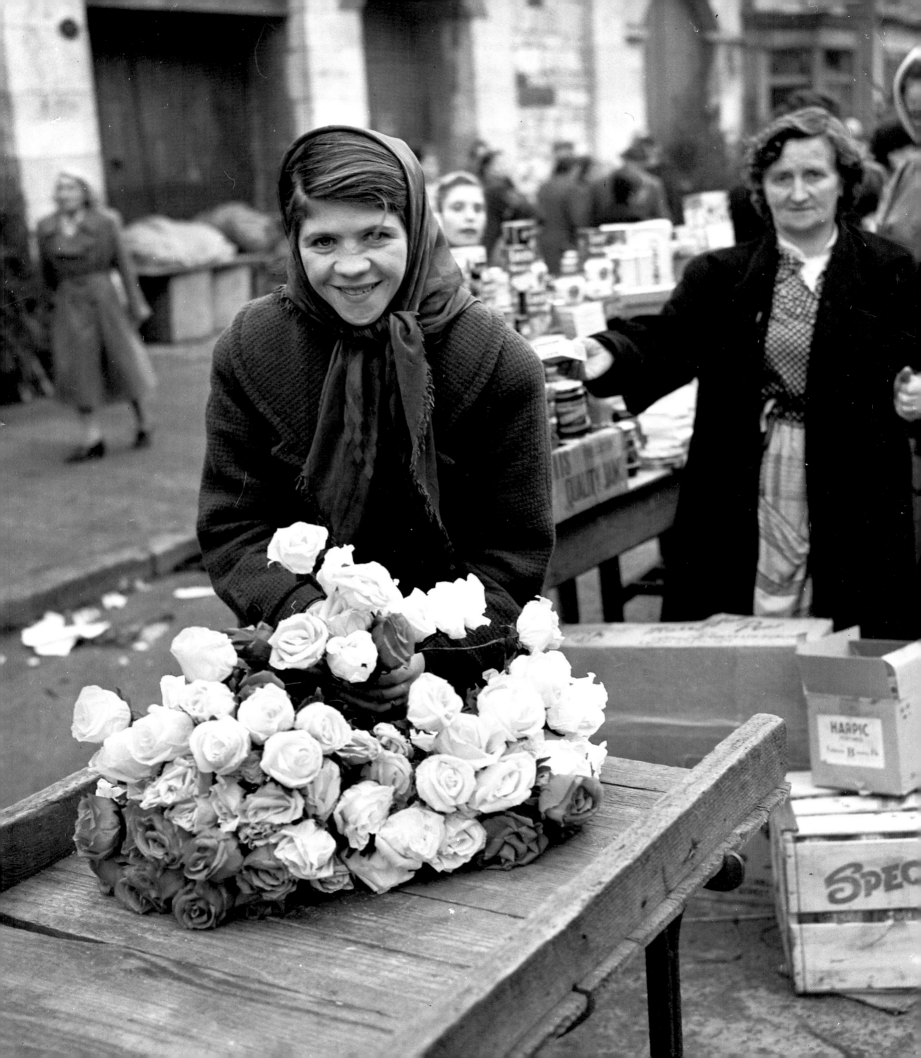

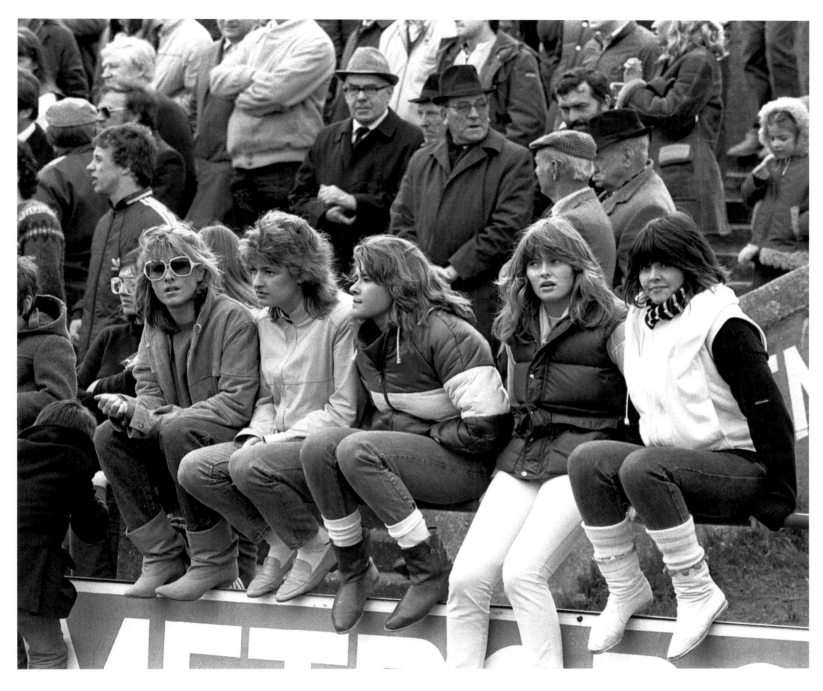

April 1983 Five glamorous fans watching the Munster Senior Cup semi-final replay between Shannon and Dolphin at Musgrave Park, Cork. *272/233*

26 January 1955 Flower seller at the Coal Quay, Cork. *103H*

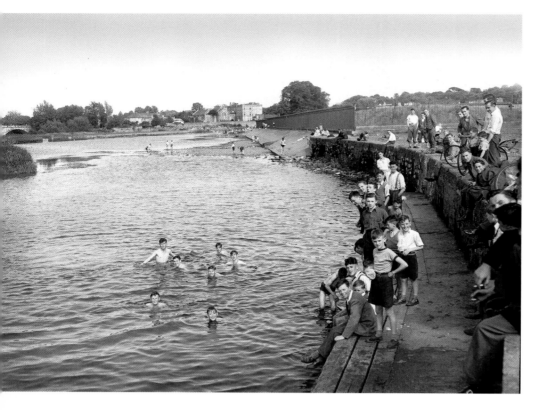

28 July 1954 Schoolboys swimming near the Waterworks, Lee Fields, Cork. *766G*

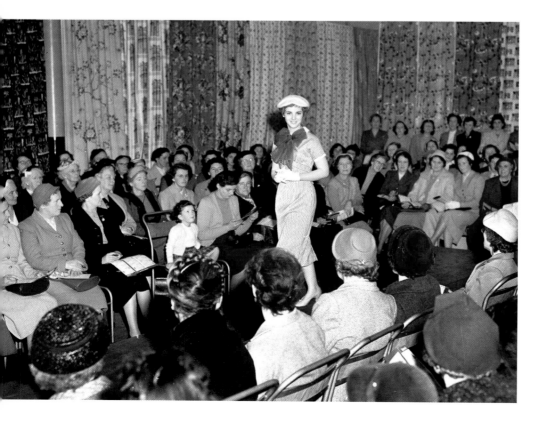

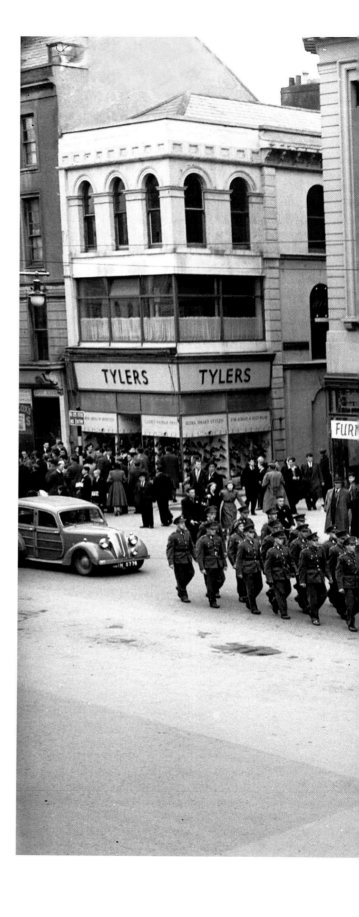

18 May 1957 Fashion show at Munster Arcade, St Patrick's Street, Cork. *483J*

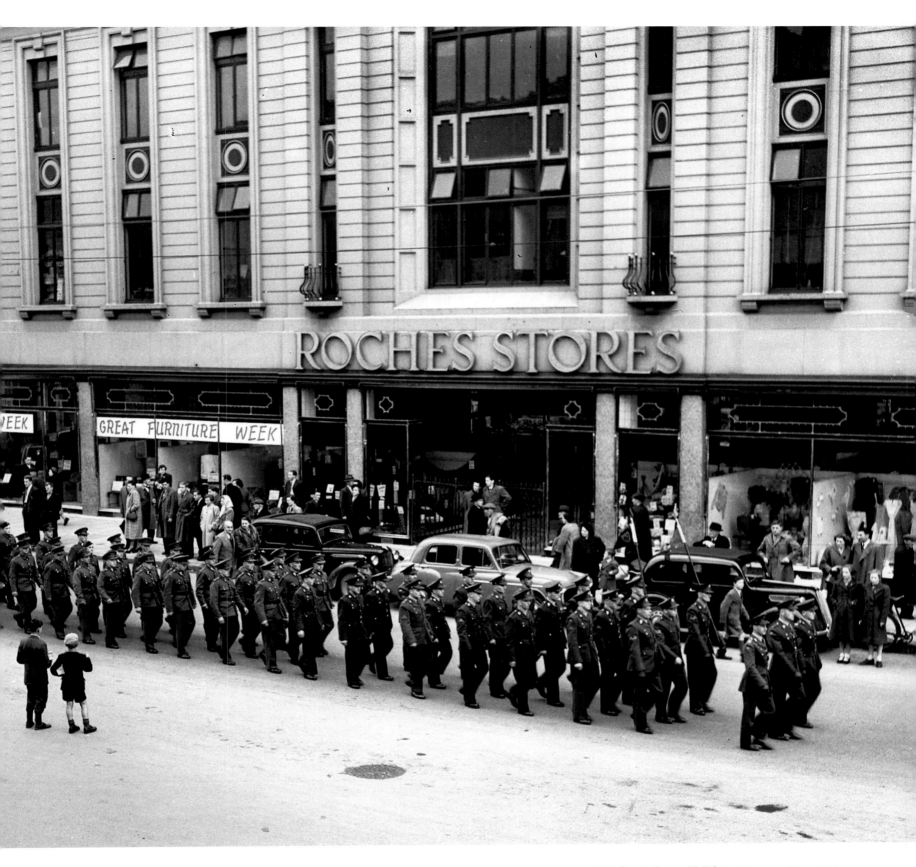

25 October 1953 Soldiers of the Irish Army parade past Roches Stores, St Patrick's Street, Cork. *282G*

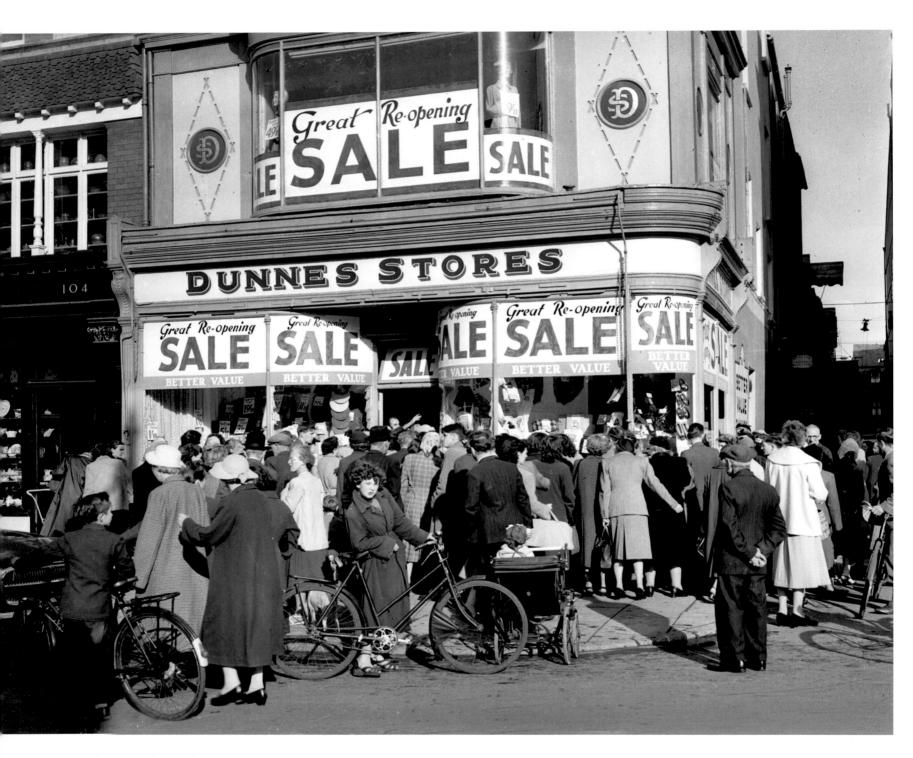

24 September 1955 Crowds of bargain hunters flock to the re-opening sale in Dunnes Stores, St Patrick's Street, Cork. *539H*

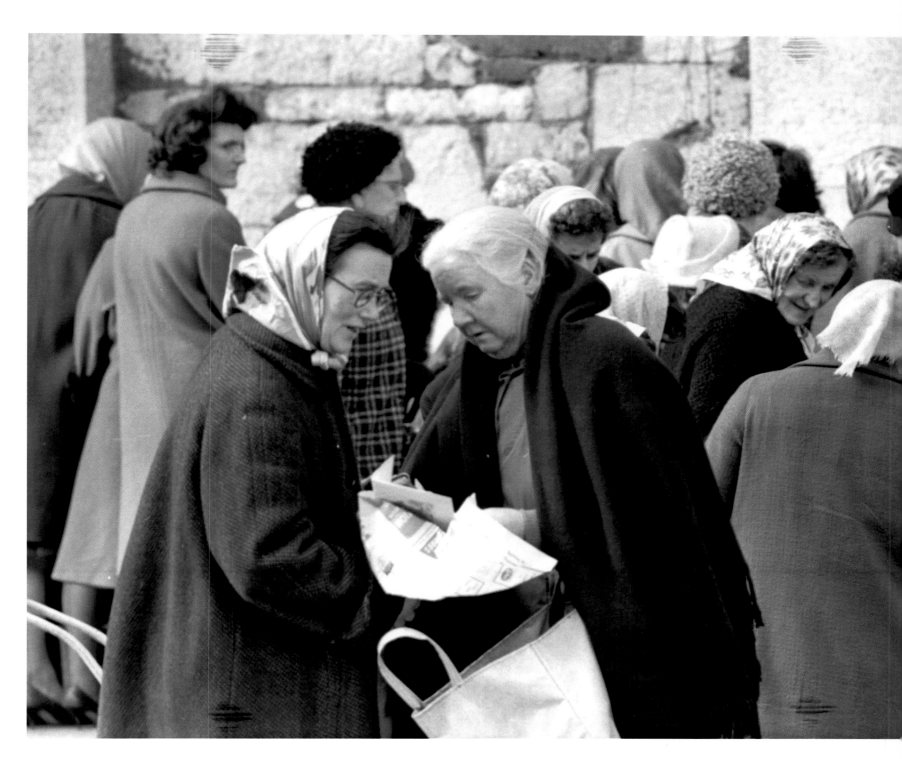

April 1965 Gathering on the Coal Quay, Cork. *3/63*

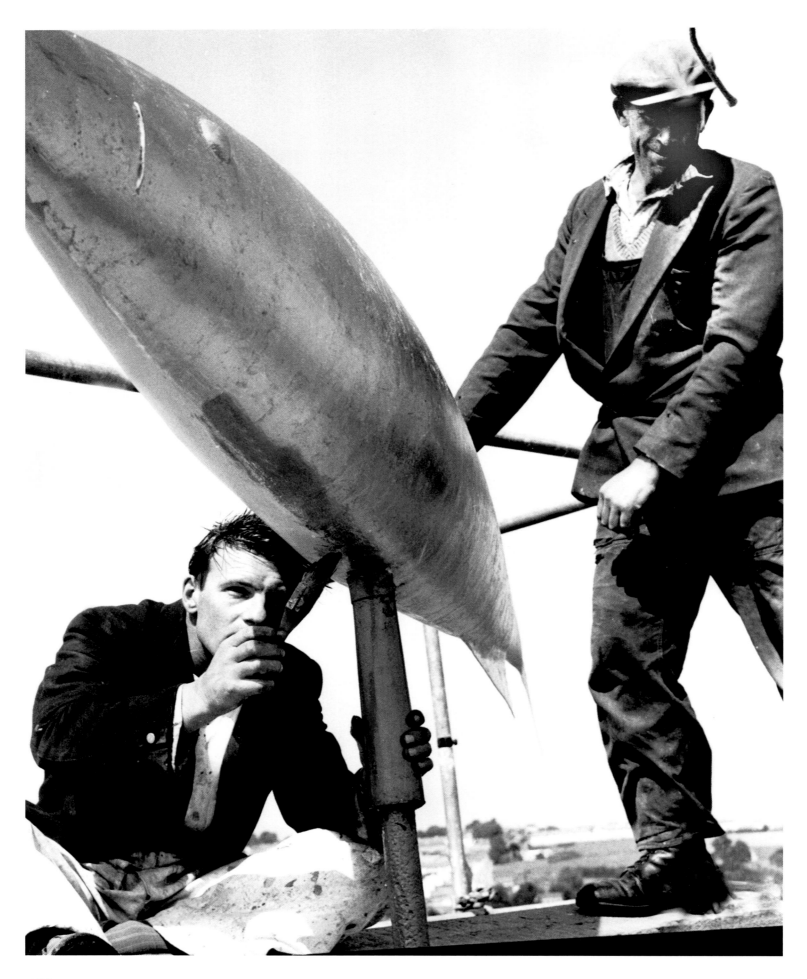

122

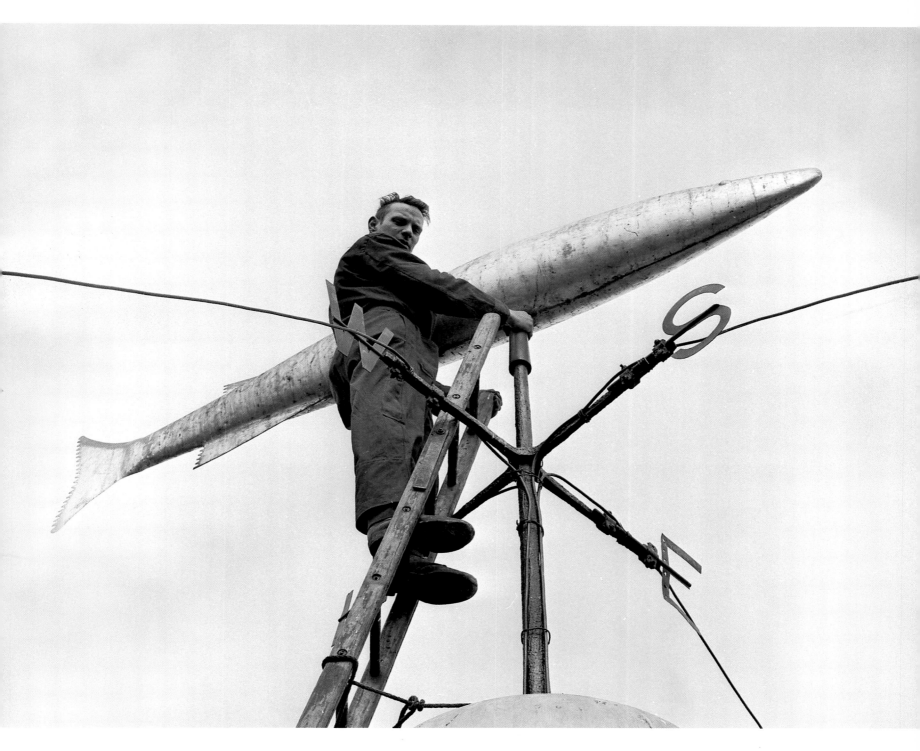

May 1967 A steeplejack on the clock tower of Shandon Steeple, Cork. *630p/012*

15 August 1959 Corporation painter Tom Holmes (left), helped by Michael O'Sullivan, 193 feet above the streets of Cork on the Shandon Steeple, gilds the 120-year-old fish with laminated gold. *797K*

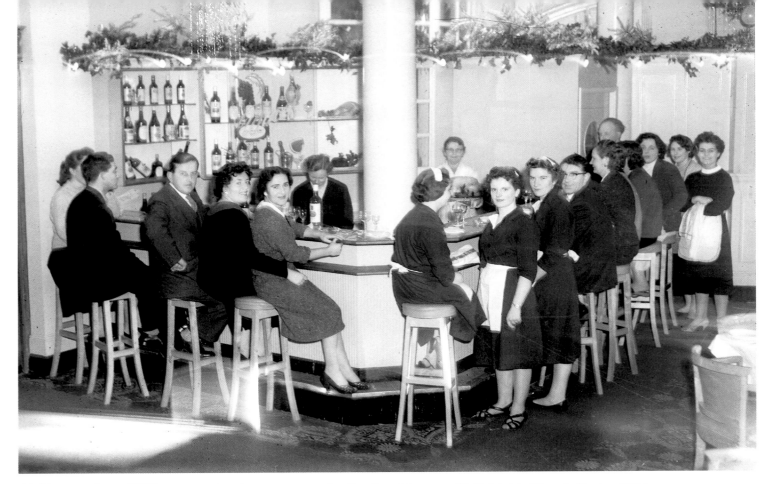

12 December 1958 A new wine bar opens at the Pavilion Cinema, St Patrick's Street, Cork. *462K*

17 April 1971 A small dog in a shopping basket on St Patrick's Street, Cork. *125/94*

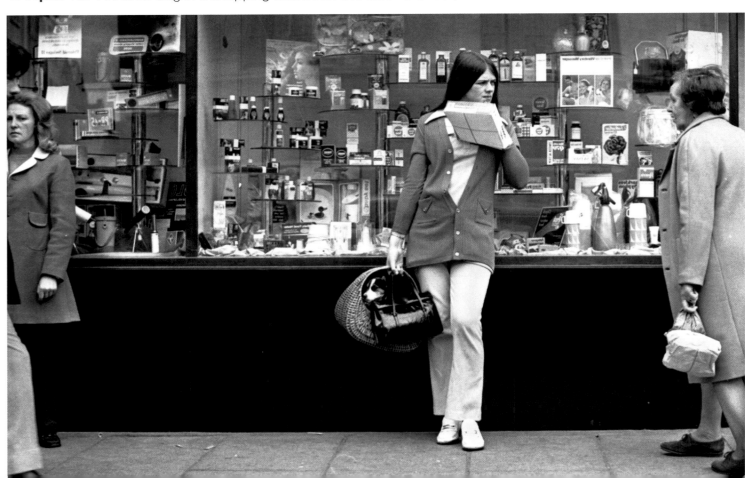

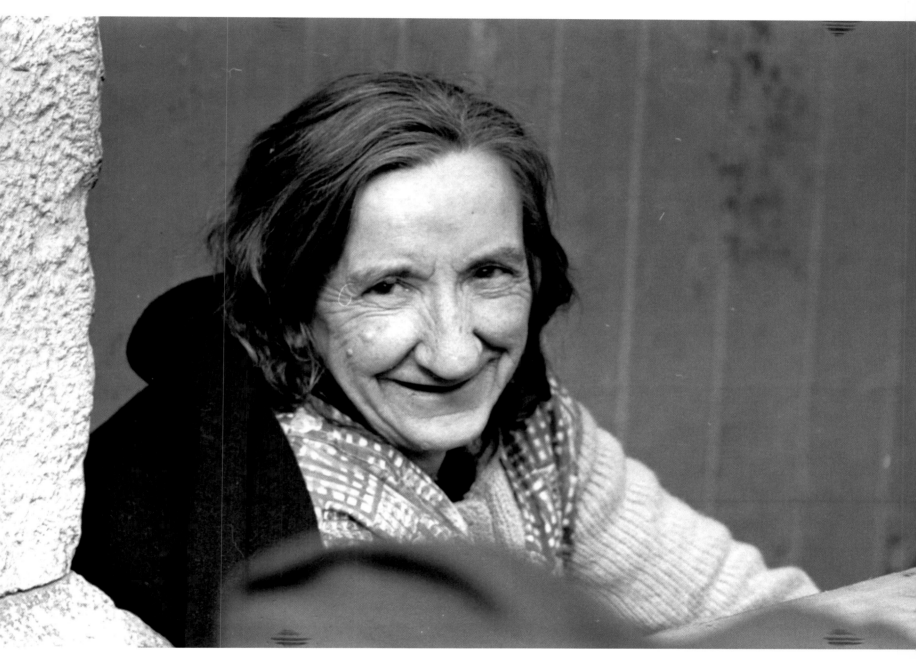

April 1965 A trader on the Coal Quay, Cork. *3/63*

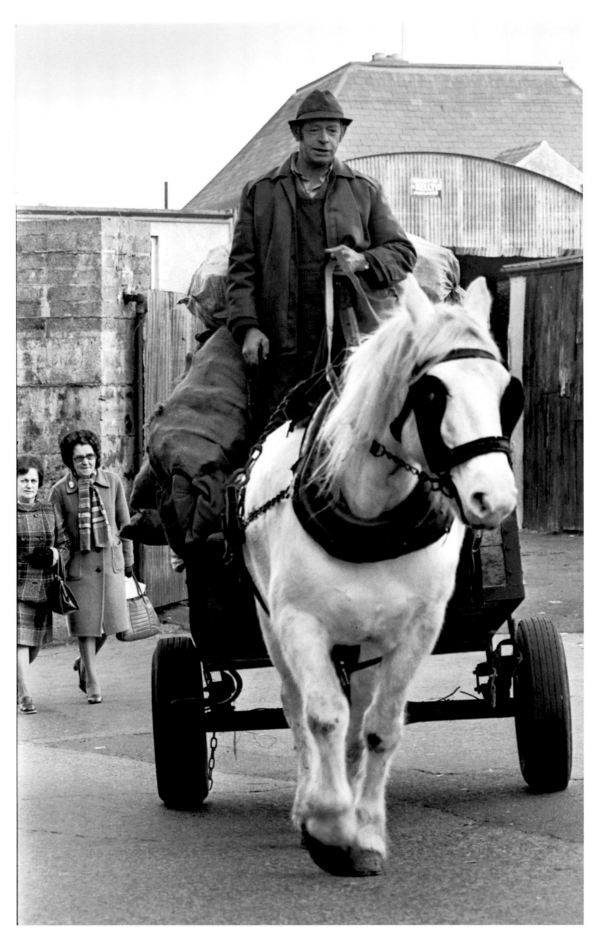

20 November 1976
Delivering coal and turf on
Barrack Street, Cork. *101/30*

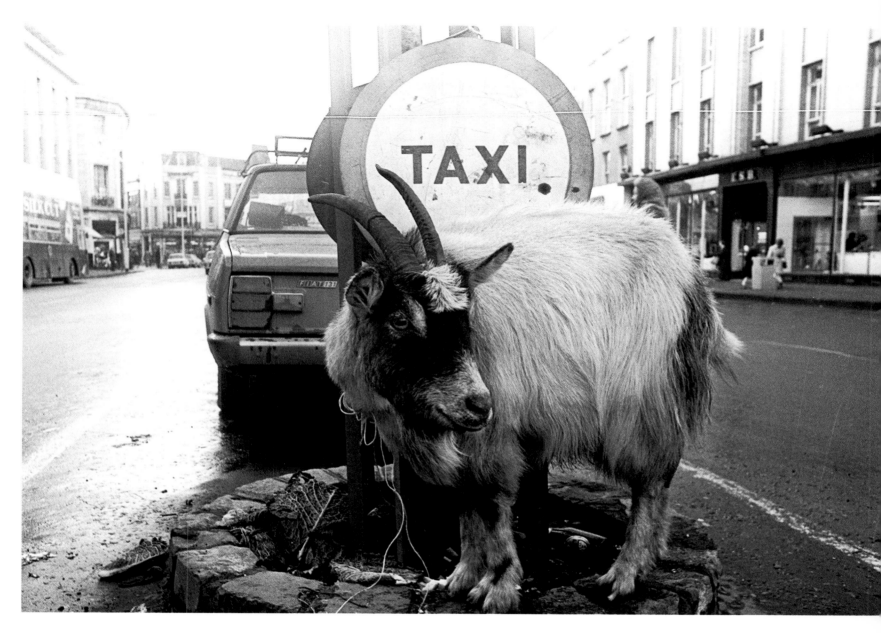

9 January 1978 A goat 'parked' at a taxi rank on St Patrick's Street, Cork. *214/243*

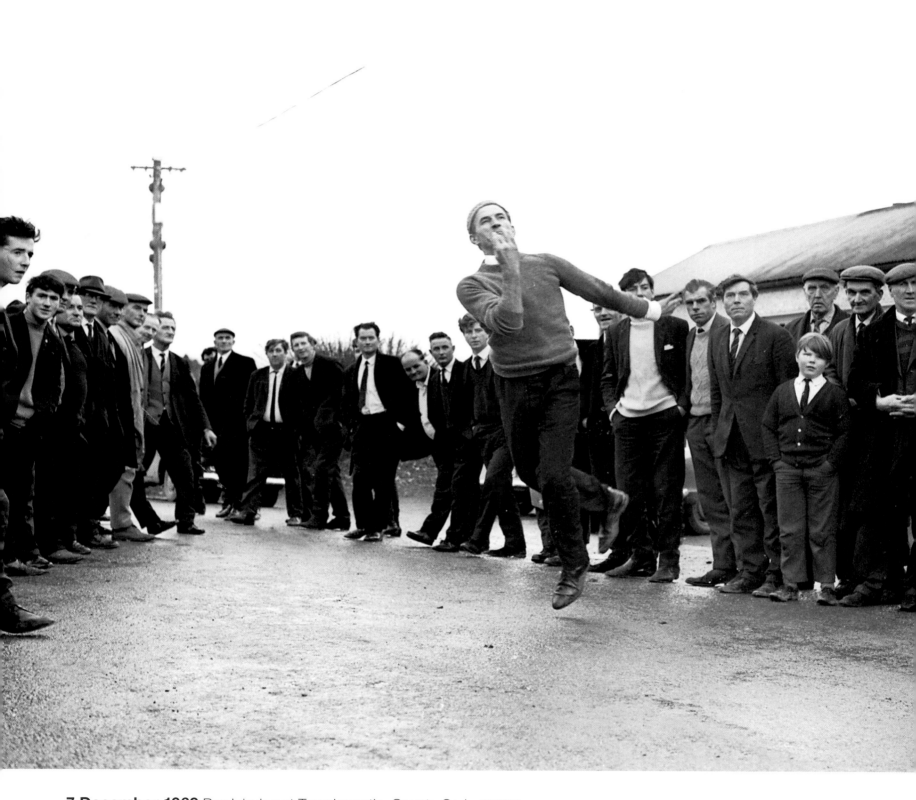

7 December 1969 Bowlplaying at Templemartin, County Cork. *106/36*

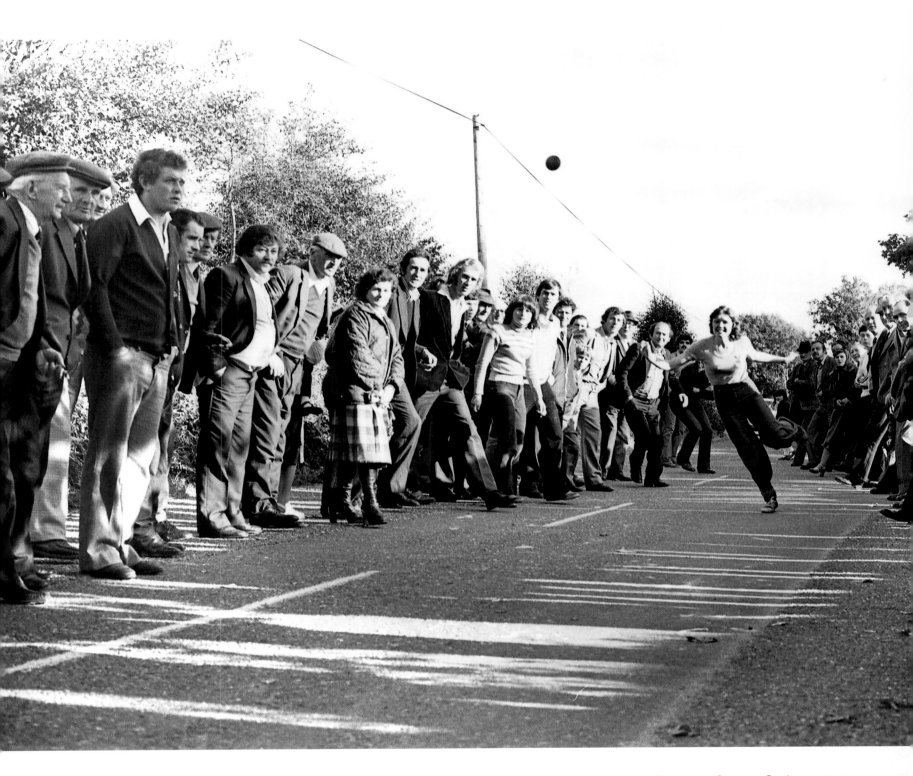

12 October 1980 Ladies' Road Bowling at Ballyshonin, Berrings, County Cork. *243/002*

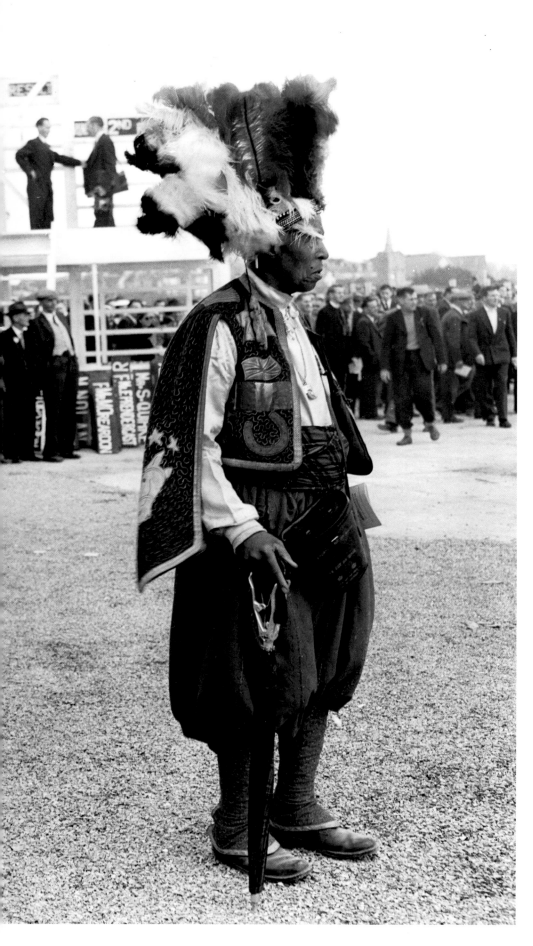

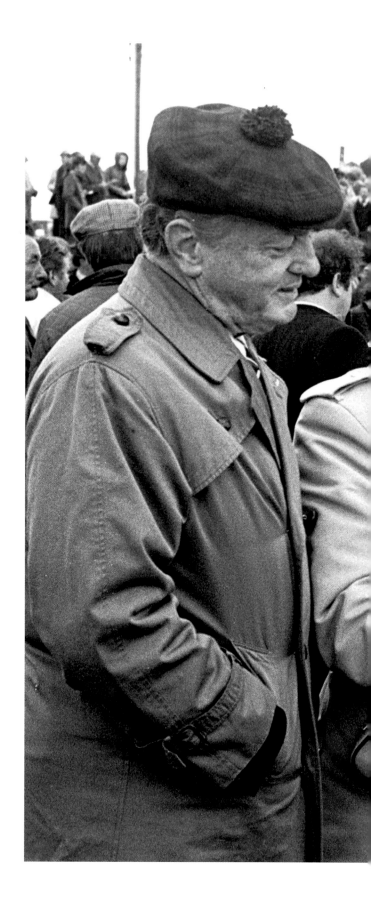

29 September 1959 World-famous racing tipster Ras Prince Monolulu visiting the Listowel Races, County Kerry. *871K*

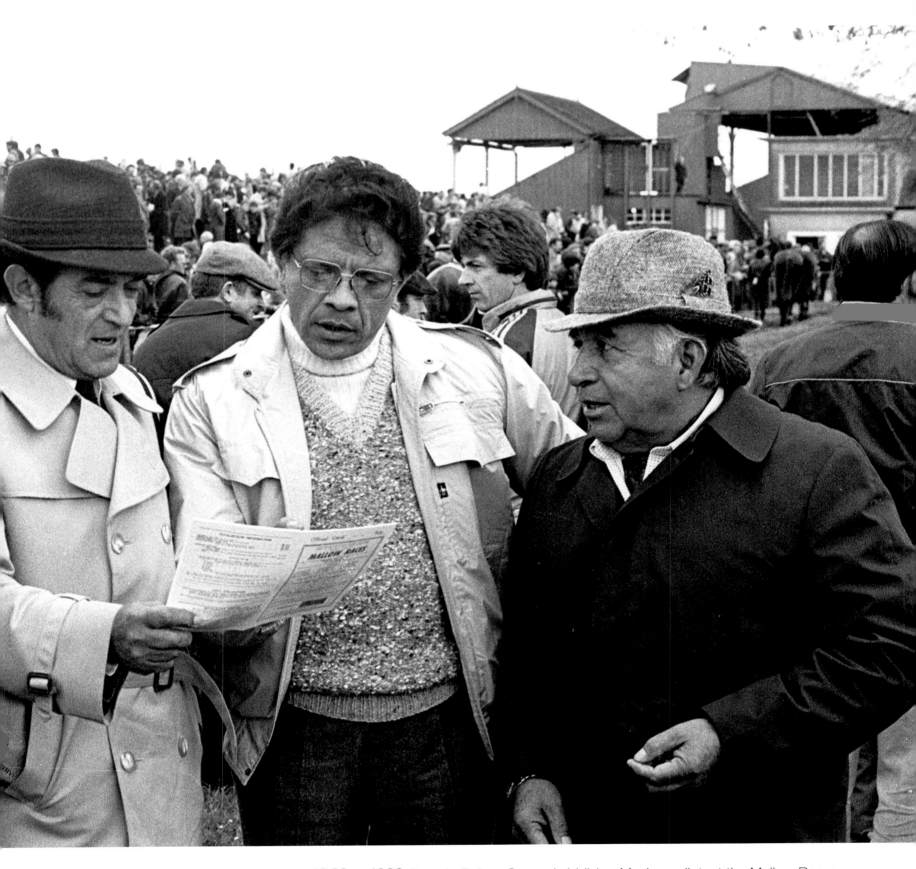

16 May 1983 Captain Ruben Ocana (middle), a Mexican pilot, at the Mallow Races, County Cork. Captain Ocana had made a successful emergency landing at Mallow Racecourse of a Gulfstream II jet, saving the lives of four passengers and crew. *273/249*

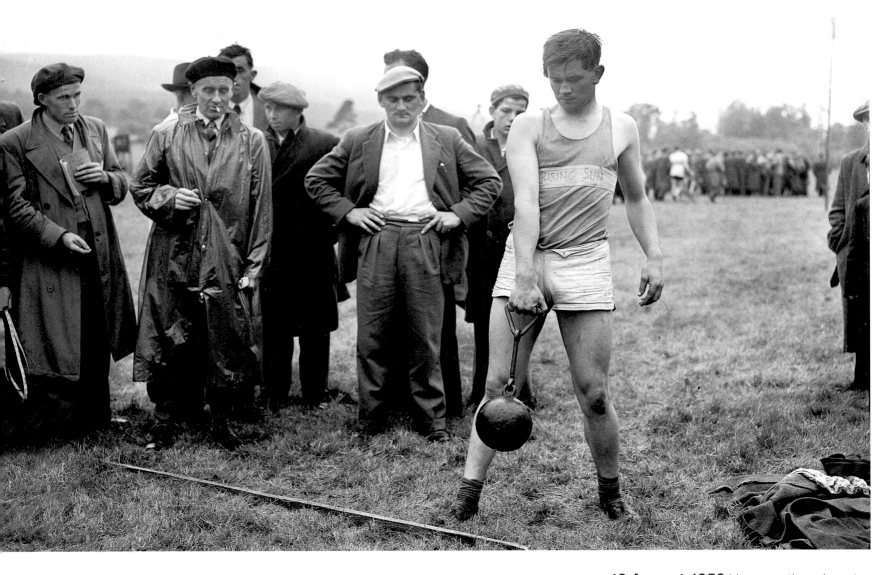

12 August 1956 Hammer throwing at Ballyhooly Sports Day, County Cork. *72J*

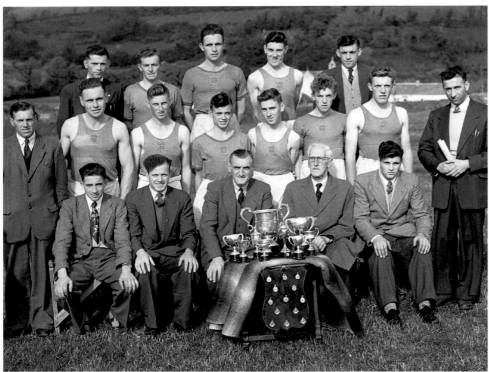

15 October 1957 The Tracton Athletic Club with trophies won during the year. *737j*

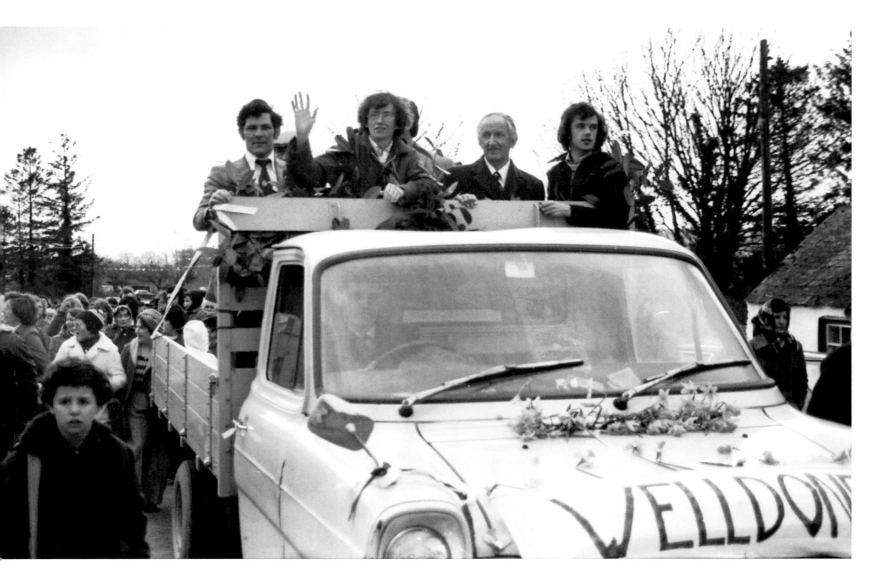

28 March 1978 John Treacy is welcomed home to Villierstown, County Waterford, after his World Senior Cross Country Championship win in Glasgow. *216/240*

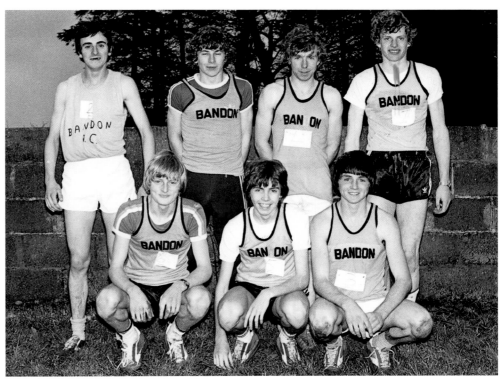

25 November 1979 Bandon athletic team, winners of the Cork County junior team championship at Mitchelstown. *234/194*

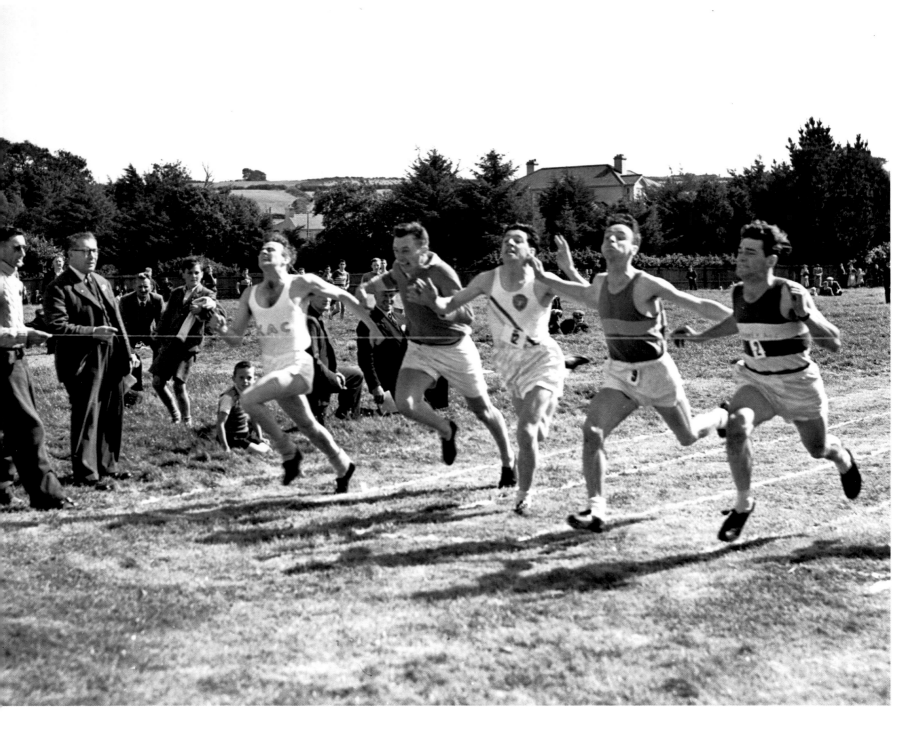

26 August 1956 Five competitors go all-out
for the tape in the 100-yard dash at
Skibbereen Sports, County Cork. *97J*

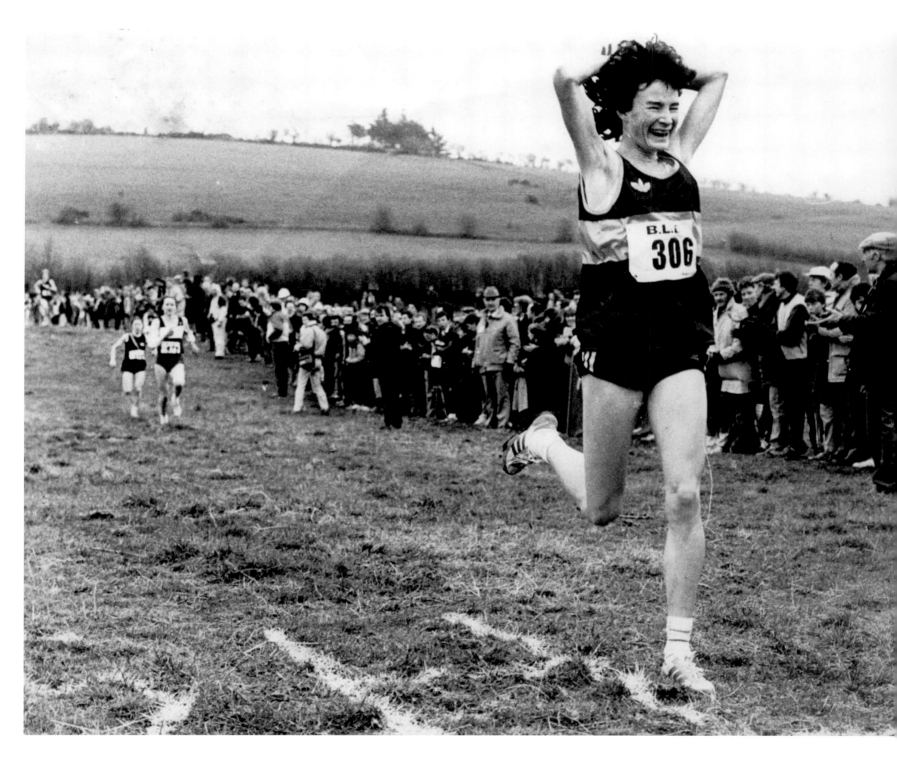

22 February 1987 Sonia O'Sullivan wins the BLE Interclub Cross Country Championships in Killenaule, County Tipperary. *346/145*

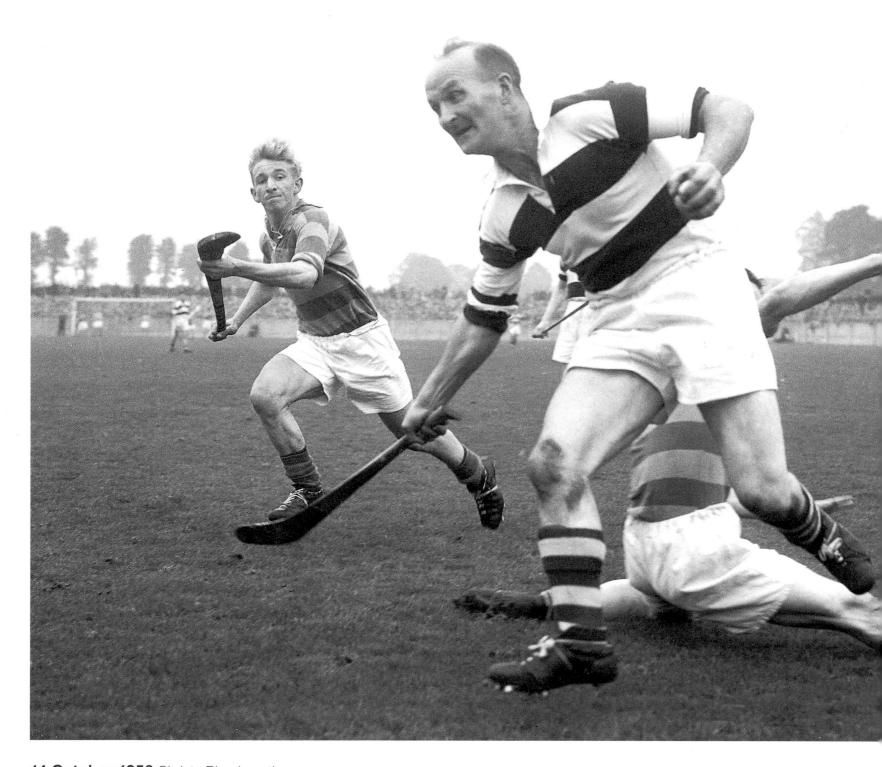

14 October 1956 Christy Ring in action
at the Cork County Hurling final between
Blackrock and Glen Rovers, at the Athletic
Grounds, Cork. *166J*

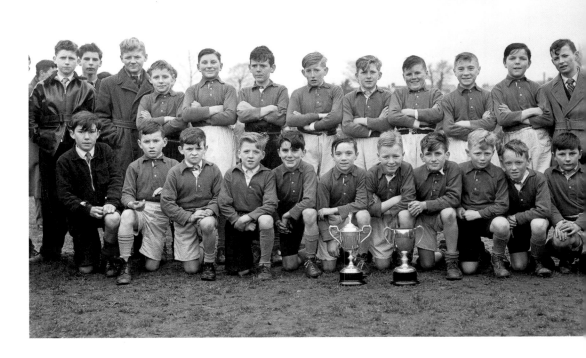

18 March 1956 Greenmount Crescent, first-round winners of the Lough Parish hurling league. *817h*

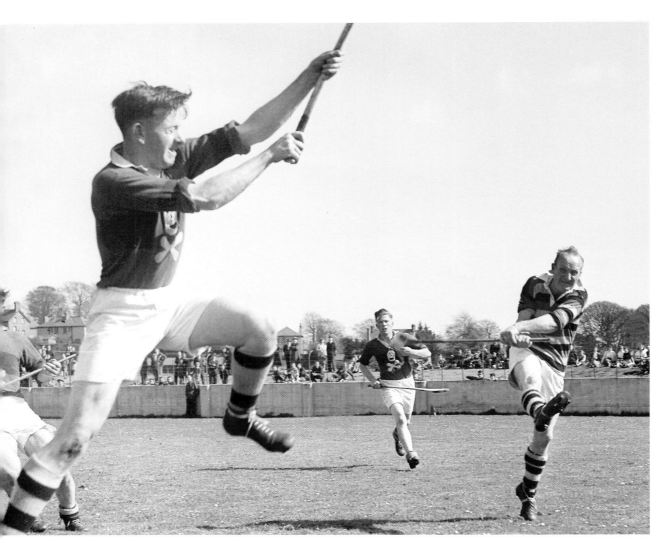

24 April 1955 Christy Ring in action during the
Glen Rovers v UCC Senior Hurling Championship
at the Athletic Grounds, Cork. *249h*

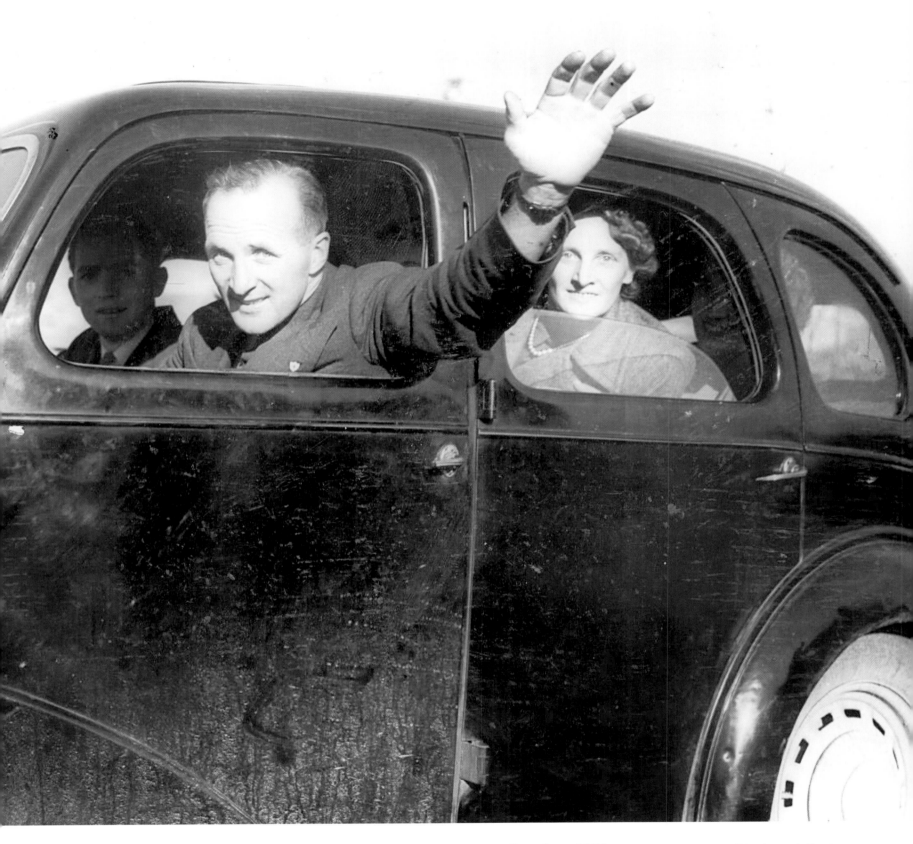

10 October 1951 Christy Ring leaves Blackpool, Cork, for Shannon Airport, prior to his first visit to the USA. *224E*

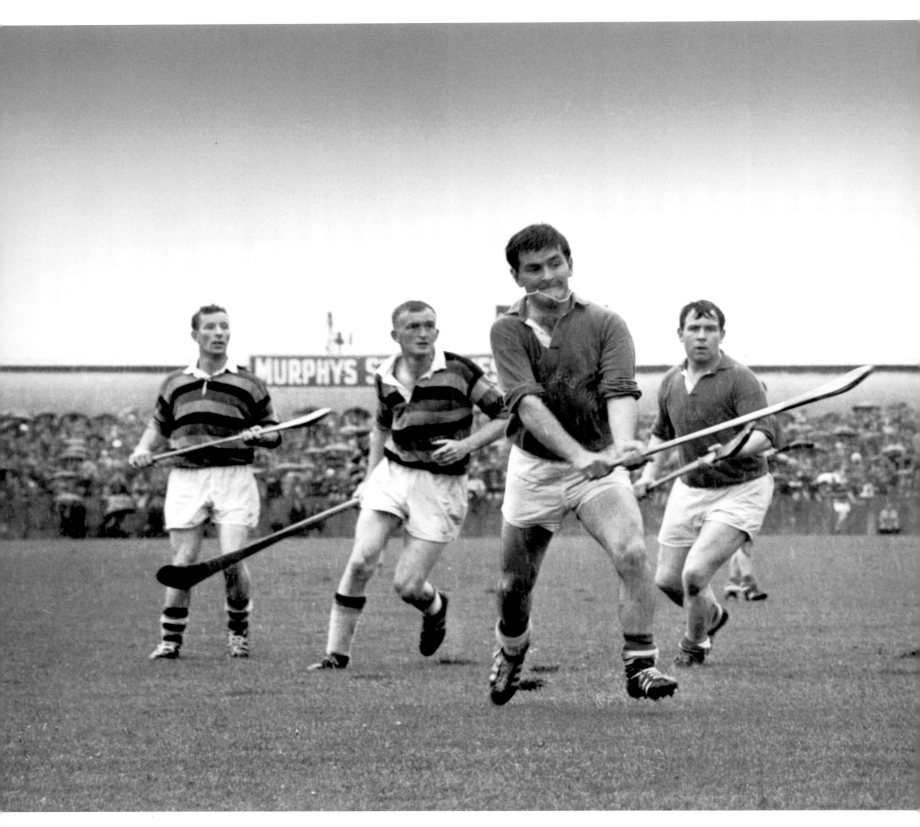

8 October 1967 At the Cork County Senior Hurling final at the Athletic Grounds, Cork, St Finbarr's Charlie McCarthy shoots for goal, watched anxiously by (l–r): Sean Kennefick and Denis O'Riordan of Glen Rovers and teammate Mick Archer. *627P124*

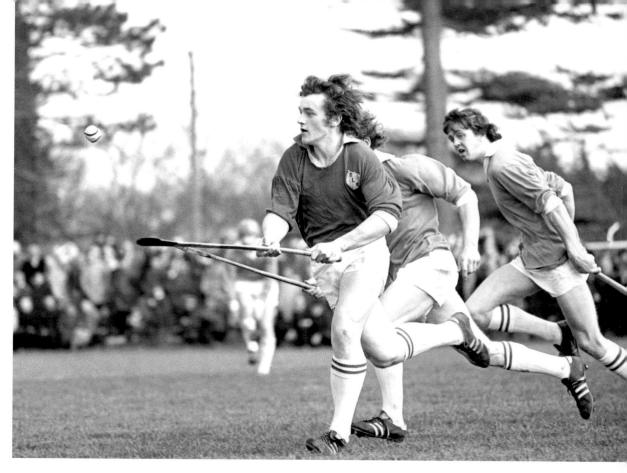

4 April 1976 St Flannan's from Ennis in action against De La Salle, Waterford, in the Dr Harty Cup final at Bansha, County Tipperary. *201/088*

28 May 1967 The Glen v St Finbarr's in the annual Cork Eucharistic Procession hurling match at the Mardyke, Cork. *42 (6-8)*

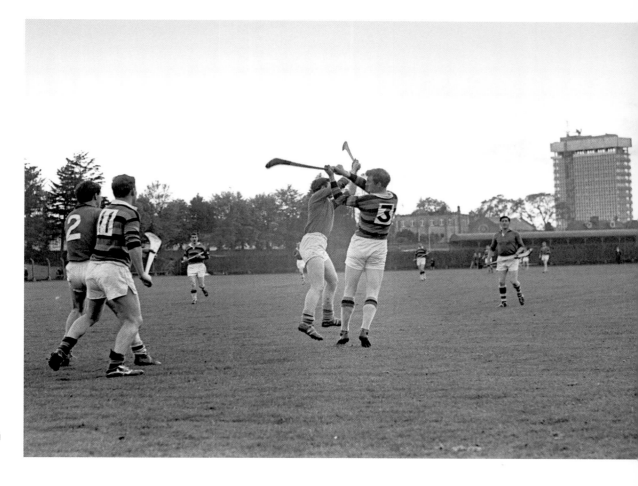

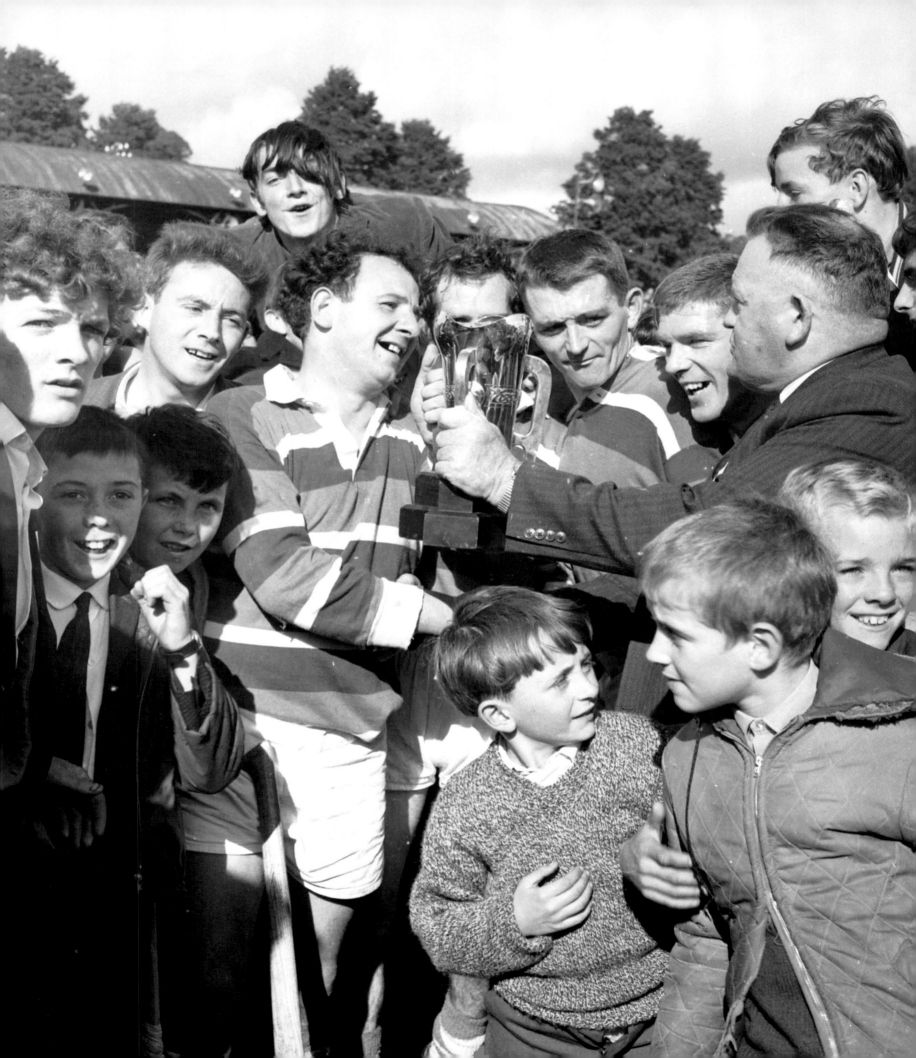

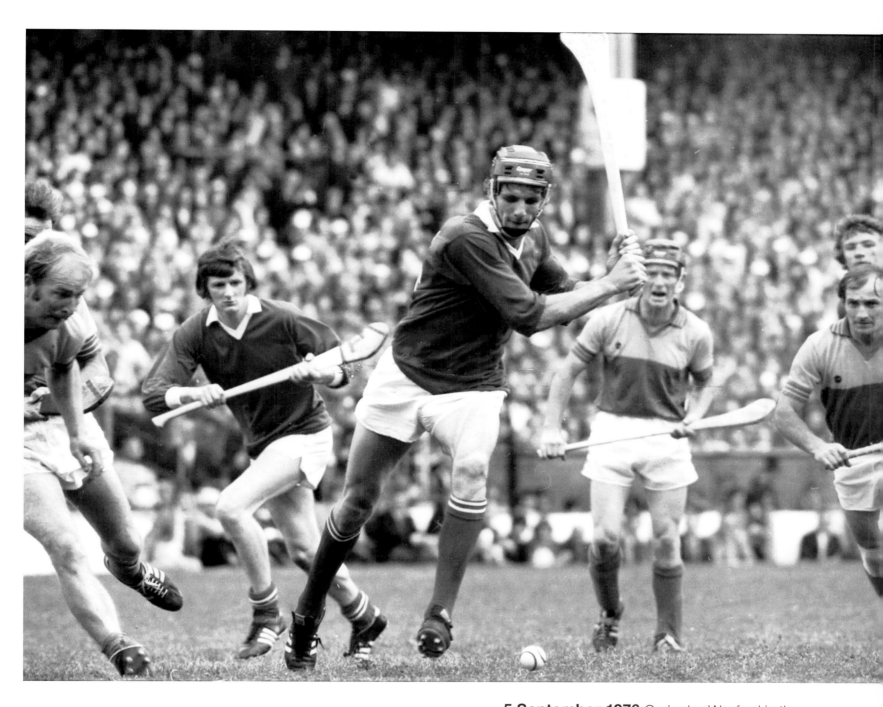

3 February 1972 Members of the victorious Dillons Cross team and young fans after the defeat of the Old Youghal Road team in the Schoolboys' Street League Football final at the Tank Field, Cork. *644P-5*

5 September 1976 Cork play Wexford in the All-Ireland Senior Hurling final at Croke Park, Dublin. Cork's Ray Cummins (centre) is watched by teammates Eamon O'Donoghue (second from left) and Jimmy Barry Murphy (far right). *205/21*

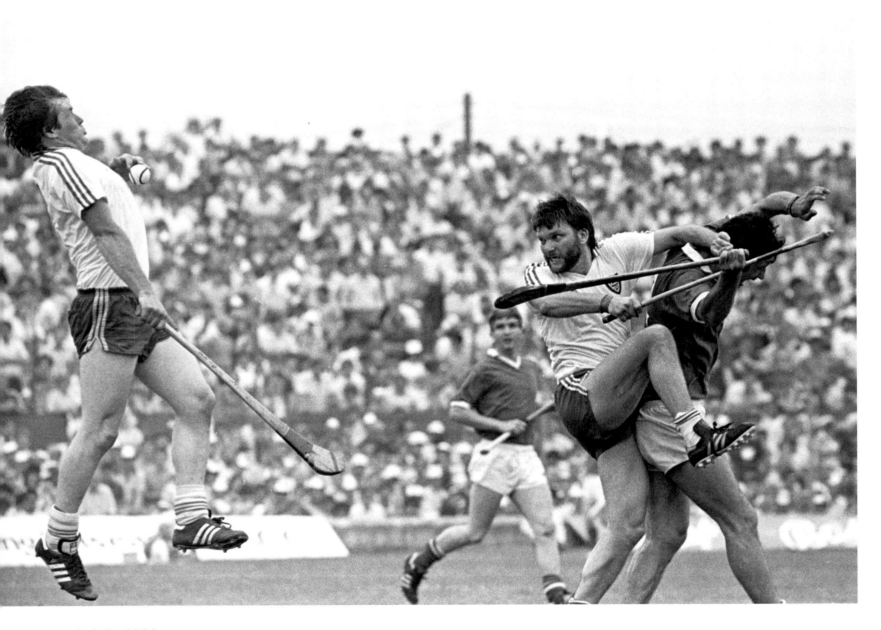

10 July 1983 Cork v Waterford in
the Munster Senior Hurling final at the
Gaelic Grounds in Limerick. *276/057*

10 August 1986 A GAA supporter in
defiant mood during the All-Ireland Senior
Hurling Championship semi-final of Galway
v Kilkenny at Semple Stadium, Thurles,
County Tipperary. *335/060*

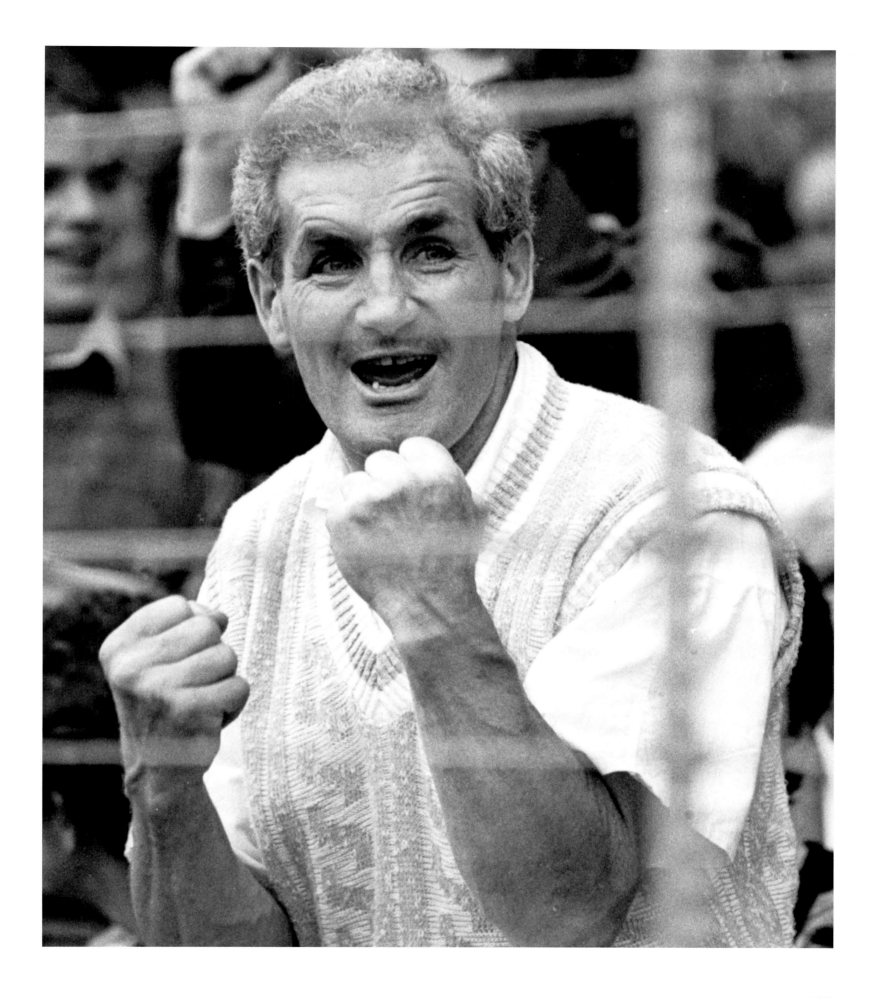

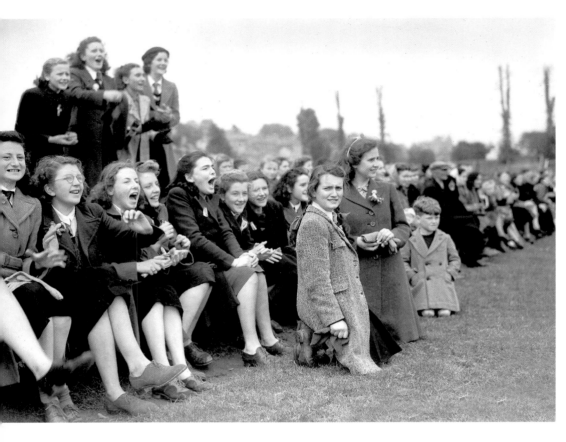

29 May 1946 Supporters cheer on their team at the Cork Schools Camogie final between St Aloysius and the School of Commerce at the Mardyke, Cork. *71D*

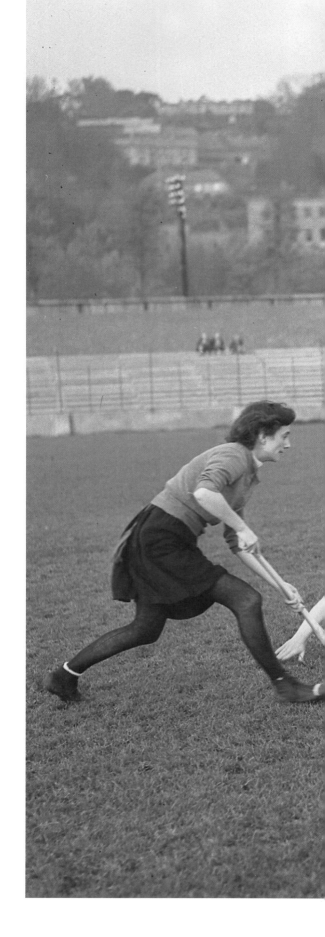

21 November 1954 Glen Rovers take control in the camogie county final against Blackrock at the Athletic Grounds, Cork. *3h*

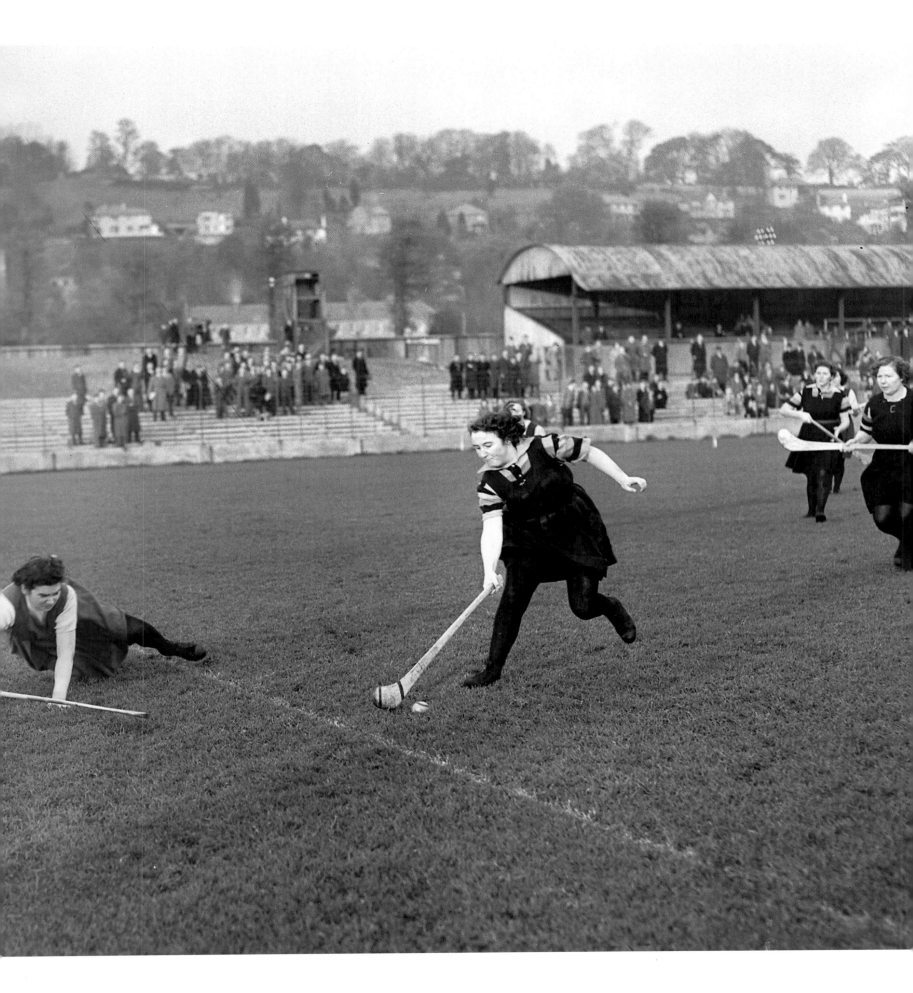

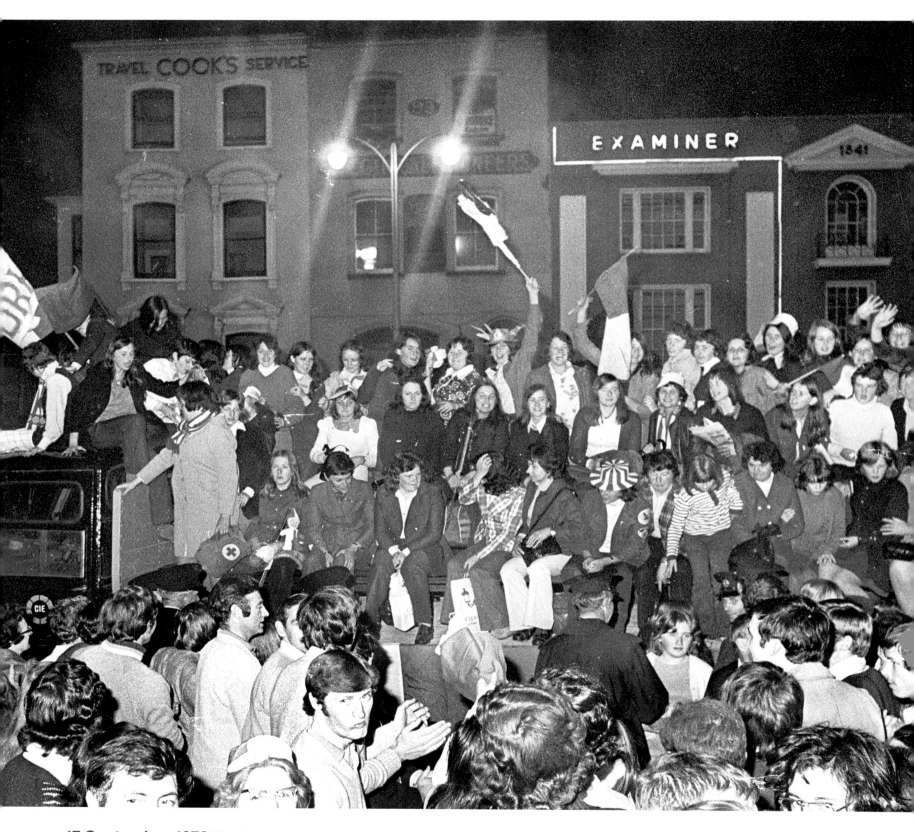

17 September 1973 The homecoming reception for the Cork Junior and Senior All-Ireland winning camogie teams, outside the Victoria Hotel, St Patrick's Street, Cork. *165/25*

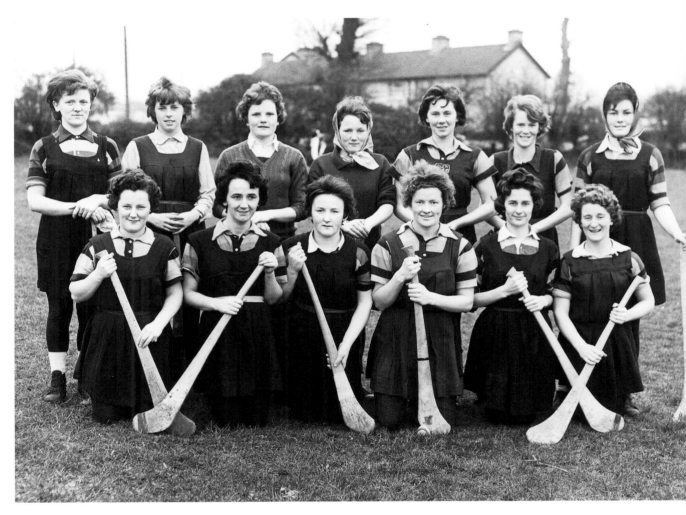

1 March 1964 The Glen Rovers camogie team before their League
Final match against Old Aloysuis at the Church Road, Cork. *189p*

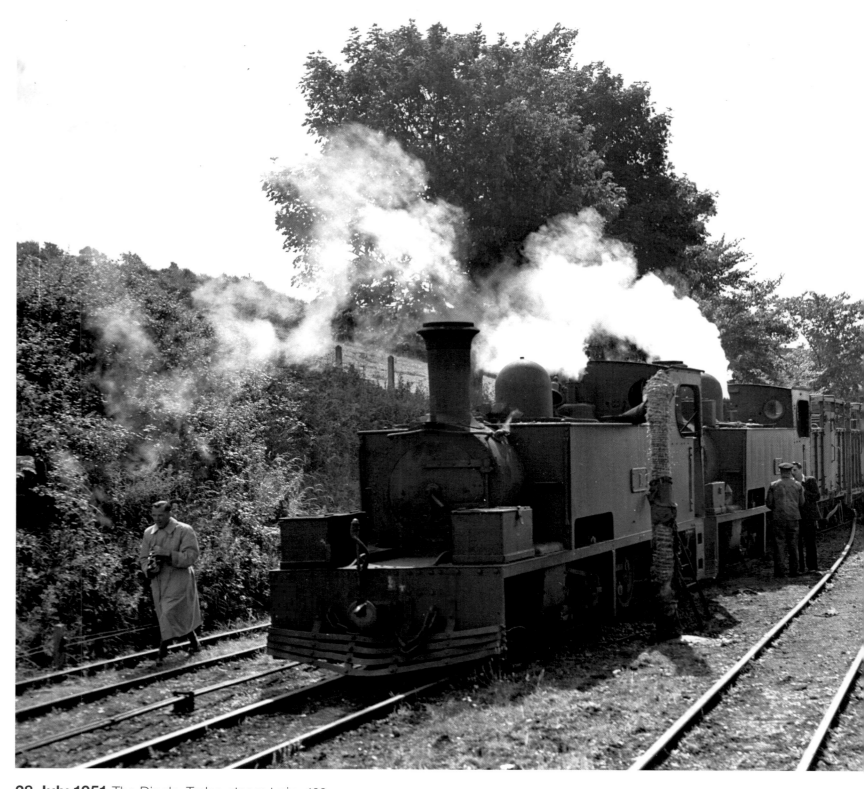

28 July 1951 The Dingle–Tralee steam train. *123e*

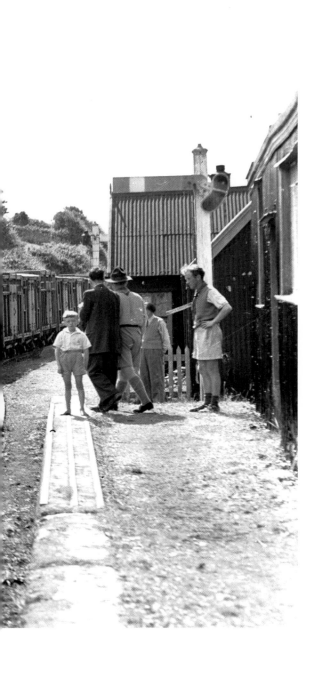

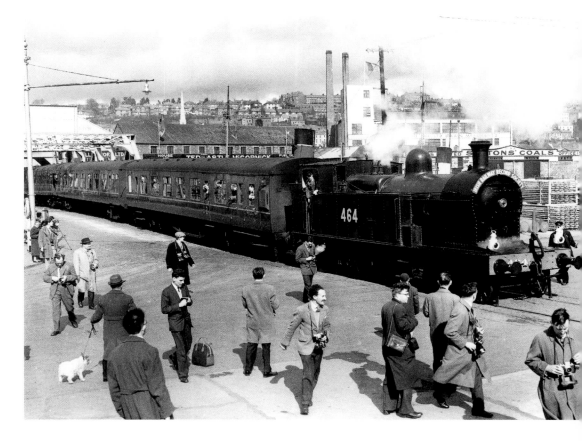

16 March 1961 The Irish Railway Record Society at Albert Quay Railway Station, Cork. *655L*

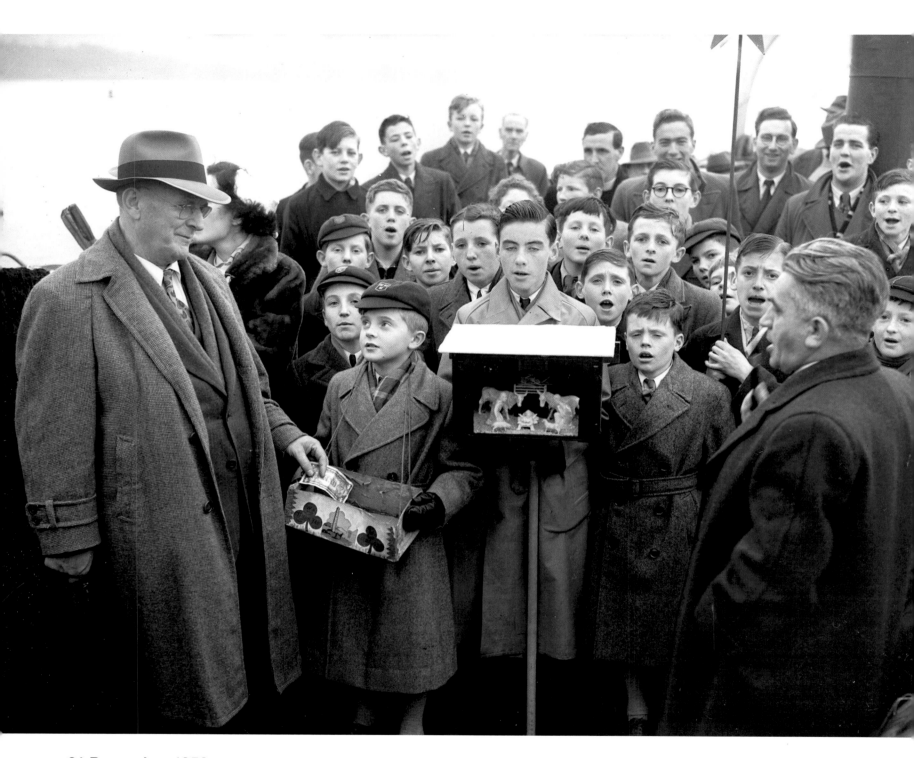

21 December 1953 Passengers from the liner
America donate to charity singers, travelling to Cobh,
County Cork, on the tender. *366G*

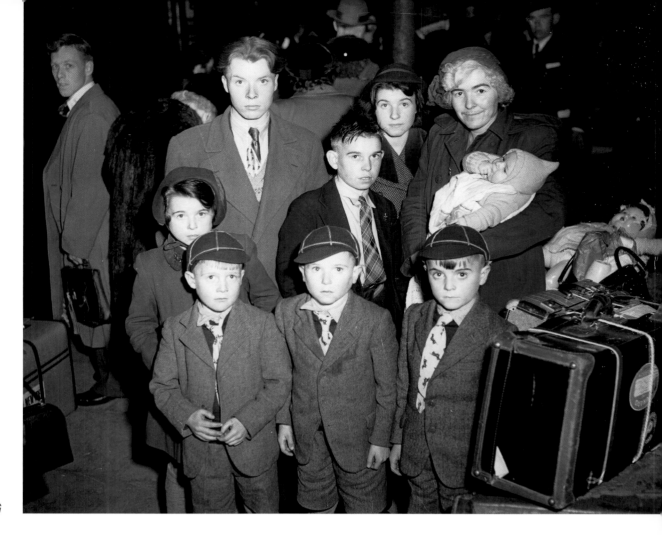

2 October 1953 Emigrants leaving Cobh, County Cork, for Canada on a Cunard liner. *222G*

16 November 1953 Islanders arrive on the mainland after leaving the Blasket Islands, Kerry. *297G*

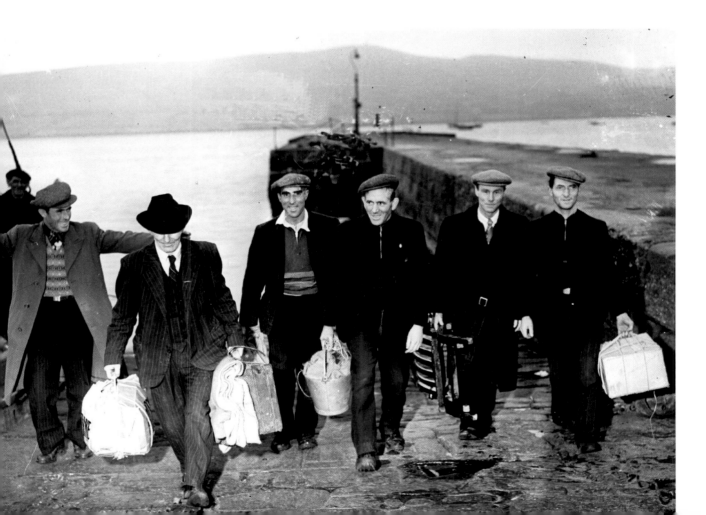

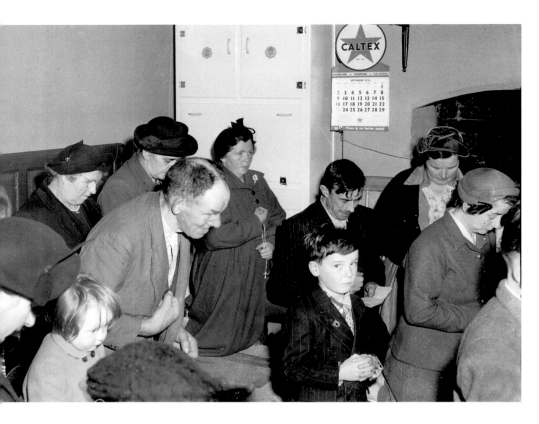

3 November 1956 Celebrating the Station Mass at a house in Ballinhassig, County Cork. *173J*

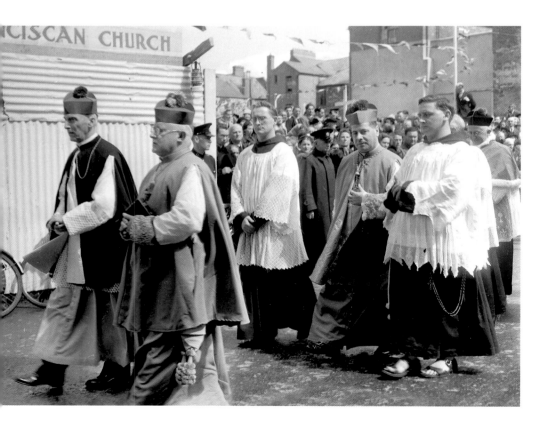

3 August 1949 In procession towards the laying of the foundation stone of the new St Francis Church at Liberty Street, Cork. *656D*

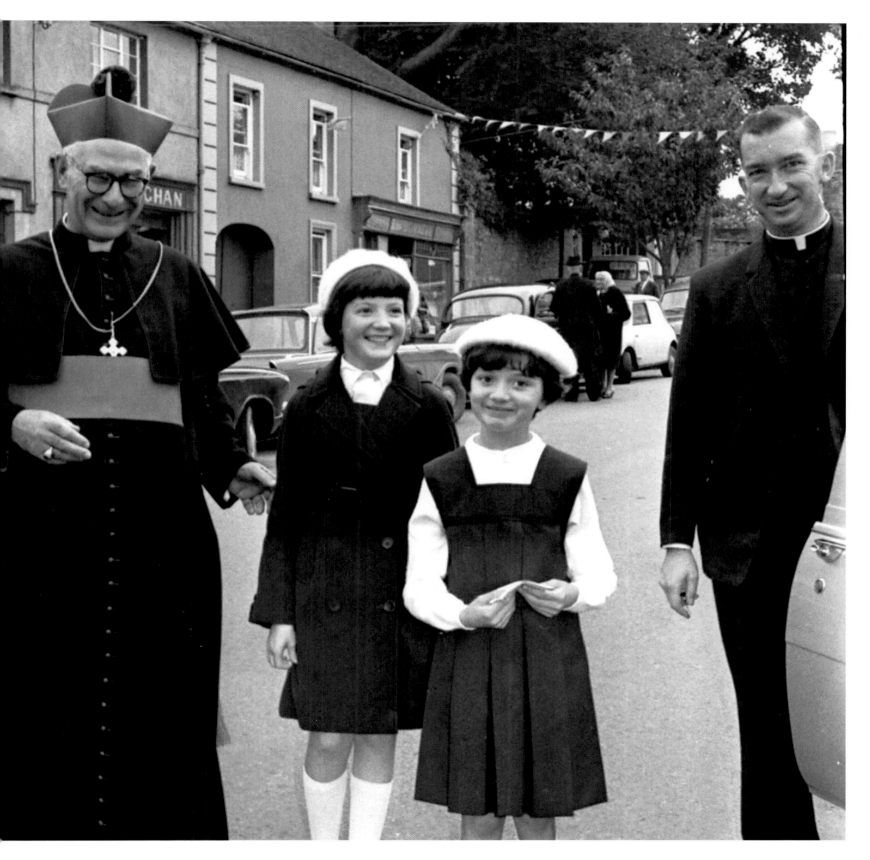

3 October 1968 Attendees at the celebrations for the 150th anniversary of the foundation of the Presentation Convent at Doneraile, County Cork. *70/21*

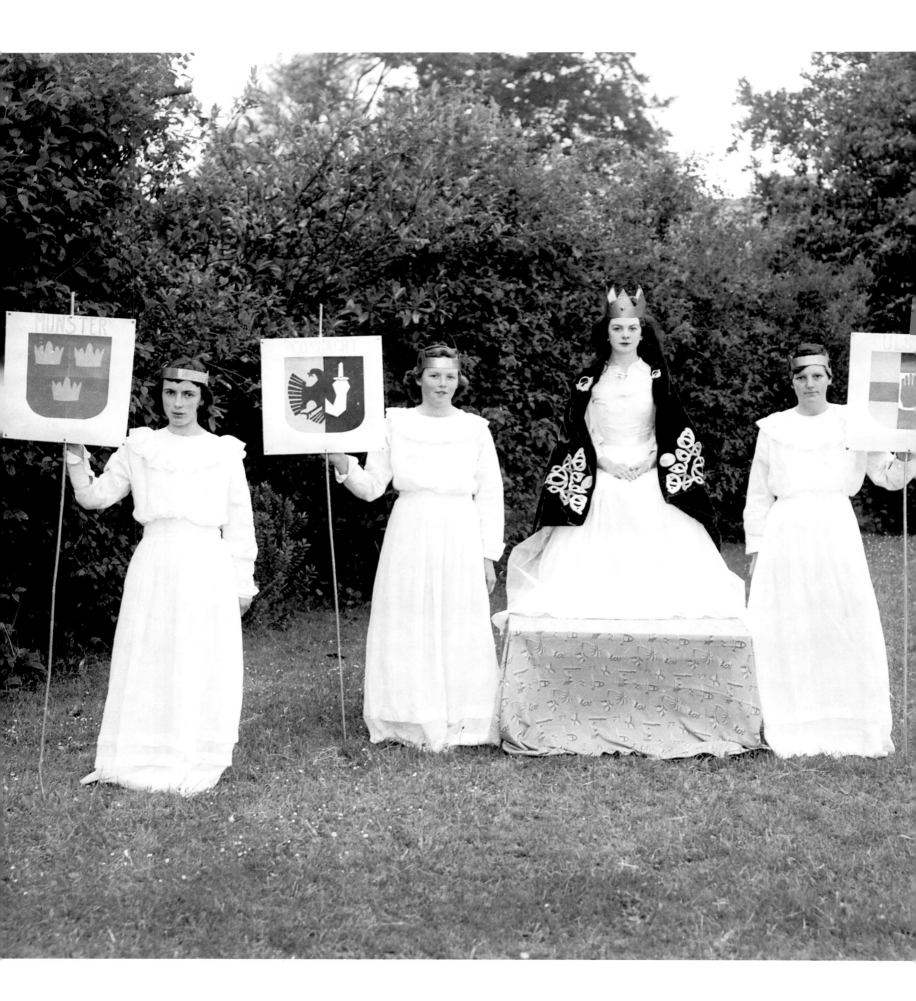

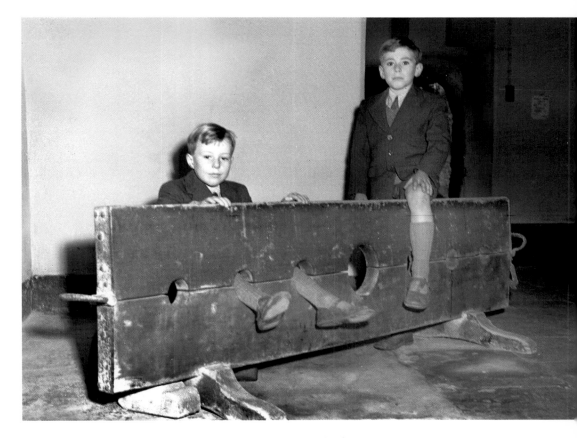

23 February 1956 Two schoolboys try out the stocks at St Multose, Kinsale, County Cork. *775H*

1 June 1957 A pageant at Ardfoyle Convent, Ballintemple, Cork. *552J*

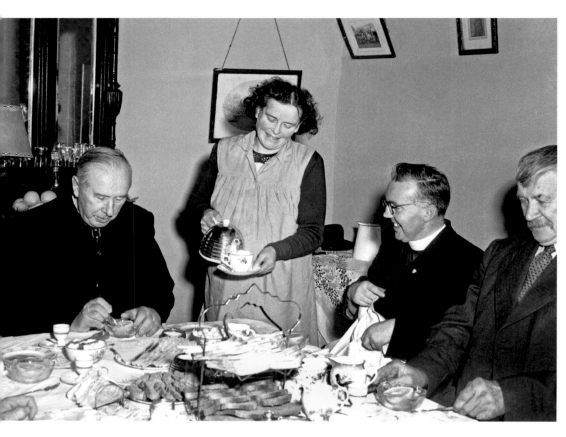

3 November 1956 Tea is served to the parish priest (left) and his curate (second from right) following a Station Mass at a house in Ballinhassig, County Cork. *173J*

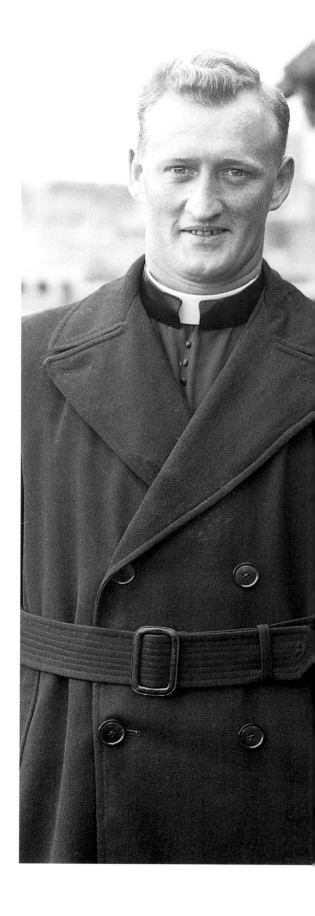

31 July 1957 The Callanan brothers from Bandon, County Cork, home from the missions. *614j*

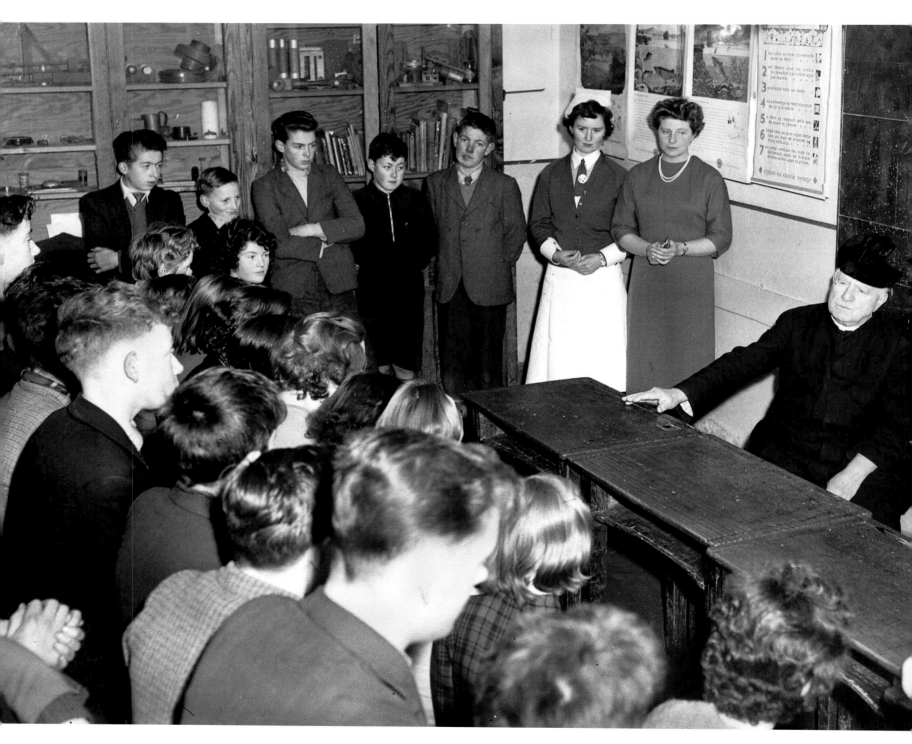

18 January 1961 Fr O'Flynn of 'The Loft' fame
(a drama school) addresses pupils of Passage
West Vocational School, County Cork. *577L*

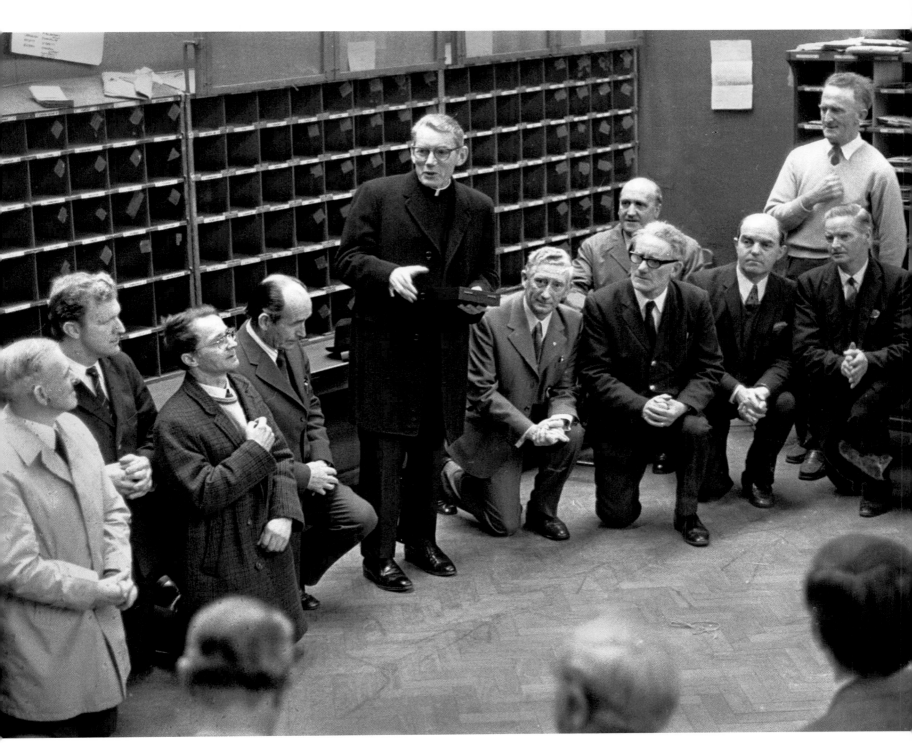

13 March 1973 Cardinal Timothy Manning, Archbishop of Los Angeles, blesses postal workers at Brian Boru Street sorting office in Cork. *156/016*

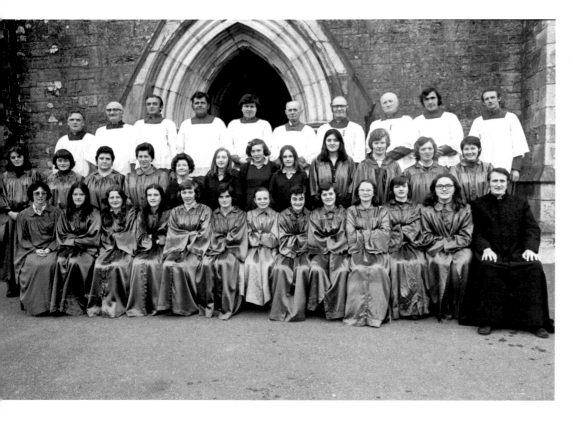

2 June 1976 St Patrick's Church Choir, Bandon, County Cork. *203/005*

1 October 1979 Pope John Paul II waves to the crowd in Limerick, a smiling Cardinal Tomás Ó Fiaich to his right. *232*

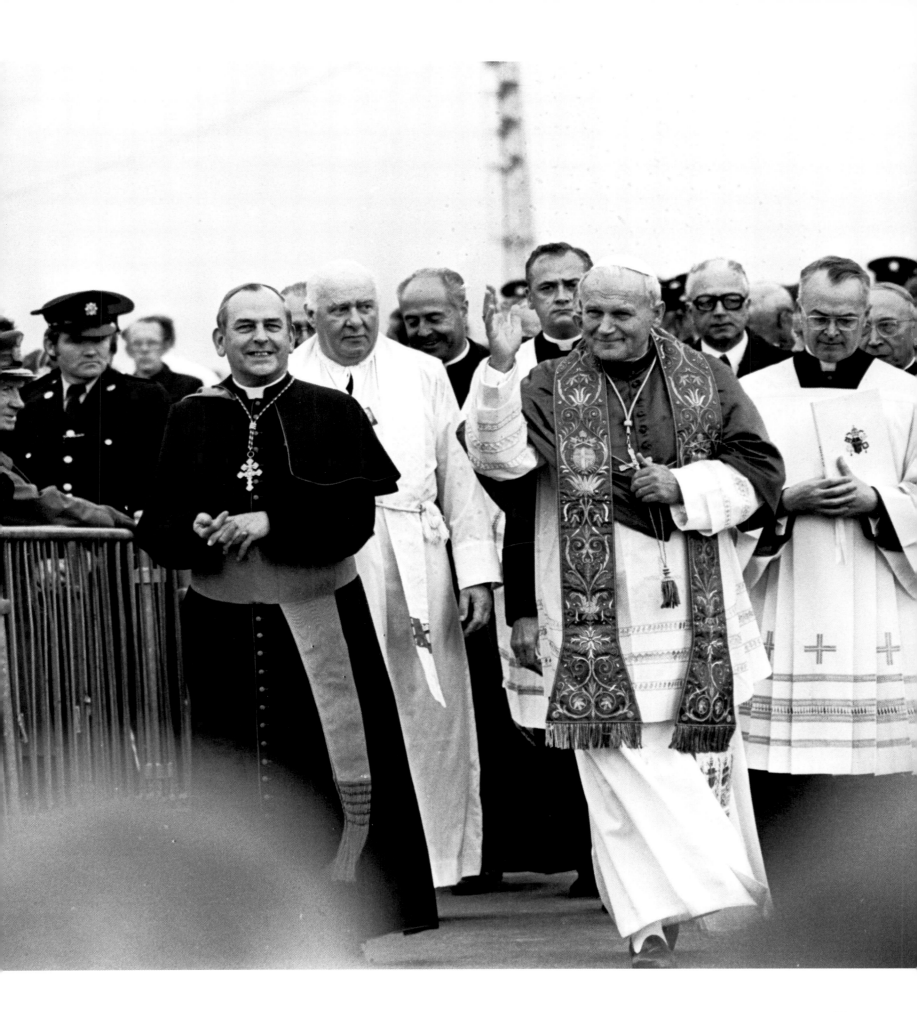

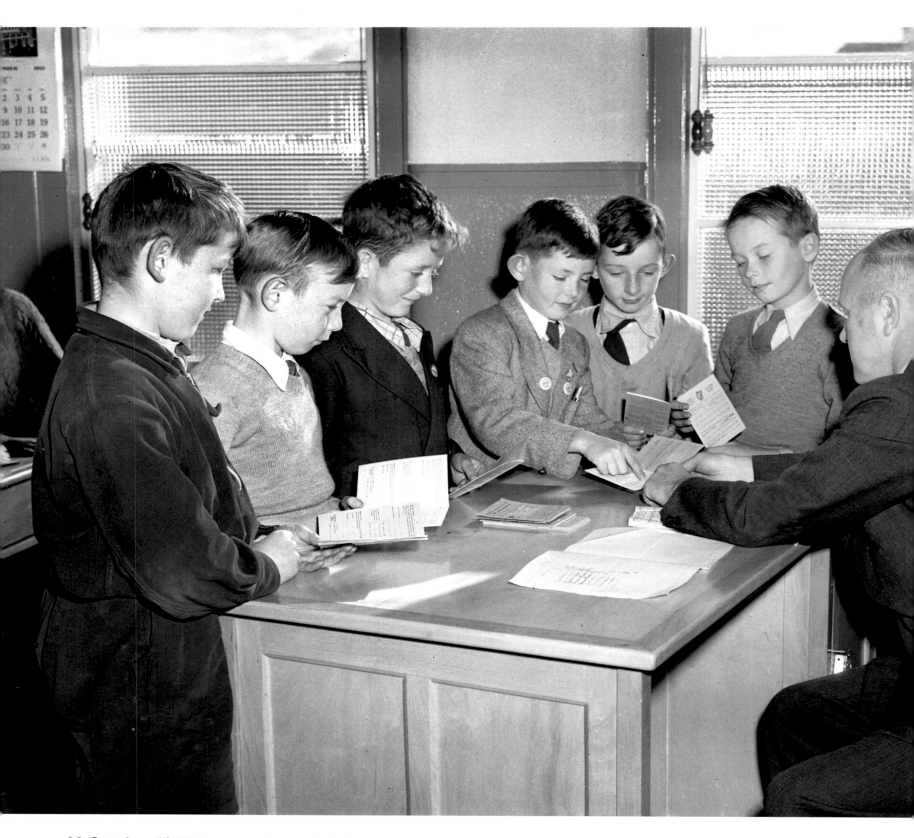

28 October 1955 Young students and their teacher at the new Glasheen School, Cork. *586H*

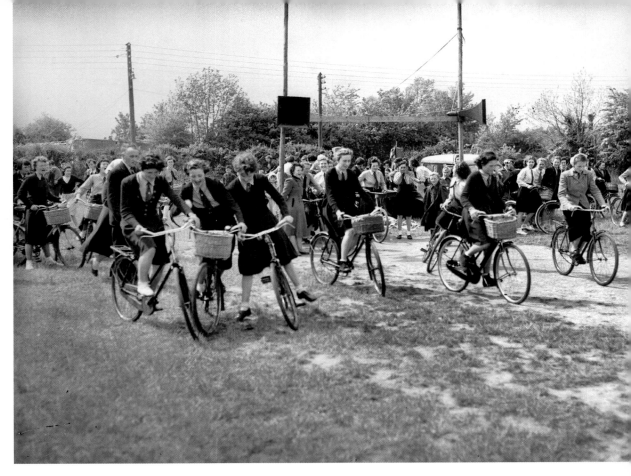

25 May 1955 South Presentation Convent's sports day at Church Road, Blackrock, Cork. *336H*

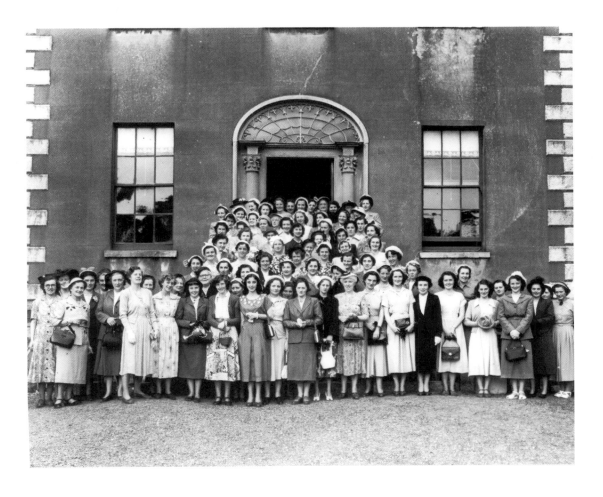

23 May 1952 Ursuline Convent, Cork, past pupils' reunion. *505E*

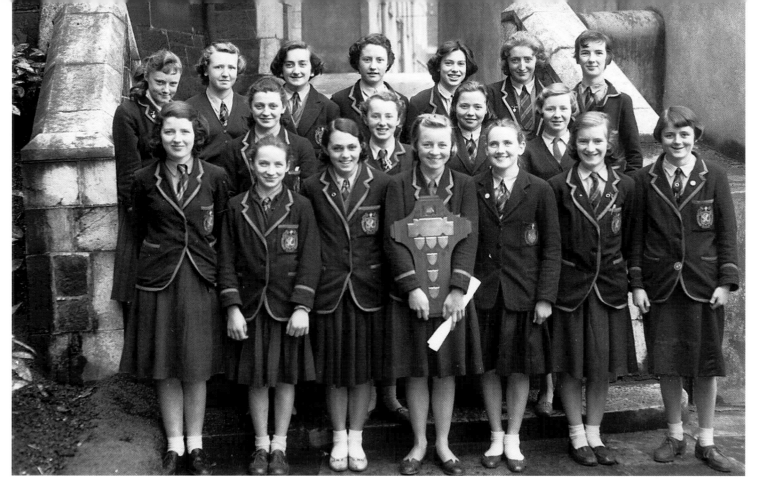

13 April 1959 South Presentation Convent, Douglas Street, Cork Feis Maitiú winners. *660K*

16 August 1956 Boys from the Irish Summer College at Garryvoe, County Cork, enjoy a day out at the beach. *66J*

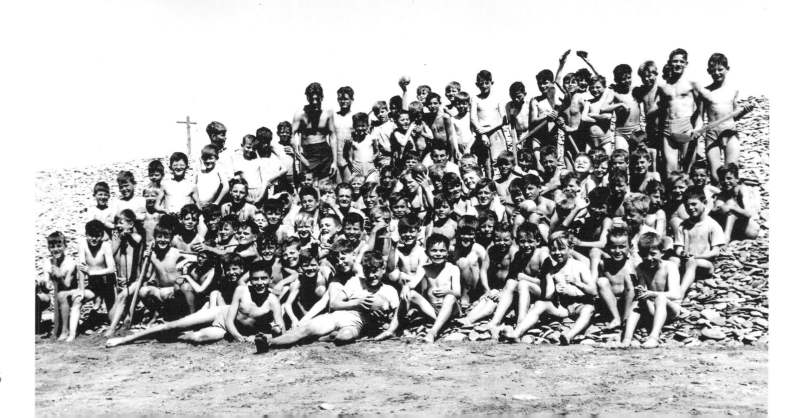

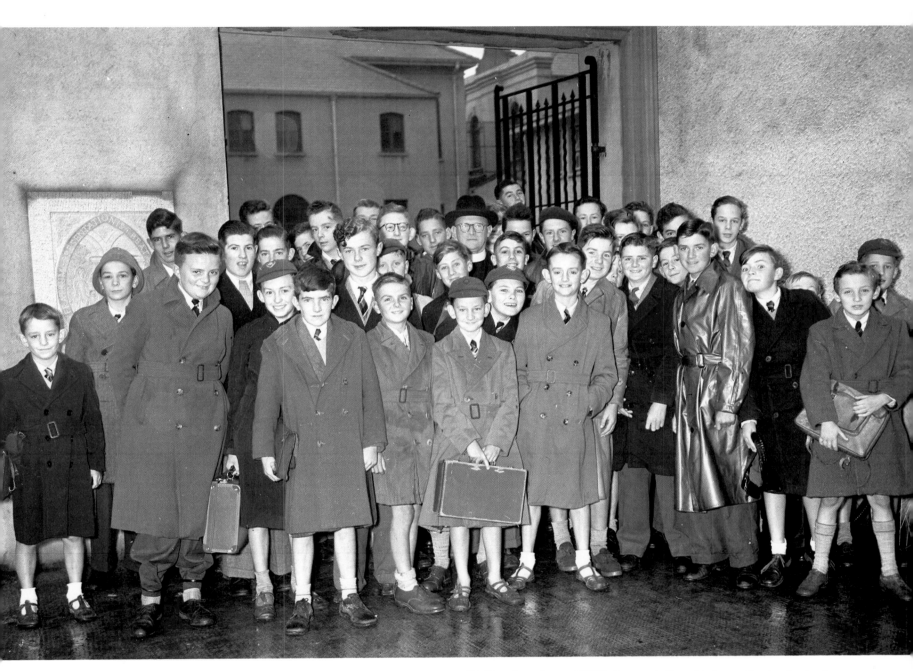

17 September 1956 Presentation College Cork students, pictured on the first day of the school term. *130J*

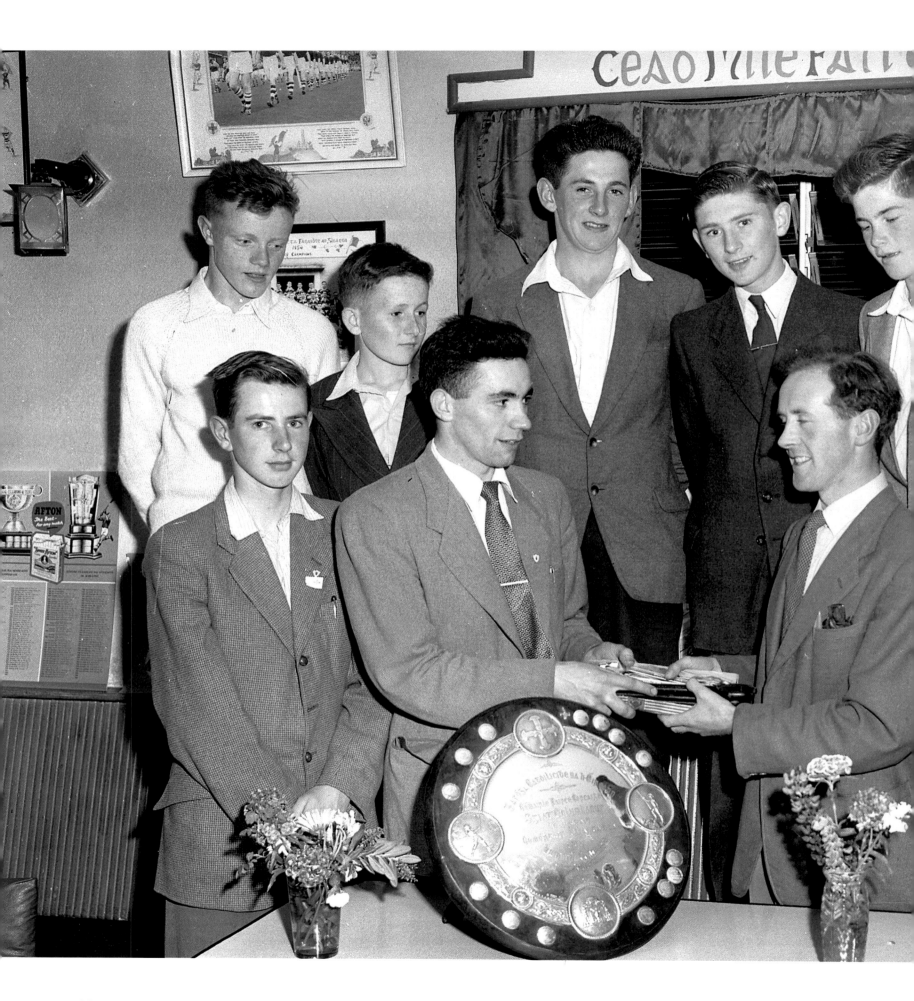

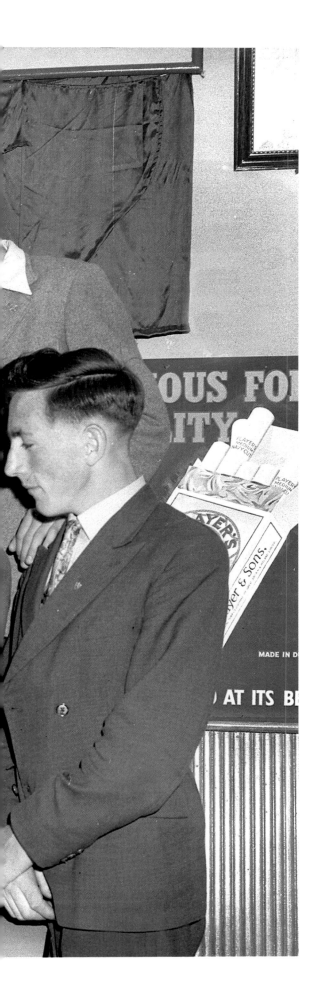

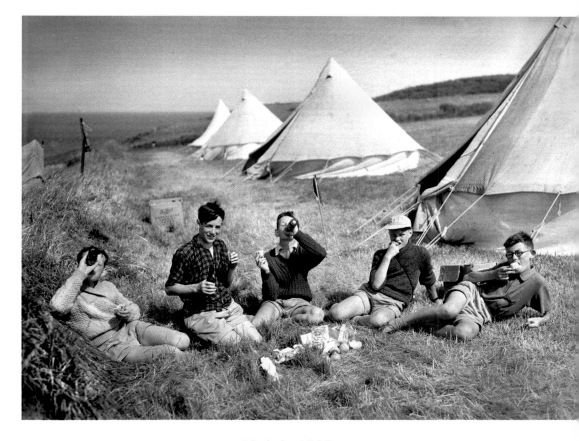

13 July 1960 Boys from Christian Brothers College at Knockadoon holiday camp, near Youghal, County Cork. *281L*

28 June 1957 Scout presentation at 'An Stad', Leitrim Street, Cork. *567J*

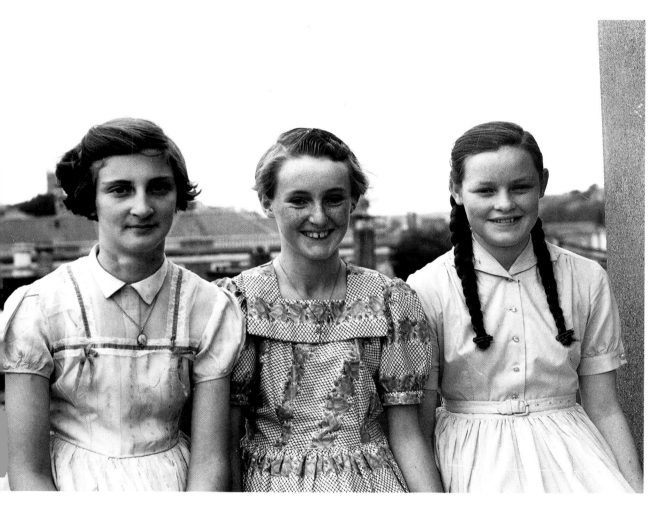

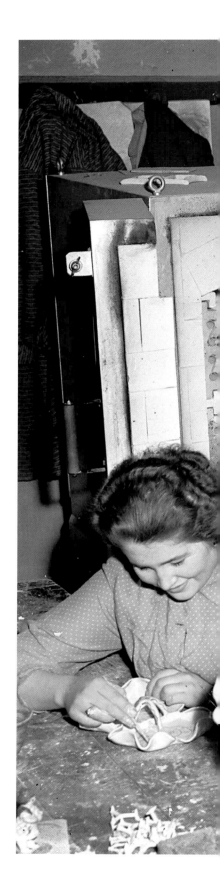

14 September 1960 Cloghroe National
School scholarship winners, Blarney, County
Cork (l–r): Eleanor O'Leary, Mary O'Leary and
Angela Murphy. *413L*

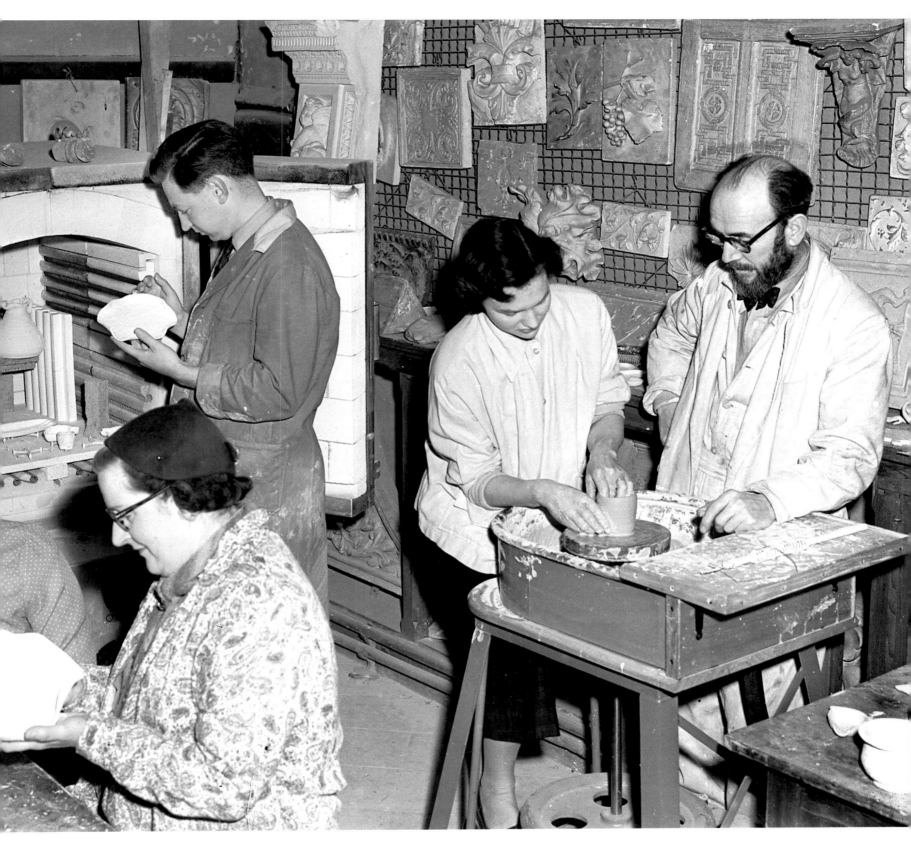

12 December 1956 A pottery class at the
Crawford School of Art, Emmet Place, Cork. *255J*

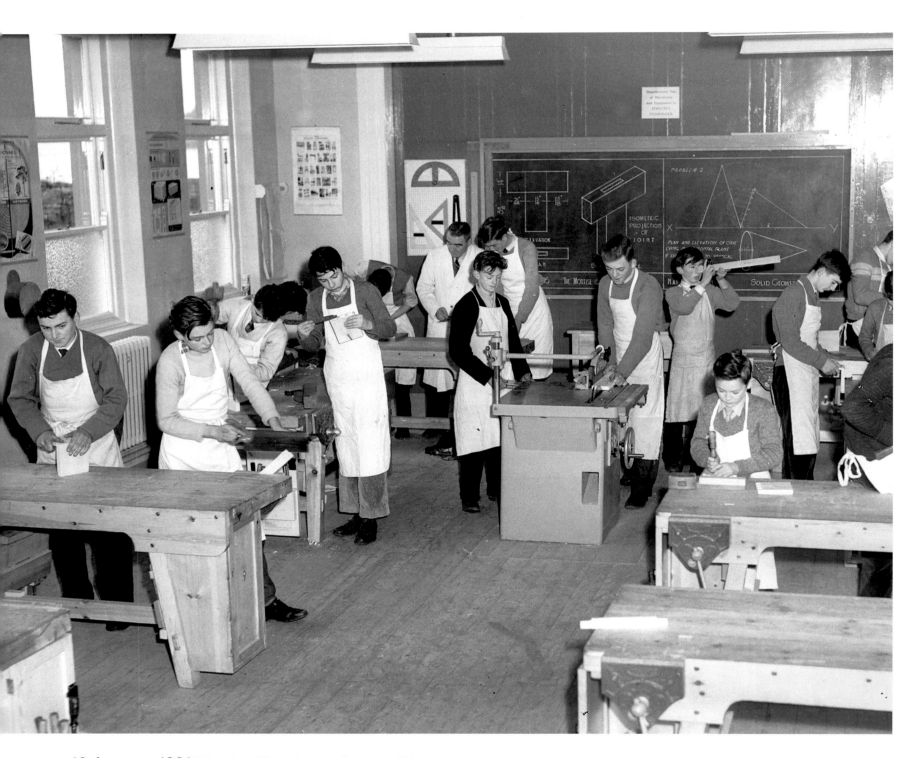

18 January 1961 Woodworking class at Passage West
Vocational School, County Cork. *577L*

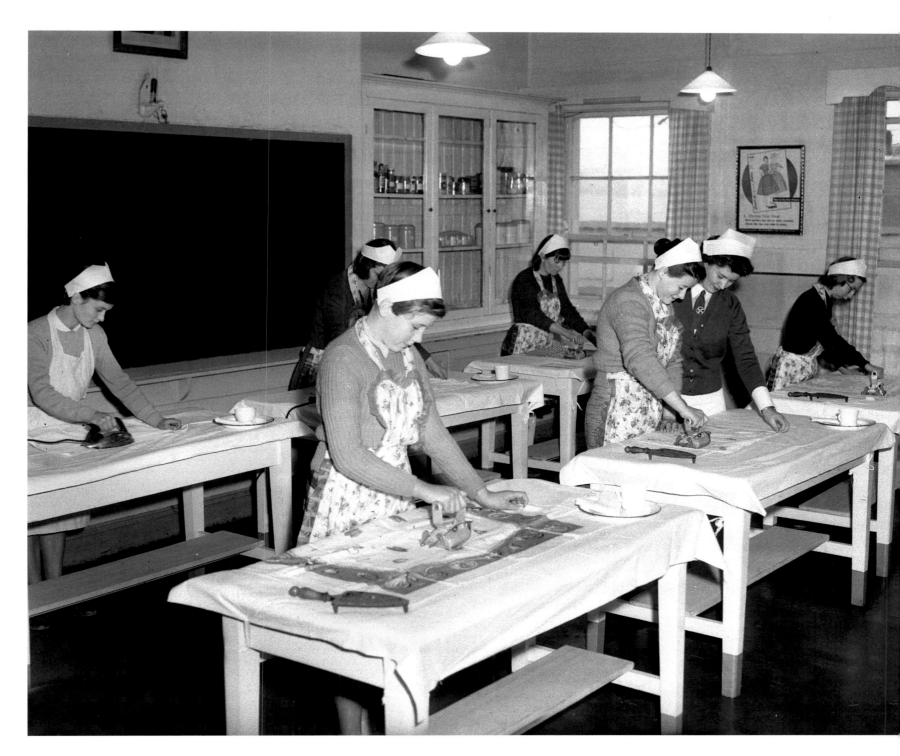

18 January 1961 Embroidery class at Passage West Vocational School, County Cork. 577L

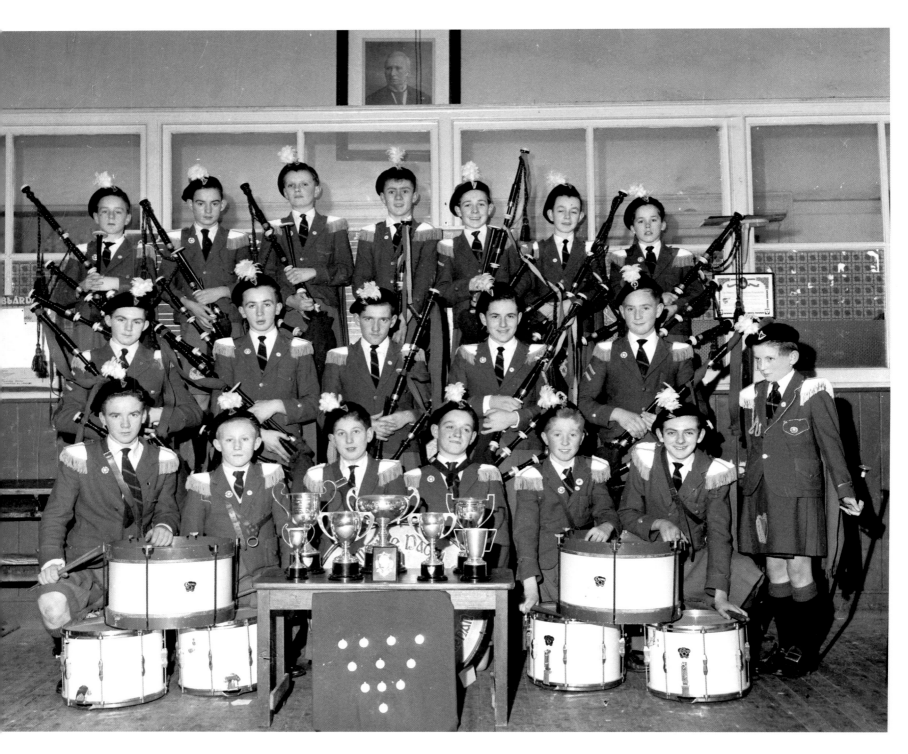

3 December 1961 Blarney Street CBS Pipe Band, Cork. *147M*

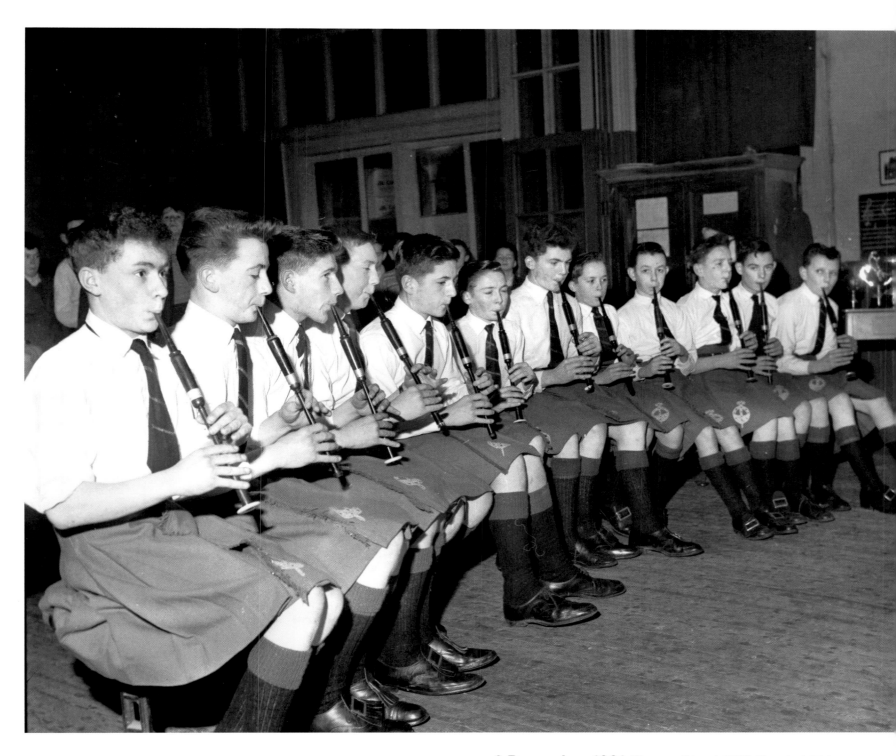

3 December 1961 Blarney Street CBS Band. *147M*

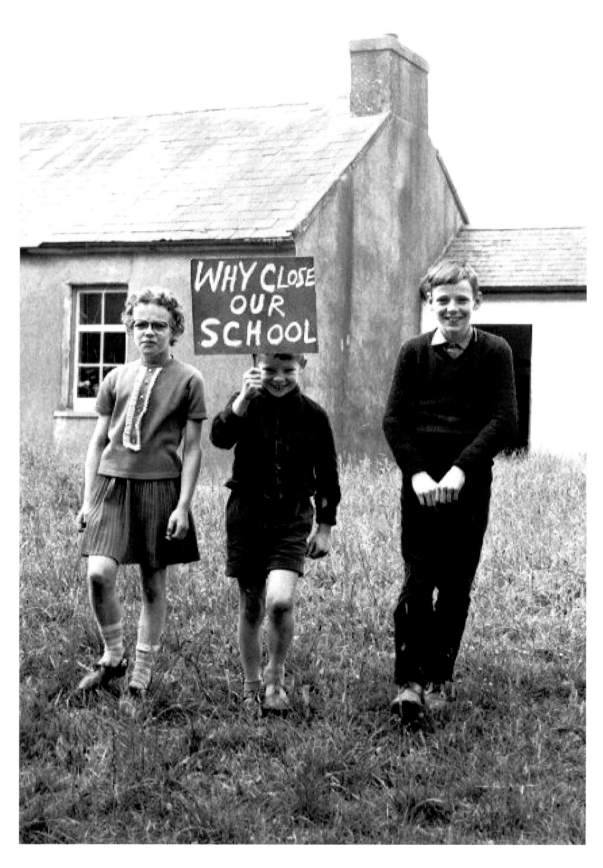

June 1967 Students protest the closing of Tullig National School. Coachford, County Cork. *625P/007*

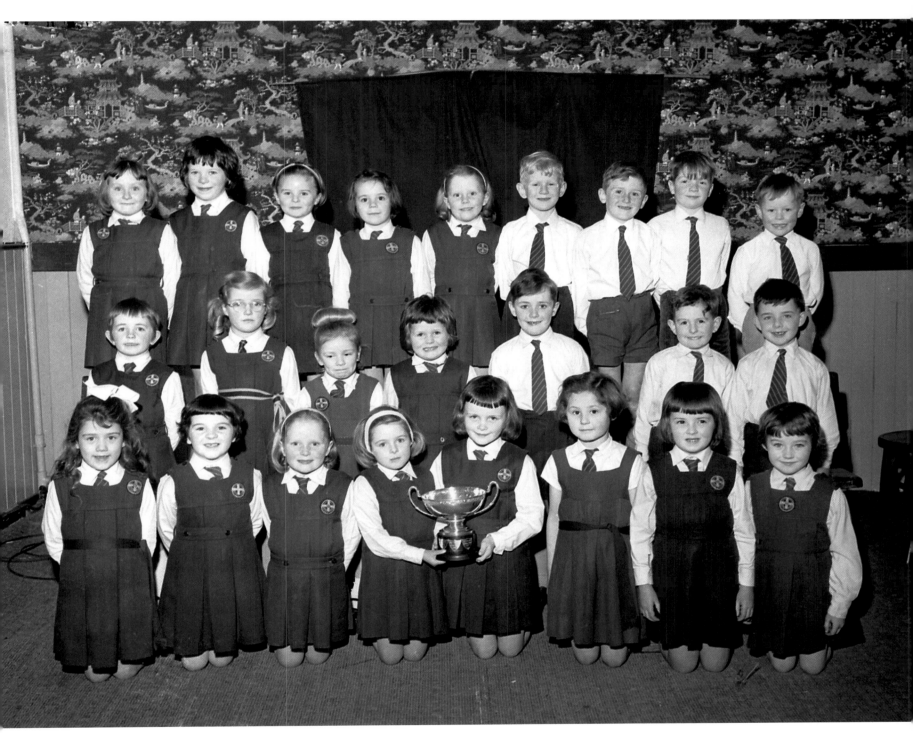

15 March 1966 Winners of the Juvenile Cup at Feis Maitiú from Our Lady of Lourdes School, Ballinlough, Cork. *569P*

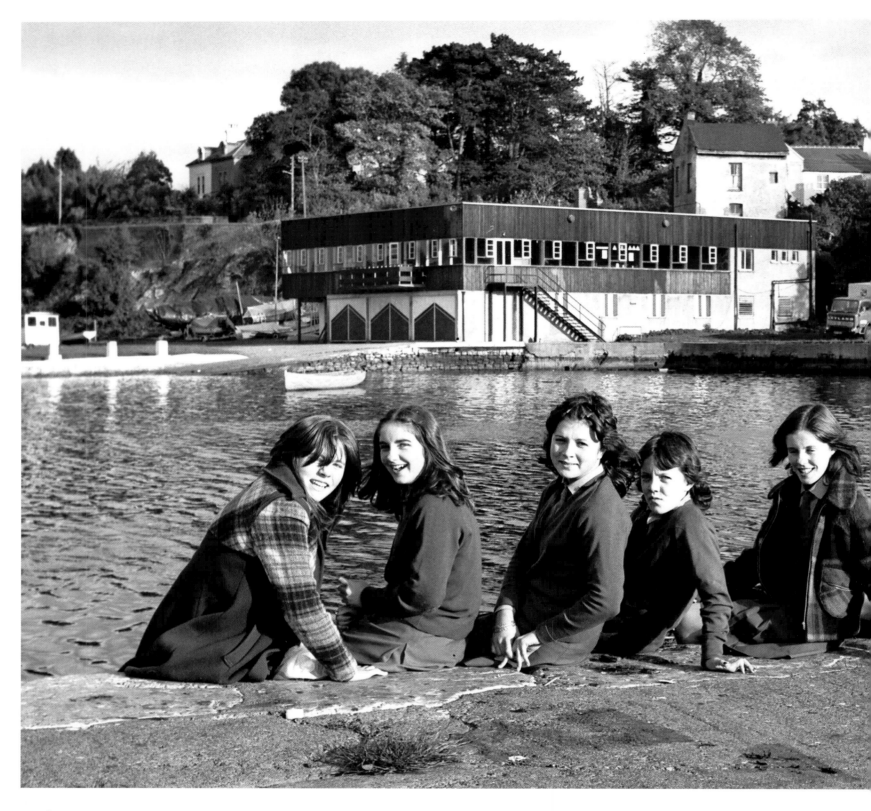

23 October 1973 Young students enjoying
the sunshine at Blackrock, Cork, with Cork
Boat Club in the background. *645P-160*

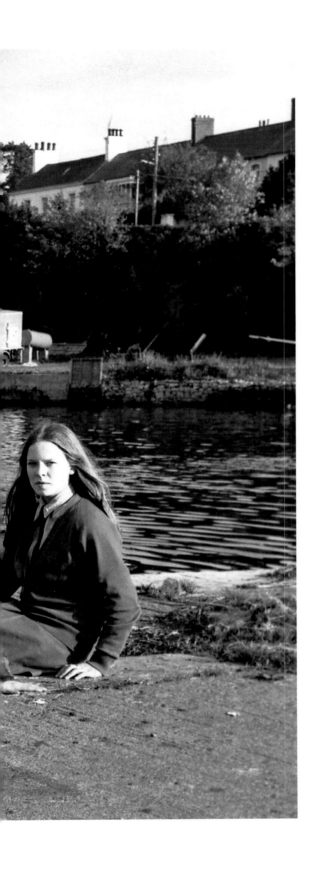

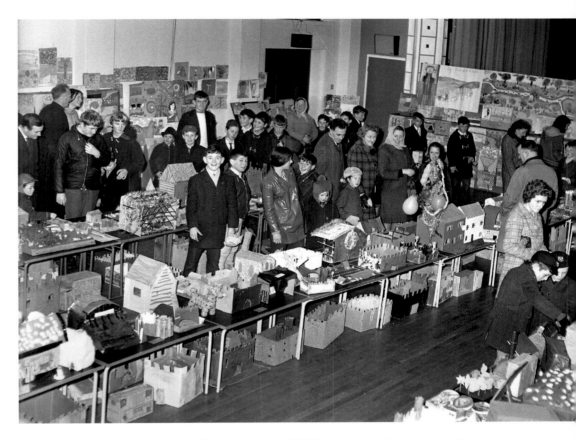

December 1969 Arts and Crafts exhibition by pupils at Greenmount School Hall, Cork. *636p174*

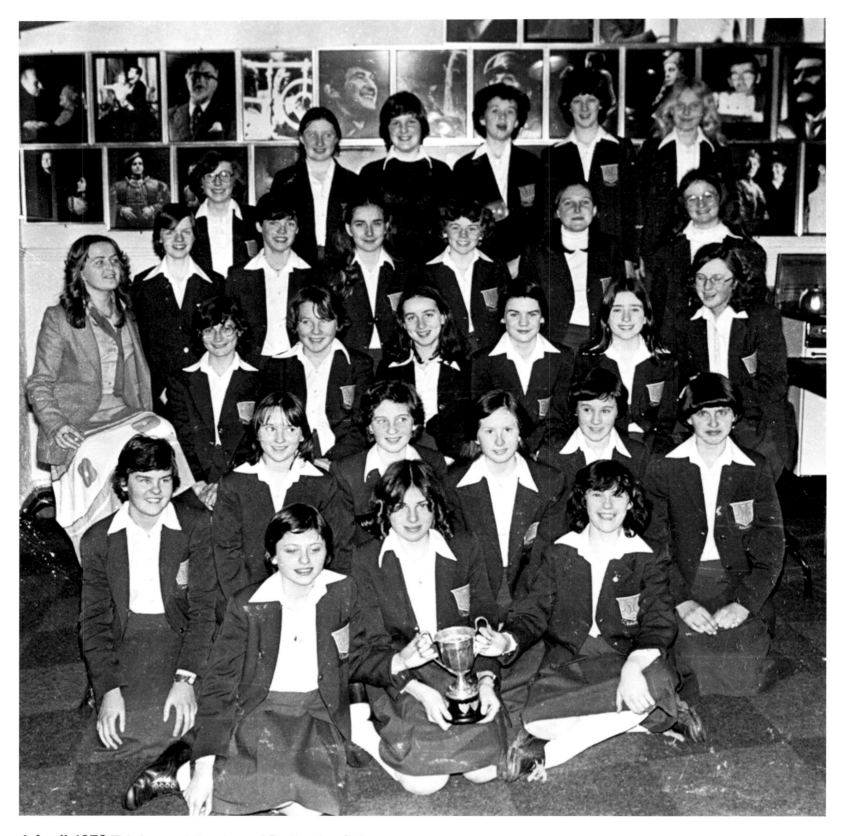

4 April 1979 Third year alpha class of St Aloysius College, Carrigtwohill, County Cork. They won the Nolan Cup for Choral Verse at Feis Maitiú at Father Mathew Hall, Cork. Included in the picture is their teacher, Miss Kay Curtin. *226/258*

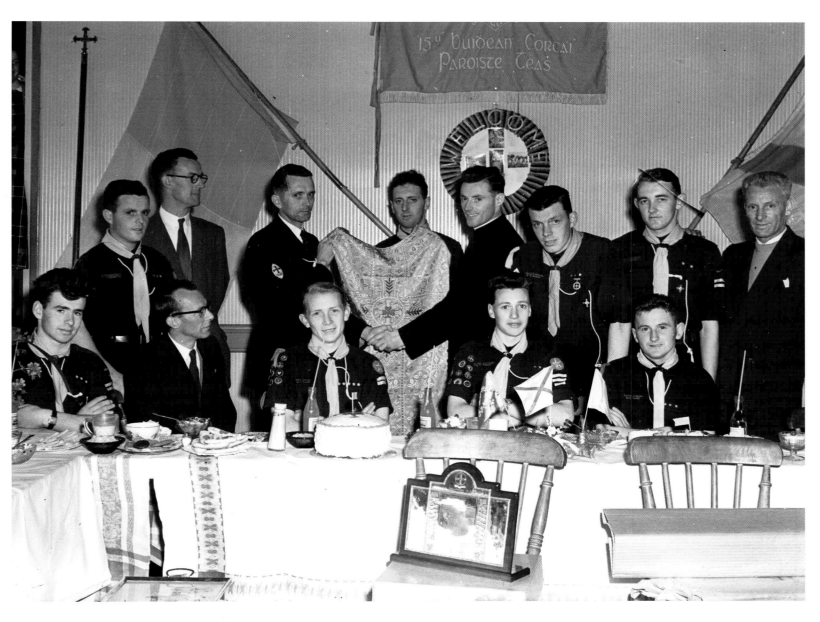

23 June 1958 Presentation of vestments to Fr Kidney by the scouts of South Parish, Cork. *193K*

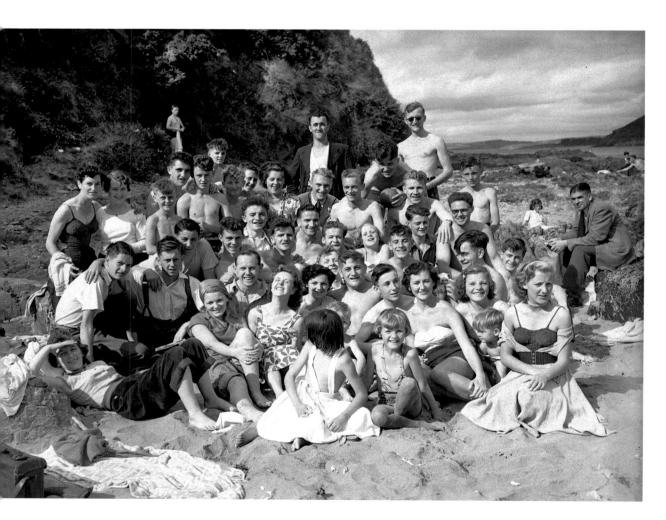

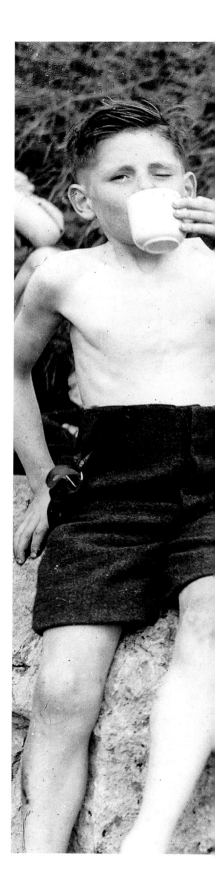

2 August 1953 Soaking up the sun in Crosshaven,
County Cork. *199G*

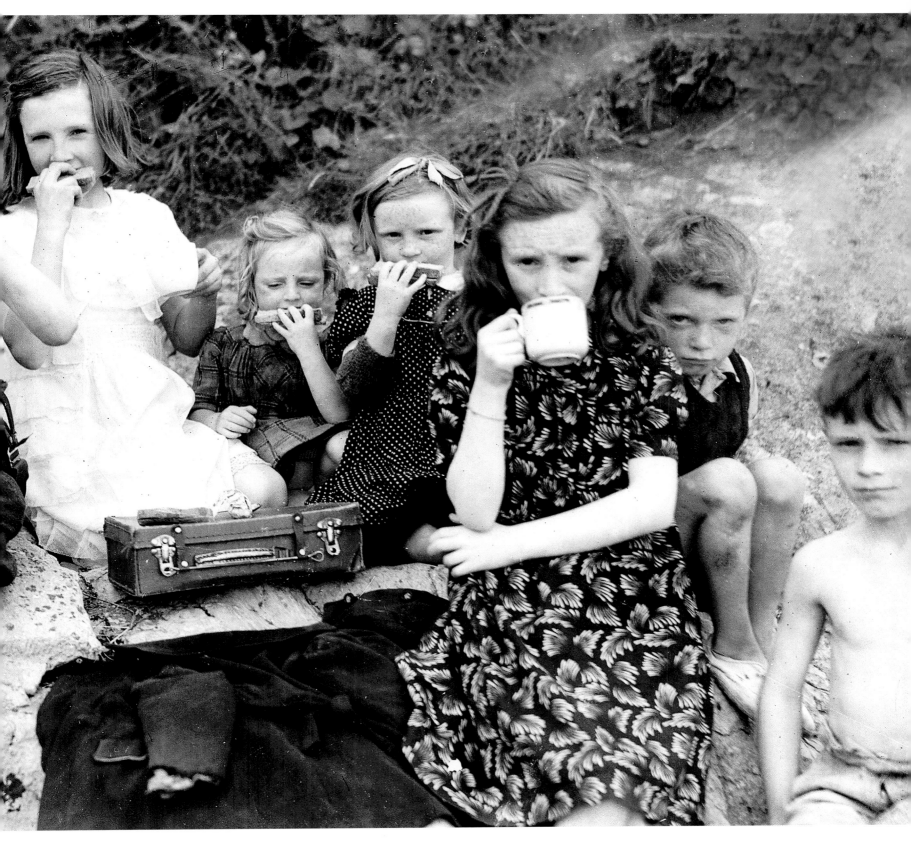

1946 Children enjoying a summer picnic at Lough Mahon, near Blackrock Castle, Cork. *113D*

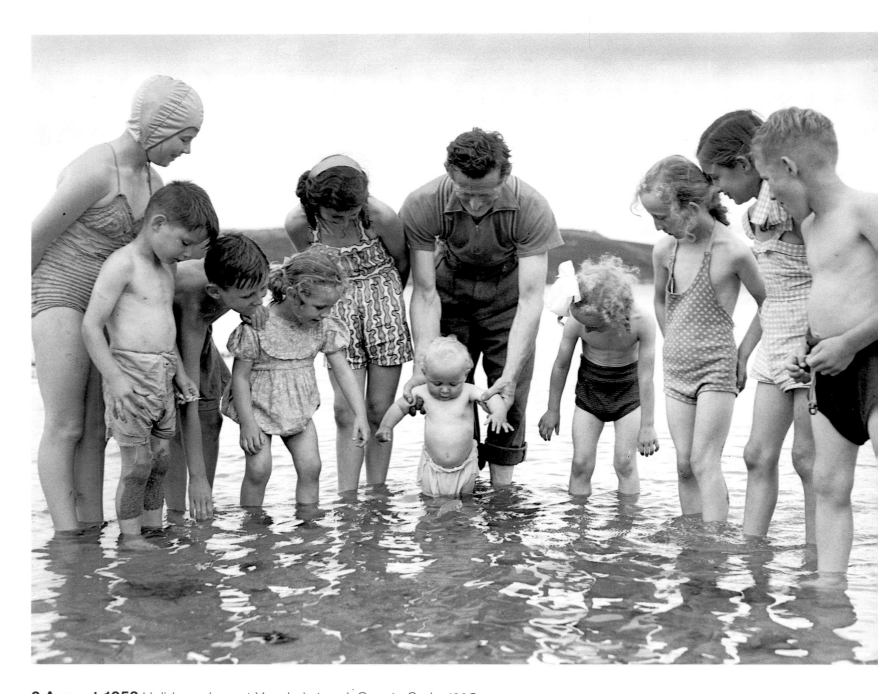

2 August 1953 Holidaymakers at Youghal strand, County Cork. *199G*

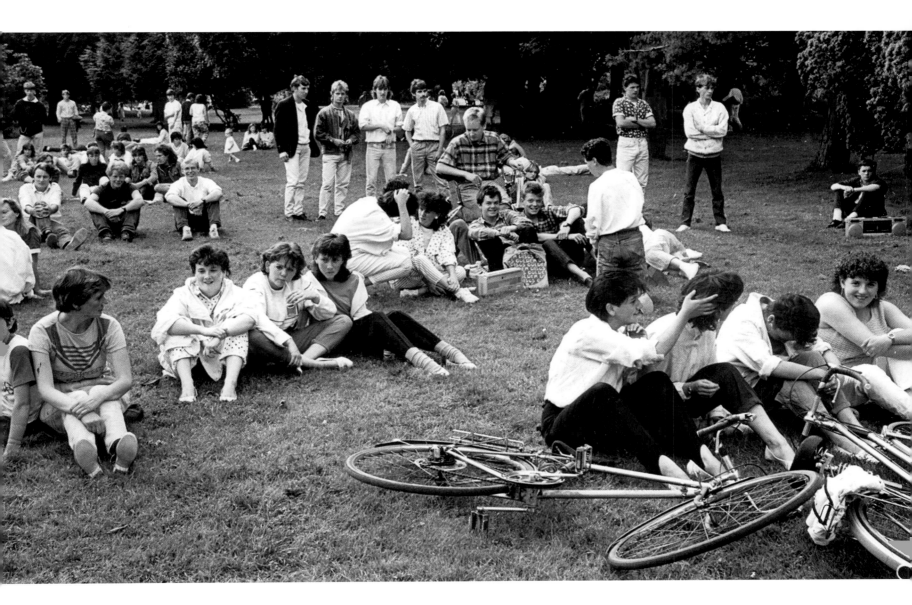

August 1986 Watching a Sunday afternoon concert at Fitzgerald Park, the Mardyke, Cork. *334/001*

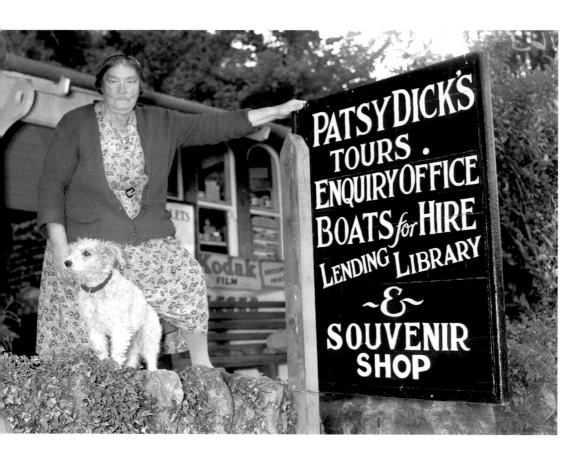

29 June 1956 Shopkeeper at Glengarriff, County Cork. *16J*

9 August 1956 Girls relax on holiday in Crosshaven, County Cork. *56j*

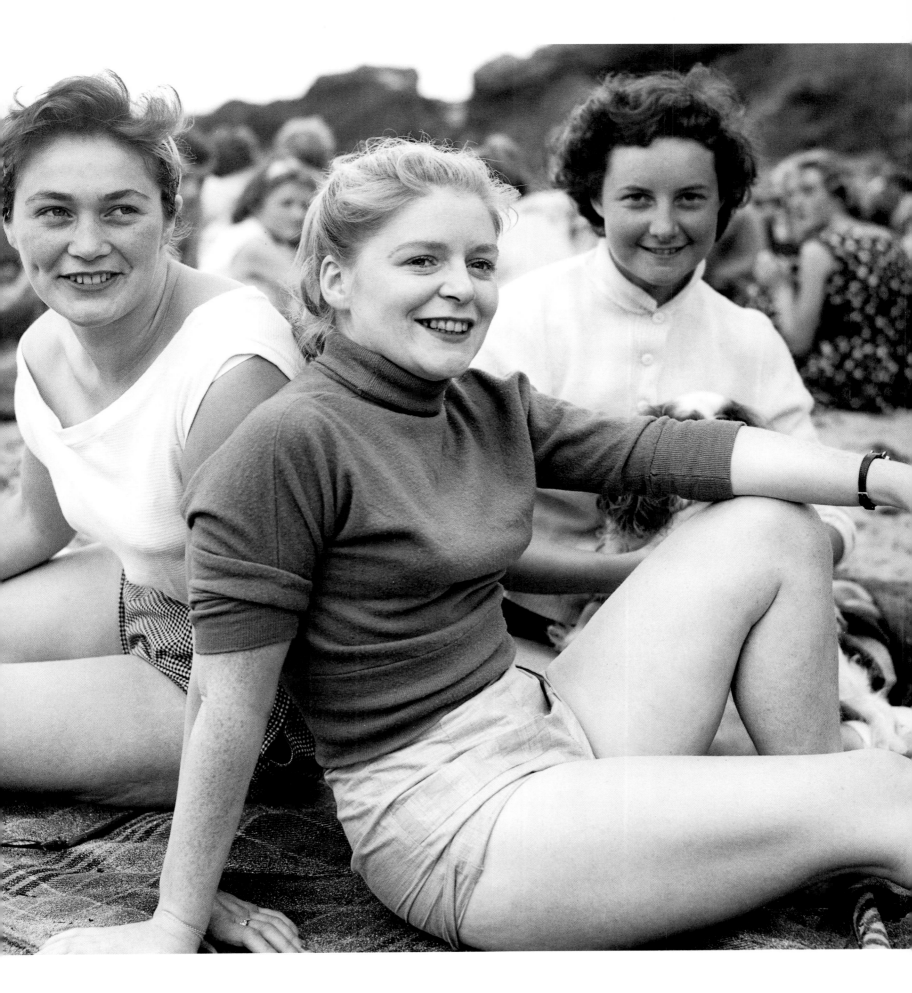

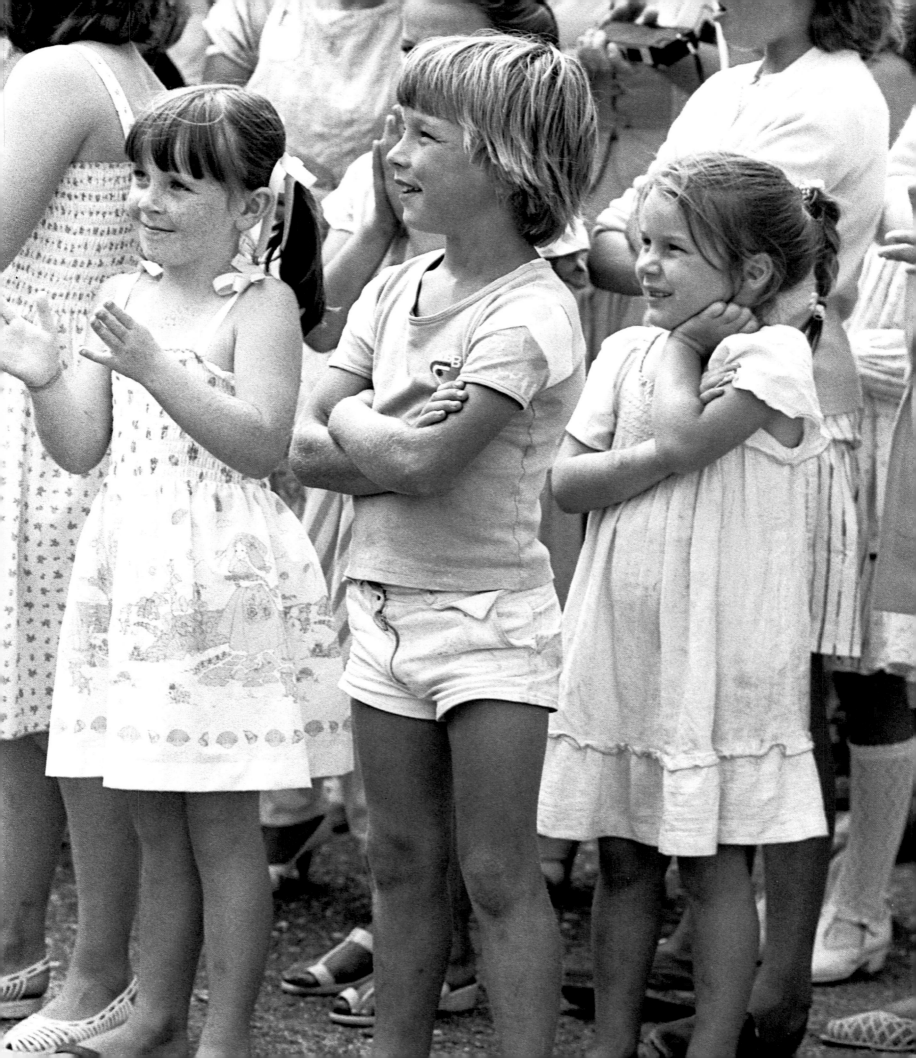

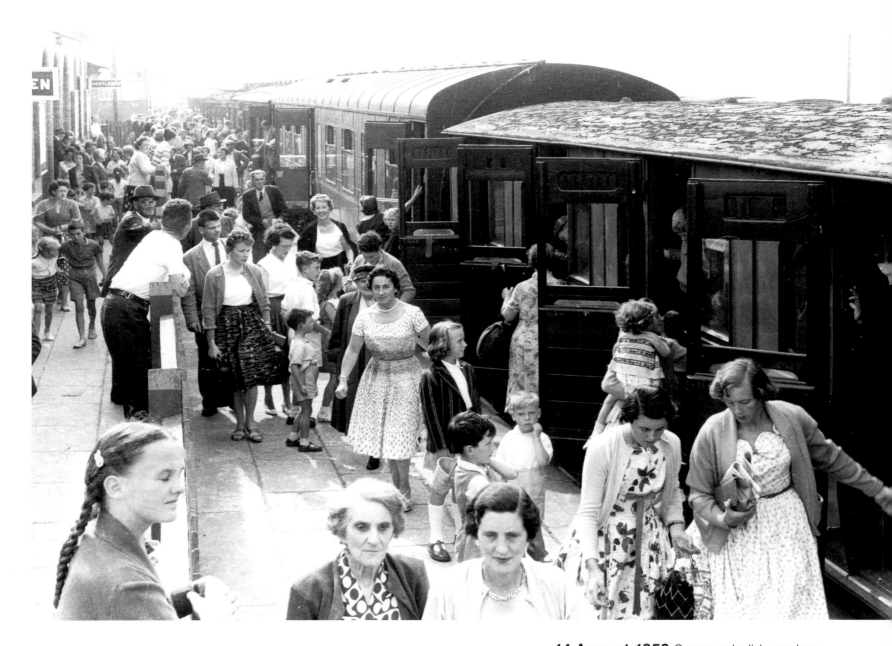

14 August 1959 Summer holidaymakers disembarking from the train at Youghal, County Cork. *797k*

5 August 1984 Children having fun at the Crosshaven carnival, County Cork. *293/072*

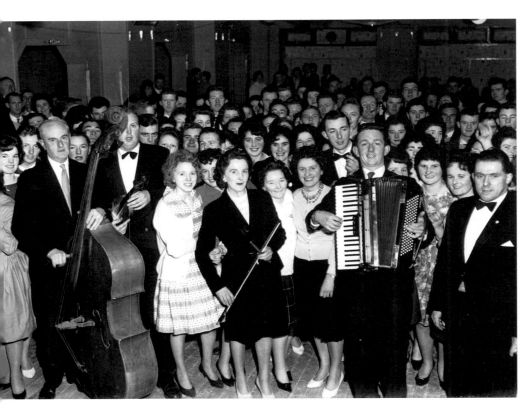

3 January 1962 Revellers at the Palm Court Ballroom, Cork. *144M*

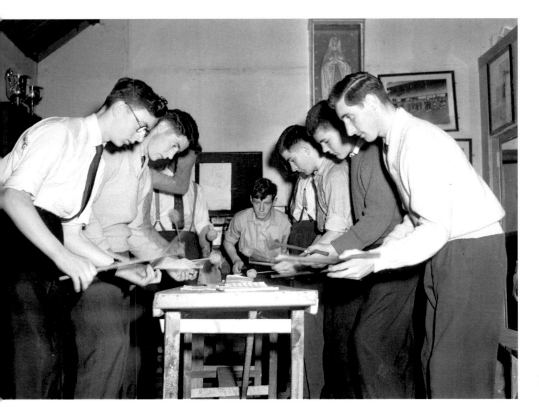

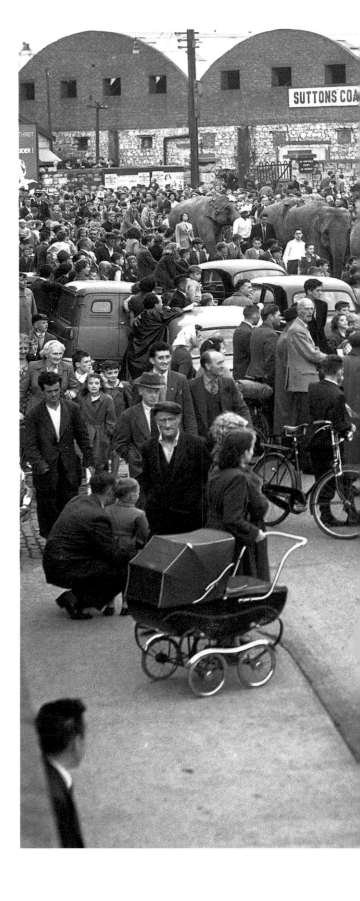

24 August 1960 Members of Carrigaline Pipe Band in practice, County Cork. *367L*

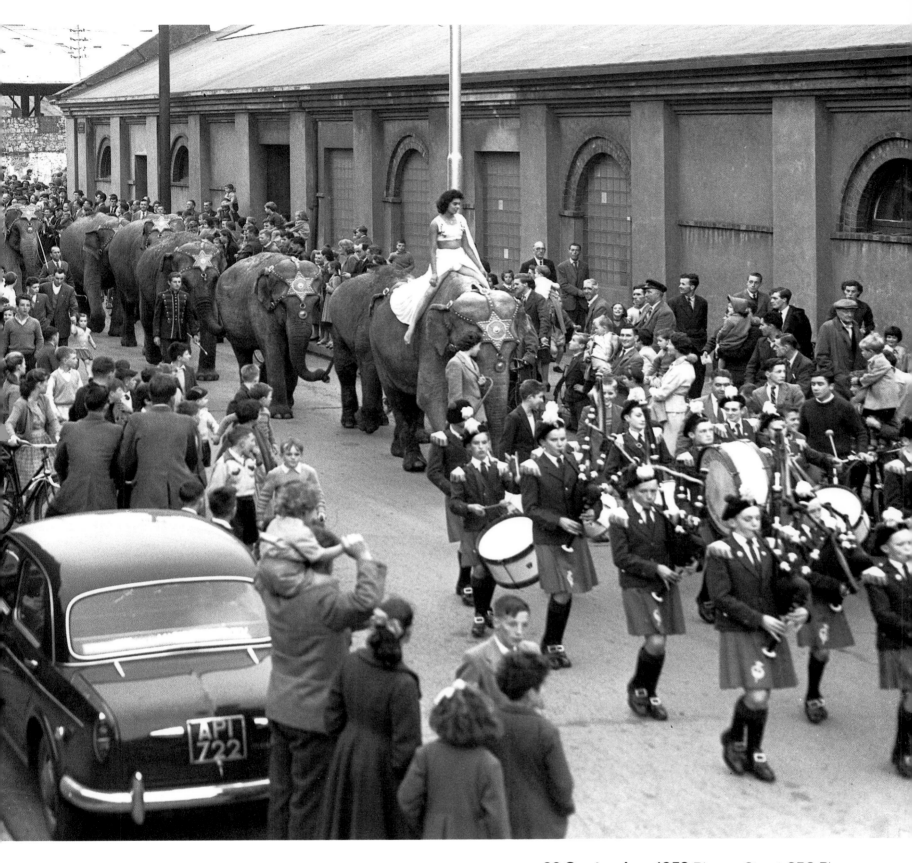

22 September 1959 Blarney Street CBS Pipe Band leading the parade of elephants from the Bandon Railway to Chipperfield's Circus. *860k*

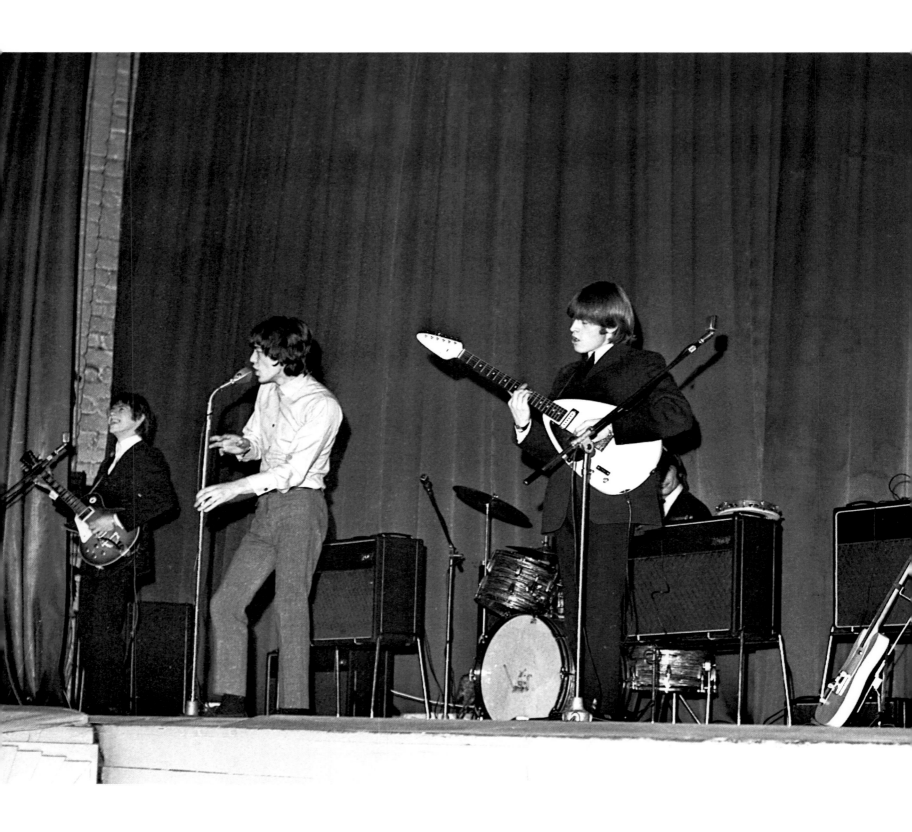

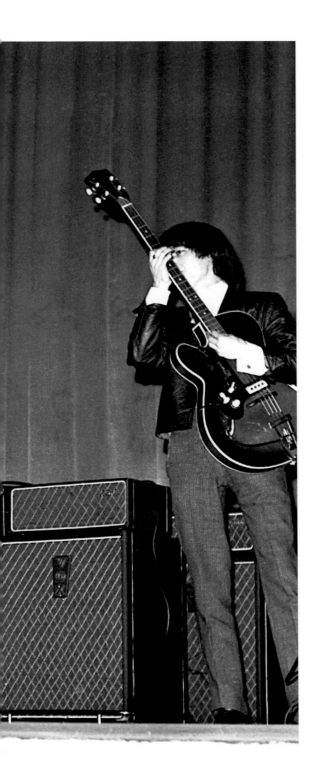

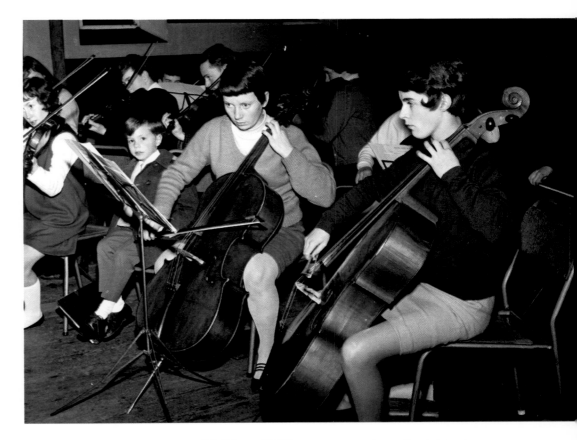

28 May 1968 Members of the Cork Youth Orchestra in rehearsal. *629P/364*

8 January 1965 The Rolling Stones playing at the Savoy, Cork. *449p015*

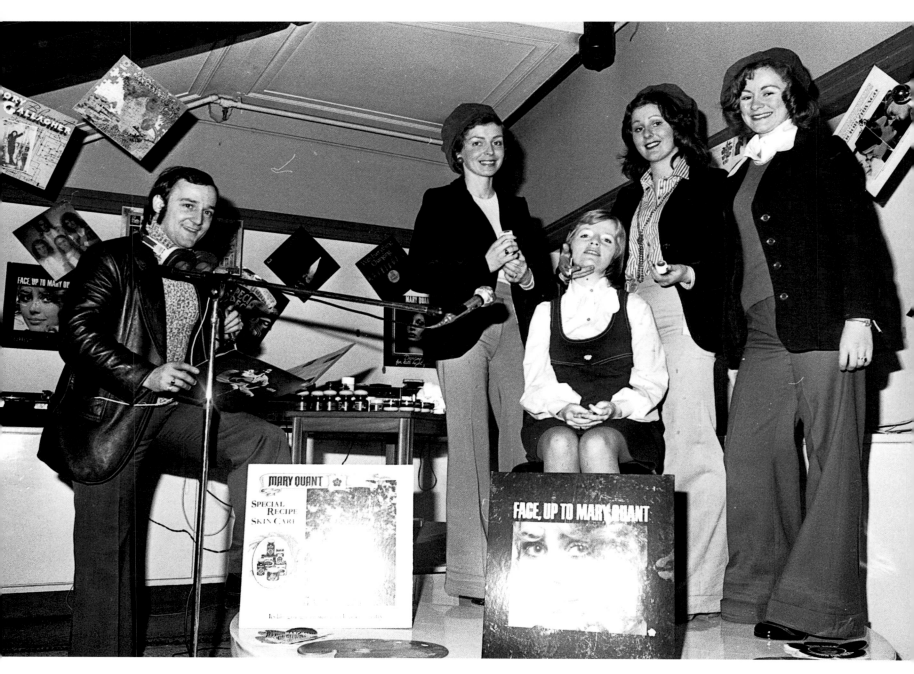

20 November 1973 Mary Quant and the pop group, the Go-Go Girls in Cork. *167/070*

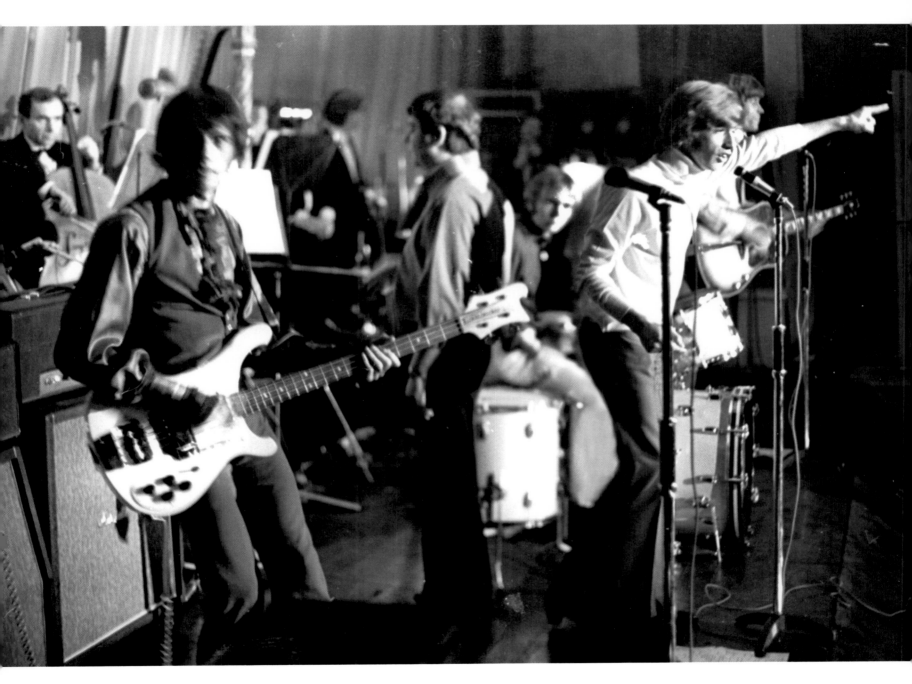

1 May 1968 Internationally famous pop group
The Bee Gees on stage at the Savoy, Cork. *60/048*

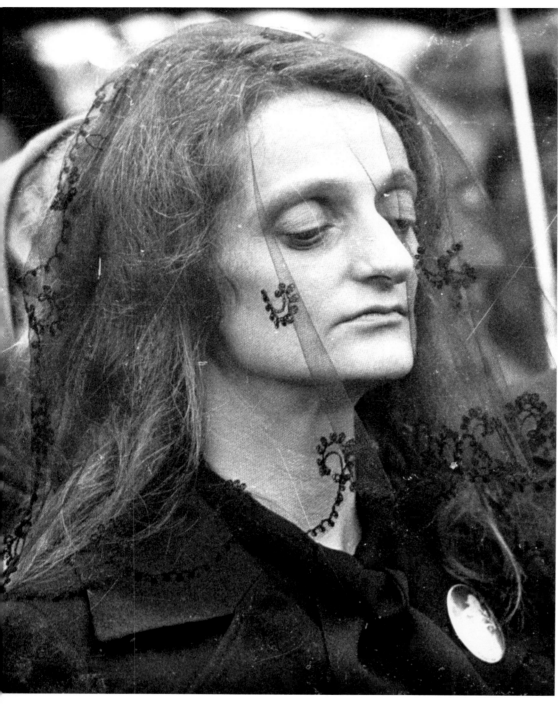

8 October 1971 Ruth Ó Riada at the funeral of her husband, Seán Ó Riada, in Coolea, west Cork. *132/098*

3 January 1974 Rock musician Rory Gallagher in session. *168/92*

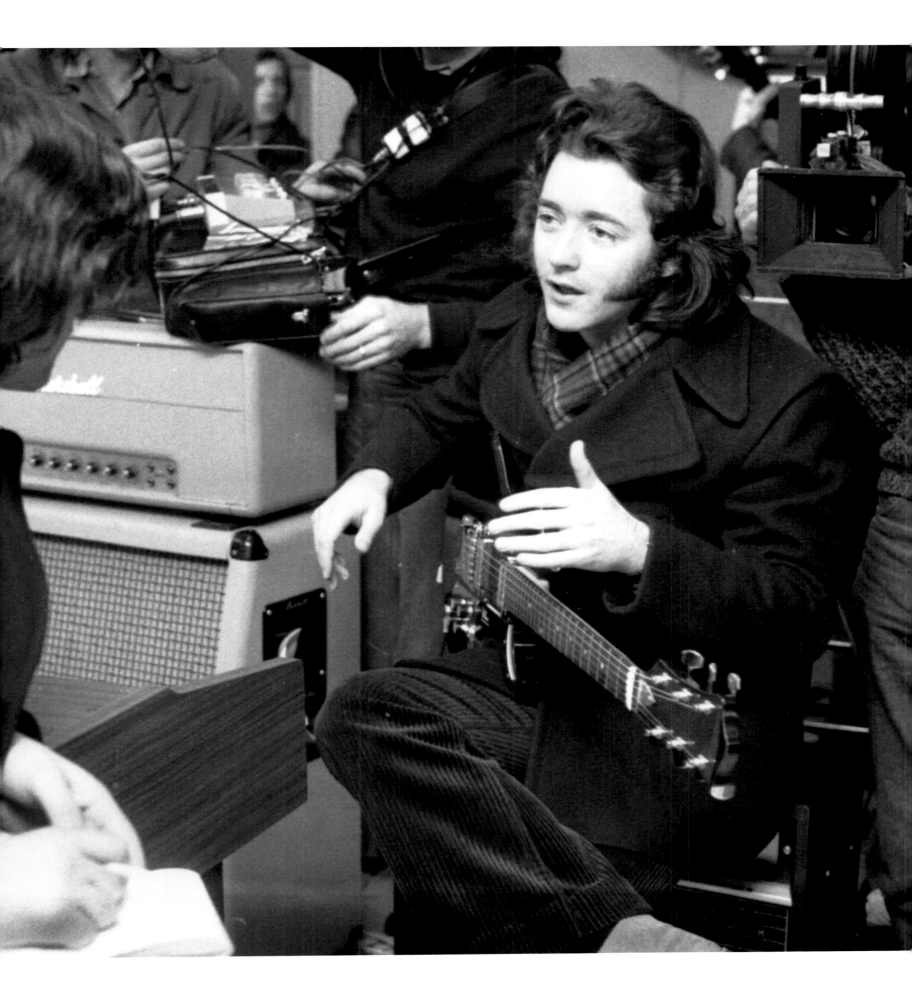

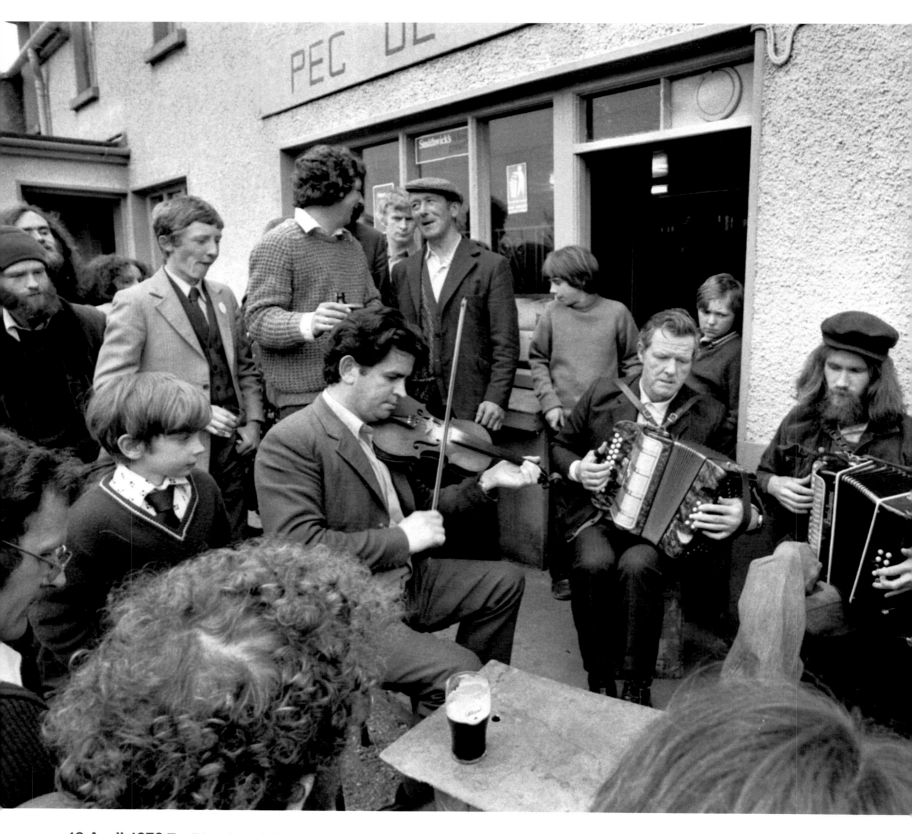

18 April 1976 Traditional musicians play at Glóir Ceoil at Kilnamartra, County Cork. Second from the right is accordion player Jackie Daly. *201/160*

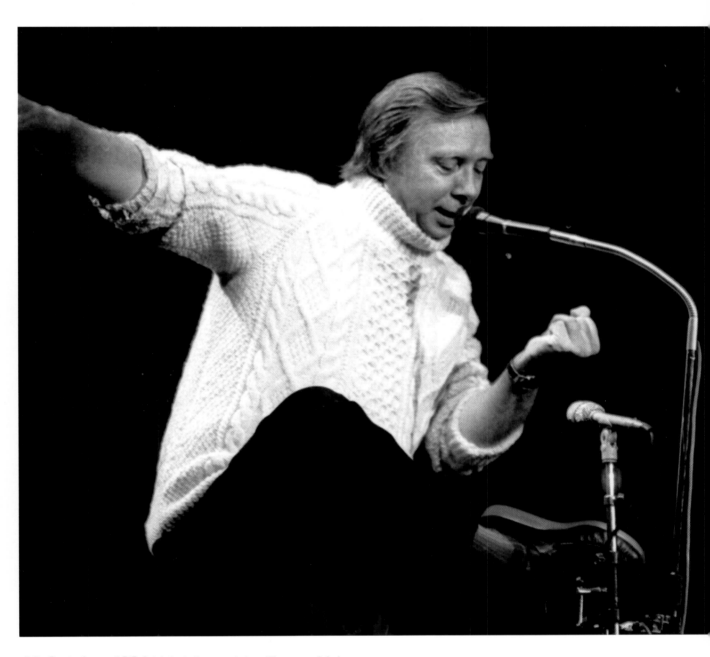

29 October 1984 Irish folk musician Tommy Makem
at the Opera House, Cork. *297/150*

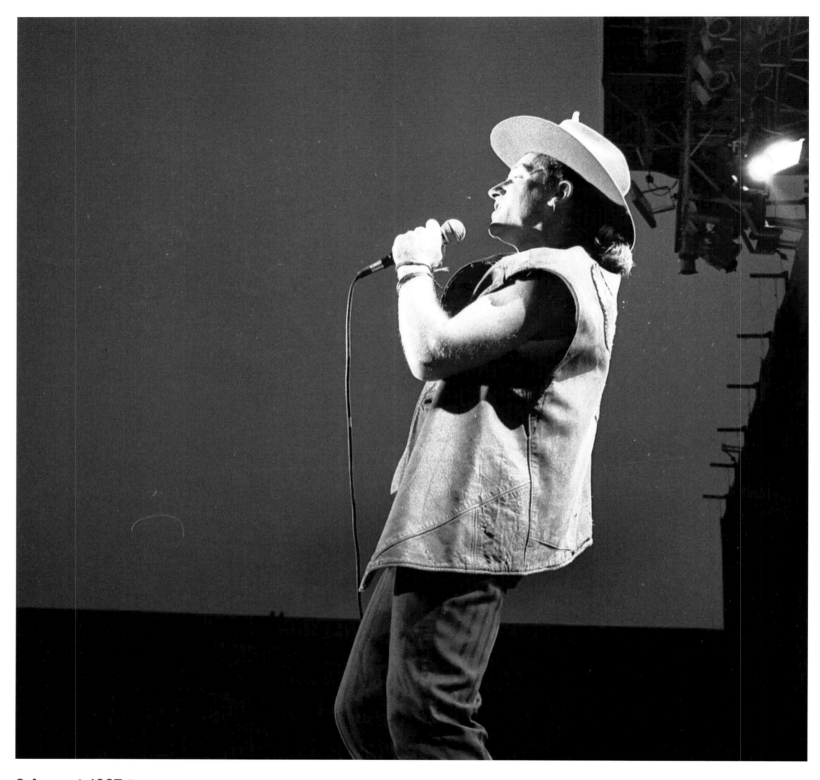

8 August 1987 Bono serenades the crowd at U2's concert at Páirc Uí Chaoimh, Cork. *357/108*

27 July 1986 John Denver and Brendan Grace on stage at Siamsa, Cork. *334/119*

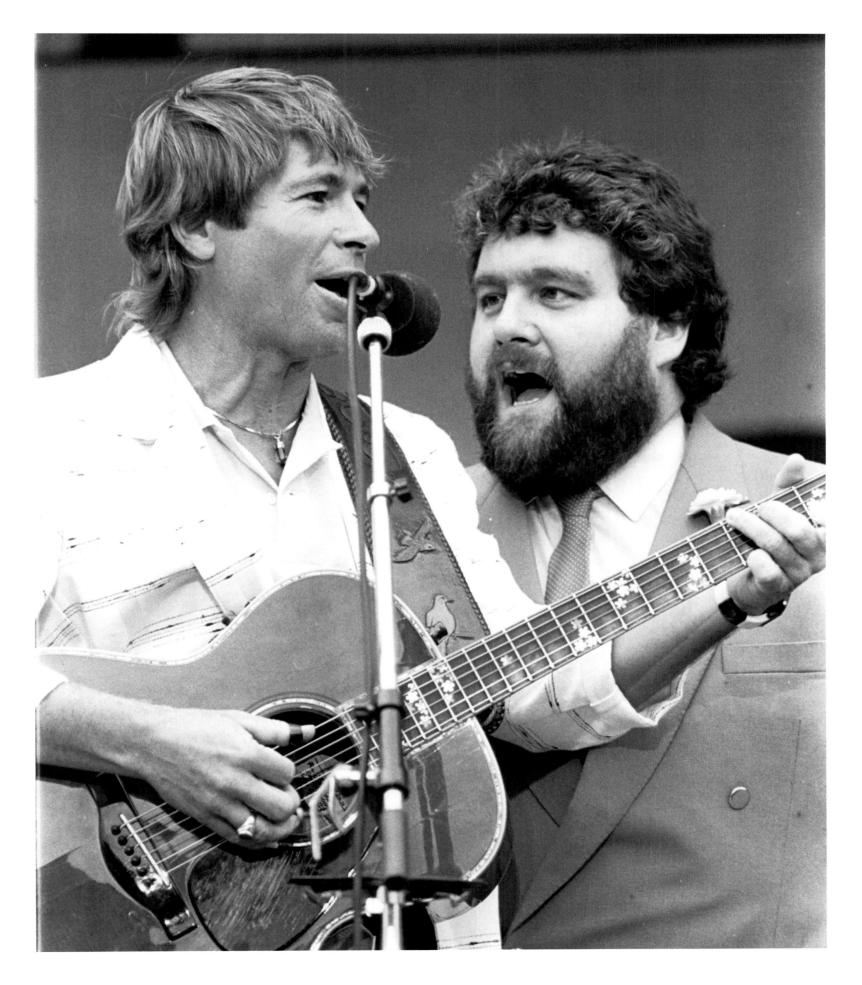

29 September 1958
Cork author Frank
O'Connor on the liner
Mauritania in Cobh,
County Cork. *361k*

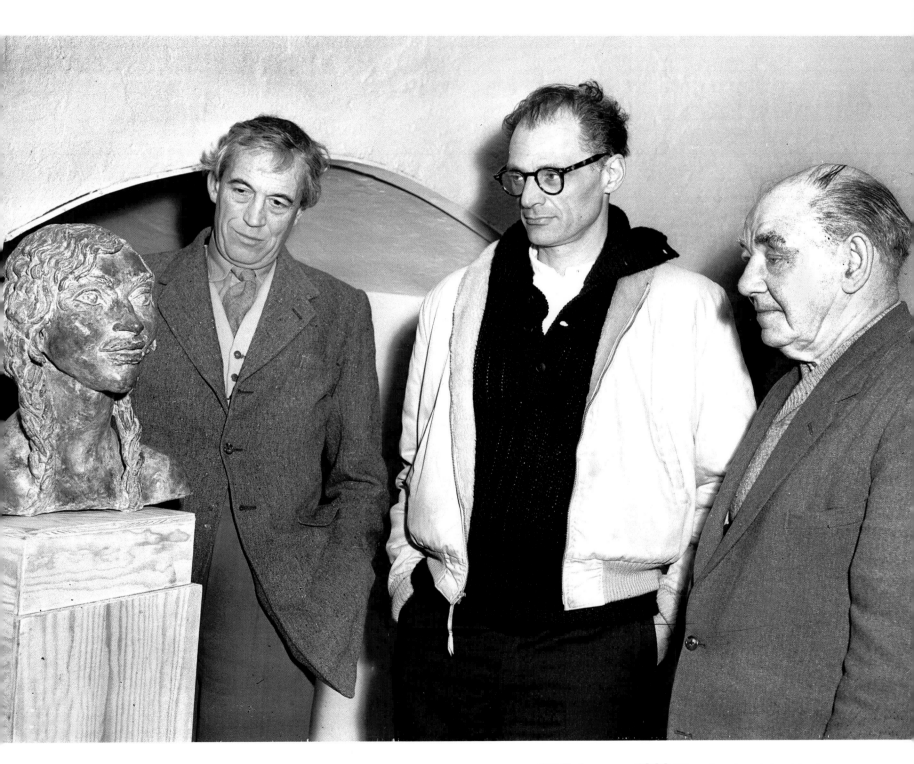

25 February 1960 Film director John Huston (left) and playwright Arthur Miller (middle) on a visit to Blackrock Castle, Cork, to see the Epstein Collection of Mr & Mrs Robert Jackson. *89L*

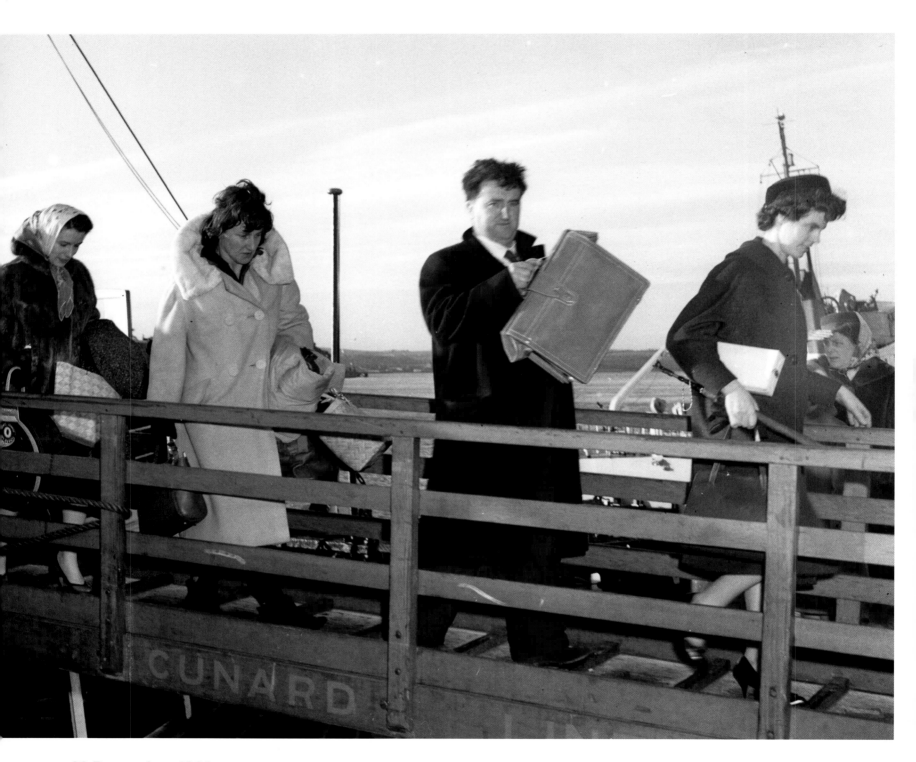

20 December 1960 Brendan Behan disembarking from the liner *Saxonia* at Cobh, County Cork. *553L*

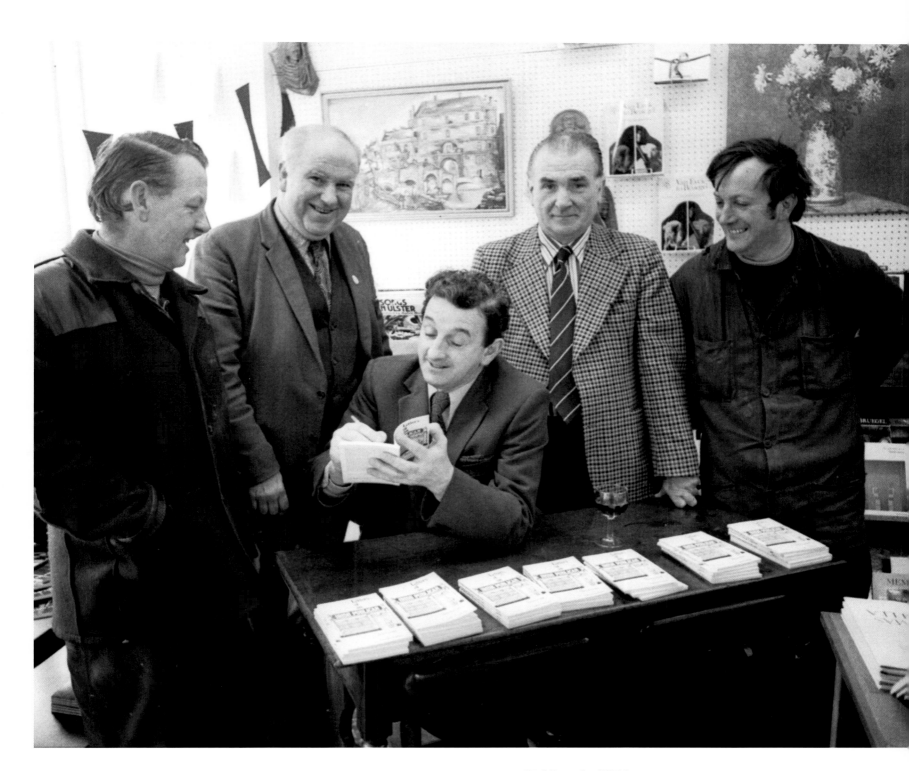

15 March 1974 John B. Keane signs copies of his book *Letters of an Irish Publican* at the Mercier bookshop, Academy Street, Cork. *171/43*

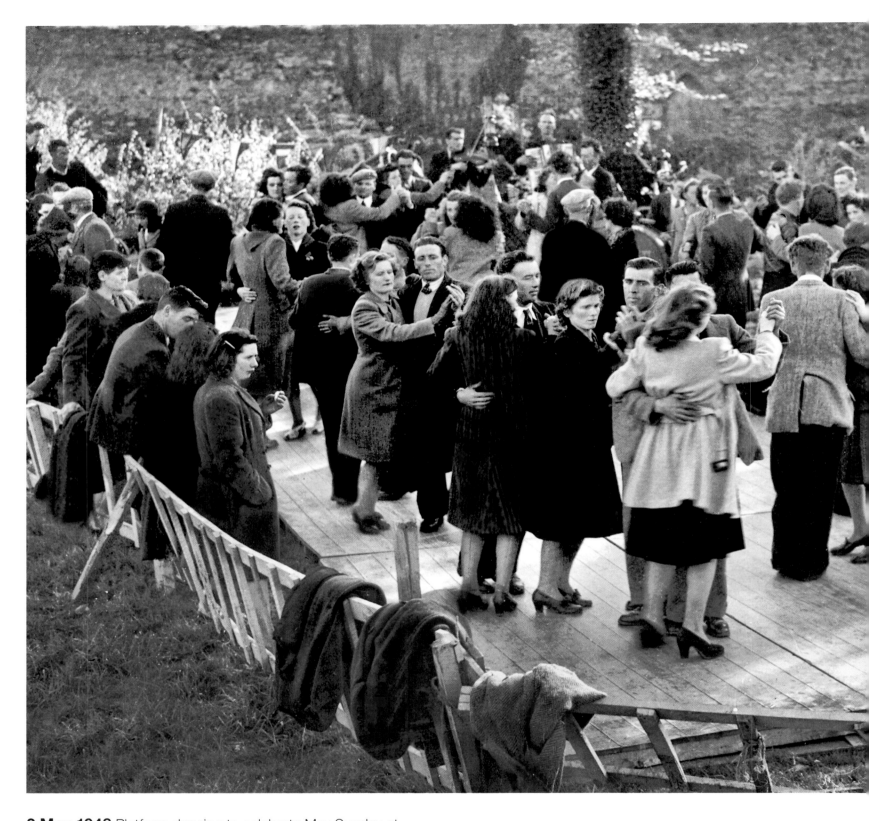

2 May 1948 Platform dancing to celebrate May Sunday at Glenbower, Killeagh, County Cork. *445D*

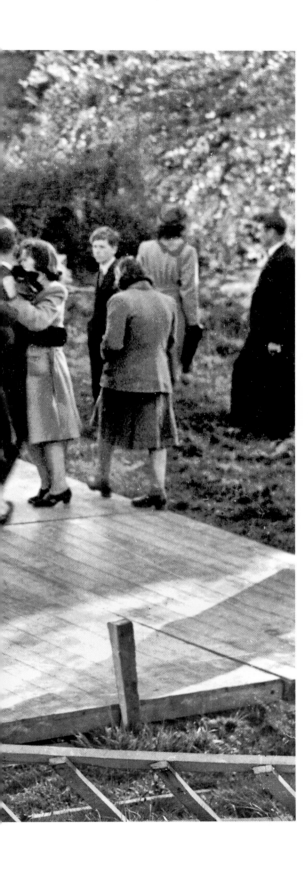

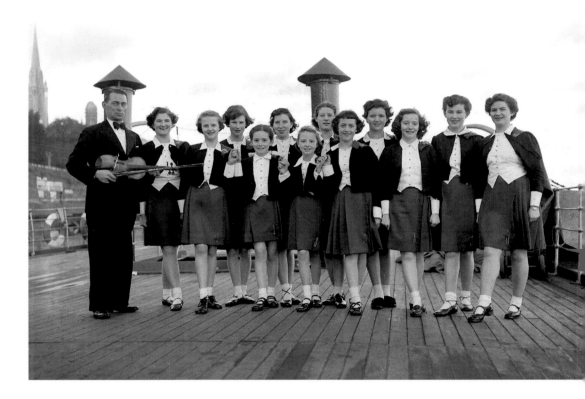

30 March 1953 The Cowhie troupe of dancers visit the liner *Maasdam* at Cobh, County Cork. *958E*

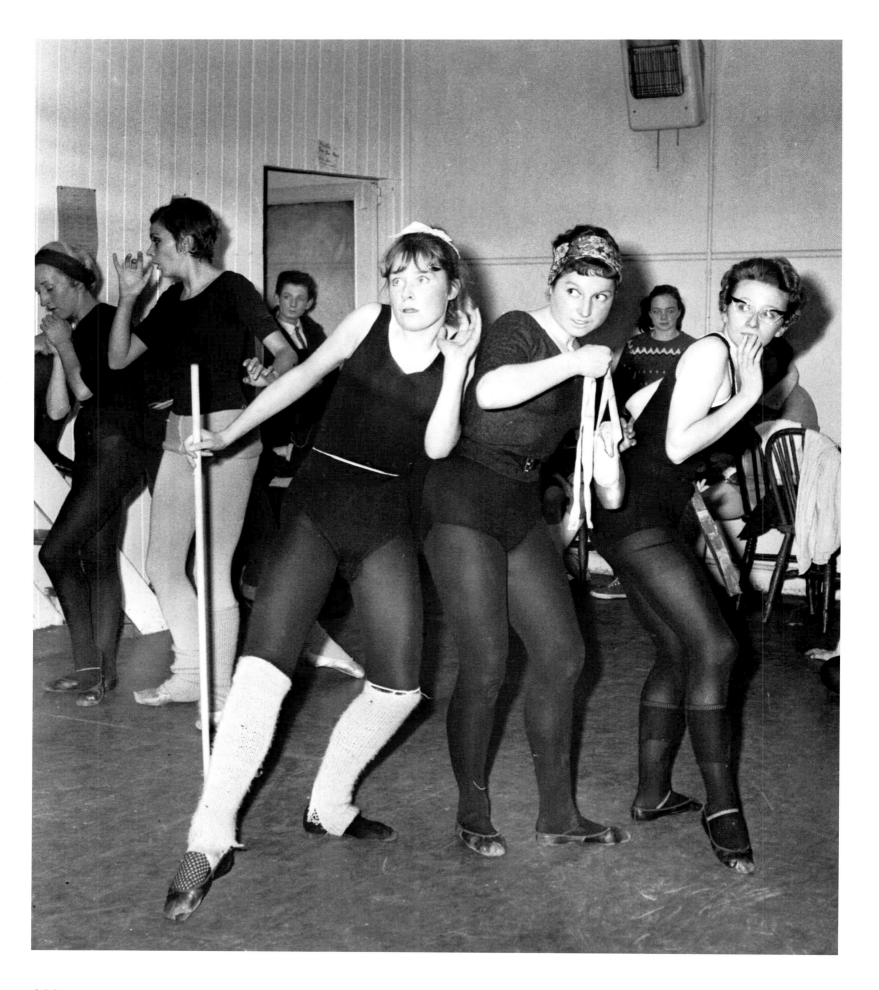

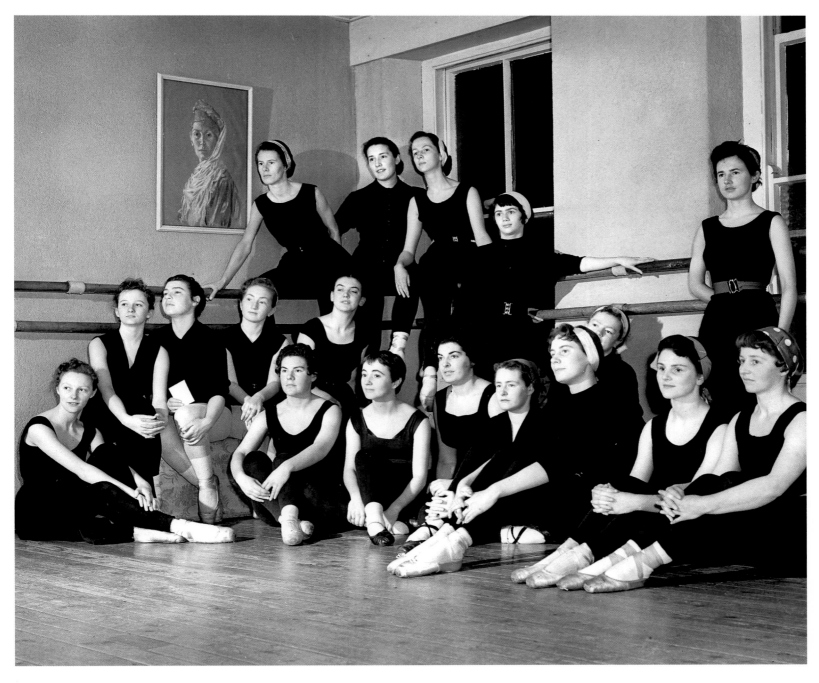

18 May 1957 A ballet group at Joan Denise
Moriarty Studio, Emmet Place, Cork. *420J*

1 November 1967 Rehearsals at the Irish
Ballet Company at Emmet Place, Cork.
627P/257

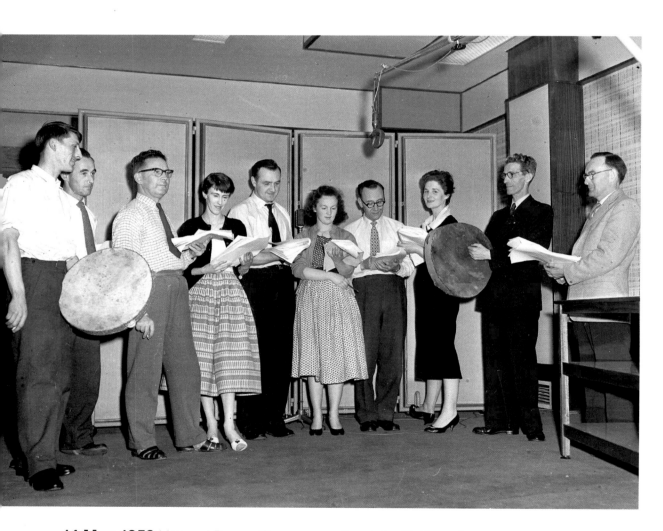

14 May 1959 Listowel Drama Group recording John B. Keane's play *Sive* at Cork Radio Station, Sunday's Well, Cork. *669K*

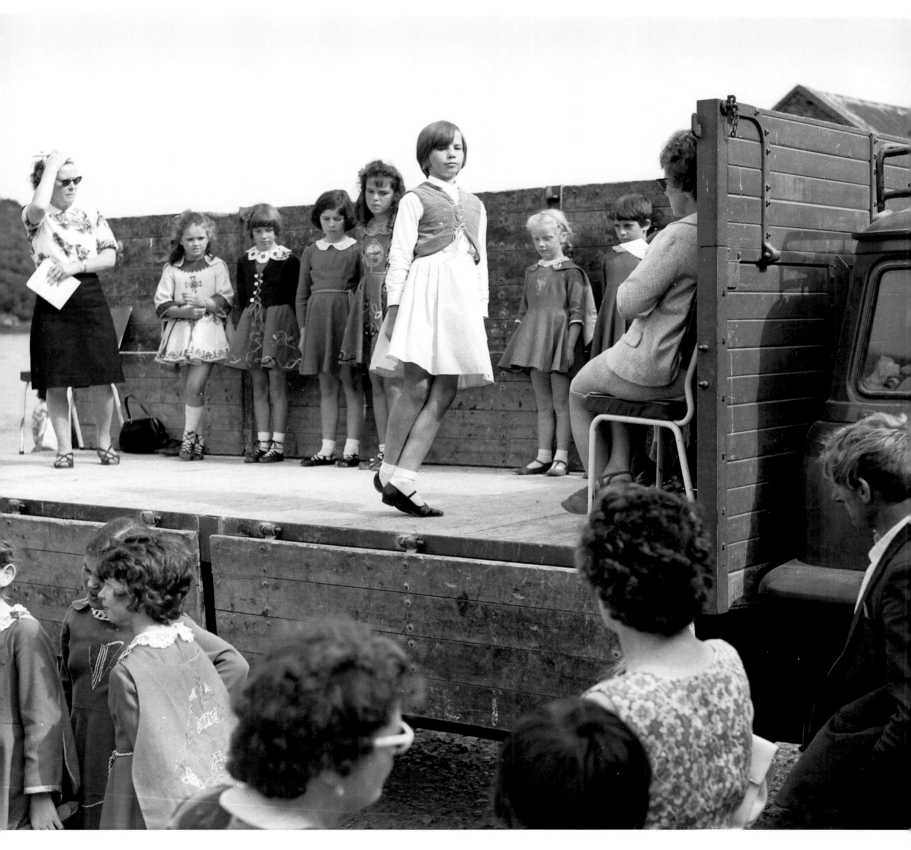

August 1968 Dancers on stage at the Ballinadee Carnival Feis at Kilmacsimon Quay, Bandon, County Cork. *632P-6*

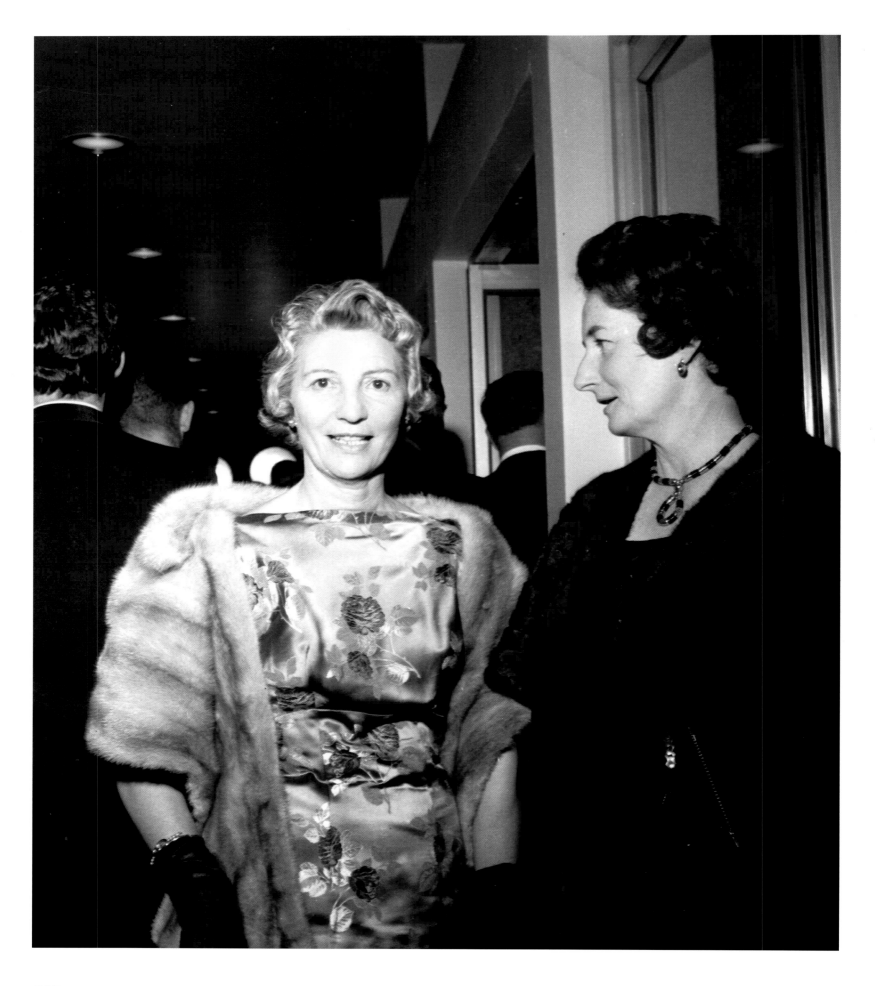

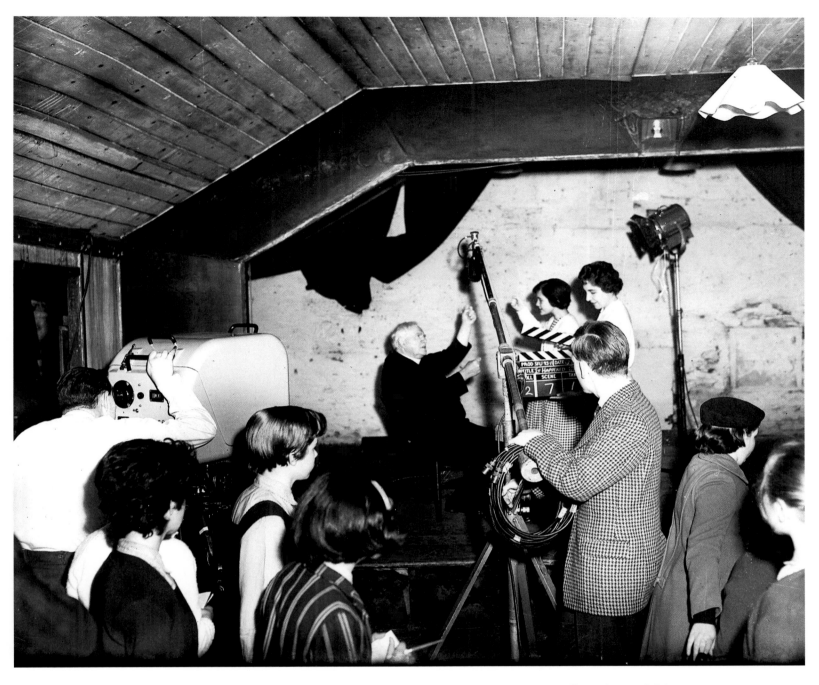

12 October 1960 A BBC television unit films Fr O'Flynn and pupils in the Loft at Shandon Street, Cork. *458L*

31 October 1965 Stylish ladies at the opening of the new Cork Opera House, which was rebuilt after a massive fire destroyed it on 12 December 1955. *541P-17*

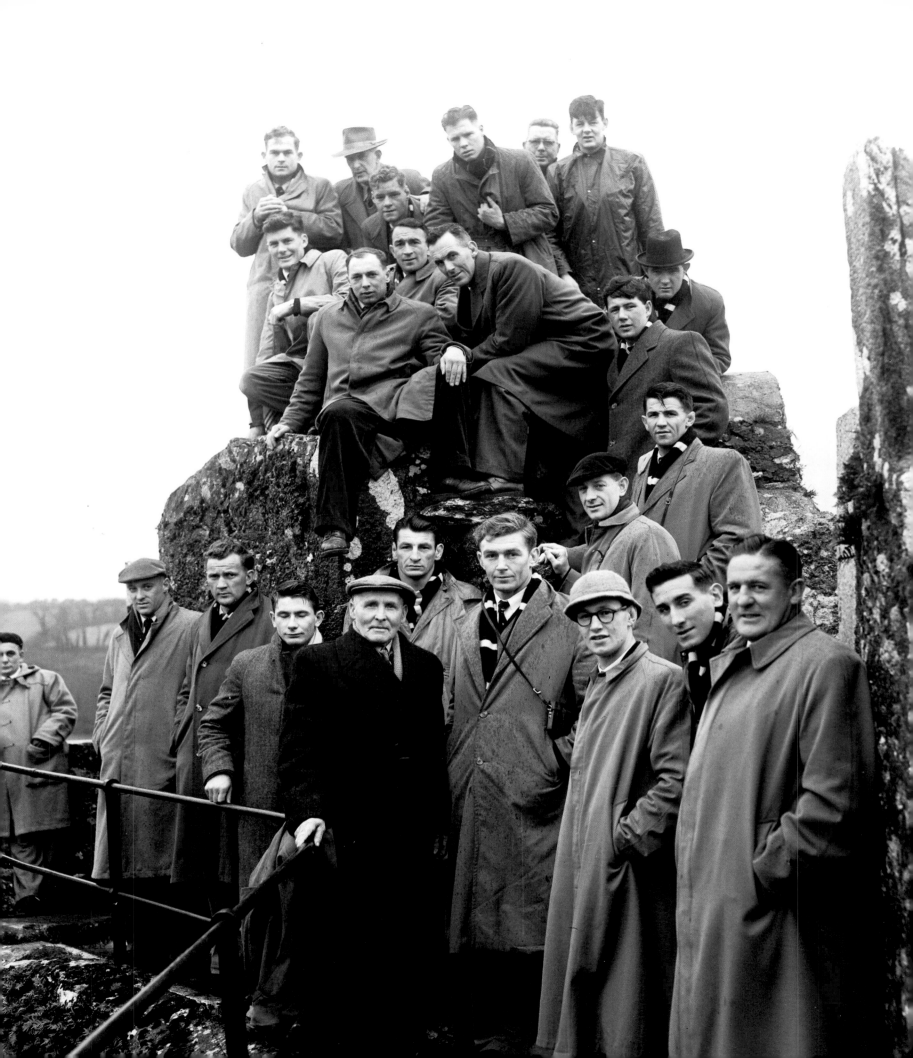

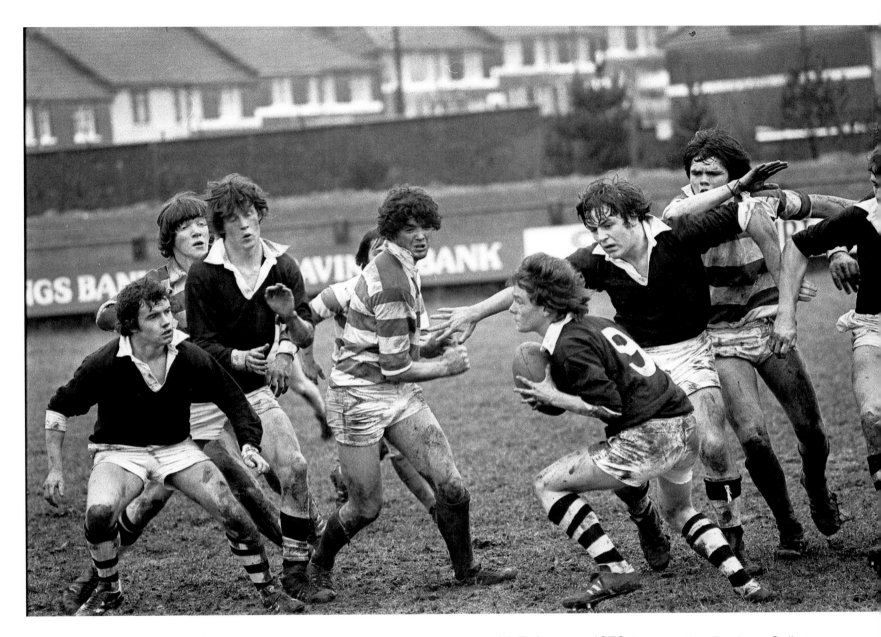

23 February 1978 Presentation Brothers College scrum half David Kelly-Walker about to set his backs in motion following a line-out during the Munster Senior Schools Cup game against Rockwell at Musgrave Park, Cork. *215/296*

12 January 1954 New Zealand's All Blacks rugby team visit Blarney Castle, Cork. *400g*

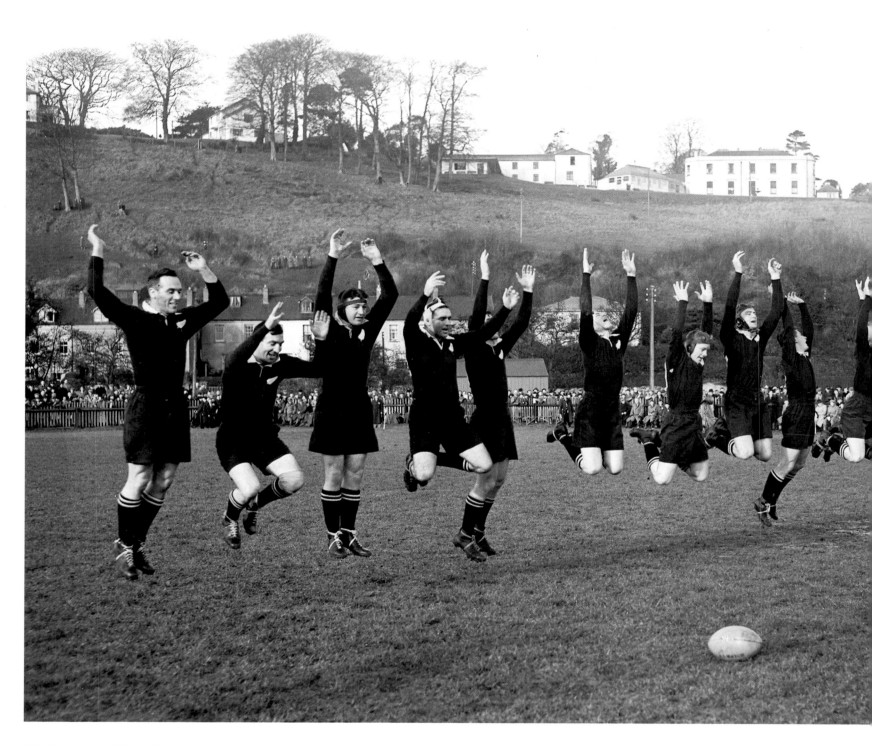

13 January 1954 The New Zealand rugby team perform the Haka before playing Munster at the Mardyke, Cork. *401g*

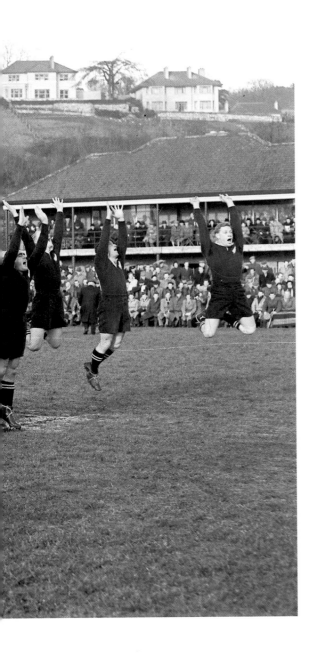

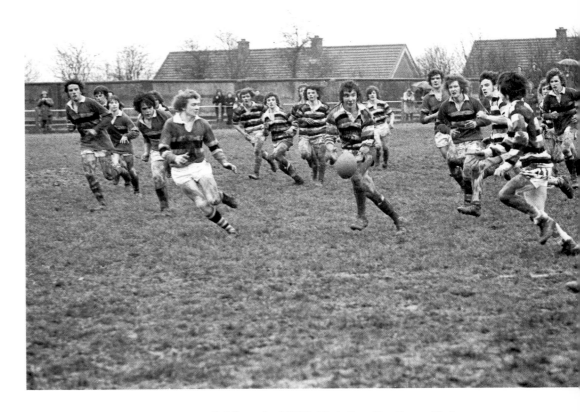

6 March 1974 Christian Brothers College, Cork v Crescent College, Limerick in the Munster Schools Senior Cup semi-final at Thomond Park, Limerick. *117/003*

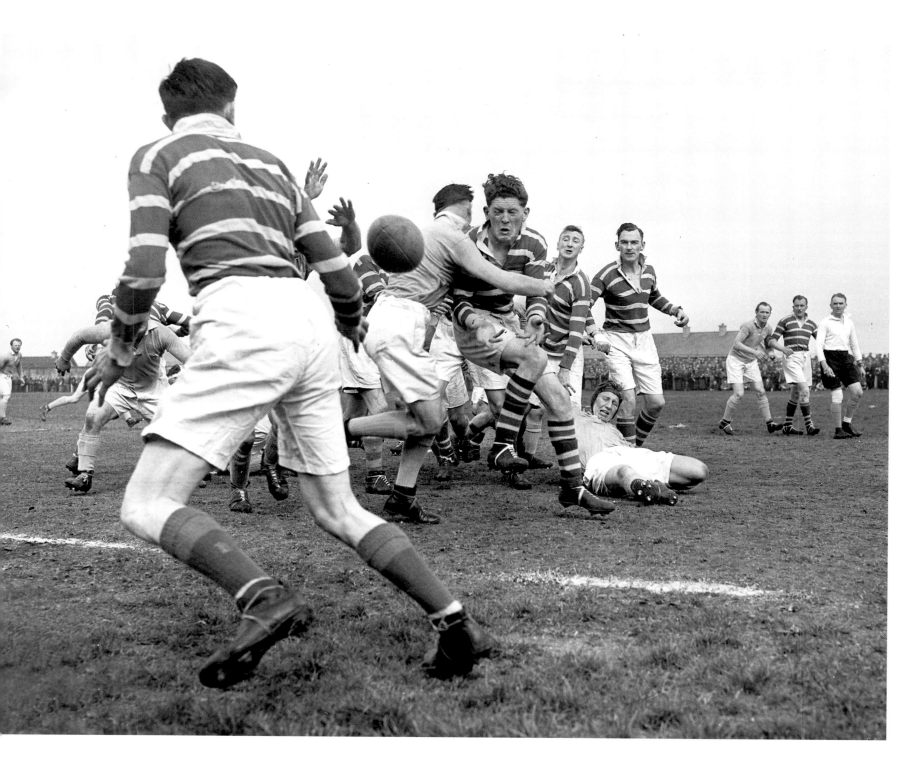

24 April 1954 Sunday's Well v Garryowen in the
Munster Cup final at Thomond Park, Limerick. *595G*

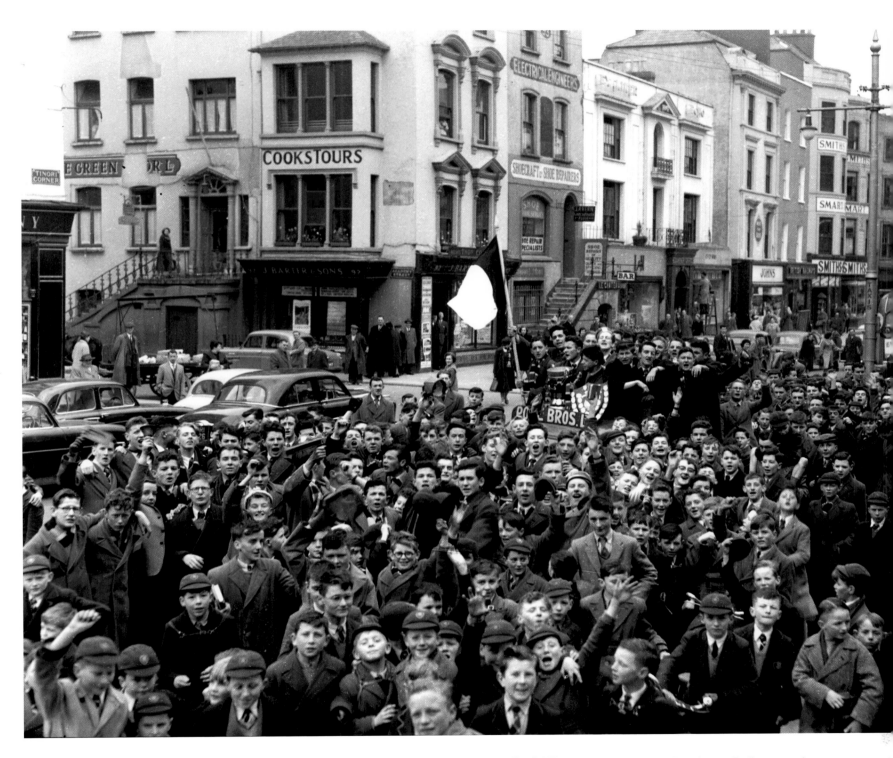

8 April 1957 The Presentation Brothers College rugby team parades through St Patrick's Street, Cork, with the Senior Schools Cup. *444J*

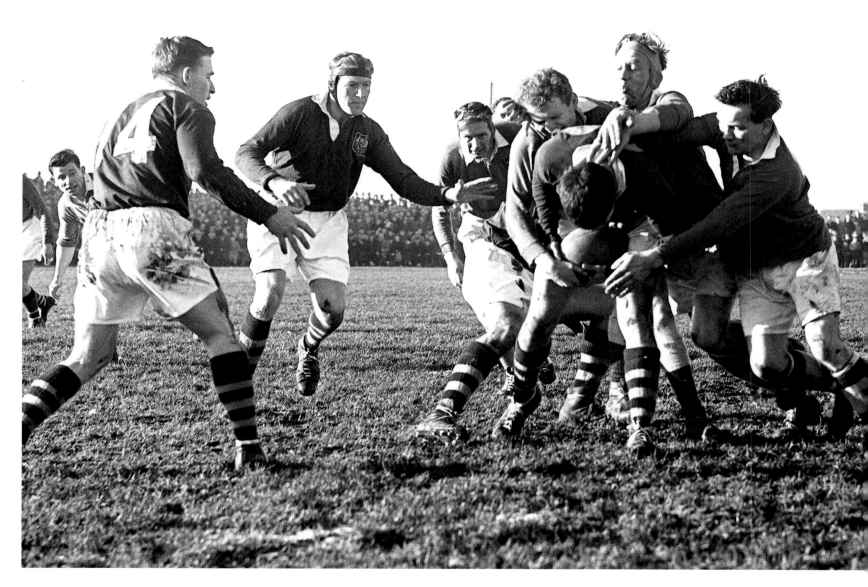

21 January 1958 An Australian forward is held by Martin O'Connell, Tom Nesdale and Bob Dowley during the Munster v Australia rugby match in Limerick. The final score was three all. *898j*

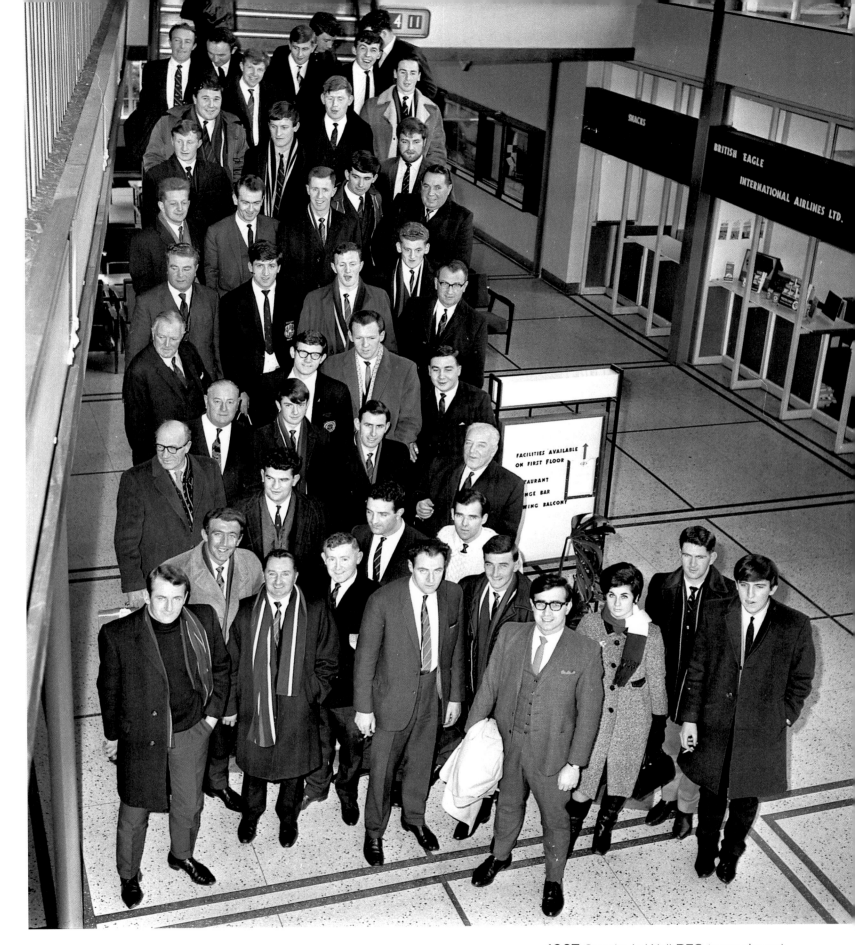

1967 Sunday's Well RFC team depart for Cardiff from Cork Airport. *623P-275*

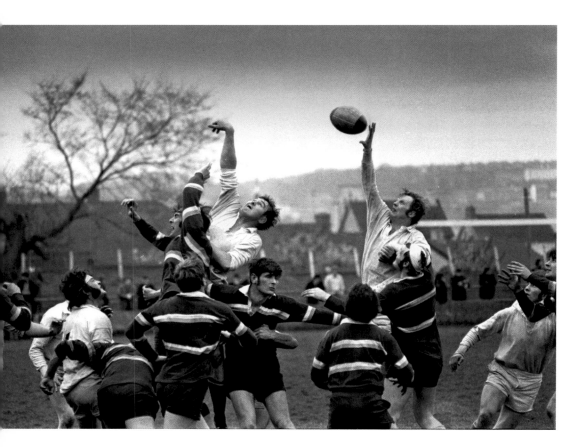

29 April 1973 Cork Constitution win the line-out against Dolphin in the Munster Senior League Rugby Cup final at Musgrave Park, Cork. *158/19*

1 November 1974 Touring All Blacks rugby players and Noel Murphy (second from left) catch up on the news on St Patrick's Street, Cork. *179/67*

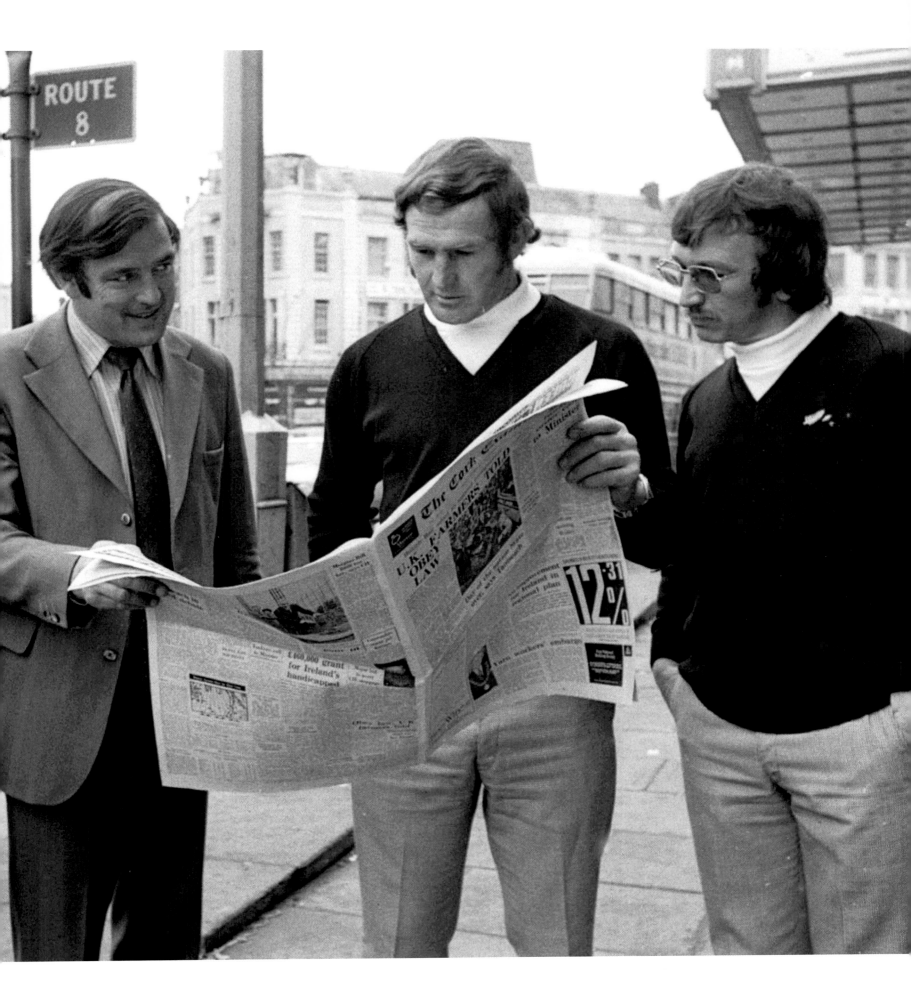

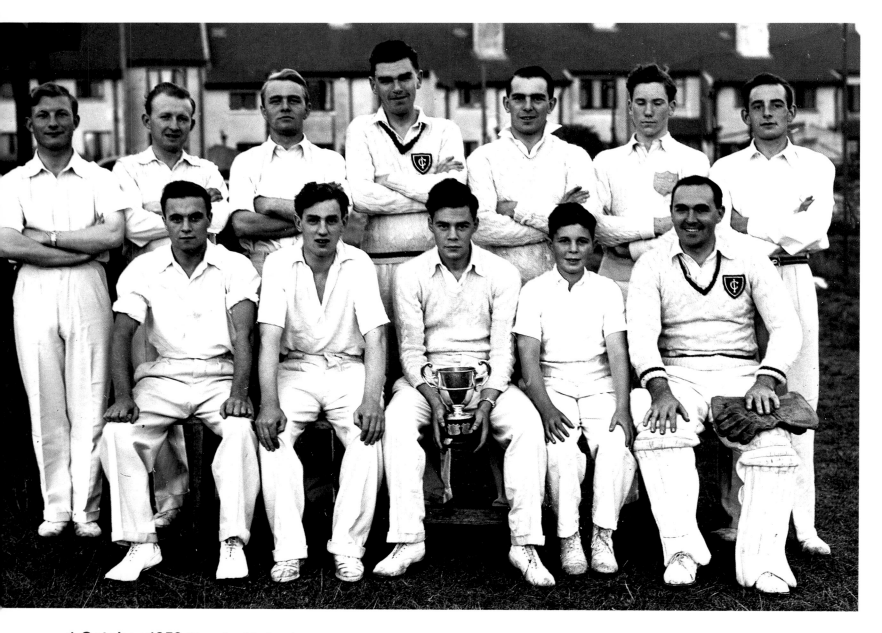

1 October 1952 Church of Ireland
cricket team, winners of the Cork
County Junior League. *703E*

1 May 1965 Dog halts play during a
Cork County v Clontarf cricket match
at the Mardyke, Cork. *4/085*

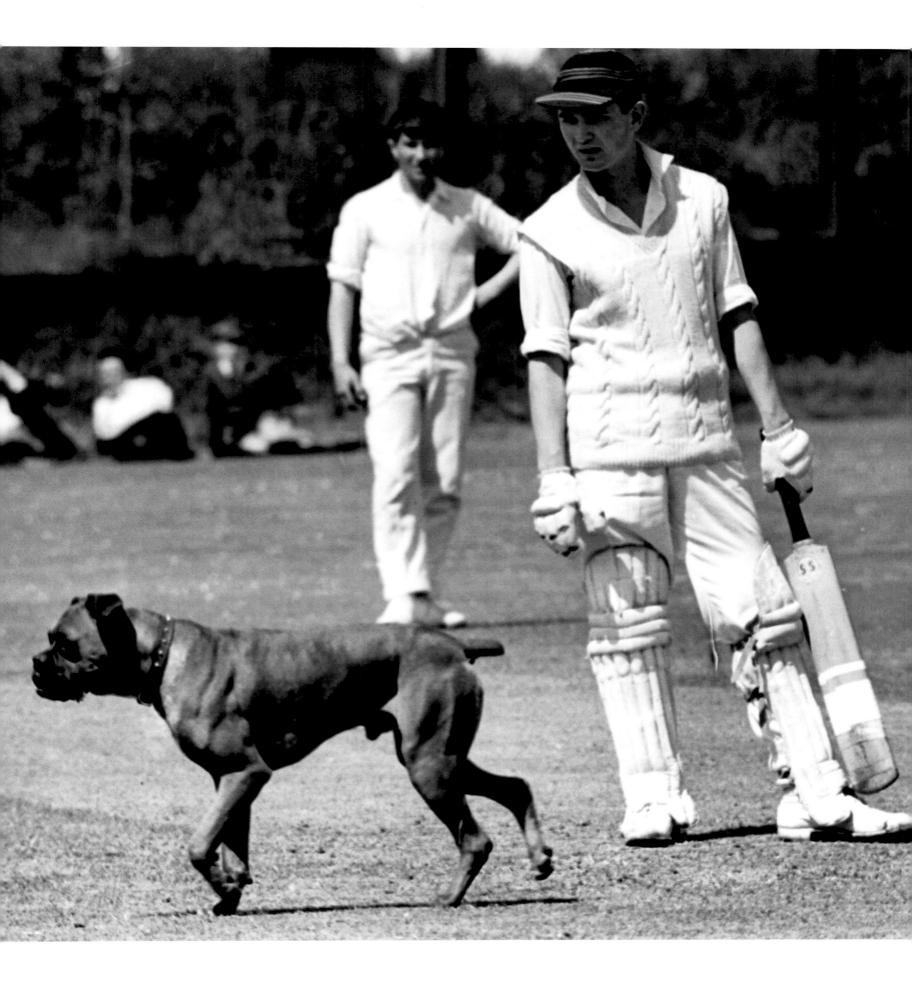

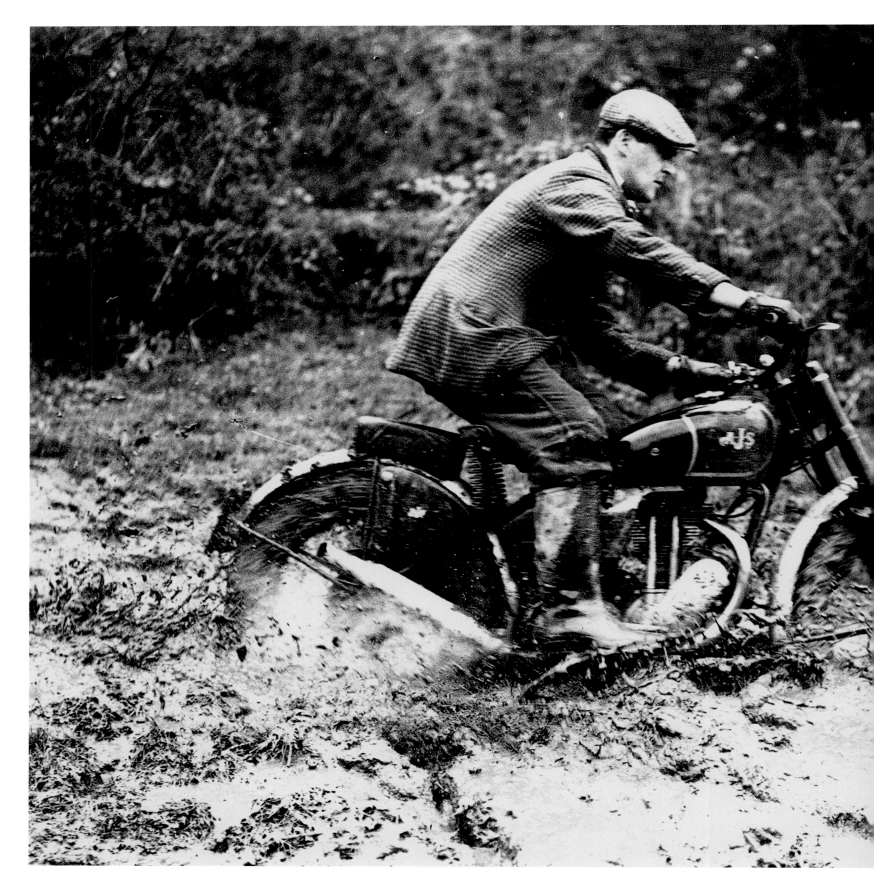

30 March 1948 Motorcycle trials in
Inniscarra, County Cork. *432D*

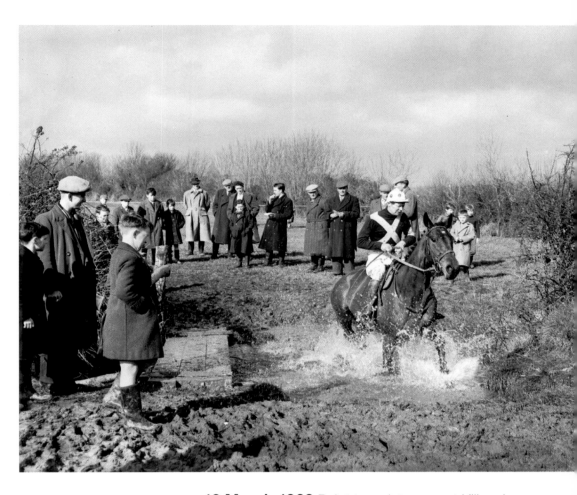

12 March 1960 Point-to-point races at Killeagh, County Cork. *116L*

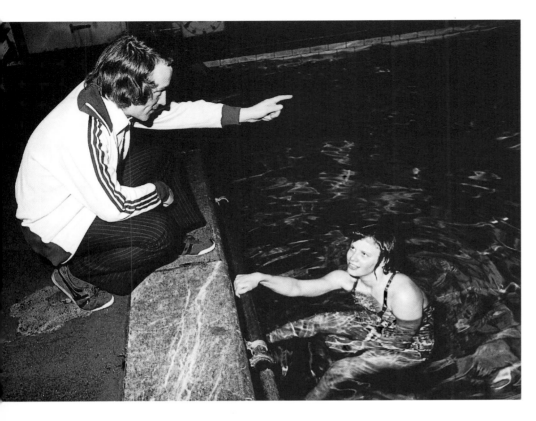

26 January 1976 Irish Olympic swimmer Deirdre Sheehan training at Eglinton Pool, Cork. *199/001*

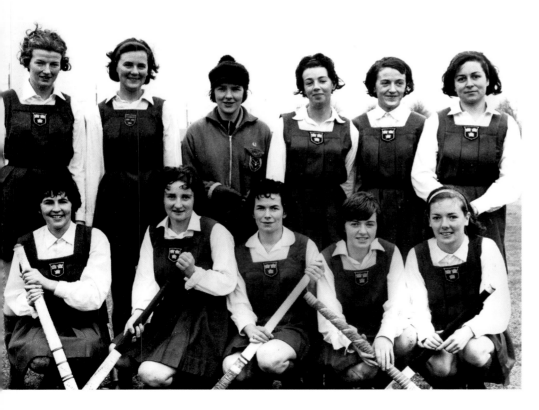

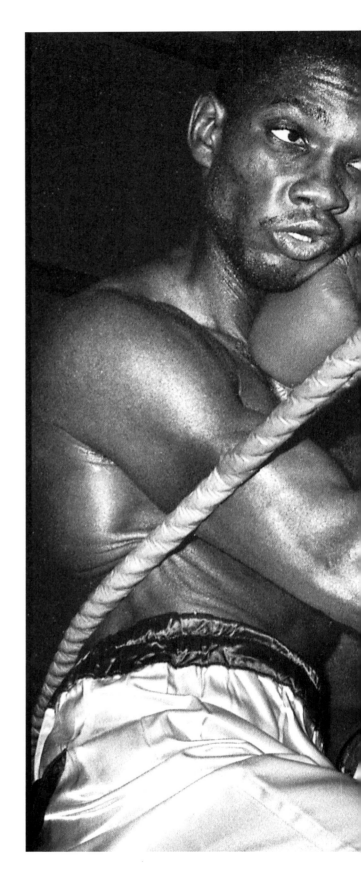

12 December 1964 The Munster team which defeated Ulster in the Ladies' Senior Hockey Interprovincial. *443P-17*

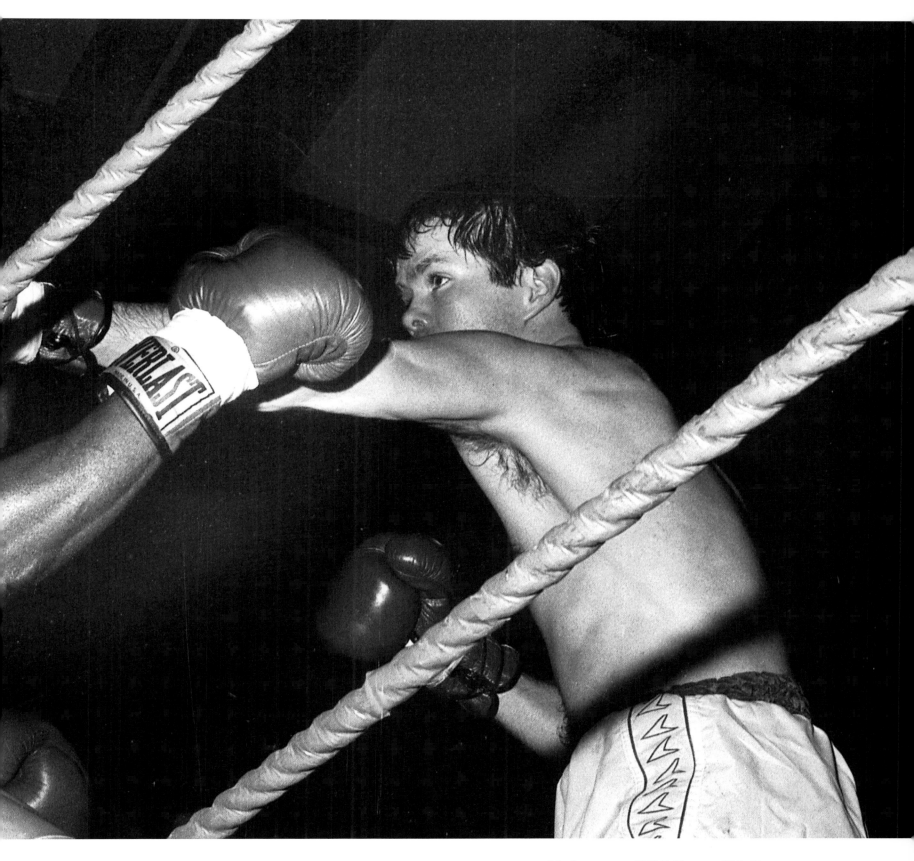

11 January 1985 Shawn O'Sullivan connects with a straight left to Marvin McDowell's chin at the Neptune Stadium, Cork. *301/042*

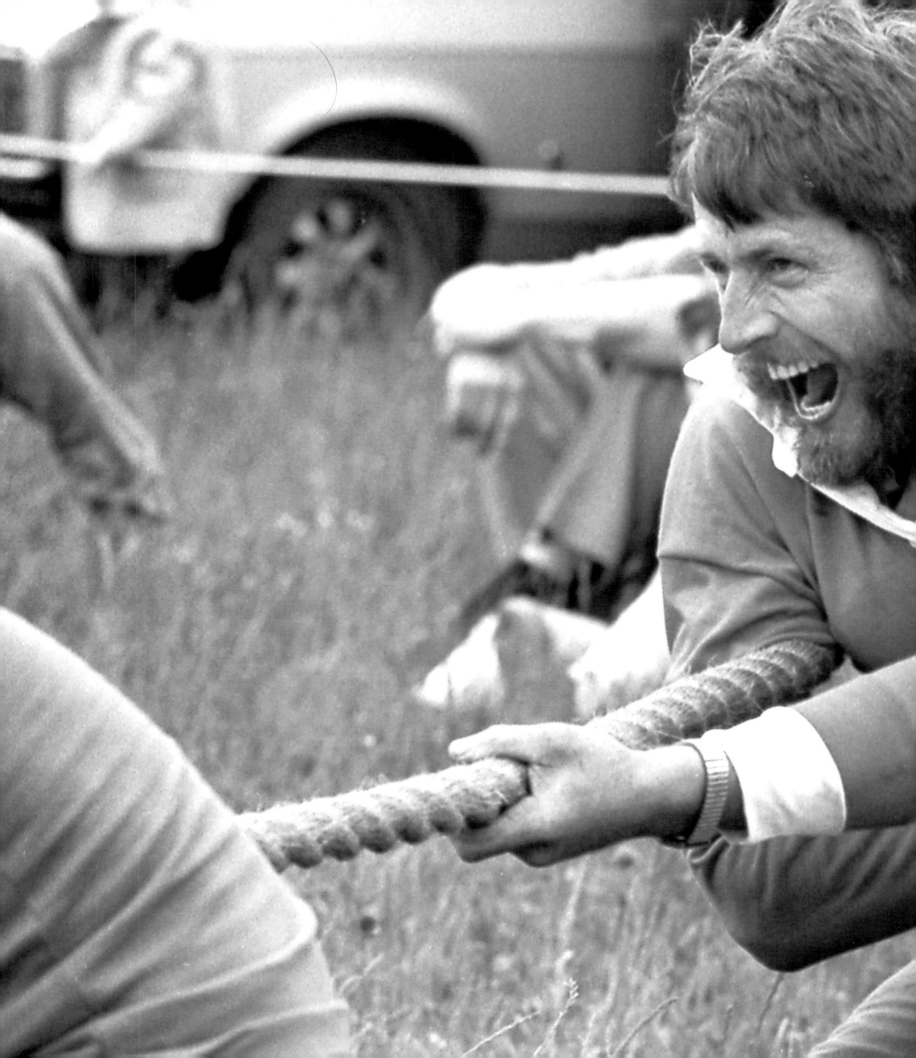

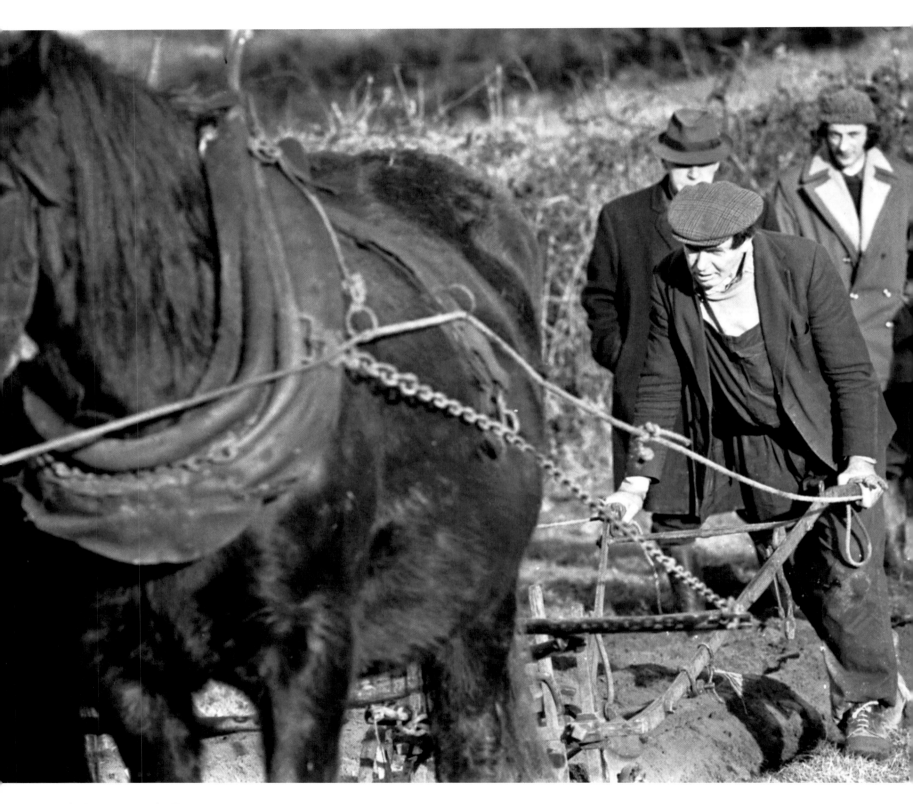

9 January 1977 Jerry Horgan of Ballinagree, Macroom, County Cork, winner of the Banteer Ploughing Championships. *207/105*

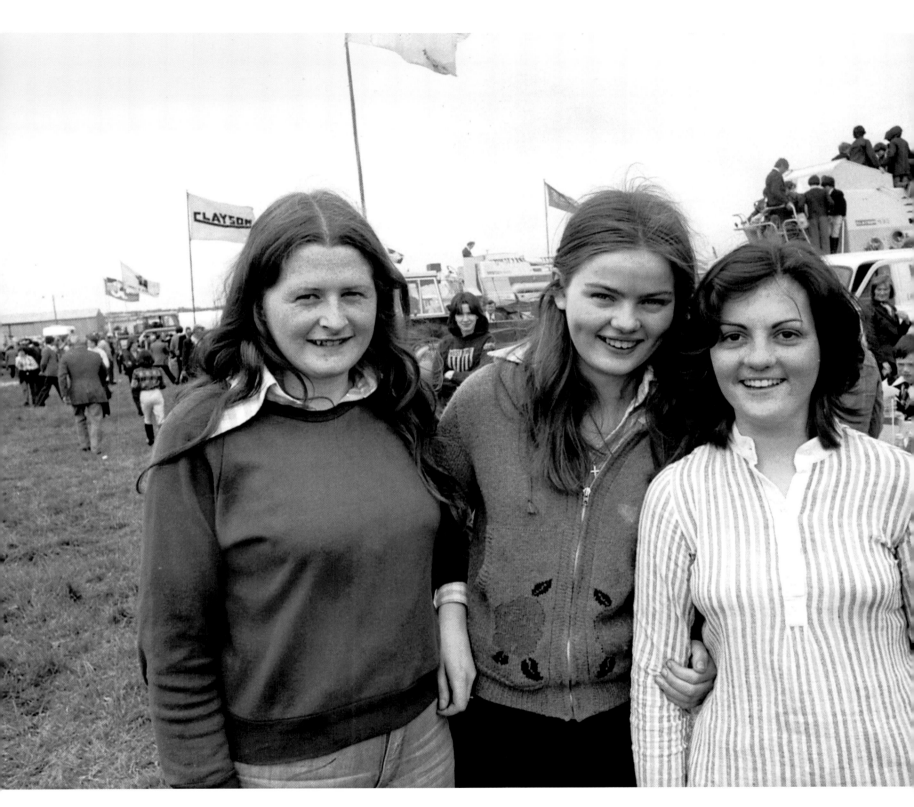

20 May 1977 Enjoying the sunshine at Bandon Show, County Cork, (l–r): Rosarie Cullinane from Bandon, Joanne O'Donovan and Louise Deane from Dunmanway. *209/305*

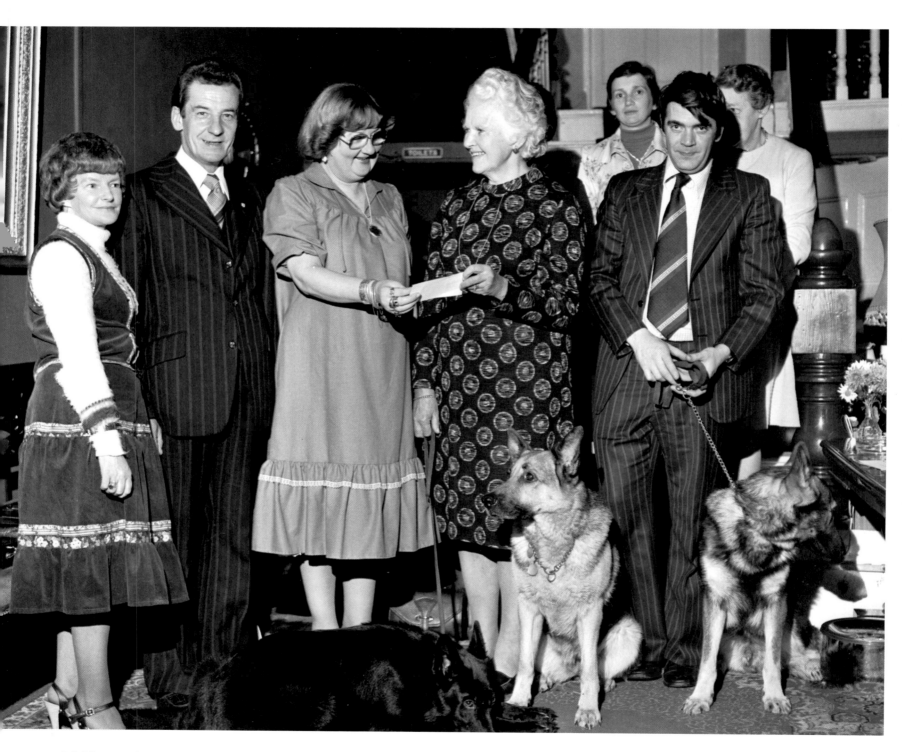

24 November 1978 Presentation of cheque to Mary Dunlop (middle) of the Irish Guide Dogs Association, at Innishannon Hotel, County Cork. *656P-145*

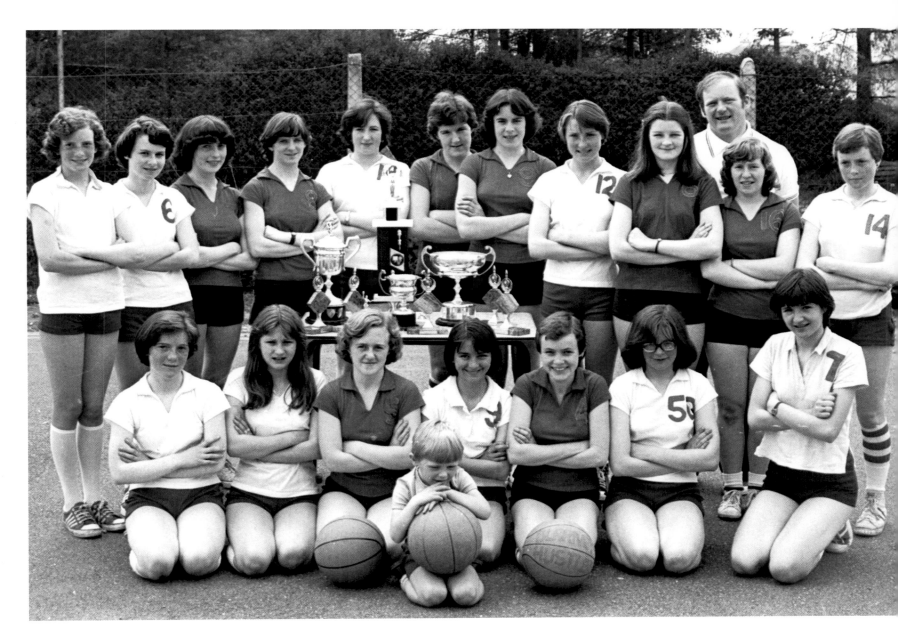

21 May 1978 Blarney Secondary School basketball team, County Cork, display their trophies. *218/100*

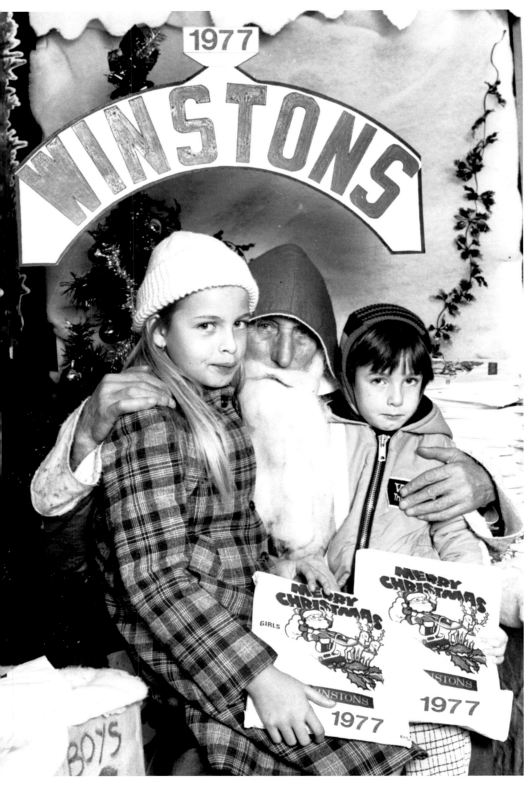

8 December 1977 Children receiving their presents from Santa Claus at Winstons, Cork. *214/31*

19 December 1970 Children visiting Santa Claus at the Munster Arcade, St Patrick's Street, Cork. *639P/101*

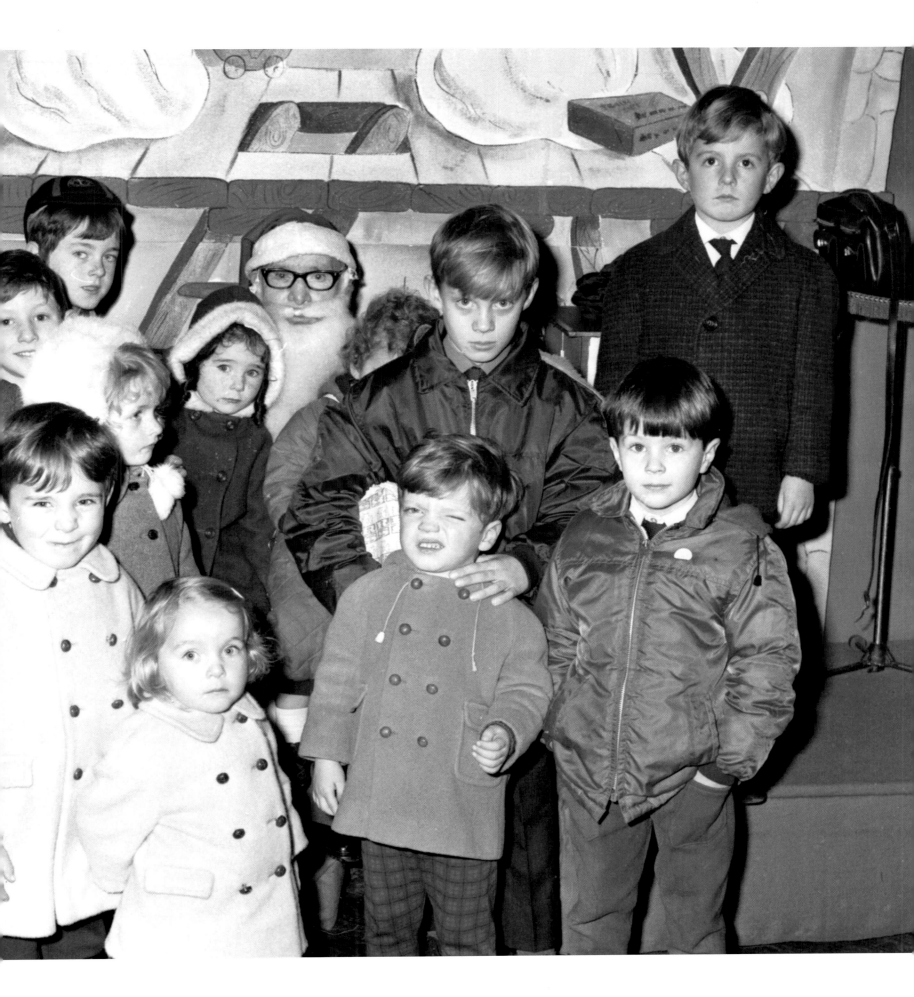

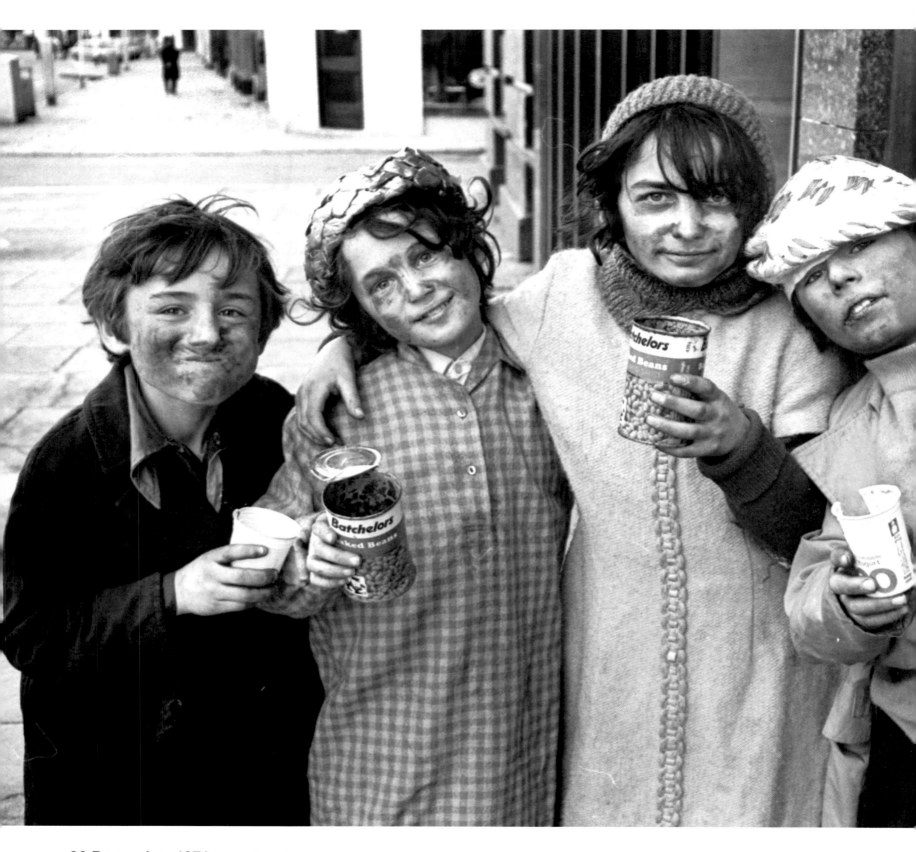

26 December 1974 Wren Boys in
St Patrick's Street, Cork. *181/100*

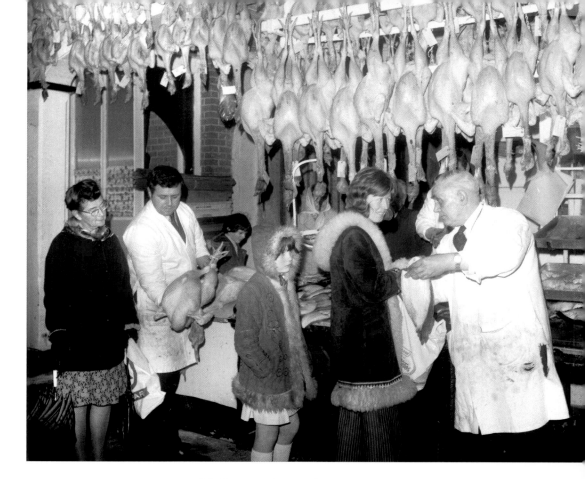

20 December 1974 Turkeys for sale at Mulcahy's Stall, the English Market, Cork. *649P-50*

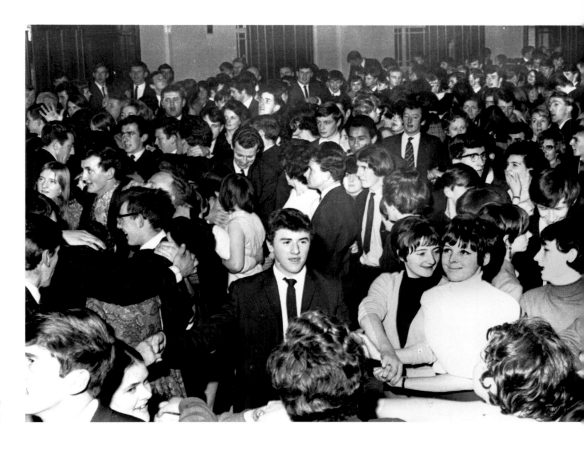

31 December 1967 New Year's Eve celebrations at Cork's City Hall. *53/033*

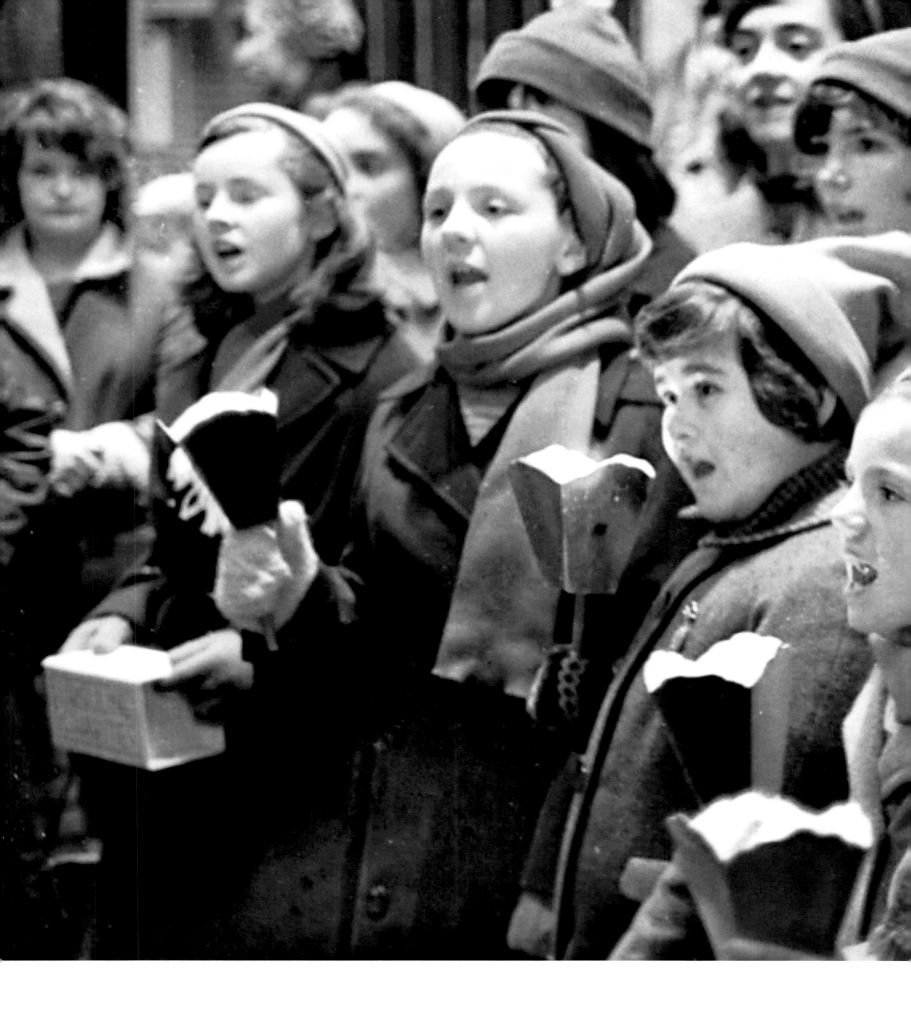

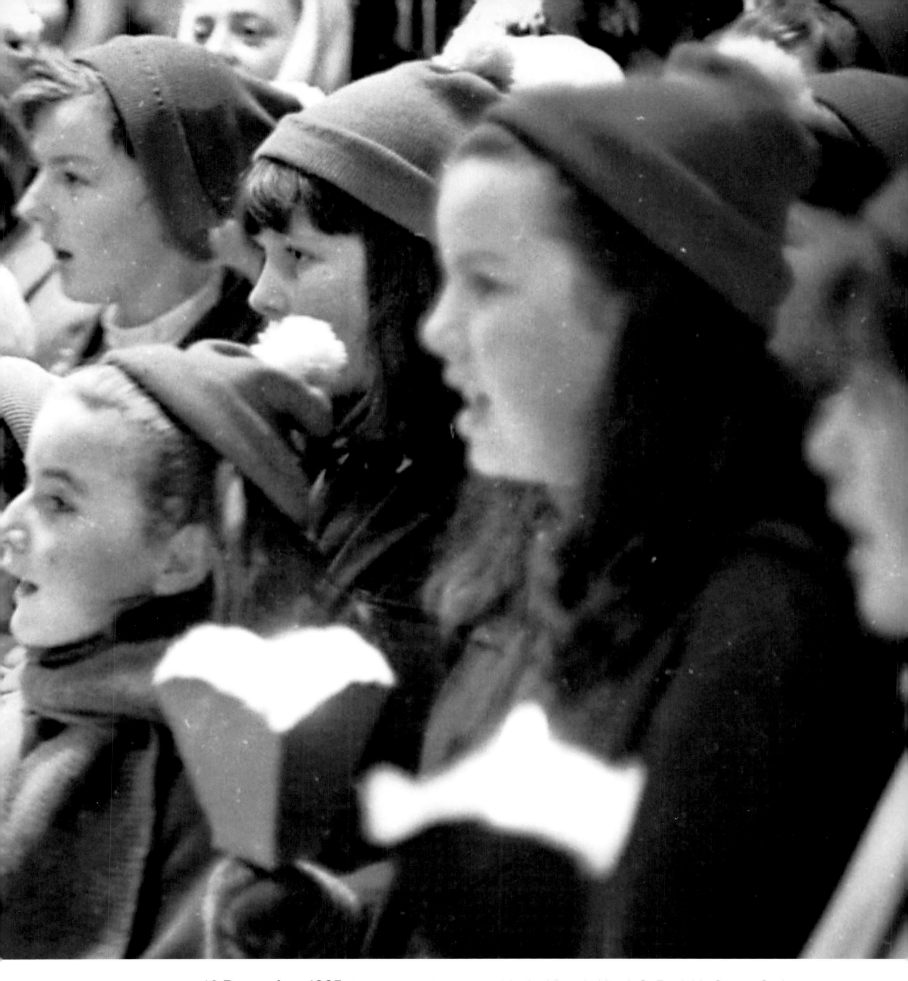

16 December 1965 Young carol singers outside the Victoria Hotel, St Patrick's Street, Cork. *12/100*

REMEMBER WHEN

FIRST PUBLISHED IN 2010 BY
The Collins Press
West Link Park
Doughcloyne
Wilton
Cork

British Library Cataloguing in Publication Data

Remember when : pictures from the Irish Examiner archive.
1. Ireland—Social life and customs—20th century—Pictorial works. 2. Ireland—Social conditions—20th century—Pictorial works. 3. Ireland—History—20th century—Pictorial works.
I. Kearney, Anne. II. Irish Examiner.
941.5'082'0222-dc22

ISBN-13: 9781848890626

Compiled by Anne Kearney, Head of Library Services, *Irish Examiner*

Design and typesetting by Glen McArdle

Typeset in 11 pt Helvetica Neve Lt

Printed in Malta by Gutenberg Press Limited

Acknowledgements
A special thank you to *Irish Examiner* photographers and all in the Image department who made this book possible.

Purchase Details
We hope you enjoy the images in this book, all of which are available to order from the *Irish Examiner*. To purchase any of these photographs, please contact the *Irish Examiner*, Photo Sales Department, on 021 480 2393 or e-mail counter@examiner.ie. To place an order for a photograph you will need the caption and the unique reference code. For example, to order the image of the Wren Boys on p. 238, the caption to this photograph is: 26 December 1974, Wren Boys in St Patrick's Street, Cork, and the reference code is: 181/100.